THE POSER 5
HANDBOOK

THE POSER 5 HANDBOOK

R. SHAMMS MORTIER

CHARLES RIVER MEDIA, INC.

Hingham, Massachusetts

Publisher: Jenifer Niles
Production: Publishers' Design and Production Services, Inc.
Cover Design: The Printed Image
Cover Image: Shamms Mortier

CHARLES RIVER MEDIA, INC.
20 Downer Avenue, Suite 3
Hingham, Massachusetts 02043
781-740-0400
781-740-8816 (FAX)
info@charlesriver.com
www.charlesriver.com

This book is printed on acid-free paper.

Shamms Mortier. *The Poser 5 Handbook.*
ISBN: 1-58450-229-0

Library of Congress Cataloging-in-Publication Data

Mortier, R. Shamms.
 The Poser 5 handbook / Shamms Mortier.— 1st ed.
 p. cm.
 ISBN 1-58450-229-0 (paperback with CD-ROM : alk. paper)
 1. Computer animation. 2. Human figure in art—Computer programs.
3. Poser (Computer file) I. Title.
 TR897.7 .M678 2003
 006.6'96—dc21

 2002151773

Printed in the United States of America
02 7 6 5 4 3 2 First Edition

For Chris and Nicole Berry

CONTENTS

PREFACE

Welcome to *The Poser 5 Handbook*. In some ways, it seems like a century has passed between the release of the first version of Poser and this fifth edition, yet it's been only a scant five or so years. From its inception, Poser broke new ground as a character posing tool, although its initial purpose differed greatly from what it has evolved into. Pushed ahead with masterful programming and the suggestions and interests of one of the most rabid and diverse user communities in the computer graphics and animation industry, and supported along the way by the best extended content providers, there is no longer any question that Poser now takes its well-deserved place as the premier character development and animation tool on the market. If you are a new Poser user, you'll be amazed by all you'll be able to do with a modicum of study and exploration. If you're an old hand at Poser, this newest version will sweep you away, giving you the latest high-end features and tools needed to create professional results. I hope this book will be of use to you in smoothing out your Poser 5 learning curve.

INTRODUCTION

CuriousLabs' Poser 5 is an electronic adventure in character creation and animation. Designed to address the needs of the computer graphics and animation professional, while remaining open and friendly for first-time users, Poser 5 is also one of the most fun-packed applications around.

PREPARATIONS

This book covers Poser for both new and advanced users, so all you really need to know are basic computer skills—how to start your computer and use the mouse, and how to install software from a CD-ROM.

MUST HAVES

The items discussed in the following sections are essential.

CuriousLabs' Poser 5 (Mac and/or Windows Version)

Obviously, without the software, your appreciation of this book will be either nonexistent or severely limited. You need to purchase Poser 5 or upgrade your existing Poser (Version 1, 2 or 3, or 4—piracy is illegal, and hurts everyone). Check with your local or mail order vendor for current prices and upgrade policies.

A Computer to Run the Poser 5 Software

You will need a PowerMac or Pentium system to make creative use of Poser 5. The system used in the creation of this book was a Dell Dimension 1.7GHz running Windows 2000 Professional. This system proved to

be adequate for both creating the illustrations in the book and rendering the animations on the CD-ROM. Faster is always better when it comes to generating computer art and animation, and Poser 5 is a very demanding application when it comes to memory and speed. If you can afford an acceleration card, better yet. If your computer runs at less than 300MHz or so, your Poser 5 rendering speed will suffer.

RAM

The more random access memory (RAM) your computer has the better. More RAM allows for larger scenes, which in turn render faster. The system used in the creation of this book had 2GB of RAM. Running Poser 4 with less than 128MB of RAM is not advisable.

Hard Drive Space

Poser 5 needs at least 500MB of hard drive space, and much more if you plan to download and install other goodies. Just to give you an idea of the space that can be eaten up by Poser 5 and extras, the author's Poser 5 directory contains about 10GB of data, with room for more.

CD-ROM Drive

CD-ROM drives are so commonplace that one is probably already installed on your system. A 10X speed CD-ROM is the lowest speed drive you should be using, with 24X and higher CD-ROM drives now common. Since all of the animations referenced in the book are also included on the companion CD-ROM, you have to have a CD-ROM drive to use the book's CD-ROM added content.

SYSTEM REQUIREMENTS

Poser 5 runs on Windows systems. At the time this book went to press, no Mac version was available. That might change in the future.

Windows

500MHz Pentium class or compatible (700MHz or greater recommended); Windows 98, 2000, ME, or XP; 128MB system RAM (256MB or greater recommended); 24-bit color display, 1024 × 768 resolution;

500MB free hard disk space; CD-ROM; Internet connection required for *Content Paradise*, a new Poser 5 content Web connection utility.

THE STRUCTURE OF THE BOOK

This book has been carefully laid out into two comprehensive sections: *Poser for Beginners* and *Poser for Advanced Users*. Depending on your skill level as an experienced Poser user and/or digital animator, you might want to skim the *Poser for Beginners* part. Moreover, since the new Poser Room navigation is contained in this part of the book, you might want to skim its contents even if you are an experienced Poser user.

Part I: Poser for Beginners

Everyone has to begin somewhere, so don't be embarrassed if you are a Poser novice. The chapters in this part of the book deal with the structure and use of the content and features in the Poser 5 *Rooms*. Other chapters provide helpful material to get you up and running with Poser 5.

Part II: Poser Animation

The chapters in this part of the book walk you through Poser 5's animation features and tools. If you are already familiar with Poser's animation capabilities from previous editions of Poser, you might want to simply browse these chapters to brush up on your skills.

Part III: Advanced Topics

If you are just starting to use Poser, we strongly recommend that you hold off reading the material in this part of the book until you have a better grasp of the Poser basics. The material here is meant for intermediate to advanced Poser users. This includes a number of chapters that go under the heading of "Voices of the Masters," a series of articles and tutorials written by master Poser users, covering various topics.

Part IV: Poser Audio

This part of the book contains information about Poser's audio capabilities, and how to add audio to Poser projects. Advanced Poser users also need to be aware of a number of valuable audio add-on applications

designed to allow Poser characters to literally speak via speech synthesis engines.

Color Plate Details

This separate chapter of the book walks you through the creative thinking and Poser techniques used to generate the color plates shown in the Color Gallery section of the book.

End Matter

Appendix A: About the CD-ROM
Appendix B: Contributor Biographies
Appendix C: Vendor Contact Data
Appendix D: Poser Resources on the Web

On the Book's CD-ROM

Movies, extra props and backgrounds, new templates, poses, and more. The CD-ROM that accompanies this book is loaded with content, adding hundreds of dollars' worth of Poser extras.

HOW TO USE THIS BOOK

The way you use this book will depend on how much experience you have with Poser and computer art and animation in general. Following are some basic categories that describe various users. If one of these seems to closely resemble how you define yourself, you might find it helpful to use the underlying text as a guide for the way to explore the contents of this book.

The Experienced Poser User and Computer Animator

If you are an experienced Poser 3 or 4 user, and have invested a good amount of time mastering your computer animation skills in other applications, you will find Poser 5 easy to understand. Because Poser 5 has tools and options not contained in other 3D applications, however, you should definitely read this entire book, perhaps spending a bit less time on the Beginner's part. You should look at all of the animations and other material on this book's CD-ROM, and customize various items according to your needs.

The Poser User with Little or No Animation Experience

If you are an experienced Poser 1, 2, 3, or 4 user, but have little or no animation experience, be sure to read the animation parts in the Beginner's part of the book thoroughly. Since you are new to computer animation, save your study of Part Two of the book until later, after you feel comfortable creating basic animations in Poser 5. After you have reached that comfort level, you can study and customize the items contained on this book's CD-ROM.

The Experienced Computer Animator with No Previous Poser Experience

If you feel that this user category describes you best, you can use this book to your best advantage by reading and working through it entirely. When you have a good feel for how the general tools and options work, move on to Poser 5's animation capabilities. Remember that although your previous experience as a computer artist/animator might have already given you a good understanding of the necessary vocabulary of the trade, Poser 5 does many things differently than other 3D applications do. Compare Poser 5's options and methods with those you are already familiar with in other 3D software, and if necessary, jot down the differences and similarities for continued comparison, exploration, and study.

The Experienced 2D Computer Artist with No Poser or 3D Animation Background

The great thing about Poser 5 for 2D computer artists ready to move into 3D is that you can use the Poser 5 presets to create astounding 3D graphics and animations with ease. For the 2D artist, creating (and printing out) Poser 5 images is the best way to familiarize yourself with the graphic user interface (GUI) design and the tools. Do this before you move on to the animation options. Create a series of single images. When you feel ready to move into animation, do so slowly, so you can appreciate the options and power of each succeeding step along the way. You should also study as much animation as possible—on TV, in movies, and on the Web. Also notice and pay attention to your own movements as you go about the day, because the human Poser characters emulate real human movements.

The Novice User, with No Previous Experience in Computer Art or Animation

If you were attracted to this book without knowing why, you have still made a wise choice. Before you can make good use of it, however, you

will have to get accustomed to computer basics. This includes a familiarity with your system and its components. You might be an artist or animator whose experience includes art and/or animation with noncomputer media. Poser 5 is a great way to move from "traditional" to electronic media, because you can create amazing graphics and animations with a minimum of effort. More advanced projects will take deeper study and concentration, but that comes in time. When you are ready, purchase the Poser 5 version meant for your computer. Work through the examples presented in this book at a steady and comfortable pace. You will be amazed at how quickly your efforts will result in professional images and animations.

NEW FEATURES IN POSER 5

Poser 5's features and tools are a major leap forward over those in version 4. All of these features are detailed in the following chapters of the book, so here's just a brief rundown:

The Interface: Poser 5 has a new multi-tabbed interface. Each tab takes you to one of seven separate *Rooms* where various operations take place. The tabbed Rooms are named *Pose*, *Material*, *Face*, *Hair*, *Cloth*, *Setup*, and *Content*.

The Pose Room: This is the one place that will be familiar to Poser 4 users. All the standard fare is here, from access to the libraries to the parameter dials, camera, and light controls. The newest feature here are the completely remodeled Poser standard figures, which have far more detailed and numerous morphing controls.

The Material Room: Replacing the Poser 4 Materials dialog, this new Poser 5 utility space allows you to instantly create a nearly infinite variety of textures and shaders for your targeted Poser content. This texturing facility matches or surpasses that of other high-end 3D software on the market. Professional users familiar with developing content for *channel* data in a shader will be right at home here.

The Face Room: The most stunning aspect of the Face Room is the capability to develop unique faces, geometry and texture, for your Poser 5 character from a front and side photograph. This is a very high-end feature, worth many hundreds of dollars all by itself. You can also develop faces from randomizing and caricature controls, and tweak everything until the face is exactly what you want.

The Hair Room: Unlike the rather plastered look of the Poser Hair Props, you can use the controls in this room to create actual stranded hair, hair that also reacts to wind effects. Hair can be applied to any

object in a Poser scene, so it's easy to create grass and other effects as well as human hair.

The Cloth Room: Cloth simulation is the name of the game in this room. Create cloth that shows wrinkles and smooth flowing curves as it moves with any Poser character, or clothes hanging on a clothesline affected by a breeze. Full collision detection is supported as well.

The Setup Room: This module in Poser 5 takes much of what the Poser ProPak did and makes it accessible for all users. Import new models and add Bones and joint limits, among other features.

The Content Room: If your system is connected to the Web, use the controls in the Content Room to grab loads of Poser content, and automatically decompress it and place it in the correct folders and directories on-the-fly.

FireFly: This is Poser 5's new super renderer, giving you the highest possible quality results.

Morph Putty Tool: Sculpt new Morph Targets in real time, just as if you were working with clay!

Collision Detection: Prevent animated objects from passing through each other as they speed along.

New Upgraded Content: Poser 5 has a wealth of remodeled characters and other content, all guaranteed to give you super-realistic professional results.

New Python Scripts: Explore the use of Python Scripts to quickly apply scene elements.

POSER FOR BEGINNERS

1

THE BASICS

In This Chapter

- Important Advancements
- New to Poser
- Basic Poser Operations for Beginners
- Assumptions about Poser 5 Beginners

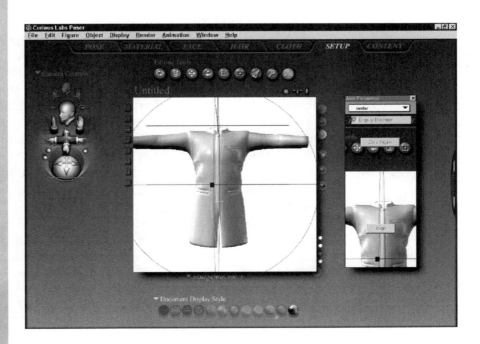

T his first section of the book is mainly for the Poser beginner. It does, however, include chapters that detail the Poser 5 "Rooms," a new interface design for this version of the software. Therefore, the seasoned Poser user might also want to skim this section to glean items of interest.

IMPORTANT ADVANCEMENTS

Poser 5 is loaded with new features, as well as fixes and upgrades to features added in previous editions of Poser. The interface is no longer contained on a single screen, but separated into individual *Rooms*, each dedicated to a number of specific tasks: *Pose*, *Material*, *Face*, *Hair*, *Cloth*, *Setup*, and *Content*. The Rooms are detailed in separate chapters in this part of the book.

Poser: A Brief History

To really appreciate where Poser is today and what it does, it's necessary to understand how and why it came into being in the first place. Poser was originally conceived as a way to provide fast and accurate digital reference models for drawing the human figure, to be used as copy for 2D artists to trace over. It was developed as a utility for Procreation's (a division of Corel Corporation) Painter software. Poser was originally based on the concept of a live model posing in an artist's studio, and on the mannequin models that many artists still have sitting on their work tables. Almost immediately after Poser's initial release, however, users started to clamor for more enhanced 3D and animation features. This constant unrelenting pressure from Poser's user base has continually driven Poser's development toward a more professional 3D art and animation application, and that same user response continues to inspire each new version.

Poser is the result and embodiment of both the 2D and 3D artists' needs. The creation of poseable human and animal models and detailed props for the 2D artist has never been so easy or accurate, as well as affordable. 3D artists and animators, on the other hand, are presented with a huge array of options and functionality in Poser 5. Many of these features could only be found in very expensive workstation-based 3D applications just a few years ago, and many of Poser's newest features have never been seen before on any platform at any price.

NEW TO POSER

Poser 5 has so much new content, representing years of advanced development, that seasoned users will be awed and ecstatic. New users will enter the world of 3D character design and animation at the very summit of the present technology. Everything is fully detailed in the coming chapters, so we'll just include an overview of Poser 5's new features here. Each of the Poser Rooms, a new interface concept in itself, contains its share of the new features. The Rooms are accessed by selecting one of the seven tabs at the top of the Poser interface (Figure 1.1).

FIGURE 1.1 LMB (Left Mouse Button) Clicking on any of the seven Room tabs at the top of the screen transports you to that room.

Let's look at each of the Rooms to detail what can be accomplished there, and what features and tools are present.

The Pose Room

The Pose Room is where you'll spend most of your creative moments in Poser (Figure 1.2).

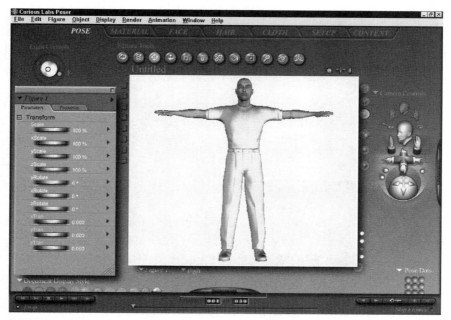

FIGURE 1.2 The interface for the Pose Room, accessed by clicking on the Pose tab.

The Pose Room is where you create and manipulate the components for your Poser scenes. Figures are added, deleted, and choreographed in the poses they are to assume. Adjustments to lighting are made and a viewing camera is selected. Access to the Poser Library is also found here, as well as controls for configuring animations. The Poser parameter dials, used to alter any selected element in Poser scenes, make their home in this room as well. If you've had any experience with Poser 4, you'll be quite familiar with this room, since it represents the Poser 4 interface where you did everything. Chapter 2 details everything in the Pose Room.

The Material Room

The Material Room is where you'll find all of the necessary tools and controls for creating and customizing any and all of the textures in your scenes (Figure 1.3).

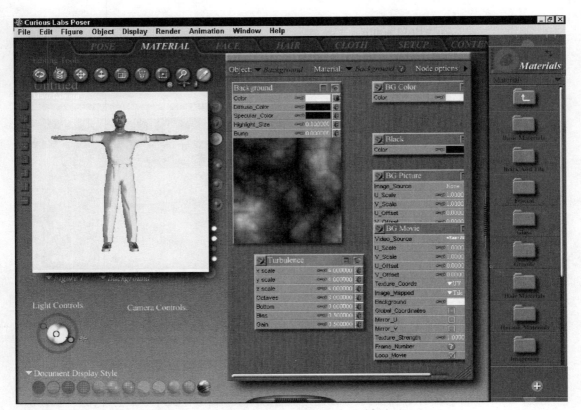

FIGURE 1.3 The new Material Room is where textures are created and modified.

If you have any experience with other professional 3D graphics and animation applications, you will appreciate the depth of the texturing tools that can be accessed from this room. Poser 5 addresses more mapping *channels* (texturing layers) than almost any other 3D software on the market. You can create background and element textures here, and perform a number of additional related tasks. The Material Room is detailed in Chapter 3.

The Face Room

The Face Room is new to Poser 5, and represents the absolute cutting edge of state-of-the-art character development software tools (Figure 1.4).

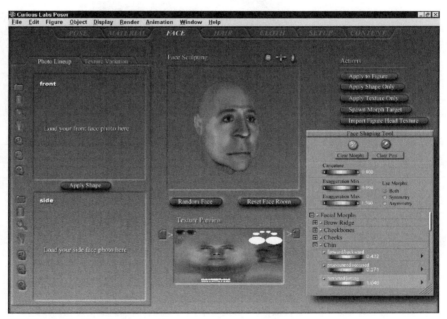

FIGURE 1.4 The Face Room interface.

The Face Room contains controls that allow you to infinitely augment and customize the face geometry of a selected Poser character. In addition, you can import photographic front and side views of faces and create new character faces based on those images. The Face Room operations are detailed in Chapter 4.

The Hair Room

The Hair Room is where you create photorealistic hair on any selected model or model part in the scene (Figure 1.5).

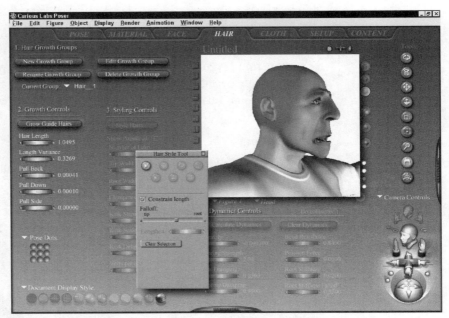

FIGURE 1.5 Now, everything in your scene can sprout configurable hair!

Very few 3D applications on the market allow you to create hair for selected objects, and none can match Poser 5's gentle learning curve. You can use this feature to create grass and other similar features in a scene as well. The Hair Room is detailed in Chapter 5.

The Cloth Room

In the Cloth Room, you can assign real-world fabric properties to any targeted clothing item (Figure 1.6).

Most 3D applications that offer anything like cloth properties features require the purchase of an expensive plug-in. Poser 5 gives you cloth and fabric controls as well as collision detection, another feature reserved for high-end computer software. The Cloth Room is detailed in Chapter 6.

The Setup Room

The Setup Room is meant for more experienced Poser users and computer graphics designers who have some experience with fine-tuning a model's bend and bone elements (Figure 1.7).

Experienced Poser users will recognize the controls present in this room as those found in the Poser ProPack add-on. The Setup Room is investigated in Chapter 7.

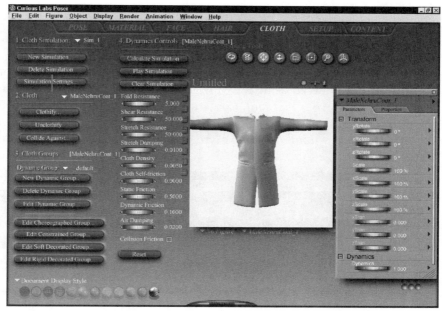

FIGURE 1.6 The Cloth Room controls.

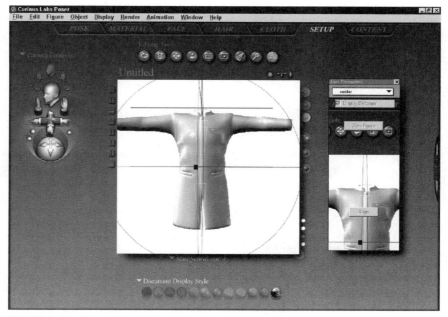

FIGURE 1.7 The Setup Room.

The Content Room

There is no chapter dedicated to the Content Room, also called *Content Paradise*, in this book. The use of the Content Room is extremely intuitive, and requires little explanation. You have to be connected to the Web using the same computer on which Poser 5 is installed to make use of this room. Content Paradise automatically connects you to Poser sites on the Web, where you can download and install new Poser content instantly, with everything placed in the correct folders (Figure 1.8).

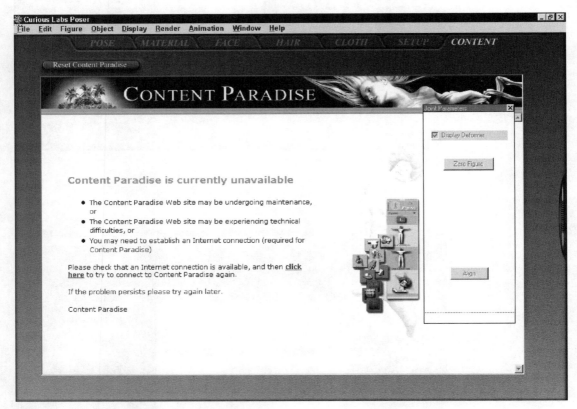

FIGURE 1.8 The Content Paradise interface.

Upgraded in Poser 5

A number of elements in Poser 5 have been seriously upgraded as compared to the previous version. Some of the upgrades involve bug fixes that you won't notice right away, and smaller fixes that won't necessarily jump out at even the most experienced user. Three very noticeable up-

graded features dominate: the new Rooms interface and their enhanced features (covered previously), the new Firefly rendering engine, and the new Poser 5 models.

Firefly Rendering

As part of the enhanced Rendering palette, the Firefly engine produces super high-quality image and animation output for high-end printing, film, and broadcast needs (Figure 1.9).

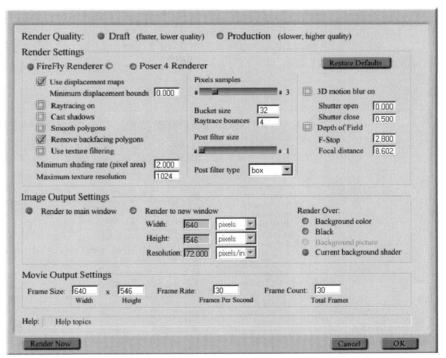

FIGURE 1.9 The brand new and greatly enhanced Rendering options include a button for the Firefly rendering engine in Poser 5. The Poser 4 basic rendering controls have been completely replaced.

New Poser 5 Models

The bar has been raised much higher for Poser high-quality models in Poser 5.

The Poser Content CD

Poser ships with two CD-ROMs. One holds the application, and the other is packed with content. Placing the Install application CD in your drive

automatically initiates the installation process. Placing the Content CD in your drive forces the computer to attempt to install content from the Internet. If you would rather install the content from the Zip files on the CD, browse the CD first and decompress and install the zip files one by one. To browse the CD, RMB click on the CD icon on the desktop and select Explore. You will need WinZip or another decompression utility to do this.

If you plan to install all of the content on your hard drive, be prepared to have a few hundred MB of extra space. The Poser Content CD contains over 500MB of extra Poser Library content. When either importing or opening these files, be sure to show Poser where the correct folders are located, or Poser will be unable to find the files (Figure 1.10).

FIGURE 1.10 Browsing the Poser Content CD reveals a wealth of extra content that can be installed.

BASIC POSER OPERATIONS FOR BEGINNERS

If you already have some experience working with previous editions of Poser, you can skip the next few items. They are meant to alert the beginning Poser user to some important Poser features and command locations.

Parameter Dials

Many of Poser's controls are presented as parameter dials. Parameter dials are used for all sorts of operations, from posing figure parts to customizing various attributes. Parameter dials work by clicking on them with the LMB and dragging the dial left or right. As you drag the dial, you will see the values change in the numeric area next to the dial. You can also click in the numeric area to activate it and type in a specific value. Keeping an eye on the preview screen (the Document window) gives you immediate visual feedback concerning what your parameter alterations are doing.

The right-pointing arrows next to each parameter dial reveal a list of options when you LMB select them. The Parameter Dial palette has two tabs at the top, Parameters and Properties. The parameter dials are under the Parameters tab, and the selected object's properties are under the Properties tab (Figure 1.11).

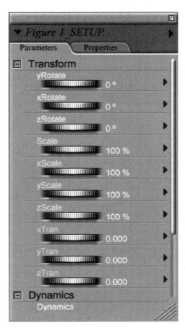

FIGURE 1.11 Mastering Poser's parameter dials is vital for Poser work.

Libraries

All Poser content is stored in Poser Libraries. Content is stored within folders, which might be embedded in other folders. Pose Library content includes *Figures*, *Poses*, *Expressions (*previously called *Faces)*, *Hair*, *Hands*, *Props*, *Lights*, and *Cameras*. LMB clicking on the Library Handle will reveal/hide the Library. LMB clicking on the name of the Library will reveal its present content. To select other content in the same Library type, click and hold on the Down arrow beneath the Library name, and select another content directory from the list that appears. To select a highlighted item in any Library folder to add to your scene, LMB click on the double-arrow icon at the bottom of the Library folder. LMB clicking on the single-arrow icon replaces the current selection on the screen with the new Library item. LMB clicking on the Plus sign adds the currently selected item on the screen to that Library folder, and LMB clicking on the Minus sign removes the item in the Library currently highlighted. If you see a statement in this book such as Library>Figures>Clothing P5 Male>P5 Male TShirt, it means to go to the Library, find the mentioned folders, and select that item. A scroll bar appears on the right of each folder that contains too much content to be seen all at once. Click and drag to scroll (Figure 1.12).

Editing Tools

The Editing tools are very important in Poser. They are located just above the Document window by default, although you can click and drag them anywhere you want to customize the interface to your liking. Slide your mouse cursor over the Editing tools to reveal the name of each (Figure 1.13).

Menu Bar

No matter which Room you select, the menu bar at the top of the Poser interface remains accessible and in the same place. The menu bar contains drop-down menus for *File*, *Edit*, *Figure*, *Object*, *Display*, *Render*, *Animation*, *Window*, and *Help*. If the book asks you to go to File>Save As, it means to go to the top menu bar, click on the File menu, and select Save As from the list (Figure 1.14).

ASSUMPTIONS ABOUT POSER 5 BEGINNERS

In order to design this book so that it addresses the concerns of all Poser users, maximizing everyone's skill levels and learning curve, it was

FIGURE 1.12 Poser content is stored in
the Poser Library folders.

FIGURE 1.13 The Editing tools.

FIGURE 1.14 The menu bar.

necessary to assume that the beginning user already has some basic skills and knowledge. If you are a Poser beginner (don't be embarrassed, everyone has to start somewhere), then here is what the author has assumed about you. If any of these assumptions are not on target regarding your present knowledge, you should gather that required skill before jumping into this book:

- You know how to operate your computer, including how to turn it on, load software from a CD-ROM (you have to have a CD), use your mouse to select items on the screen and click/double-click when required, and to navigate to different parts of a software interface when required.
- You own a Windows machine capable of loading Poser. The requirements are detailed in the Introduction to this book. As of this writing, there is no Mac version of Poser.
- You are excited enough by what Poser promises to allow you to do that you will remain motivated through the learning process. Some things will take longer to understand than others, although every step will require some exploration and dedicated time.

If these three basic requirements sound okay to you, there is no reason why you won't be able to realize your Poser dreams after working through this book at a steady pace.

CONCLUSION

In this chapter, we introduced you to the Poser basics. The following chapters in this part of the book will pay attention to what you can do and how you can do it in the seven Rooms. Get ready for some fun!

THE POSE ROOM

In This Chapter

- The Document Window

- The Menu Bar

- The Room Tabs

- Light Control

- Editing Tools

- Camera Controls

- Document Window Controls

- The Parameters/Properties Panel

- Display Style Controls

- Current Figure Element

- Animation Controls Toggle

- Memory Dots

- Library Toggle

- Creating Content

- Important Menu Options

The Pose Room is accessed when you click on the Pose tab at the top of the Poser interface (Figure 2.1).

The tools and command panels that allow you to do things in the Poser Room are indicated by key letters in Figure 2.1, the definitions of which follow.

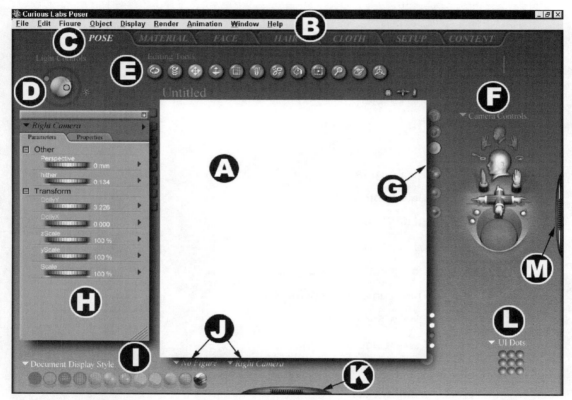

FIGURE 2.1 The Pose Room.

 If you click and drag on the title to those elements indicated by key letters that are movable, you can place the contents anywhere on the Poser interface. For that reason, be aware that the location of the items indicated in Figure 2.1 might be different on your screen.

A. THE DOCUMENT WINDOW

The Document window is where you set up the elements of a Poser scene and display what your *camera* sees. At the very left of this area (almost

invisible) are the controls that set up the Document window for different views. The default view is a single camera view. By clicking on alternate icons at the left of the Document window, you can set up this area to display two, three, or four simultaneous views. Multiple views are valuable when you are placing content in a scene that has to be in some defined proximity from other elements in the scene. You can save a lot of adjustment time by working in multiple views in the Document window.

B. THE MENU BAR

At the very top of the Poser interface, remaining in place no matter what Room you are in, is the menu bar. Each of the nine menus can be accessed by LMB clicking on the title of the menu and selecting one of the displayed options. Just about everything in Poser can be accessed from one of these menus, although it's often faster to use the on-screen icons in most cases. In this book, when you see a direction such as XXX>YYY, it means go to the menu named XXX (perhaps the File menu) and then select YYY (one of the choices listed under that menu). Knowing what is in what menu is something you learn over time through your exploration of Poser, so you need not try to memorize the menu contents at the start.

C. THE ROOM TABS

These seven tabs transport you to any of Poser 5's seven rooms: Pose, Material, Face, Hair, Cloth, Setup, and Content. The tabs remain selectable no matter what room you are in.

D. THE LIGHT CONTROLS

These are the controls for lights. The small spherical icons can be clicked and dragged around the larger sphere to direct the light's XYZ direction. As you reposition a light, you can see the effect instantly in the Document window on whatever objects are in place. Selecting one of the small movable spheres that represent a light already in the scene brings up that light's controls at the right of the larger sphere. These controls represent Light Color, Light Properties, Delete Light, and Create New Light (Figure 2.2).

As you can see in Figure 2.2, there is a slider-like arrangement at the lower left of the light controls that also appears when you select a light.

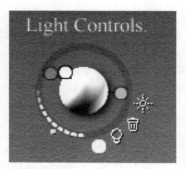

FIGURE 2.2 A light's controls appear when you select that light.

This is the intensity slider. Moving (clicking and dragging) this slider to the left dims the light, while moving it to the right makes the light brighter.

Light Color

Clicking the Light Color button brings up the Light Color Picker. Selecting any color will apply that color to your light (Figure 2.3).

Color is interpreted as emotion by the human eye and brain. In general, blues tend to lower the heart rate of the viewer and cause the image to be seen as calmer, with a preponderance of blues giving a sense of sad-

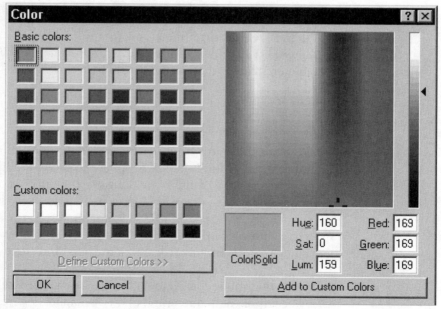

FIGURE 2.3 Select any color for the light from the Light Color Picker.

ness. Greens are interpreted as somewhat eerie. Yellows soften the scene, and are associated with sunlight; however, an overabundance of yellow can become uncomfortable to view. Reds and oranges tend to elevate the viewer's blood pressure and indicate excitement and possibly danger. A painter's trick is to use multiple lights to balance each other in a scene. The best multiple light combination is to use lights with complimentary colors: red/green, yellow-orange/blue, and yellow/indigo (purple). Using complimentary lights pops out the scene contents and creates interesting shadow effects. You can also explore what happens when you select a very dark or even black color for one or more lights. Light color can be keyframe-animated (see Part II of this book), so that your scene can go from midnight to high noon over a number of frames.

Light Properties

When you click on the Light Properties button, the light's properties are displayed in the Parameters/Properties panel (see key letter H in Figure 2.1). See Figure 2.4.

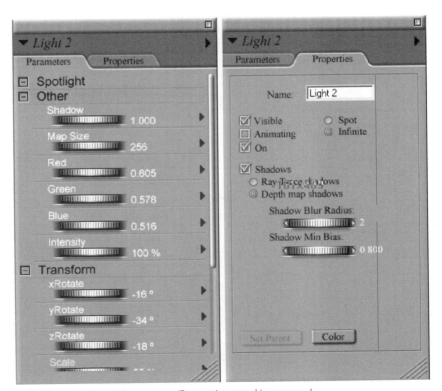

FIGURE 2.4 The light's Parameters/Properties panel is accessed.

Light Properties *Parameters*

Under the Light Properties Parameters tab are controls for adjusting all of the parameters associated with that light. You can adjust the light's Spotlight parameters (if the selected light is a spotlight, as determined under the Properties tab), its shadow, position, and rotation by using the associated parameter dials.

Light Properties *Properties*

Under the Properties tab, you can rename the selected light by typing a new name in the name area. Click the Color button to access the Color Picker to customize the light's color. Use a parameter dial to adjust the edge blur of the light's shadows, and select either RayTracing or ShadowMapping for the shadows. Select RayTracing for more authentic shadow effects, although rendering times will increase somewhat. There are three checkboxes that can be activated here: *Visible*, *Animating*, and *On*. Leave Visibility checked as a default. When Animating is checked, you can keyframe-animate the light (see Part II of this book). The light can be switched off by unchecking the On box.

There is one important button at the very bottom of the Properties panel that you should remain aware of: Set Parent. When you click on it, the Choose Parent panel appears (Figure 2.5).

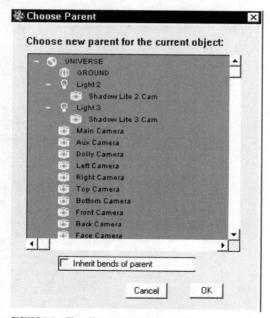

FIGURE 2.5 The Choose Parent panel.

This panel is exactly like the Hierarchy Editor as far as its contents go—something we will revisit later. Everything in your scene is located here. Selecting any item in this list will make that item the parent of the light, meaning that the light will be attached to the selected element. If the selected item is a ball in the scene, for example, the light will move and be rotated as the ball is moved and rotated. If the item is a miner's helmet, and the light is a spotlight, you could create a light that shines from a miner's helmet.

Delete Light

Clicking the Delete Light button (the icon that looks like a garbage can) brings up a panel that asks you if you are sure you want to delete the light. Clicking OK removes the selected light. It cannot be brought back, so use this command with care.

Create New Light

Clicking the Create Light button (the icon that looks like a sun) will instantly create a new light in the scene. You can adjust the light through its appearance in the Parameters/Properties panel.

E. Editing Tools

Each of the icons in this row triggers one of the Editing tools. Left to right, they are Rotate, Twist, Translate (move), Translate (Zoom), Scale, Taper, Chain Break, Color, Group, View Magnifier, Morph Putty, and Direct Manipulation (Figure 2.6).

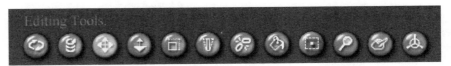

FIGURE 2.6 The Editing tools.

Rotate, Twist, Translate/Move, Translate/Zoom, Scale, and Taper are pretty easy to understand. Clicking on any of these tools allows you to apply that transformation to any selected element in the Document window. If nothing is selected in the Document window, than the translation will be applied to the entire view. It takes a little getting used to for these tools to feel comfortable. Chain Break removes the link between a Parent

and Child object. In the case of the miner's helmet and the linked spotlight detailed previously, selecting the spotlight and clicking on the Chain Break tool would disconnect the spotlight from the miner's helmet.

Selecting the Color Edit tool (it looks like a paint can) and passing it over any content in the Document window (including the background) allows you to instantly change the color of anything selected. If you are using colored lights, be aware that the way they interact with an object will change if you change the object's color.

The Morph Putty tool is new to Poser 5, and is discussed in Chapter 4, "The Face Room," along with the direct manipulation process.

F. CAMERA CONTROLS

Using the Camera Controls, you can adjust the view in the Document window (Figure 2.7).

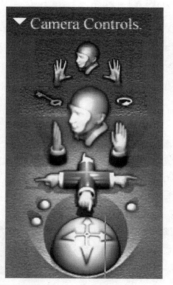

FIGURE 2.7 The Camera Controls.

You can always go to Display>Camera View and select a camera from the listed options, but using the Camera Controls is much quicker. At the top of the Camera Controls are three icons: a Left Hand, a Head, and a Right Hand. Clicking on any one of these snaps you to the Left Hand, Face, and Right Hand camera, respectively.

Below that is an icon of a much larger Head. Clicking and dragging over this icon moves you through various camera views. This icon's direction always indicates what camera is in use. To the left of this icon is a Key icon that is gray when off and orange when on. When on, you can keyframe-animate the camera (see Part Two of this book). To the right is an icon that looks like a circular arrow. When you click it, the scene in the Document window will animate, allowing the camera to fly around the view. This allows you to see the scene's contents from an orbiting perspective. As you move the mouse, the perspective changes. Clicking anywhere in the interface stops the animation.

The larger Hand icons on either side of the large Head icon are used to pan the camera in either the XZ or XY axis. Results are displayed instantly in the Document window. The In/Out and Left/Right camera moves are controlled by clicking and dragging on the crossed-arms icon. The Large spherical icon (called the Trackball) at the bottom controls camera rotation in the Document window, either up/down or left/right. On the sides of the Trackball are three small buttons. Clicking and dragging on these buttons controls Camera Scale, Focal Length, and Roll.

The Camera Controls are used for two main purposes. The first is to get the Camera view as displayed in the Document window exactly where you want it for rendering purposes. The second is to set up different keyframe views when the camera is to be animated (see Part Two of this book).

G. DOCUMENT WINDOW CONTROLS

On the right side of the Document window is a column of additional controls, separated top and bottom. The top controls address Tracking, Depth Cuing, Shadow Display, and Collisions. Tracking affects how the contents of your Document window are displayed, especially in animation preview playback. There are three Tracking options: Box, Fast, and Full. Box Tracking is the fastest, displaying all Poser content as boxes. Use Box Tracking when the position of scene elements is more important than their exact shape. Fast Tracking is the default. In an animation preview, Fast Tracking still shows everything as a box, but selected frames displayed in the Document window are displayed with their forms intact. Full Tracking is used when you need to see the animated preview with the full forms displayed.

At the bottom of this column are four Color Picker controls for Foreground, Background, Shadow, and Ground. Use these buttons for quick color alterations.

H. PARAMETERS/PROPERTIES PANEL

Any item selected in the Document window will have its parameter dials and properties displayed in this panel. This is so you can edit and transform selected elements quickly and accurately. This panel can be accessed, and toggled on or off, by selecting it from Window>Parameter Dials.

I. DISPLAY STYLE CONTROLS

Poser allows you to set the display style of all contents in the Document window. From left to right, the Display Style controls are Silhouette, Outline, Wireframe, Hidden Line, Lit Wireframe, Flat Shaded, Flat Lined, Cartoon, Cartoon with Line, Smooth Shaded, Smooth Lined, and Texture Shaded (Figure 2.8).

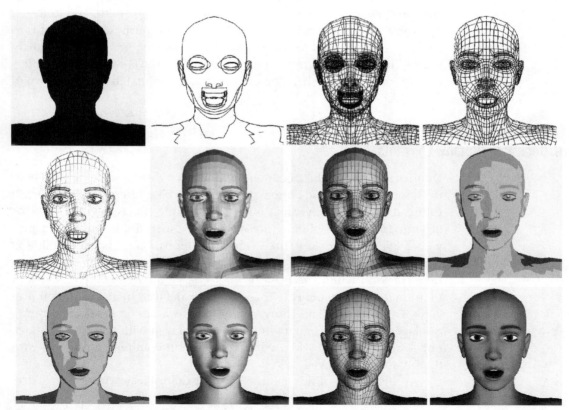

FIGURE 2.8 A Poser head showing the different display styles.

 By going to Display>Element Style, any selected elements in your scene can display different display styles.

J. CURRENT FIGURE/ELEMENT

Clicking on either of these triggers and selecting items from the list allows you to select any item or element in the scene for modification. This is much easier than trying to click on that item or element with the mouse, especially when the scene is very complex.

K. ANIMATION CONTROLS TOGGLE

Clicking on this handle will bring up the Animation Controls. See Part Two of this book

L. MEMORY DOTS

The nine Memory Dots displayed here can be toggled from three separate types: Pose, Camera, and UI Dots. Memory Dots are used to save current modifications in Poser by simply clicking on a dot to store that configuration. Pose Dots save the current selected figure's pose. Camera Dots are used to save the current Camera view and parameters. UI Dots are used to save your current User Interface arrangement, since it is possible to move many of Poser's on-screen items to new placements. After anything is saved to a Memory Dot, it can be recalled by simply clicking on that dot.

M. LIBRARY TOGGLE

Clicking on this handle opens/closes the Poser Libraries. Once the Library panel is open, you can select folder content from the eight Library categories: Figures, Poses, Expressions (previously named *Faces*), Hair, Hands (Hand Poses), Props, Lights, and Cameras. Poser ships with loads of presets for each category, and the availability of both free and priced content can expand these Library folders to the max. In a Poser session, you'll spend a fair amount of time accessing the Library folders.

TUTORIAL CREATING CONTENT

If you are a beginning Poser user, here's an example of how to use the Library folder content to create a Poser scene. If you carefully follow along in this exercise, you will be well on your way to a mastery of the Poser Library. Do the following:

1. Open the Library by clicking on the handle (toggle). Locate the Figures folder, and select the Poser 5 Figures folder. The contents will be displayed in the Library.
2. Double-click on the Figure named Judy_Casual. The Judy_Casual model will appear in the Document window. Select the Face camera, and use the Move XY control in the Camera Controls to center Judy's image in the Document window (Figure 2.9).

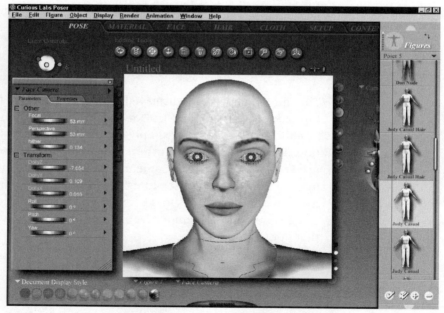

FIGURE 2.9 Judy appears in the Document window when she is loaded in from the Figures Library.

3. Go to the Library and to Poses>Poser 1-4 Poses>Action Sets. Use the scroll bar to find the Hit_from_the_Side Pose, and double-click it. Change to the Main camera, and you'll see that the pose has been applied to Judy.
4. Go to the Library and to Hair>Poser 4 Hair>Female Hair 2, and double-click it. You might have to use the Hair's parameter dials to move the hair into place on Judy's head. Make sure the Hair is parented to Judy's head by

going to Object>Change Parent, and selecting Head from the list (Figure 2.10).

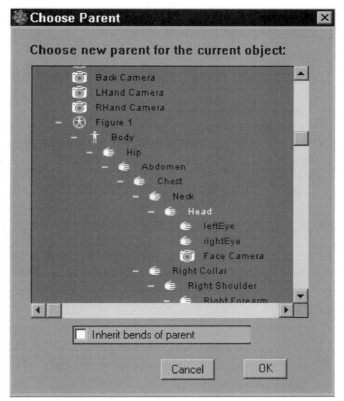

FIGURE 2.10 Make sure that Judy's head is the parent of the Hair object.

5. Go to the Hands Library>Hand Puppets, and double-click on the Bird L Hand and then the Swan R Hand to apply them. When asked what hand to apply them to, answer appropriately.
6. Go to the Props Library>Extras folder, and double-click on the Circus Ring to place it in the scene. You might have to use the Ring's parameter dial to move it up or down on the Y-axis so that it just touches Judy's lowest foot.
7. Double-click on the Poser 5 Box object in the same folder to add it to the scene. Use its Scale parameter dial to scale it down in proportion to Judy. Go to Figure>Drop To Floor to place the box on the Circus Ring. Move it into place with the Transform/Move tool.
8. Go to the Props Library and the Primitives folder. Place a ball in the scene, and drop it to the floor.

9. Go to the Lights>Light Sets folder in the Library. Apply the From_Above light.

10. As a last step, use the Color tool to add a light blue hue to the background in the Document window. Your finished scene should look something like Figure 2.11.

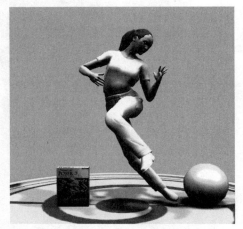

FIGURE 2.11 Your finished scene will resemble this one.

IMPORTANT MENU OPTIONS

Many of the commands and triggers available in the various menus are alternate ways of doing what the on-screen commands and buttons do in Poser. There are a few exceptions, however, items that you should know how to locate and use.

Important Items in the File Menu

Aside from the basic File commands, you should be aware of the location and use of the following functions.

Revert

If you select this command, the scene will revert to the last scene saved to disk. This is like saying "I want to start over again." Be careful when you use this operation, because there's no turning back.

Import/Export

You can import and export all types of content in and out of Poser. Imports include:

- **AVI Footage:** This is a movie file. Movies can be applied as Poser Backgrounds.
- **Background Picture:** Any image in a format that Poser can read can be used as the Background image. Images can be applied to selected objects in the scene from the Material Room.
- **Poser Document/Prop and Poser 1.0 Library:** Poser projects and Prop Libraries from previous versions of Poser can be imported into Poser 5.
- **Sound:** Poser can import and blend in sound files in the WAV format. See Part Four of this book.
- **BVH Motion File:** BVH Motion files are animation files recorded from real human movements. See Chapter 20, "Motion Capture Editing."
- **QuickDraw 3DMF:** 3DMF files are Apple/Mac objects. Poser can import 3DMF objects and place them in a scene.
- **3D Studio:** Poser can import objects in the 3DS format.
- **DXF:** Poser can import objects in the older DXF format, although this format is no longer in favor.
- **LightWave 5:** Poser can import objects in the NewTek LightWave 5 format. LightWave is at version 7.5 as this book is going to press, so newer LightWave objects later than version 5 might not import correctly.
- **Wavefront OBJ:** Poser loves the OBJ object format most of all, and it can easily import OBJ object and texture data.
- **Detailer Texture:** This is an older texture format that is no longer in wide use. It is doubtful that you will have use for this import option.

Exports include:

- **Image:** Poser can export rendered images in a multitude of 2D formats for image editing and compositing applications.
- **Viewport Experience Technology:** This is a 3D object format in wide use on the Web.
- **RIB:** Poser can export to the RIB format.
- **BVH Motion:** Motion files can be exported to the BVH format and imported to animate characters in other 3D applications that support BVH files.
- **Painter Script:** Poser's Sketch Designer data can be exported as a Procreate (Corel) Painter file.

- **3DMF/3DS/DXF/LWO5/OBJ/VRML:** Screen content in Poser can be exported in any of these 3D object formats.
- **HAnim:** Poser data can be exported to Hash Animator files.
- **Detailer Texture:** Poser can export in this now outdated 3D texturing format.

Convert Hier File

This is a high-end feature in Poser. If you create a character in an external application and save out its parts or boned hierarchy data, Poser can interpret that data to allow you to import the fully animatable character into the Poser workflow.

Important Items in the Edit Menu

Be aware of these two important items in the Edit menu.

Restore

If you get off track and need to get back to a non-edited version of a Poser element, figure, light, camera, or an entire scene, use the Restore function to take you back.

General Preferences

Poser allows you to save your screen configuration for the next time it starts up. Adjust the interface components to suit your needs, and go to Edit>General Preferences. When the dialog pops up, activate *Launch to Preferred State* under Document Preferences, and *Launch to Previous State* under Interface Preferences. Then, click the *Set Preferred State* button. You can also select the units of measurement Poser uses here, whether to use file compression, and the location of your preferred Python Script Editor. You can leave these options at their defaults (Figure 2.12).

Important Items in the Figure Menu

Here is a brief look at some items in the Figure menu, and why they are important.

Figure Height

You can automatically apply a Figure Height preset to any Poser figure, including animals, robots, aliens, and humans. Sometimes, the results are

a bit strange, especially when a figure is modeled with clothes on. The options are Baby, Toddler, Child, Juvenile, Adolescent, Ideal Adult, Fashion Model, and Heroic Model.

Set Figure Parent

You can set a parent to any selected figure in Poser, including to another figure or figure element. This will link the items together so that moving, scaling, and rotating the parent (figure or object) will cause the same effect on the linked (child) figure. Multiple figures can be linked to the same parent, so a single parent controls all of them at the same time. This does not prevent you from altering any of the child figure's elements separately. The most important use of this feature is that separate figure elements can be parented to another figure's elements. For example, the left hand of one figure can be parented to the right hand of another figure. Moving the parent figure's right arm will automatically move the connected figure as well.

Conform To

Poser has a folder in the Figure Library called Conforming Clothes. Conforming clothes have separate parts, so that they can bend just like any other animatable Figure. These clothes are loaded to the scene as Figures, not Props. Selecting Conform To allows you to conform/attach the clothing to a selected Figure, so that as the Figure is animated the clothing follows along.

Create Full Body Morph

Morph creation is at the heart of Poser's exclusive capabilities. A morph is a version of an object or figure whose geometry has been altered in either subtle or radical ways.

Use Inverse Kinematics

See Part Two of the book on animation. Inverse Kinematics (IK) is best turned off in most situations, although some animators swear by its use. Turning IK off leads to what is called Reverse Kinematics, the ability to move objects higher in a linked chain and having the rest of the chain tag along. It is debatable, and an issue of contention, whether using IK leads to more realistic movements.

Auto Balance

When selected, Poser attempts to maintain the figure's balance, based on the calculated weight of the collective body parts. This can be invaluable in creating more realistic figure poses and animations.

Lock Figure

Use Lock Figure to prevent a figure or its elements from moving in a scene, so that the figure is not selected by mistake when you want to adjust other figures and props around it.

Lock Hand Parts

Use this option when you want to position a hand without accidentally moving finger or thumb digits.

Drop To Floor

If you are working with a ground plane, always use this option before posing or animating. It literally keeps the figure grounded.

Symmetry

Use this option after you have adjusted elements of a figure that are mirrored on the other side (arm and leg elements). It's the easiest way to create symmetrical elements.

Important Items in the Object Menu

The following items are valuable aids when adjusting and animating any objects in the scene.

Lock Actor

Lock Actor is similar to Lock Figure, except that it is used on nonfigure elements in the scene.

Change Parent

The best way to describe this command is to think of a hat added to the scene. After carefully positioning the hat on a character's head, you want

it to stay in place when the head moves. If you select Change Parent with the hat selected, and then choose the figure's head from the hierarchical list that appears, the hat will remain in place, no matter what contortions the figure goes through.

Replace Body Part with Prop

Any prop in the scene can be used to replace a selected body part on a figure. Let's say you import a head designed in another 3D application. You would first move it into place on the character's neck, and then select the figure's head. Then, you would go to Object>Replace Body Part with Prop, and select the prop from the hierarchal list that appears. Now the prop is glued in place on the figure's neck. You have the option of using Bends with the prop, but that is best left off in most cases.

Load/Spawn Morph Target

A Morph Target can be any figure or prop in the scene that has been modified, usually severely. When you spawn a Morph Target from the selected element, a new parameter dial is created for that altered object. Morph Targets are best applied to a figure's head, although other types of Morph Targets are also possible. The figure or object should be saved to the Library after the new parameter dial is created, or the changes will be lost. Morph Targets are also a topic for the Face Room.

An Important Item in the Display Menu

You should be aware of the following item in the Display menu.

Paste into Background

Use this command to copy whatever the scene content is currently to a background image. It's a great way to create 3D background images that can be used in any future Poser project.

Important Items in the Render Menu

The following two items in the Render menu are important for you to consider. We discuss rendering itself in a number of other chapters in the book.

Sketch Style Render

If you select this option, the settings in the Sketch Designer are used for the Document window. We cover the Sketch Designer in Part Two of the book.

Antialias Document

Use this command when you need to get a more accurate idea of what a rendering will look like. The contents of the Document window will be antialiased.

An Important Item in the Animation Menu

This item in the Animation menu is often overlooked. We discuss animation in Part Two of the book.

Play Movie File

This command allows you to locate any AVI movie file on your system. The movie then appears in Poser to be previewed. Use this command to preview a movie file that you might want to use as a background.

An Important Item in the Window Menu

The following item in the Window menu is often overlooked.

Document Window Size

Selecting this option allows you to adjust the size of the Document window. This is much more accurate than simply adjusting the size manually by clicking and dragging on the lower-right corner of the Document window. You can also constrain the horizontal/vertical proportions, or change the Document window to match the size of an imported image or movie.

Important Items in the Help Menu

Keep the following two options in mind when you need help.

Poser 5 Help

Selecting this option opens the Poser 5 Help File, which is an indexed PDF document (you need to have Acrobat Reader installed to view this

document). This is more convenient than using the printed Poser 5 documentation, although some users prefer the latter.

Web Links

If you are connected to the Web, this is an option you'll want to use often. Not only can you instantly connect to the CuriousLabs site for updates and news, but you can select to connect to a number of Poser 5 developer and content sites as well.

 We have purposely not covered every item in the respective menus here. Those not covered here are discussed in other chapters that address specific topics in more detail. The menu items covered here call for your special attention as far as their location and use. You don't have to memorize these locations, because you will get to know all of these options as you use Poser.

CONCLUSION

This chapter introduced you to very important Pose Room capabilities and tools if you are a new user. Experienced users might have also been reminded of some valuable Poser data by just skimming this chapter. Now it's on to the Material Room in the next chapter.

THE MATERIAL ROOM

In This Chapter

- The Key Letters
- Instant Materials from the Library
- Tutorial Exercises

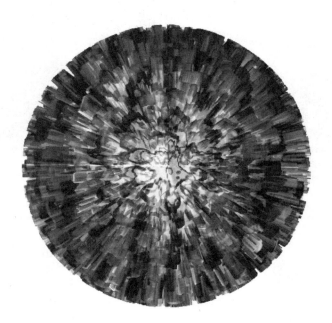

The Material Room, a new feature in Poser 5, is your destination for creating, customizing, and applying textures to any element in a Poser scene. The Material Room's controls and features pop to the screen after you select (click on) the Material tab (Figure 3.1).

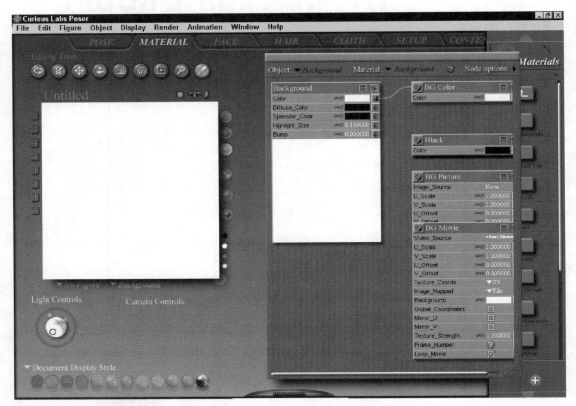

FIGURE 3.1 The Material Room.

Everything on the left side of the Material Room screen should be understandable to you, since it is a replication of icons and elements found in the Pose Room. The panel on the right side, however, is a whole new ball game. These are the controls that help you create and customize textures (Figure 3.2).

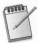

Note that the actual panel content shown in Figure 3.2 will change depending on the scene element selected.

As you can see in Figure 3.2, there are several key letters over the image. These will be referred to in the following text to guide you through the use of the Material Room tools.

FIGURE 3.2 The Material Room's main texturing controls are here, in the Shader panel.

THE KEY LETTERS

Refer to the following text to understand what the keyletters in Figure 3.2 represent.

A. Object

The arrow next to this item brings up the Objects list. Selecting an item from this list allows you to alter or create a texture for that scene element. Everything in your scene, including figures and figure parts, props, lights, and the background is included as an option. This is always your first stop in the Material Room process, since you have to select some scene content to address. Whatever is already selected in the scene will be automatically selected in the Material unless you override that selection

by choosing something else from the Objects list. Please note that lights are a possible target for textures in Poser 5. If you use a texture on a light, everything in your scene affected by that light will be affected by the light's texture component.

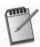

If you select Background *from the Objects list, you must use the new FireFly renderer, not the standard Poser 4 renderer, to create texture-based backgrounds. In fact, it's best to use the FireFly rendering option for all Poser 5 final renders.*

B. Material

Poser figures have materials (textures) for many different elements. Any single Poser figure or character can incorporate different textures for any of these elements, so you would expect to be able to address the customization of each of these textures/materials separately in the Material Room. Using the expanded list that pops up when you click on the arrow for the Materials option (keyletter B in Figure 3.2) allows you to select the figure or prop element whose present texture/material you want to customize (Figure 3.3).

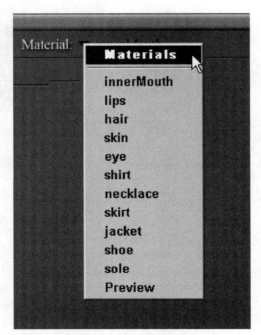

FIGURE 3.3 When the Materials list appears, it displays the elements of the figure whose textures/materials can be addressed.

Multi Sub-Object Materials

Poser 5 addresses multi sub-object materials for any selected figure. Each figure has the potential of appearing as an infinite variety of characters. This is especially the case for clothed figures, whether the clothing is part of the model or conforming or prop clothing added later.

C. Options

The list that appears when you click on the arrow next to Options deals with *Nodes*. Nodes is Poser's name for material attributes, or types, that can be selected, adjusted, and applied to any material or sub-object material. The five Node types are *Math* (Math Functions, Color Math, Blender, User Defined, Simple Color, Color Ramp, Edge Blend, and Component), *Variables*, *Lighting* (Diffuse, Specular, Raytrace, Environmental Map, and Special), *3D Textures* (Fractal Sum, fBm, Turbulence, Clouds, Marble, Noise, Granite, Wood, Cellular, and Spots), and *2D Textures* (Image Map, Tile, Brick, Weave, and Movie). The 3D Textures options are basic formulas that allow you to create your own textures. The Image Map and Movie options under 2D Textures allow you to apply your own images or AVI movies as textures to any selected material or sub-object material. To make matters even more complex, endless combinations of all of these Node options can address any element in your scene. As Nodes are added, their control panels appear for customized tweaking.

Adding Nodes from Node Options

Selecting any of the Node types from the Node Options list will add their control panels to the screen. Nodes added in this way will not be connected to any Poser surface, and will have no effect on any resulting material until you *wire* them in. To wire a node to the Poser surface for the selected material or sub-object material, click and drag from the Node panel's upper-left connector to the connector at the right of the Poser Surface connector you want to address. The Poser Surface connectors are at the right of each material channel for the material. Every material has a number of channel components, displayed in the Poser Surface panel (Figure 3.4).

Adding Pre-Connected Nodes

There is another way to add Node control panels that is suggested as the method to use when you already know exactly what material channel

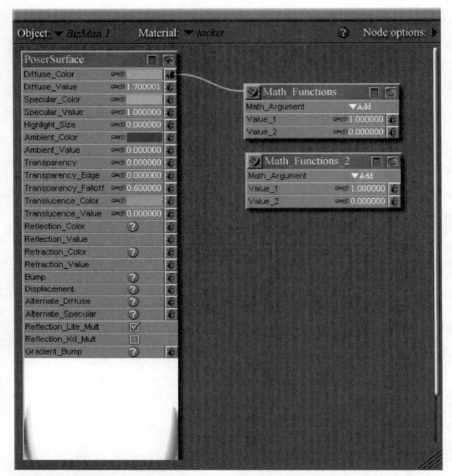

FIGURE 3.4 When a node is wired to a material channel, you will see a line connecting it to that channel. The top node's control panel is shown connected, while the bottom node's control panel is not.

you want to address. Simply RMB click on the Node connector at the right of a channel in the Poser Surface panel, and add the node from there. It will be automatically wired to that channel.

Removing All Material Sub-Object Nodes

There is no limit to how many nodes and node varieties can be added to any single material or sub-object material. Sometimes it's necessary to re-move separate nodes or all of them in order to wipe the slate clean and begin again. To remove any single node's control panel, select the control

panel's title first, and then RMB click on the title. A menu of selections will appear. Select Cut, and the panel will be deleted, along with its wiring. To remove all Node panels from the screen at once, RMB click in an empty area to bring up the Node Options. Go to *Select All*. RMB click again, and select Cut. All the Node panels are deleted, along with their wiring.

The Material Channels

Although the Poser documentation does not refer to the contents in a Poser Surface panel as *Channel* data, we're using that term because it is an industry standard way of describing different material attributes. The term will be very familiar to you if you have had any experience with other 3D art and animation software. If you are a new user, then it's a term with which you definitely should become familiar. Channel data allows you to separate and segment specific attributes that combine to create the final look of a material. Depending on what type of object you are addressing in Poser, the number and names of the channels involved in the Poser Surface panel changes (Figure 3.5).

Channel Types

The Channel Types are standardized for all 3D applications as far as their names and what they address. Poser 5, however, takes channel naming a step further by including some unique channel types not found in other 3D applications. Table 3.1 lists Poser 5's Channel Types, and what their contents address in a Poser material.

FIGURE 3.5 The Poser Surface panel for Figure, Ground, Prop, Light, and Background present some differing channel arrangements.

TABLE 3.1 Poser Surface Channel Types

CHANNEL TYPE	STANDARD OR POSER 5 UNIQUE CHANNEL	WHAT THIS CHANNEL DOES	CHANNEL CONTROL
Diffuse Color	Standard	Data in the Diffuse channel affects the color or hue of a material.	Select the Diffuse Color data from the color swatch or by connecting a Node controller.
Diffuse Value	Standard	Data in this channel affects the strength of the Diffuse Color channel data. All Value channel options are controlled by the grayscale value of Node contents, or by adjusting a parameter dial.	Select the value by adjusting the parameter dial* or by adding a Node controller with grayscale image data.
Specular Color	Standard	Specular color is the color or image contents of the *hotspot* that appears when a light shines on the object.	Select the Specular Color data from the color swatch or by connecting a Node controller.
Specular Value	Standard	Data in this channel affects the strength of the Specular Color channel data.	Select the value by adjusting the parameter dial or by adding a Node controller with grayscale image data.
Highlight Size	Standard	Data used here controls the size of the Specular hotspot.	This is usually controlled by a parameter dial, although you can also use a node.
Ambient Color	Standard	The accumulated indirect overall light in a scene as it affects the selected object. In some 3D applications (notably Corel's Bryce), Ambience is the color or image data emitted by the object when all the lights are off.	This is usually controlled by a color swatch, although you can also use a node.
Ambient Value	Standard	The intensity of the Ambient Color	This is usually controlled by a parameter dial, although you can also use a node.
Transparency	Standard	The percentage of transparency of the selected element's material. 0 is opaque and 1 is completely transparent, while values in between are transparent to a varying degree.	This is usually controlled by a parameter dial, although you can also use a node. If you use a node, transparency is controlled by grayscale image data.

TABLE 3.1 Poser Surface Channel Types (*continued*)

Transparency Edge	Standard in high-end 3D applications	This control sets the transparency of the object's edge. 0 is opaque and 1 is completely transparent, while values in between are transparent to a varying degree.	This is usually controlled by a parameter dial, though you can also use a node. If you use a node, transparency is controlled by grayscale image data.
Transparency Falloff	Standard in high-end 3D applications	This value determines how the object's material will address transparency over the entire object. When the fall-off value is small, a sharper edge is visible. When the value is large, the edge starts to disappear. At 1.0, there is no edge. This value works with the Transparency Edge value.	This is usually controlled by a parameter dial, although you can also use a node. If you use a node, transparency is controlled by grayscale image data.
Translucence Color	Poser 5 unique	When the object is transparent to any degree, this is the color of the light passing through the object.	Set by a color swatch or data from a connected node.
Translucence Value	Poser 5 unique	This sets the strength of the Translucence Color.	This is usually controlled by a parameter dial, although you can also use a node. If you use a node, transparency is controlled by grayscale image data.
Reflection Color	Standard	This sets the Reflection Color, the tint of a reflected image.	This is usually controlled by a parameter dial, although you can also use a node. If you use a node, transparency is controlled by grayscale image data.
Reflection Value	Standard	The intensity of the Reflection Color is set with this value. All materials have a Refraction Index Value.	This is usually controlled by a parameter dial, although you can also use a node. If you use a node, transparency is controlled by grayscale image data.
Refraction Color	Poser 5 unique	Refraction is the ability of a object to bend light. This value sets the color of the refracted data.	This is usually controlled by a parameter dial, although you can also use a node. If you use a node, transparency is controlled by grayscale image data.

(*Continues*)

TABLE 3.1 Poser Surface Channel Types (*continued*)

CHANNEL TYPE	STANDARD OR POSER 5 UNIQUE CHANNEL	WHAT THIS CHANNEL DOES	CHANNEL CONTROL
DRefraction Value	Standard in high-end 3D applications	This is the effect seen when an object in back of the selected transparent object looks warped by the light being bent, like a straw seen in a glass of water.	This is usually controlled by the Lighting>Ray Trace Node, and the Diffuse and Specular Color should be set to a dark gray.
Bump	Standard	Bump mapping is a way of cheating to get a 3D surface effect without actually warping the geometry of the object or sub-object.	A bump map needs grayscale image data, so any node that addresses grayscale image data can be used to create a bump map.
Displacement	Standard	Grayscale image data placed in this channel will warp the actual geometry of the object or sub-object.	Use a node to determine the image data, and an associated parameter dial to determine the degree of displacement (0 to 10).
Alternate Diffuse	Poser 5 unique	This channel addresses alternate diffuse lighting effects, used especially for Poser Hair objects.	Use any of the Lighting Nodes to control this channel data as a first choice.
Alternate Specular	Poser 5 unique	This channel addresses alternate diffuse lighting effects, used especially for Poser Hair objects.	Use any of the Lighting Nodes to control this channel data as a first choice.
Reflection_Lite_Mult	Poser 5 unique	This is on by default, allowing the reflected data to be rendered darker and therefore more visible.	Checked or unchecked.
Reflection_Kd_Mult	Poser 5 unique	Off by default. When checked, this allows the reflected data to be colored by the Diffuse color.	Checked or unchecked.
Gradient Bump	Poser 5 unique	This channel is reserved for Poser 4 users who need to place an older bump map file (.BUM) on an object.	Use an image map here for the bump data. Select the Poser 4 rendering option with *Ignore Shader Trees* checked.

*When the controller is a parameter dial, it means you would take the following action. Click on the value of the channel to reveal the parameter dial by clicking and dragging left (negative) or right (positive), and click on an empty area of the screen to hide the parameter dial and set the new value.

Multiple Wiring

When you connect a controller to a Channel node, its data can be connected to multiple nodes just as easily. In addition to that, any of its components that show a node connector can get their data from other Node control panels. The result is a possibly very complex wiring diagram. This allows you to create some very subtle material components for any object or sub-object (Figures 3.6 and 3.7).

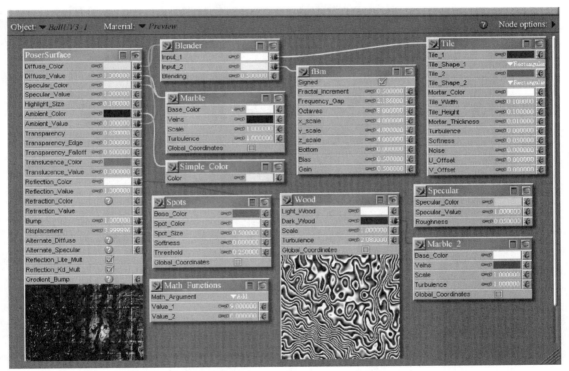

FIGURE 3.6 A Shader Tree diagram with multiple connections and multiple Node control panels.

Help at Any Time

Anywhere you see the icon with a question mark in the Material Room (or in any other Poser Room for that matter), you can click on it to reveal a detailed Help panel concerning the specific feature to which the icon is related. This is specific to that item, differing from the Help options in the menu bar, which bring up the Poser 5 PDF document or connect you to sources on the Internet.

FIGURE 3.7 The result of the Shader Tree in Figure 3.7 applied to a Ball object from the Props Library.

D. Material Preview Area

All of the Node panels have a connected preview area that shows you exactly what each node, or combination of nodes, looks like when rendered. The preview is toggled on and off by clicking on the button at the upper right of each Node control panel that appears.

E. Node Connectors

Wherever Node Connectors appear, they can activate wired nodes. RMB clicking on a Node Connector allows you to cut, copy, and paste nodes.

F. Node Content Controls

The Node Content control panel allows you to configure the content for the selected node, by using color swatches, parameter dials, or by connecting the components to yet other nodes.

INSTANT MATERIALS FROM THE LIBRARY

One of the Library options is the Materials Library. In the Materials Library are a number of folders with preset materials in them ready to apply to any object or sub-object in your scene. You can also save all of your custom shaders to one of the Materials Library folders for later use. Poser 5's Materials Library and shader controls make Poser competitive with all of the higher-end 3D applications on the market today (Figure 3.8).

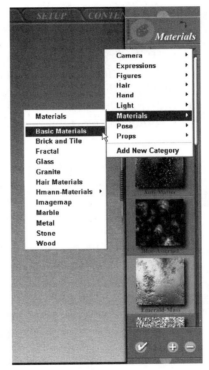

FIGURE 3.8 Use any of the dozens of presets in the Materials Library on your own objects or sub-objects, or store your own customized materials in a folder.

TUTORIAL EXERCISES

If you did nothing but spend 10 hours a day every day of the week for a year creating new materials in the Material Room, you could create new materials without ever repeating yourself. That tells you something about the creative power of the Material Room process and Node options. Here are five explorations you can engage in to create some representative materials.

TEXTURED BACKGROUND

You are no longer limited to using color alone or importing images or movies as Poser backgrounds. In Poser 5, you can use the tools in the Material Room to create background imagery. Here's one example:

1. Go to the Material Room and select Background from the Object list.
2. Click on the Node connector for the Color Channel, and select New Node>2D Textures>Weave.
3. In the Weave Node control panel, set color 1 and color 2 to muted yellow and muted blue, respectively.
4. Set U_Scale and V_Scale to 5.
5. Set the Diffuse Color Channel to a light gray color, then go to New Node>3D Textures>Clouds.
6. Use the following parameters in the Cloud Node control panel: Sky Color/Cloud Color to black and yellow, Scale to 0.1, and Complexity to 4.5.
7. Change the Specular Color channel to a dark red.

Do a test rendering with the FireFly rendering option to see what your new background looks like. If you like it, save the new material to a folder in the Materials Library. If you think it needs work, tweak the parameters some more in the Material Room.

TEXTURED LIGHT GEL

A light addressed by a material is also called a *gel*. The best lights to use with gels are spotlights, since they act like slide projectors. In fact, if you place a movie file on them in the Material Room, the light will actually act like a movie projector. In this exercise, we'll just place a material on a light. Do the following:

1. Place a Box, Cone, and Cylinder from the Props>Primitives Library in a scene. Make them each a light color by using the Color tool.
2. Delete all but one light, and give that light a white color. Make it shine from the left side of the Main View Camera scene.
3. Go to the Material Room with the light selected. The light's Shader controls will already be present in the Shader panel.
4. Change the Color Channel to white and the Intensity to 3.0.
5. In the Color Channel, go to New Node>3D Textures>Cellular.
6. Use the following parameters in the Cellular Node: Scale 0.45, Random Color checked on, Jitter 0.75, and Turbulence 1.0. Save this material to the Basic Materials folder as MyStainedGlass_01.

Do a test render. Everything in the scene looks as if it is textured with your new material, and everything you place in this scene will also look as if it is made of the same material. In reality, the material is being projected by the light (Figure 3.9).

FIGURE 3.9 The material gel causes every object in the scene to take on the new material's look.

TEXTURED PROP

Any Prop you load into Poser can have its texture altered. Do the following:

1. Load the Hi-Res Ball from the Props>Primitives Library into a scene, and go to the Material Room.
2. In the Displacement Channel, set the value to 6.
3. In the Displacement Channel, go to New Node>2D Textures>Weave.
4. Use the following parameters for the Weave Node: U Scale 13, V Scale 3, and Height 3. Leave the other settings as they are.
5. Save the new material to the Basic Materials Library as Nodes_01.
6. Do a test rendering. Displacement mapping creates new objects by altering a targeted object's surface geometry (Figure 3.10).

TEXTURED FIGURE SUB-OBJECT

Any element of a figure can have its material reconfigured in the Material Room. Here's an example:

FIGURE 3.10 The Ball object looks very different when displacement mapping is applied to it.

1. Load the Don Casual character from the Figures>Poser 5 Library.
2. Select the figure's left hand, and go to the Left Hand Camera view. Twist the hand so that you can see it from the top.
3. Go to the Material Room. Select the SkinBody Material. The current material used to map the skin on the body of this figure is displayed. We are going to create a more pathological skin variation in a few simple steps.
4. Change the Diffuse Color to a pale yellow.
5. Change the Specular Color to a bright yellow.
6. Set the Bump Channel value to 10, and use a 3D Textures>Spots Node in the same channel.
7. In the Spots Node, set Base Color/Spot Color to black/white. Set the Spot Size to 0.1, and the Softness to 0.12.
8. Render to preview, If you are satisfied, save this material to the Basic Materials Library as Disease_01.
9. From the Node Options list, Select All>Copy.

10. Open the SkinHead Material. From the Nodes Options list Paste.
11. Do a test rendering. If satisfied, save the figure under a new name to the Figure Library (Figure 3.11).

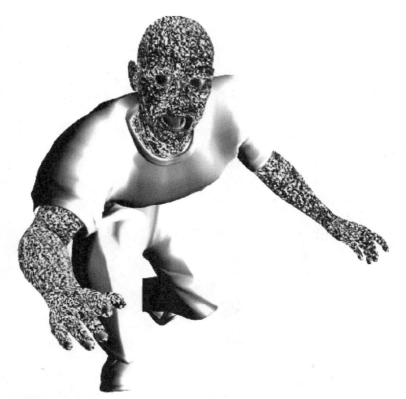

FIGURE 3.11 A scaly figure lurks around the corner.

TEXTURED CLOTHING

Adding new material looks to Poser clothing can consume weeks of your creative time. Let's explore the creation of a colorful gold quilted material. Do as follows:

1. In the Library, add the Props>Dynamic Clothing>Male>MaleNehruCoat to the scene.
2. Open the Material Room.
3. With the coat selected, use a Diffuse Color of pale yellow and a Specular Color of bright yellow. Set the Specular Value to 4.
4. For Diffuse Color, use a Math>Color Math Node.
5. In the Color Math Node, set Value 1 to a 3D Textures Clouds Node.

6. In the Clouds Node, set Sky Color/Cloud Color to yellow/blue. Set Complexity to 6, and leave all other parameters as they are.
7. In the Color Math Node, set Value 2 to a 2D Textures>Tile Node.
8. In the Tile Node, set Tile 1 to a light blue and an Ellipsoid Shape. Set Tile 2 to a bright red and a Rectangular Shape. Set Tile Width and Height to 0.11. Set Turbulence to 0.3.
9. In the same Tile Node, set Tile 1 to a 3D Textures>Marble Node.
10. In the Marble Node, set the Base Color to black and Veins to white. Set the Scale to 0.2, and Turbulence to 1.0.
11. In the Poser Surface Bump Channel, set the Value to 3.0. Set the Node to 2D Textures>Weave.
12. In the Weave Node, set Color 1 and 2 to white, and Base Color to black. Set the U and V Scales to 15, and Height to 7.0.
13. Do a test render to appreciate the gold quilted gold material, and save the material to a folder in the Materials Library (Figures 3.12 and 3.13).

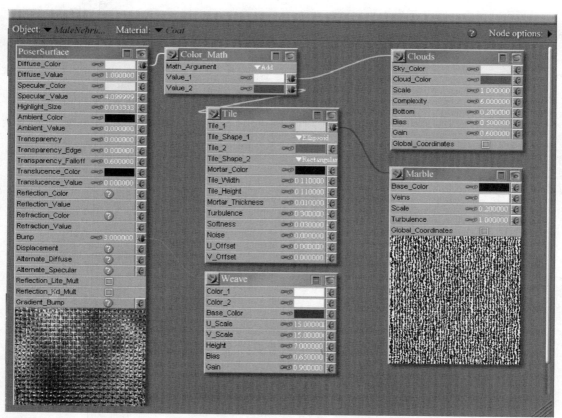

FIGURE 3.12 The shader map looks fairly complex with multiple connected nodes.

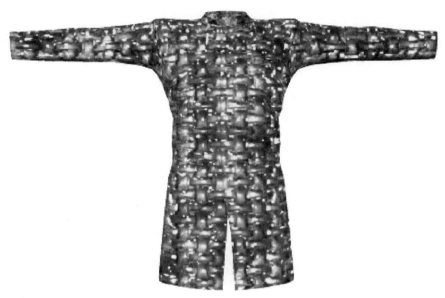

FIGURE 3.13 The rendered gold quilted Nehru coat.

CONCLUSION

We explored the Material Room in this chapter. Next, we move on to the amazing new Face Room.

4

THE FACE ROOM

In This Chapter

- Face Room Controls
- Not All Faces Are Equal
- Reversing Expression Morphs

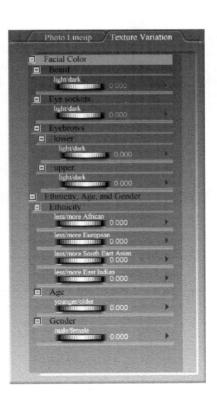

The Face Room is new to Poser 5, and offers you face-shaping features found in no other 3D application. In the Face Room, you can alter both the geometry and the texture map of a Poser 5 head. You access the Face Room by clicking on the Face Room tab (Figure 4.1).

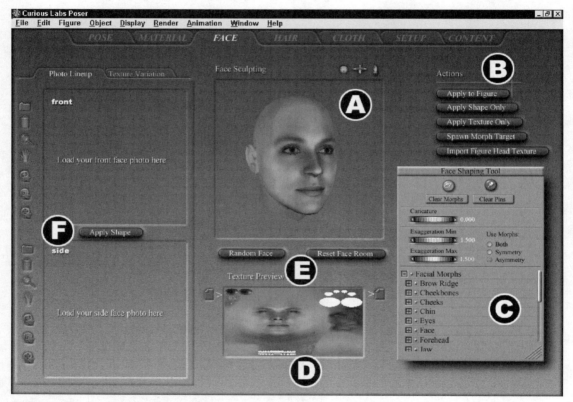

FIGURE 4.1 The Face Room.

FACE ROOM CONTROLS

In Figure 4.1 are a number of key letters placed over the image. These letters refer to the Face Room features and controls.

A. Preview Area

While you are customizing the geometry of a face, keep an eye on this area. This is where you receive immediate visual feedback that allows you to see all of the alterations you are making. At the top right of the

preview area are three mini-camera controls. Clicking and dragging on each allows you to adjust the view in the Preview window.

B. Actions

You can trigger five separate actions by pressing any one of these bars.

Apply to Figure

Clicking on *Apply to Figure* immediately applies the customized data seen in the preview to the model you are working with, changing that model's face geometry and texture.

Apply Shape Only

Clicking *Apply Shape Only* leaves the texture as it is and applies only the altered geometry.

Apply Texture Only

Clicking *Apply Texture Only* leaves the geometry of your base figure as it is, but applies any new texture alterations you've created.

Spawn Morph Target

Spawn Morph Target applies both the new geometry and the altered texture as a Morph Target, which is written as Head to your parameter dials, creating a new dial. Manipulating this dial left or right alters your face geometry according to the Morph Target parameters.

Import Figure Head Texture

Clicking on this option allows you to import your own head texture to apply to the selected geometry. This is used often after you have created the geometry from photographic references, and want to add a higher resolution texture for the figure.

C. Face Shaping Tool

The Face Shaping Tool panel allows you to customize all of the morphs of a Poser 5 head, either interactively or through the use of parameter dials.

The parameter dials are the best way to go to achieve more targeted control (Figure 4.2).

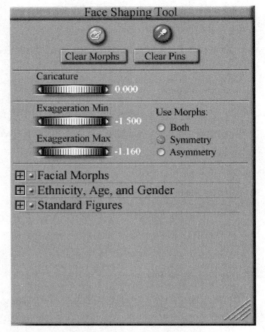

FIGURE 4.2 The Face Shaping Tool panel.

You can adjust the head morphs of a Poser 5 figure in two ways, using the Face Shaping Tool features. The first is to use Morphing Tool operations, and the second is to opt for the use of the parameter dials.

Morph Putty Tool Operations

Here's how to use the Morph Putty Tool operation to customize a Poser 5 head:

1. Load a Poser 5 figure to a scene. Select its head.
2. Open the Face Room, and go to the Face Shaping Tool panel.
3. At the bottom of the panel are three parameter lists that can be opened by clicking on the plus sign at their left: Facial Morphs, Ethnicity/Age/Gender, and Standard Figures. Open the Facial Morphs list.
4. Any element that has a green dot next to it is active. To make parameters inactive, click on the green dot to turn it into a lock.

5. Set the Exaggeration Min/Max values by adjusting the parameter dials. The wider the spread between the Min/Max values, the more the head will move in a morphing process. If you like, you can also adjust the value of the Caricature parameter dial to add more caricature-based features to the morph.

6. With the Morph Putty tool still selected, click to place a point of the head in the Preview window, and drag the mouse up/down left/right to morph the head. Stop when you like what you see.

7. Click on the Pin icon in the Face Shaping Tool panel, and click over a Morph Putty green dot on the head to pin it and prevent further morphing for that point.

8. Continue this process with other Morph Target parameters activated until you create a head that pleases you.

Parameter Dial Operations

The parameter dial alternative to this process is simpler and allows you more control over the morphs. Simply use the parameter dials that are revealed when you open the Facial Morphs, Ethnicity/Age/Gender, and Standard Figures lists.

 The morphing process can easily get away from you and cause severe distortion to the head's geometry. Remember that each morph you apply might conflict with the geometry of another morph, leading to unpredictable results. If you are planning to apply a number of different morphs by parameter dial adjustments, use lower values with each morph, and keep a watchful eye on the preview.

The Morph Putty Tool in the Pose Room

The Morph Putty tool operates on a morphed object in the Pose Room when you activate it by clicking on its icon in the Editing Tools toolbar. It is mentioned here because its use is basically replicated in the Face Shaping Tool panel in the Face Room. Morph Putty operations are best performed in the Face Room, rather than the Pose Room. Even when you use this operation in the Face Room, the use of this tool is somewhat erratic compared to using the parameter dials. The parameter dial options for customizing morphs are suggested as your first choice over the use of Morph Putty operations.

D. Texture Preview

Referring back to Figure 4.1, key letter D points out the texture preview area. You can load a new face texture by clicking on the icon at the upper

left of this area, and save a face texture by clicking on the icon at the upper right.

E. Randomize and Reset

Key letter E in Figure 4.1 represents the Randomize Face and Reset Face Room buttons.

Randomize Face

By repeatedly clicking on the Randomize Face button, the face in your preview will march through a series of character changes. You can stop the process when you get to a face you like, and then use the Face Shaping Tool parameter dials or the Morph Putty Tool process to add more alterations.

Reset Face Room

This button is self explanatory. Clicking on it resets the head geometry to its original Poser 5 parameters.

F. Photo Lineup and Texture Variation

See Figure 4.1 to locate the key letter that points out this feature. At the very left of the Face Room is an unmovable panel with two tabs: Photo Lineup and Texture Variation.

Photo Lineup

One of Poser 5's unique new features is the ability to create head geometry and textures based on your own photographic input. This is an advanced topic, and one that is covered thoroughly in Chapter 12, "Character Making in Poser 5," by S. Brent Bowers. Read Chapter 12 for a detailed tutorial about the Photo lineup process.

Texture Variation

Another new feature in Poser 5 is the ability to alter facial texture maps with parameter sliders, as long as the figure is a Poser 5 figure (Figure 4.3).

As you tweak the Texture Variation parameter dials left or right, you will see the results displayed in both the Preview window and on the

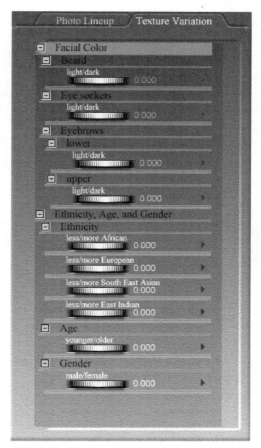

FIGURE 4.3 The Texture Variation parameter dials.

Texture Preview area. Lighten/darken beards and add racial color variations to the facial skin texture easily.

NOT ALL FACES ARE EQUAL

The Face Room is designed to allow you to customize Poser 5 heads and faces. If you attempt to use it with a non-Poser 5 figure, a warning will appear telling you that the results might be unpredictable. Using the Face Room's features to alter the head and face geometry and texture of a non-Poser 5 figure can result in two possibilities. The new head might have a tear between its neck and that of the original body, and/or the facial morphs of the original head might not work at all with the new head.

You can even use the Face Room to add human faces to human-like animals, like a chimp, gorilla, or alien, as long as you are aware of what might happen and are able to redress these anomalies.

Repairing a Neck

If you need to use the Face Room to create a new head for a non-Poser 5 figure, and you suffer the neck-tear situation, there are two ways to repair the damage.

The Right Way

The best way to repair the neck-tear situation is to do the following:

1. Save out the neck from the original figure in a format that your external 3D software can import (e.g., 3ds, LWO, OBJ, DXF, Hash).
2. Import this prop into your external 3D application, and elongate its vertical dimension. Save it out in a format that Poser 5 can import.
3. Import the new neck prop into Poser 5, and parent it to the original neck after adjusting its size and placement to connect to the new head from the body.
4. Adjust the color of the prop to match the skin color of the body and head.

Now you should be able to carefully animate the figure and all of its parts, save for the fact that the face morphs might or might not work.

Cheating

Here's a sneaky way to solve the neck-tear problem. Cover the tear with a neck band prop of some type to hide the tear, and parent the prop to the neck.

REVERSING EXPRESSION MORPHS

In both the Face and Pose Rooms, remember that the parameter dials that affect large areas of the head can also have negative values. They produce emotions that are different from their opposite counterparts. In other words, using a negative *Happy* parameter value will not create a *Sad* look,

but some other subtle emotion. Always explore negative as well as positive parameter values when altering a morph.

CONCLUSION

In this chapter, we detailed the Face Room tools and features. In the next chapter, we move on to the Hair Room.

THE HAIR ROOM

In This Chapter

* Steps to Creating Hair
* The Secret to Creating Unique Hair Forms

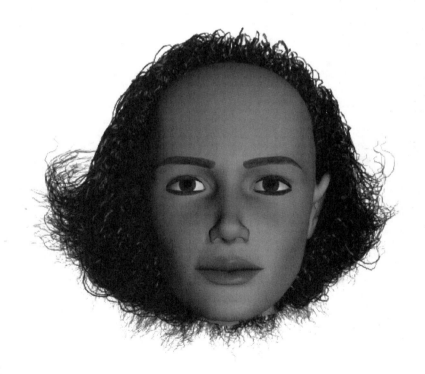

The Hair Room is yet another new Poser 5 feature. The creation of virtual hair is something found only in higher-end 3D applications, and usually at a very high price in addition to what you paid for the software. Poser 5 includes this feature in the price of the software. Using this capability, you can add hair to any Mesh object in a Poser scene, although higher Mesh objects display hair more authentically than low Mesh objects do. The Hair Room is accessed by selecting the Hair Room tab at the top of the Poser 5 interface (Figure 5.1).

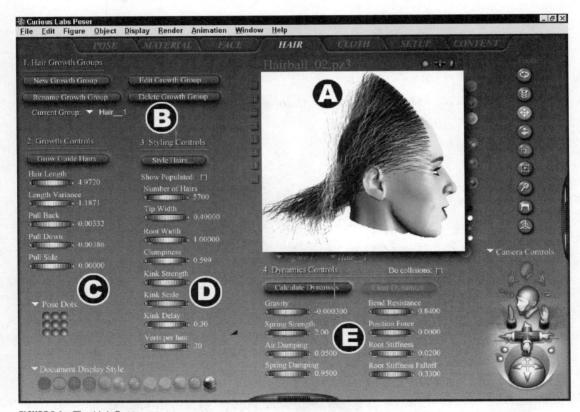

FIGURE 5.1 The Hair Room.

Steps to Creating Hair

The key letters in Figure 5.1 point out the location of various tools and commands that will be noted in the following text. The basic way to create hair in the Hair Room is as follows:

1. The first thing you need is an object from which to grow the hair. You can use the Skullcap objects in Hair>Poser 5 Hair>Skullcap-Wig,

ON THE CD

or the dense mesh sphere or alternate skullcap provided for you in the Models>Misc folder on this book's CD-ROM. Load your choice of hair object to the scene.

2. Zoom in on the object until it appears in clear view in the Document window (key letter A in Figure 5.1).

3. Go to the Face Room by clicking on its tab at the top of the Poser interface.

4. With your hair-base object selected, click on *New Growth Group* under the Hair Growth Group controls (key letter B in Figure 5.1). This will bring up a small dialog asking you to name your growth group. By default it's named Hair_1. Click OK (Figure 5.2).

FIGURE 5.2 Name the New Growth Group.

5. Click on Edit Growth Group under the Hair Growth Group controls (key letter B in Figure 5.1). The Group Editor panel will appear (Figure 5.3).

6. By default, the Grouping tool will appear, and the view in the Preview window will turn into a black silhouette. Use the Grouping tool to click and drag a marquee around that part of the hair-base object that is to grow hairs. If the object is a skullcap, you can select the entire object.

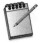

Sometimes, it's a good idea to create several different groups on the hair-base object to create layers of different hair.

7. After selecting the group area, it will turn red in the preview. Close the Group Editor panel.

8. Make sure Hair_1 is selected as your current figure. Click on *Grow Guide Hairs* under Growth Controls (key letter C in Figure 5.1). You will see an array of stubble appear on the hair-base object where the group has been selected.

FIGURE 5.3 The Group Editor panel.

9. Now comes the fun part, designing your hair look. Under Growth Controls (key letter C in Figure 5.1), use the parameter dials to adjust the hair's Length, Variance, Pull Back, Pull Down, and Pull Side values. Take your time to achieve an interesting wig.

10. Adjust the parameter dials under the Styling Controls (key letter D in Figure 5.1) to add more variance to your hair creation. A good value to use as a start for the Number of Hairs is at least 5000. The higher the Kinkiness value, the more the hair will curl.

11. When your hair design is complete, go to the Material Room with the Hair_1 object selected to create a texture for your hair model.

12. Select your hair-base object, and go to its Properties panel. Make it invisible so that all you see is the hair itself. If you have selected the sphere from the Models>Misc folder on the CD-ROM as your hair-base object, the hair you have created might resemble that shown in Figure 5.4.

FIGURE 5.4 This hair was created on a sphere with a dense mesh, which is invisible.

13. At this point, you can save the project as a PZ3 file, and merge it into another project at any time to use the hair. Just for fun, you can also load a Head model from the Figures>Additional Figures Library and scale the hair to fit on the head, parenting it to the head. The hair shown in Figure 5.5 has a neo-shaggy look.

The Hair Edit Tool Palette

If you click on the Style Hairs button under Styling Controls, you will bring up the Hair Edit Tool Palette (Figure 5.6).

Detailed styling takes place in the Hair Edit Tool Palette. When it first opens, the Selection tool is on by default. Clicking and dragging over the Hair model will select individual hairs for customization. Once hairs have been selected, the other tools become available. These tools have labels

FIGURE 5.5 A healthy head of hair.

that appear when the mouse cursor passes over them. Selecting any of these tools allows you to adjust the curl, placement, size, and other parameters of the selected hairs by using clicking and dragging the mouse in the Preview window (Figure 5.7).

Hair Dynamics

Poser 5 allows you to set the parameters for hair in motion, in accordance with the physics of movement. This is another feature that is either rare in high-end 3D applications, or one that you will pay a lot extra to have included. The hair dynamics controls are indicated in Figure 5.1 by key

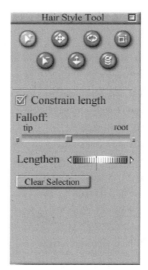

FIGURE 5.6 The Hair Edit
Tool Palette.

FIGURE 5.7 After using the tools in the Hair Edit Tool Palette, the hair look can be altered drastically. Compare this image with Figure 5.5. The same hair appears in both images.

letter E. You can set the following dynamics by adjusting the parameter dials:

- **Gravity:** The force of gravity acts on everything on Earth. The stronger this force, the more force is needed to move an object. You can set the gravity value for hair.
- **Spring Strength:** Set the Springiness value to give the hair a bouncy movement.
- **Air Damping:** This is the resistance of the hair to wind and other forces. Use small increments to adjust this value.
- **Spring Damping:** This value sets the hair's stretchiness.
- **Do Collisions:** When checked, this option sets the hair so that it will not penetrate surrounding objects, such as a head. This increases rendering time in an animation.
- **Bend Resistance:** At lower values, the hair will tend to bend in on itself when moving.
- **Position Force:** The higher this value, the more the hair will be forced to stay in its set position, as if hair spray were involved.
- **Root Stiffness:** This is another hair spray simulator, determining how stiff the hair will be at its roots.
- **Root Stiffness Falloff:** This is a secondary root stiffness control.

Clicking on *Calculate Dynamics* sets up the simulation according to your set values.

Wind Force Fields

After you have created the necessary dynamics for either hair or dynamic clothing, you need to configure a force that will address these objects. That can be done by going to Object>Create Wind Force. This creates a Wind Force prop object with its own Parameters and Properties panel (Figure 5.8).

Wind Force Field Parameters

Tweaking the selected Wind Force Field parameter dials allows you to adjust the following:

- **Scale/XYZ Scale:** Adjusts the size of the force field. A larger-sized force field affects more dynamic objects in a scene.
- **XYZ Rotate:** Rotates the force field to point where you want it to.
- **XYZ Translate:** Moves the Force Field prop in the selected axis direction.

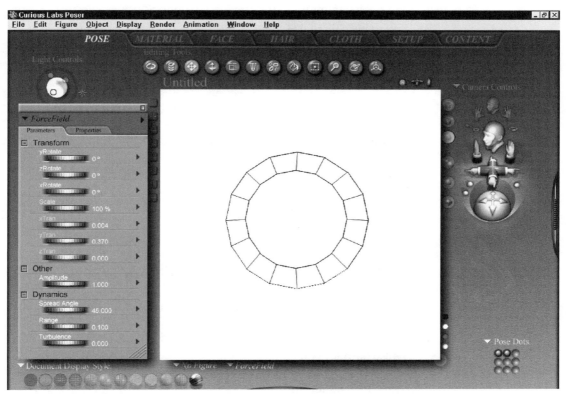

FIGURE 5.8 Adding a Wind Force places a prop outline in your Document window that looks like a large fan, with controls in the Parameters and Properties panel.

- **Amplitude:** Increases the speed of the wind emanating from the Wind prop.
- **Spread Angle:** Adjusts the angle of the wind stream. Lower values create a very thin directed stream, while wider angles disperse the stream.
- **Range:** This parameter sets the overall range of the effect in the selected units.
- **Turbulence:** This parameter sets the amount of irregularity in the wind gusts.

Wind Force Field Properties

After you have set the parameters for the wind, switch Visibility and Shadowing off for the Wind prop, since it is best left unseen in an animation.

Use the *Set Parent* option to link the force field to another object in a scene, especially a moving object.

THE SECRET TO CREATING UNIQUE HAIR FORMS

Remember that you learned this technique in this book first!

The secret to creating unique hair forms is to create skullcaps in a 3D application outside of Poser. Two reasons make this imperative:

- Poser does not contain mesh generation and editing tools that allow for the creation of diverse forms.
- The skullcaps you create absolutely must have a dense polygon mesh in order to accommodate Poser's hair strands.

If you want to create a super high hairdo, for example (maybe like that of Marge Simpson), do the following:

1. Open your 3D application (3ds max, LightWave, Carrara, Cinema 4D, etc.) and sculpt the form, using whatever modeling tools are needed. In the case of a high hairdo, you might start with a cone, and give it a twist on its vertical axis.
2. Increase the polygon count to create a very dense mesh. In 3ds max, as an example, you can do this by applying the Tessellation Modifier a few times.
3. Export the model from your 3D application in a 3D format that Poser 5 can import. Open Poser, and File>Import the hair mesh you just created.
5. Go to the Hair Room with the 3D skullcap hair form selected, and use this form as the base for the creation of a hair look you need. You'll probably have to use 5000+ strands.
6. Go to the Material Room to create a texture for the hair.
7. Return to the Pose Room and bring up the imported prop for the skullcap (not the new hair group).
8. In the skullcap's Properties panel, make the mesh invisible. This will leave you with just the hair strands.
9. Save the new Hair model to a Library folder of your choice. Note that you will have to use the *Select Subset* option in order to save the skull-cap as well.

With the new Hair model (and its texture) saved to the Library, you can apply your spiffy hairdo to any figure you like, just by parenting it to the figure's head (Figure 5.9).

FIGURE 5.9 Some interesting 21st century hair can be created by using a variety of sculpted base objects.

CONCLUSION

In this chapter, we explored the Hair Room. It's on to the Cloth Room in the next chapter.

6

THE CLOTH ROOM

In This Chapter

- Parts of the Cloth Room
- Creating a Cloth Type

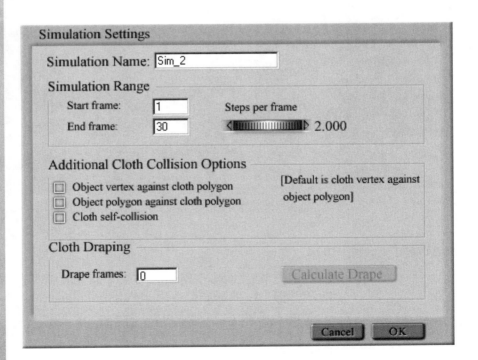

The ability to create objects that behave like cloth is new to Poser 5, with the controls for this feature in the Cloth Room. Access the Cloth Room by clicking on the Cloth tab at the top of the Poser interface (Figure 6.1).

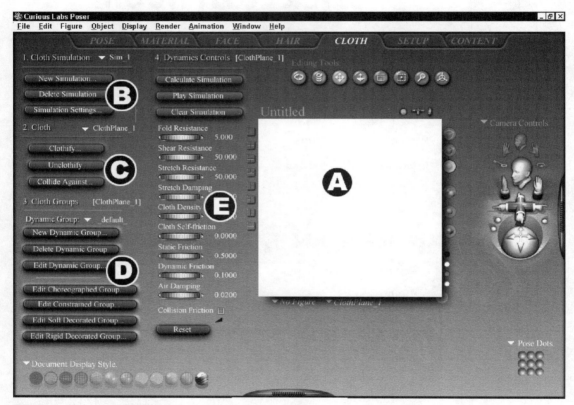

FIGURE 6.1 The new Cloth Room. The key letters indicate separate parts to be detailed.

PARTS OF THE CLOTH ROOM

The Cloth Room has five main areas, as indicated by the key letters in Figure 6.1: A—Preview, B—Cloth Simulation Controls, C—Cloth Controls, D—Cloth Groups Controls, and E—Dynamics Controls.

A. Preview

This is the area that displays the model you are working on. The Preview screen is just a smaller version of the Document window in the Pose Room.

B. Cloth Simulation Controls

There are three buttons here: New Simulation, Delete Simulation, and Simulation Settings.

New Simulation

This is the starting place when you set up Cloth parameters. Clicking this button brings up the *Simulation Settings* dialog (Figure 6.2).

FIGURE 6.2 The Simulation Settings dialog.

- **Simulation Name:** Use a name for your cloth simulation that reminds you what it's about; for example, My_Tablecloth_01.
- **Simulation Range:** The Start Frame/End Frame values usually reference the start and end frames of your current animation, but they don't have to. You can start and stop the cloth simulation at any segment of your current frame range. The Steps Per Frame value, set by a parameter dial, can be kept at the default of 2. Pushing this value higher results in more time for calculations.
- **Cloth Collision Options:** These are options you can explore if your simulation runs into trouble, such as tears or holes in the cloth. The

default is *Cloth Vertex against Object Polygon*. Checking *Cloth Self Collision* is a good idea if you are creating a Cloth object with self-folds, like a towel or flag, although this also adds to computation time.

- **Cloth Draping:** The *Drape Frames* value sets the number of frames required to *settle* the cloth. Clicking *Calculate Drape* starts the simulation process.

When you are finished setting the values, click OK to reveal the *Clothify* button.

Delete Simulation

This is an obvious command. The present simulation is deleted.

Simulation Settings

Clicking here brings up the Simulations Settings dialog again, in case you need to edit your settings.

C. Cloth Controls

The next step is to click the Clothify button, which brings up the Clothify dialog. Here's where you select an object in the scene to transform into cloth from a pull-down menu of all objects in the scene (Figure 6.3).

FIGURE 6.3 The Clothify dialog allows you to select your soon-to-be Cloth object.

Selecting the object and clicking Unclothify returns an object to a non-cloth state. The last step is to tell the computer what object will be used to collide with the cloth. This is done by selecting the Collide Against

button, and selecting that object from a pull-down list in the *Cloth Collision Objects* dialog, which will open a hierarchal list of all objects in the scene for you to choose from (Figure 6.4).

FIGURE 6.4 Select the object the cloth will interact with in the Cloth Collision Objects dialog.

As you can see in Figure 6.4, the Cloth Collision Objects dialog has four parameter dials: *Collision Offset, Collision Depth, Static Friction*, and *Dynamic Friction*.

- **Collision Offset/Collision Depth:** The range is from .1 cm to 10 cm. Collision Offset/Depth emulates cloth thickness (Offset + Depth), and you have to explore various values to get the right one for each simulation.
- **Static Friction/Dynamic Friction:** You will have to explore different values here as well. Friction is the result of one material coming into contact with another. A silk kerchief placed on a glass table has little friction, while a piece of raw wool placed on a piece of rough wood has more friction. Static friction is the value for objects at rest, while objects in motion evidence dynamic friction.

Figure Collision Options

If the Collision object is a figure/character, more options are displayed at the bottom of the Cloth Collision Object dialog (Figure 6.5).

FIGURE 6.5 More options are displayed if the Collision object is a figure or character.

The Figure Collision options are *Start Draping from Zero Pose*, and *Ignore Head/Hand/Feet Collisions*. It's a good idea to leave the Zero Pose option selected. Cloth simulations are best applied before you pose your figure. Checking the *Ignore* options is used when the cloth will not come into contact with head, hand, or feet body parts.

D. Cloth Group Controls

Please read Chapter 24, "Mastering the Cloth Room," by Eddie Johnson to get an idea on how these controls are used.

E. Dynamics Controls

Calculate/Play/Clear Simulation allows you to preview, and if necessary delete, the simulation animation you have set up. The most important parameters for controlling what type of cloth the Cloth object is to emulate are nine parameter dials: *Fold Resistance, Sheer Resistance, Stretch Resistance/Damping, Cloth Density, Cloth Self-Friction, Static Friction, Dynamic Friction*, and *Air Damping*.

- **Fold Resistance:** If your cloth is stiff and unbendable to a large degree, use a higher value here. Lower values allow more bending.
- **Sheer Resistance:** Does your cloth have the ability to bend (sheer) side to side? If so, use lower values here. Higher values prevent sheering dynamics.
- **Stretch Resistance/Damping:** Use lower Stretch Resistance values if your cloth is to stretch, and higher values to prevent stretching. Normally, leave Stretch Damping set to its default of 0.01. You can explore some interesting effects by using higher values.
- **Cloth Density:** Is your cloth light (low value) or heavy (higher values)? Use the parameter dial to set its relative weight.
- **Cloth Self-Friction:** How easily does the cloth slide over itself? Lower values set the sliding as easier than higher values do.

- **Static Friction:** How easily does the cloth slide over solid objects? Lower values increase the sliding, while higher values cause more friction between the cloth and solid objects.
- **Dynamic Friction:** This value is similar to Static Friction, with the difference being that the setting refers to the cloth in motion.
- **Air Damping:** Be careful to move this parameter in small increments, since the results of higher values are unpredictable. This is the cloth's resistance to air when it is in motion; for example, a sail.

Cloth Parameters and Properties

You can control all of the expected cloth parameters and properties in the Parameters/Properties panel, just as you would another prop.

CREATING A CLOTH TYPE

Poser 5 allows you to create two distinct cloth types: Conforming Cloth and Dynamic Cloth.

Conforming Cloth

Please read Chapter 24 to get an idea on how to configure conforming cloth.

Dynamic Cloth

Once you have set up your cloth dynamics in the Cloth Room, all you need to do is to create a physical force in the scene that will interact with the cloth's dynamics.

Wind Force Fields

As with dynamic hair, after you have created the necessary dynamics for dynamic cloth, you need to configure a force that will address these objects. That can be done by going to Object>Create Wind Force. This creates a Wind Force prop object with its own Parameters and Properties panel.

Wind Force Field Parameters

Tweaking the selected Wind Force Field parameter dials allows you to adjust the following:

- **Scale/XYZ Scale:** Adjusts the size of the force field. A larger sized force field affects more dynamic objects in a scene.
- **XYZ Rotate:** Rotates the force field to point where you want it to.
- **XYZ Translate:** Moves the force field prop in the selected axis direction.
- **Amplitude:** Increases the speed of the wind emanating from the Wind prop.
- **Spread Angle:** Adjusts the angle of the wind stream. Lower values create a very thin directed stream, while wider angles disperse the stream.
- **Range:** This parameter sets the overall range of the effect in the selected units.
- **Turbulence:** This parameter sets the amount of irregularity in the wind gusts.

Wind Force Field Properties

After you have set the parameters for the wind, switch Visibility and Shadowing off for the Wind prop, since it is best left unseen in an animation. Use the *Set Parent* option to link the force field to another object in a scene, especially a moving object.

CONCLUSION

In this chapter, we explored the Cloth Room. In the next chapter, we move on to the Setup Room.

7

THE SETUP ROOM

In This Chapter

- Your First Boned Figure

The Setup Room appears when you select its tab at the top of the Poser 5 interface (Figure 7.1).

The Setup Room's focus is on allowing you to create animatable models for Poser scenes, and to allow you to customize the animated parameters of existing models. The core feature of these processes is the creation and adjustment of *Boned* skeletal components of the selected model or figure. "Boning" is a standard industry term that means to add an articulated animatable skeleton to a model. All of the figures that can be animated and posed within Poser 5, and any animatable figures created for Poser 5 by other developers, have a bone structure in place. The only exceptions are models that state that you are expected to bone the model yourself.

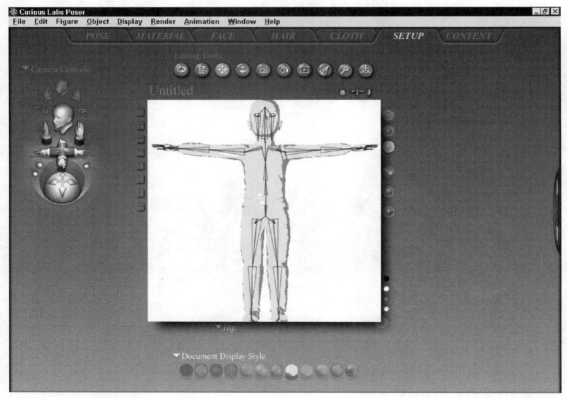

FIGURE 7.1 The Setup Room.

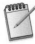

In order to work with Bones in the Setup Room, you should work in a display mode that allows you to see the boned skeleton clearly. The author prefers using the Cartoon *or* Outline *display modes for this purpose.*

If you import a figure developed in another 3D modeling application into Poser, with the hopes of posing its parts, you must bone the figure. If the figure has all of the named parts of a Poser figure, you might be able to simply apply a standard Poser boned structure to your new figure. If you need to bone your imported model from scratch, the suggested procedure to use is as follows:

1. Select the *Bone* icon from the Edit Tool palette, and click and drag out a bone for an element of your figure that is to bend, twist, or rotate. New bones are always added to (made children of) any selected bone. Position/rotate the bone exactly as needed. Create the boned skeleton in this manner.
2. Rename the bone if you need to by double-clicking on it to bring up its Properties palette.
3. Use the Grouping process to assign specific groups in your model to the bones that will affect these groups.
4. Open the Joint Editor and assign rotation orders for the bones. Adjust as necessary.
5. In the Pose Room, assign IK in the Hierarchy Editor.
6. Assign and customize Joint Limits.

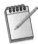

Since boning and associated processes are advanced features of Poser, this chapter does not cover boning in any detailed way. Instead, see Chapters 13, 15, 17, and 18 in the Advanced part of this book for a detailed look at the processes and commands used to develop articulated boned models.

Your First Boned Figure

If you are a beginning Poser user, do the following exercises to get a grasp on how boned figures can be created.

The Articulated Tear

Here is a simple boning exercise. Do the following:

ON THE CD

1. Go to the Model>Prims folder on this book's CD-ROM, and import the Tear1.OBJ object. Accept all of the defaults for importing. The Tear object will appear in your Document window. Scale and center as needed (Figure 7.2).
2. Go to the Setup Room with the Tear object selected. A warning will pop up telling you that the prop will be turned into a figure. Click OK.

FIGURE 7.2 The imported Tear object, shown in the Hidden Line Display mode.

3. Use the Bone tool to add three bones to the tear as shown in Figure 7.3. Work from the tip down.
4. Click on the Grouping tool. When the panel opens, click on *Auto Group*. The bones are automatically assigned groups that encompass different areas of the Tear object.
5. Go to the Pose Room. In Current Figure, select Figure 1>Body Parts, and you should see Bone 1, Bone 2, and Bone 3 listed. Selecting any one will allow you to rotate, scale, or move each separate boned area of the Tear object, by adjusting the relative parameter dials for the selected bone.

Note that if you select Bone 1 and move it on any axis, the entire object moves. This is because Bone 1 is the Parent object.

To learn how to tweak the Joint Editor settings for this object, read Chapters 13, 15, 17, and 18 in the *Advanced* part of this book (Figure 7.4).

FIGURE 7.3 Add three bones like this by clicking and dragging to add each linked bone.

FIGURE 7.4 The Tear object responds to any translations applied to its boned areas, creating new poses.

CONCLUSION

In this chapter, we looked at the Setup Room. In the next chapter, we delve into the posing and customizing of Poser characters.

POSING AND CUSTOMIZING POSER CHARACTERS

In This Chapter

PAYING ATTENTION

Artists and animators have a long history of paying attention to the human body and the bodies of other creatures. To be able to shape a piece of art in a way that reminds the viewer of the body, especially the body in motion, is to call attention to the greatest mystery of life and time. All visual art is the art of storytelling. We can intuit more in a few seconds from a body pose or a facial expression than we can from hundreds of words. The first demand this book makes on you is that you pay attention to all the life forms that surround you, human and nonhuman, day and night. Creating fast and easy populated scenes and movies in Poser 5 is certainly possible, but so is paying attention to the nuances and the finer points involved to deepen your appreciation of the living world. Notice how various life forms dance through your day, and take that same information back to your work and play sessions in Poser.

BASIC POSING

Make sure that you understand how the Editing tools and parameter dials work before proceeding with these exercises.

TUTORIAL

YOUR FIRST POSING EXERCISE

Get ready to take some mental notes, although you might write down what we're going to ask you to do later. After reading this paragraph, put the book down. Relax, either in the chair you're sitting in or another favorite chair. Let your body find a comfortable position. Take note of how each part of your body is either bent or twisted, Where are your feet? Where are your hands? Is there a noticeable angle between your torso and the rest of your body? Take a mental picture of every body part and how it relates to every other body part. Come back to the book after you have done these things. While the memory of your relaxed sitting body pose is still fresh, jot down what you recall. Open Poser 5.

Use whatever figure is on your screen at the start for this initial exercise. Do the following:

1. Import a basic Box prop from the Props Library. Place it somewhere in the center of the scene. This will be a stand-in for the chair you were just sitting in.

2. Resize the box with the Resizing tool in the Edit tools above the Document window. Hold the Shift key down while resizing so that the box has relative proportions to substitute for a chair, as compared to the figure's size.

3. Turn off any Inverse Kinematics (IK) for your figure. Move your figure somewhere in proximity to the box-chair. Use the orthogonal side camera view and the front view. Click Drop To Floor for both the box-chair and the figure.

4. Select and Bend both thighs at a value of –86, using each thigh's parameter dials.

5. Bend each shin at an angle of 72. Move the model so that it sits on the box (use the Translate/Pull tool in the Edit toolbar, while keeping the mouse over the tool, and not in the Document window).

6. This step is optional. We've have added another box to act as the chair back (Figure 8.1).

FIGURE 8.1 The progression of steps so far.

7. From here on, adjust the figure according to the pose you were sitting in. Your pose might be quite different from the one depicted here. Angle the abdomen by using a Bend of –30 or so, so that the model is leaning against the back of the chair. Make the final adjustments later.

8. This relaxation pose is rather complex, since both hands are placed behind the head in a locked position. If you were using IK, you could just move the hand into place and the upper arm parts would follow.

When posing a model, switch camera views as often as necessary to get the best view for the task at hand.

When making global changes to a hand, always select Lock Hand Parts *from the Figure menu. This allows you to select and rotate the hand without accidentally selecting the thumb or a finger joint.*

9. Now for some Poser magic. In this case, we used Figure/Symmetry/Right to Left to instantly snap the left arm and hand into place, instead of arduously modifying them separately (Figure 8.2).

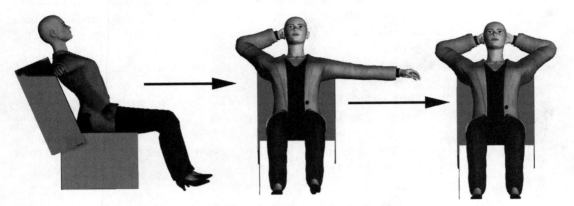

FIGURE 8.2 In this case, Symmetry is used to place both hands behind the head.

10. When you have completed the basic pose, it's time to make small adjustments. First, destroy perfect symmetry a little wherever it exists; organic forms are never completely symmetrical. In this case, we adjusted the model's legs so that they are not exactly at the same angle. It doesn't take much movement to interrupt symmetry, just a little here and there. We also adjusted the model to fit the confines of the chair more accurately. We placed hair on her head for two reasons: to enhance reality, and to hide her hands. We wanted to hide her hands so that a close-up wouldn't reveal that we didn't spend the necessary time locking her hands exactly together. We could have done that, but for this pose, it wasn't necessary (Figure 8.3).

Now that you have the pose you want, the first thing to do is to save it to the Poses Library. Just go to the Poses Library, find a suitable folder, and click the Plus sign. Name your pose and click OK. Since you have the pose, you can apply it to any selected figure that is modeled in a similar fashion (Figure 8.4).

It is seldom wise to apply a Pose across species lines. The Zygote bear model, for instance, dislikes having its forelegs placed behind its head.

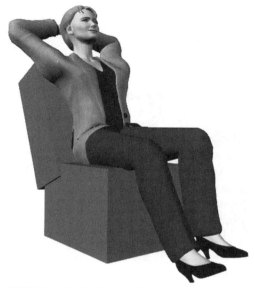

FIGURE 8.3 The final pose after adjustments are made.

FIGURE 8.4 Here we've applied the same pose to all of these models.

TUTORIAL ANOTHER POSING EXERCISE

This time, we'll investigate another pose, one that displays emotion. There are times when your camera is not pointed at the face of a figure. At those times, you have to depend on the overall body pose to work as the narrator, so that the intended emotion is clearly understood by the body pose alone.

One of the best ways to study body poses and how they can evoke emotions is to watch silent films. The poses of the characters are often exaggerated in order to make up for the lack of audio, and for that reason, the poses are easier to understand and mimic.

Here is one way to emote despair with a body pose. You can always add your own personal touches later.

1. Load in a figure of your choice. Despair is a crushing weight, felt by every part of the body. Imagine the figure besieged by a weight above it, and shape the figure accordingly by bending its knees slightly, and rotating the neck so that the shoulders are hunched.
2. Use a Bend of 90 degrees to drop the right shoulder (Figure 8.5).

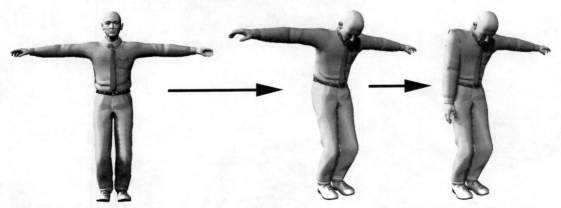

FIGURE 8.5 The weight of despair has affected the model; the knees are bent and the shoulders are hunched. The figure is also bent slightly at the abdomen. The right shoulder hangs limp from the emotional weight.

3. Now we'll use an old painter's trick to emphasize the weight of the situation. When despair hits, we feel as if our extremities have suddenly grown larger. To relate this feeling ever so slightly, select the left hand and use the Scale dial to resize it to 125%. Then, do the same with the right hand.
4. The next part's a little tricky. You have to maneuver the figure's right arm and hand so it hides part of his face. Use the Head camera for close-ups. The idea is to get the hand close, but not to poke any fingers into the head (Figure 8.6).

FIGURE 8.6 The right arm and hand are rotated into position so that the figure's face is partially hidden. On the right is a close-up of the pose.

TUTORIAL

A JOYOUS POSE

Let's do one more pose, just in case the despair exercise left you feeling blue. We'll opt for pure joy. If despair is a weight that drives us down, then joy can be described as an emotion that lifts us up, sort of an anti-gravity response. Where despair makes us fold up and cave in on ourselves, joy opens us to the world and literally lifts our spirits. With all that in mind, load a figure and follow along.

1. Load in your figure from the Library, any figure you will enjoy working with.

2. Use the Bend dial to bend the neck at –25. Go to the Hands Library, and double-click on the Reach hand. When the dialog appears, select Right Hand. Repeat this operation for the left hand. Raise the right shoulder to a Bend of –20, and the left shoulder to a Bend of 20.

3. We could stop right here, but we want a more ridiculous joy. Use a Side-to-Side parameter of –16 on the abdomen. Then, turn the Chest parameter dial to 15. The model bends at the middle.

4. Use a Twist of 77 and a Side-to-Side of 61 on the right thigh. Then, use a bend of 108 on the left shin.

5. We want our model to literally "click her heels," so the left leg has to be brought into position. Use a Twist of –53 and a Side-to-Side of –5 on the

right thigh. Then, use a Bend of 90 on the right shin to complete the pose (Figure 8.7).

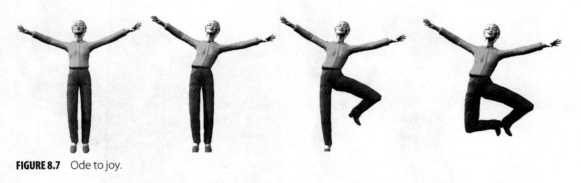

FIGURE 8.7 Ode to joy.

CUSTOMIZING THE HUMAN FORM

If you're an admirer of Bosch or Dali, you will be hungry to explore surrealism in your Poser projects. As long as you are familiar with both the Editing tools and the parameter dials, the surrealist world is your oyster.

T U T O R I A L

FIGURE AUGMENTATION BY GLOBAL RESIZING

Global resizing refers to scaling a selected element of a Poser character while holding the Shift key down with the Resize tool positioned over the selected element, or by using the Scale parameter dial. Either of these operations resizes the selected element in all XYZ directions at the same time. It sounds like a basic function, and it is. The results, however, can be quite interesting. In these exercises, we'll move from some simple customizing alterations to more radical examples.

1. Let's scale a figure's head. Load a Poser figure from any library. Resizing the head looks all the more bizarre on any business-suited figures.
2. Click on the Resize tool in the Edit toolbar. Place the cursor over the head of the model, hold down the Shift key, and click-drag the cursor upward to the right. The head of the model becomes enlarged, almost like a strange human balloon.
3. Now, do the opposite. With the same Resize tool highlighted, place it over the head and click-drag down and to the left, with the Shift key held down.

Now the figure has a pinhead, and the suspicion is that its intelligence suffers a final blow.

4. Bomber Man is our next genetic exploration. Using the same model as before, with its head shrunk, click on the Abdomen element. Using the Scale parameter dial, select a Scale of 40. Notice how scaling the abdomen down gives the model the appearance of a wasp.

5. Resize the left/right shins, shoulders, and forearms to 50. Resize the left/right thighs to 125. We call this fella Bomber Man, since it looks like all he needs is a World War II flying cap and a scarf blowing in the wind (Figure 8.8).

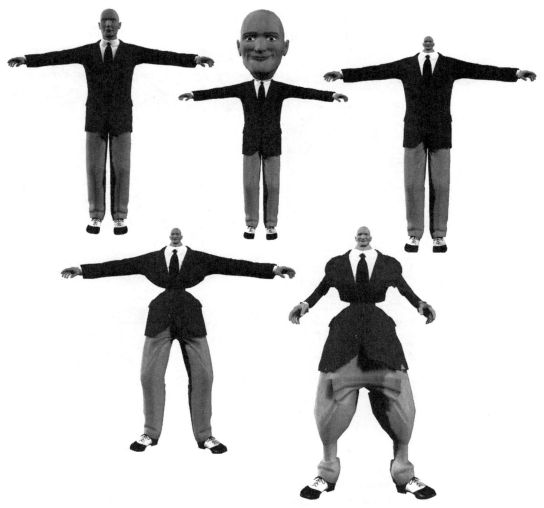

FIGURE 8.8 Variations on a theme, including the modified Bomber Man character.

INTRODUCTION TO DEFORMERS

In this tutorial, you can use any model you like—it's the process that's important. Do the following:

1. Load the model to the Document window, and size it appropriately in the Pose view.
2. Select the head, go to the Head view, and select the Wireframe Display mode.
3. Use the Twist tool to make the head face to your right. Click on the Group tool, and select New Group from the dialog. Name the New Group Nose_1. Using the mouse, click and drag to select just the nose area. Exit the Group process by closing the window. You have just set up a *deformation zone* (Figure 8.9).

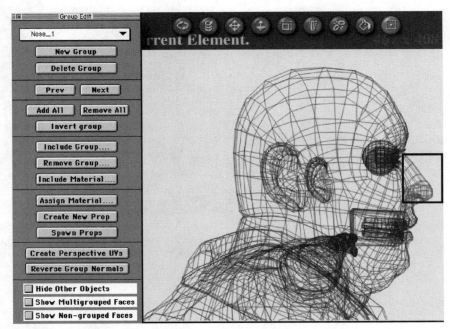

FIGURE 8.9 The Group tool is used to select just the nose of the model.

4. With the head still selected, go to the Object menu and select Create Magnet. When the Magnet appears, resize it and move it away from the head so you can see it clearly. Don't worry if the entire head distorts. Select the magnet's *Zone*. With the Zone selected, go to its Properties window. Click on Group. Your Nose_1 item should now be selected. Close the Properties

window. Adjust the position and size of the zone so that it rests over the nose alone. Just the nose should distort when you move the Magnet. Move the Magnet until the nose distorts in some interesting fashion.

5. Select the head, and from the Object menu, select *Spawn Morph Target*. Name the Morph target Nosey_01 when the window pops up.

6. Select the Magnet and delete it; you don't need it anymore. If you look at the top of your parameter dials for the head, you'll see that you have a new dial called Nosey_01. This controls the morphing of the nose. Explore the creation of additional Morph Targets (Figure 8.10).

FIGURE 8.10 When you tweak the Nosey_01 parameter dial, you alter the shape of the nose.

7. With the head selected, apply a Wave Deformer from the Object menu. Select the Nose_1 Group in the Wave Zone's Properties window. Place the Wave Deformer and its associated Zone as shown in Figure 8.11. Set the Wave's parameters as follows: Phase 0, Amplitude .1, Wavelength 1, Stretch .5, Noise 0, Sinusoidal 1, Square 0, Triangular 1, Turbulence .5, and Offset .5. The nose now exhibits a rhino horn.

Just as you did with the Magnet Deformer, create a Morph Target parameter for this new deform operation. Delete the wave, and the new deform

FIGURE 8.11 A horn is created for the nose.

parameter (we called it *Rhino*) appears as a parameter dial. You can use this same technique to create hundreds of variations for any human figure.

POSING AND CUSTOMIZING HANDS

There are two icons in the Camera Controls that display a left and a right hand. Click on either, and the camera zooms in on the model's appropriate hand (Figure 8.12).

Important Hand-associated controls are contained in a number of places in Poser:

- The *Lock Hand Parts* command in the Figure menu. When selecting a hand on a model, or a stand-alone Hand model, it's important to have this option. Otherwise, it can be difficult to select the hand instead of a finger or thumb joint by mistake.

FIGURE 8.12 The Left and Right Hand icons in the Camera Controls module zoom to a view of either hand.

- The *Properties dialog*. Properties are important for Hand models. You can selectively turn any element's visibility off, which can create hands with fewer digits than normal.
- The *Hands Library Folders* and the *Additional Figures* folder. There are two Hand models, Left and Right, contained under Additional Figures. They are disembodied hands so that you can add them to a scene as stand-alone items. The Hand Libraries in Poser 5 are Hand Poses, and contain far more posed examples than the previous edition of Poser.
- The *Joint Parameters* dialog and the associated Use Limits command are important for hand poses because they lock in the standard values for resizing and other modifications. They might, however, prevent you from doing things such as altering a hand to achieve an alien or monstrous appendage (Figure 8.13).

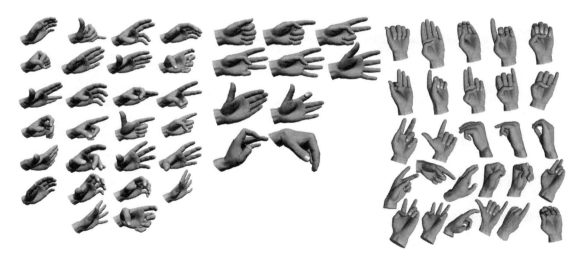

FIGURE 8.13 Poser 5 offers you dozens of preset hand poses.

General Rules for Posing the Hand

The articulated hands in Poser can be positioned into any needed pose in one of two ways. The first is to simply target a hand for a pose from the

Hands Library. You can either accept the Library pose completely, or use it as a basis for making further modifications. This is the easiest way to get a hand posed. The second method, although a little more time consuming, serves best when the pose you desire is nowhere to be found (or anything even close to it) in the Hands Library. In that case, you'll need to go in and pose each digit yourself. When that becomes necessary, follow these rules:

- Always use the Hand Camera view (either left or right) to zoom in close to the hand so you can see exactly what you're doing.
- Instead of trying to click on the appropriate digit with the mouse, use the Elements List under the Document window to select the exact part of the hand needed to be moved into position.
- For a more natural and realistic pose, make sure Use Limits is checked in the Figure menu. This sets a boundary on possible movements, and prevents you from doing things that might cause deformations in the hand's geometry.
- If your hand has to be holding an object—for example, a spear or a hammer handle or some other prop—you can use a fist pose as the easiest way to get the hand into a general position, and then tweak the pose with the parameter dials, especially the Grasp and Thumb Grasp options.

Parameter Dial Alterations for the Hand

The three most important hand controls that can be manipulated with the hand's Parameter Dials are *Grasp*, *Thumb Grasp*, and *Spread*. The parameter dials associated with selected finger and thumb joints are specific to those elements, not to the overall hand. Grasp, Thumb Grasp, and Spread are important when you want to show some hand movement from frame to frame in an animation, but aren't interested in the fancier poses offered by specific items in the Hand Poses Library (Figure 8.14).

Customizing Hands

The general process for working through a Hand customizing process is as follows:

1. Apply the modifications.
2. Save the new model to the Library in an appropriate folder.
3. Save the new pose (if there is one) to the Hands Library, preferably in a new folder named for your collection (such as MyHands or another suitable name).

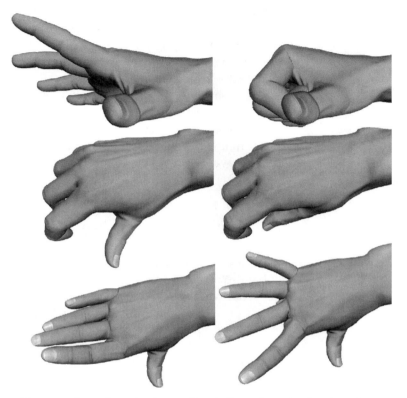

FIGURE 8.14 Grasp closes the fingers, Thumb Grasp closes the thumb, and Spread splays open the fingers. Top: Grasp open and closed; Middle: Thumb Grasp open and closed; Bottom: Spread closed and open.

Types of Hand Customizing Options

Some modifications can be applied easily to a hand in Poser, and some require more planning and work. In general, the two simplest modifications you can apply to a hand or to any of its parts are resizing and tapering. Each of these has its limits, beyond which the targeted hand will start to warp and deform uncontrollably.

It's always a good idea to rotate the hand after applying any modifications, since this allows you to see if any anomalies were caused by your efforts. If deformations are caused, then you have to decide to either retrace your steps and correct them, or to accept them as part of the new model.

When you customize hands, there are two ways to engage in the process. The first is to load one of the stand-alone hands from the Additional

Figures Library folder. This is a good option when you want to apply the hand either as a singular floating object, or to have it replace a hand (or any other body part) on a figure already in your scene. If you need to replace both hands of a model already in your scene, however, you might want to take another route. In that case, use one of the Hand Camera views to zoom in on a hand that you would like to customize. Apply the necessary modifications. When you're finished, you can simply elect to use the *Symmetry* command to apply the same modifications to the other hand. If that completes the model, then save the model out with a new name, or save it out when all modifications are completed.

The Most Difficult Modification

It's enticing to think that because Poser contains a Visible/Invisible option in the Properties dialog and on the Hierarchy List that you could easily just make some selected fingers invisible to create a two-, three-, or four-digit hand. You can do this, as long as you also address some attendant issues. When you make an element of a model invisible, you expose a hole where it once was. In the case of a hand, the hole is most visible in the front and top views of the hand. The hole will render, unless you do something to mask it. You can place and size an elongated sphere (from a Ball prop) to mask the hole, or use another imported object to do the same thing. However, that's only part of it. From that point, the hand (or the whole body of the model) will have to be glued to the patching object by making that object the parent (Set Figure Parent in the Figure menu). This can present big problems when animating, because only the patching object can be set to animate. The solution? Do not make any elements of the hand invisible to achieve an alien or cartoon hand—it isn't worth it. Besides, if you really need an alien hand, you can model it in another 3D application and import it for placement in Poser.

Alien Hands

If you want to remain in Poser, and still need to create alien-looking hands, you have some options for doing so. Raising the Scale value on the tip of the fingers can create bulbous or padded looking fingertips. Decreasing the Scale of the fingertips to 10 and then lengthening the X Scale to 300 creates sharp, knife-like finger tips. Playing with the Taper values for the hand and all of its digits can also lead to some interesting looks (Figure 8.15).

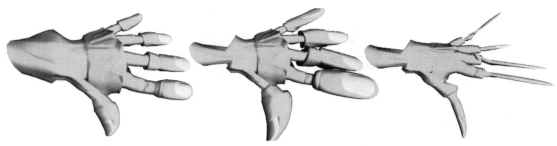

FIGURE 8.15 A series of alien hands, customized by using different Scale and Taper values from the Hand's parameter dials.

TUTORIAL

THE ALIOD HAND MORPH

A science fiction film that played in the theaters in the 1950s had little green aliens in it with super long fingernails that poked cows and drank their blood through their fingers (yech!). Here's a way to create that Aliod hand:

1. Place any Hand model on the screen, or use a Hand Library to get a close-up of any human model's hand. Shape the hand with the "Five" Hand from the Hands/Counting Library. This splays the fingers so you can work on them.

2. You are going to use five Magnet Deformers, one for each finger and another for the thumb. Each will be targeted to the tip of that appendage. Move each Magnet Zone so that it covers just the upper half of the respective tip. Move the magnet away from each finger and the thumb until you get a Morphed shape like that shown in Figure 8.16.

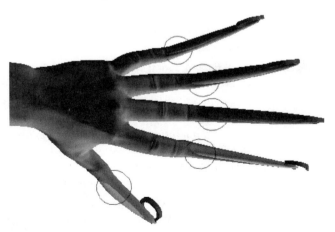

FIGURE 8.16 The finger tips and tip of the thumb are extruded by each Magnet Deformer.

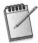
You can also use the Grouping tool to select just the fingernails, one at a time, before applying a Magnet Deformer.

Creating Expressive Faces

If the eyes are the window to the soul, then the face is the house that surrounds those windows. The human face is the central subject in the majority of works of art. The face is so powerful that we look for signs of faces in the natural world—driftwood, rocks, trees, mountain sides, anything that emulates the features of a human face is revered and given suspected powers. The faces on Mount Rushmore are just one example of how the structure of the face overwhelms our senses.

Three Methods for Face Modification

Poser allows you to mold the expressions of a face in three ways. First, you can select either eye and scale or rotate it. Scaling the eye is usually accompanied by moving it along the Z-axis, in or out of the surrounding face. Otherwise, it will just be scaled inside of the head, with no noticeable alterations unless the scaling approaches zero or is very large. The second way that Poser allows you to adjust the seemingly emotional content of the face is to alter the parameter dials associated with the head, especially for the new Poser 5 Head Morphs in the Face Library. A third way is to use Magnet and Wave Deformers to alter the facial geometry itself. With the introduction of the Face Room controls in Poser 5, this third method has become obsolete.

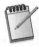
Some of Poser 5's new figures have dozens of new Face Morph parameter dials associated with modifying faces globally. Parameters such as Sadness, Worried, and other emotional states have morphs that address more than just one facial feature, but many at the same time. The temptation is to mix these morphs to create more subtle facial alterations, but this can lead to problems if you use higher parameter values. The problems arise because morphs can interfere with each other, distorting the surrounding geometry in unsuspected ways. The distortions might not be apparent in a single rendering, but might appear when the face is animated from one expression to another. If you want to create your own unique expressions, the best way to do it is to use combinations of facial morphs that are targeted to more defined areas of the face.

Parameter Dial Combinations

Detailing and displaying all of the Head parameter dial combination settings you can use in Poser to achieve subtle emotive looks would add hundreds of extra pages to this book. What we can do, however, is give you some idea of just how potentially variable the Head parameter settings can be, when used in combination with each other, and what different combinations lead to. To do this, we've devised a table (Table 8.1, page 114–115) that lists some of the settings as keyed to the faces represented in Figure 8.17. Apply these settings as shown to develop the intended looks, and also be sure to explore settings not represented here to develop your own library of different facial expressions.

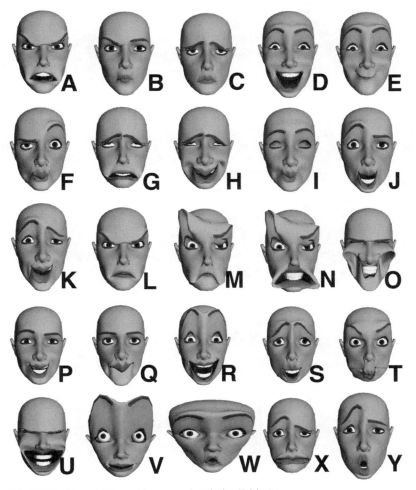

FIGURE 8.17 These 25 keyed faces are detailed in Table 8.1.

TABLE 8.1 The parameter dial combinations represented in this table detail how you can create specific emotional and personality styles for Poser Heads. See Figure 8.17 for the visual display of the 25 key letter descriptions in this table.

FIGURE KEY	DESCRIPTION	OPEN LIPS	SMILE	FROWN	MOUTH	TONGUE	BROW DOWN	BROW UP	WORRY
A	Antagonistic	1.26	.58	2.84	0	0	0	0	2.75 L&R
B	"Well, I never!"	0	0	0	O=1	T=−1	0	0	−1.3 Right
C	"Not a good day today . . ."	0	−1.4	0	0	0	0	−1.4 L&R	2 L&R
D	"Yippie!"	2.5	1.9	0	0	0	0	3.5 L&R	0
E	Innocence	−.3	2	0	M 3.7	0	0	3.8 L&R	0
F	Whistler 1	0	−1.5	−3	0	0	−.6 Left	1.4 Right 3 Left	0
G	Seasick (eyes rolled up)	.4	0	2.6	F −.28	L .37	0	0	1.7 L&R
H	Drunk (eyes rolled up)	.4	1.5	−2.9	F −2.8	L .37	0	0	1.7 L&R
I	"Gimmee a kiss . . ." (eyes closed by using a −.02 Z translation)	−1	−.2	−3	O .5 F .2	L .4	0	.2 L&R	0
J	"It's you!"	0	−1.1	−2.7	0	L 2.8	0	3.6 R	.9 R
K	"Heh-heh . . .guess I goofed"	0	.1	−2.7	0	−4.5 T 4.5 L	−1 L	3.6 R	.9 R 2.5 L
L	"Grrrrrr!"	0	0	2.19	0	0	0	0	2.8 L&R
M	Deformed by anger	0	−.7	3.8	0	0	−3.6 R 1.7 L	6.4 R 3.1 L	−4.9 R −3 L
N	Deformed by anger #2	0	−.7	3.8	−11 M	0	−3.6 R 1.7 L	6.4 R 3.1 L	−4.9 R −3 L
O	Snapper	0	4.9	−10	0	−6.5 T	0	−1.7 L&R	0

TABLE 8.1 The parameter dial combinations represented in this table detail how you can create specific emotional and personality styles for Poser Heads. See Figure 8.17 for the visual display of the 25 key letter descriptions in this table (*continued*).

P	"Hello there."	0	.6	-2.3	0	-1.4 T	0	1.3 R	0
Q	Unilip	1.2	-1.5	-4.6	-1.5 O 2.2 F .5 M	-10 T 2.75 L	0	0	0
R	"Holy Moley!"	1.4	0	-2.8	1 O	2.5 L	0	8 L&R	0
S	"Golly Gosh."	-1.7	-1.9	-1.6	0	3 T 1.6 L	0	2.7 L&R	2.4 L&R
T	Canary Head	-.5	-1.9	-1.6	-3.7 F 4.8 M	3 T 1.6 L	0	2.7 L&R	2.4 L&R
U	Whacko Fatmouth	0	3.1	0	-7 M	0	0	-2.6 L&R	0
V	Ta'ak (taper added to .9 head, and eyes adjusted at Y and Z Translations values of .004)	0	0	-1.6 F	1.8 T	0	11.6 R 10.2 L	0	
W	Peter L. (Taper used on t he Head, and eyes adjusted Z Translations values of .003)	.5	-1.2	0	.7 O 2.3 F	.6 L	0	3.5 L&R	0
X	Sad Clown	1	-1.2	0	-1.5 O -1.9 F	0	0	2.5 R -1 L	1.6 L&R
Y	Opera Singer	0	0	0	2.09 O -4.2 M	0	0	4.2 R	2.6 R .7 L

Using the parameter dials for the Morph attributes, you can create your own Poser personalities. Five examples are shown in Figure 8.18. The Parameter settings for these five Morphed models are detailed in Table 8.2.

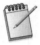 *With the new caricature and other controls in the Face Room, you can quickly create hundreds of facial character variations. This is just another way to go about it.*

FIGURE 8.18 Top left to bottom right: Shamal, Jakur, Mandy, Maria, and Red Bear. See Table 8.2 for the Morph parameter settings. Alternate Hair props were used for more character variance.

TABLE 8.2 Morph parameter details for the models shown in Figure 8.18.

PARAMETER SETTINGS FOR MODELS IN FIGURE 8.18

PARAM'S	SHAMAL	JAKUR	MANDY	MARLA	RED BEAR
Round Face	−3.5	−3	1.1	−3.4	0
Long Face	−1.2	0.6	−2.3	−2.5	−0.8
Flat Face	−1.7	−0.7	−0.1	.4	0
Heart Face	0	−0.4	0.8	−0.7	0
Square Face	0	1.3	1.8	−0.3	2.3

TABLE 8.2 Morph parameter details for the models shown in Figure 8.18 (*continued*).

PARAMETER SETTINGS FOR MODELS IN FIGURE 8.18

PARAM'S	SHAMAL	JAKUR	MANDY	MARLA	RED BEAR
Flat Bridge	0.75	0.7	1.1	0.3	−0.3
Jaw Strength	.6	1.9	1.2	−0.2	0
Eyes	0	0.9	−2.5	−0.8	1.7
Brow	0	1.9	1.9	0.6	1.5
Lashes	−.6	0.6	1.7	−0.6	0
Bump Nose	0	3.5	−5.2	−0.7	3.6
Flat Nose	0	−2.9	−2.4	1.3	−1.05
Pointed Nose	0	−1.3	1.7	1.8	−1.3
Round Nose	0	0	−1.0	−0.4	4.5
Cheeks	0	−0.7	0.7	−0.2	3.3
Chin	0	0.6	0.06	−0.9	0,4
Lips	0	0.065	1.3	1.1	0.9
Hair Model	Female Curly Hair	Male Afro Hair	DAZ 3D: Fem Hair w/Bun	Default Hair	Default Hair resized

POSING AND CUSTOMIZING ANIMAL MODELS

Poser's animals are fully articulated, so they can be interactively posed with ease. The parameter dials for each Poser Animal might be configured differently, especially for different species. The Horse, for example, has controls for all four feet, while the Dolphin (which has no feet) has parameter dials for the fins.

There are two ways to think about posing the Animal models. The first is to pose them naturally, taking advantage of the ways in which the targeted animal moves in real life. The second way is to think of the Animal models as cartoon figures, so that their poses become more related to humans than to the specific animals. Both of these alternatives are possible in Poser.

Real-Life Posing

Remember that any body can communicate emotion as well as the face can. This is certainly true of a selection of Poser animals. Each Poser animal has certain animatable features, controlled by specific parameter dials, that allow them to display basic (and sometimes quite subtle) emotions.

Each Animal model is quite different in this regard, with some able to display a wider range of emotions, and some a more bounded range.

For example, you can body-pose the Cat model into any number of evocative positions. Here are just a few examples to explore:

Angry: Mouth 1.12; Waist Bend −19; Shoulders: Twist −5, Side to Side −12, Bend −44; Tail 1 Bend −47; Forearms: Y–Scale 121, Twist −18, Side to Side 14, Bend −17; Thighs: Bend −22.

Begging: Mouth .35; Neck Bend −10; Shoulders Bend −30; Forearms Bend −67; Wrists Bend 25; Hands Bend 24; Tails bend (1 to 4) 67, 53, 61, 33; Thighs Bend 51; Legs Bend 23; Shins Bend 34; Feet Bend 2.

Sleep Curl: Eyes .6; LEar Turn .45; REar Back .28; Chest: Side to Side −48, Bend −2; Feet: Bend 11, Side to Side −9; Forearms: Twist 16, Side to Side −15, Bend −60; Hands Bend 78; Legs: Twist −2, Side to Side −6, Bend 23; Shins: Side to Side 49, Bend 14; Shoulders: Twist 11, Side to Side 14, Bend −21; Thighs: Twist 22, Side to Side −42, Bend −67; Wrists: Twist 10, Side by Side −2, Bend 144; Neck: Twist −6, Side to Side −21, Bend 107; Tail 1: Twist 10, Side to Side 45, Bend −3, Curve .9; Tail 2: Twist 3, Side to Side 14, Bend −48, Curve 1; Tail 3: Twist 0, Side to Side 0, Bend −34, Curve 1; Tail 4: Twist −1, Side to Side −2, Bend 13, Curve 1.

Stretching: LEar Turn .45; REar Back .28; Abdomen Bend 18; Chest: Bend −13; Feet: Bend −40, Side to Side 5; Hips Bend −5; Forearms: Twist 18, Side to Side −14, Bend −31; Hands Bend 31; LLeg: Twist −2, Side to Side −7, Bend 16; RLeg: Twist −2, Side to Side −7, Bend 23; Shins: Side to Side 5, Bend 39; Shoulders: Twist 10, Side to Side 12, Bend —52; Thighs: Twist 0, Side to Side −8, Bend 54; Wrists: Twist −10, Side by Side 3, Bend 11; Neck: Bend −39; Tail 1: Twist 0, Side to Side 0, Bend 36, Curve .9; Tail 2: Twist 0, Side to Side 0, Bend 79, Curve 1; Tail 3: Twist 0, Side to Side 0, Bend 75, Curve 1; Tail 4: Twist −1, Side to Side −2, Bend 13, Curve 1.

The Cat model is somewhat limited when it comes to displaying emotions by customizing the Head elements. Aside from opening and closing the mouth, the Cat model can display a limited range of emotions by eye open/close (no side-to-side eye movements), and ear movement. Ear movements offer the most variation. If you have ever observed a cat, you realize that it shows a pretty full range of emotions or feeling by the way its ears move, if you watch carefully.

The Poser Dog model has a wider range of emotional possibilities than the Cat model does. This is mainly because the mouth and ears have many more variation options. Instead of eye controls to open and shut the eyes (as the Cat has), the Dog model has moveable eyebrows. Create

the following Dog model poses by inputting the following parameters (Figure 6.7):

Ambling Along: Chest Bend −13; Head: Side to Side and Bend −34; Mouth .68; Hip Default; LEar (1, 2, 3) Default; REar (1, 2, 3) Default; Eyebrows Default; LFoot Bend 27; LForearm Bend −57; LHand Bend −35; LLeg Bend 27; LShin Bend −50; LShoulder Bend 46; LThigh Bend −13; LWrist Bend 56; RFoot bend 58; RForearm Bend −57; RHand Bend −2; RLeg Bend 28; RShin Bend −48; RShoulder Bend −1; RThigh Bend −52; RWrist Bend 56; Neck1 Bend 94; Neck2 Bend −21; Tail (1, 2, 3, 4) Bend −47, −25, −11, 19; Waist Bend 9.

Sniff Air: Chest Bend −13; Head: Bend −47; Mouth 0; Hip Default; LEar1 (Twist, Side to Side, Bend) 29, 15, 79; REar1 (Twist, Side to Side, Bend) 0, 8, −79; Eyebrows Default; LFoot Bend 66; LForearm Bend −24; LHand Bend −33; LLeg Bend 28; LShin Bend −48; LShoulder Bend 26; LThigh Bend −47; LWrist Bend 22; RFoot bend 28; RForearm Bend 20; RHand Bend −41; RLeg Bend 28; RShin Bend −17; RShoulder Bend 5; RThigh Bend −6; RWrist Bend 65; Neck1 Bend 64; Neck2 Bend −14; Tail (1, 2, 3, 4) Bend −13, 7, −2, 0; Waist Bend 9.

Bark Jump: Chest Bend −13; Head: Bend 0; Mouth 1.15; Hip Default; LEar (1, 2, 3) Default; REar (1, 2, 3) Default; Eyebrows Default; LFoot Bend 43; LForearm Bend −57; LHand Bend 19; LLeg Bend −57; LShin Bend −48; LShoulder Bend 34; LThigh Bend −34; LWrist Bend 15; RFoot bend 40; RForearm Bend 15; RHand Bend −2; RLeg Bend 28; RShin Bend −48; RShoulder Bend −34; RThigh Bend −46; RWrist Bend 23; Neck1 Bend −2; Neck2 Bend 0; Tail (1, 2, 3, 4) Bend −30, −25, −11, 19; Waist Bend −13.

Sit and Beg: Chest Bend 61; Head: Bend 0; Mouth 0; Hip −79; LEar1 Bend 6; REar1 5; Eyebrows Default; LFoot Bend −6; LForearm Bend −10; LHand Bend 61; LLeg Bend 87; LShin Bend 68; LShoulder Bend −91; LThigh Bend −75; LWrist Bend 115; RFoot Bend −17; RForearm Bend 14; RHand Bend 27; RLeg Bend 112; RShin Bend 37; RShoulder Bend −19; RThigh Bend −74; RWrist Bend −5; Neck1 Bend 16; Neck2 Bend −25; Tail (1, 2, 3, 4) Bend 90, 35, 42, 55; Waist Bend 11.

The Poser Dog model has a wider range of motion and emotion related to its Head parameters than does the Cat. The eyebrows do more than just open or close the eyes, they also add a range of expressions. The ears are separated into three parts, and each can be manipulated separately. The mouth can open and close as expected, and can also snarl both front and back.

Explore the following parameter alterations for the horse to create interesting poses:

Munch: Chest Bend –5; Lower Neck Bend –82; Upper Neck Bend –14; Head Bend –48.

Kneel and Drink: Abdomen Bend 33; Chest Bend –23; Head Bend –48; Ankles Bend 9; Feet Bend –18; Forearms Bend 109' Hands Bend –23; Shins Bend –47; Shoulder Bend 28; Thigh Bend –12; Upper Arms Bend –75; Wrists Bend 17; Lower Neck Bend 51; Tail 1 Bend –45; Upper Neck Bend –28.

Fast Trot: Abdomen Bend 13; Chest Bend –5; Head Bend –44; LAnkles Bend 67; RAnkle Bend 67; LFoot Bend –20; RFoot Bend –20; LForearm Bend 19; RForearm Bend 95; LHand Bend –38; RHand Bend –38; LShin Bend –82; RShin Bend –82; LShoulder Bend 32; RShoulder Bend 32; LThigh Bend –7; RThigh Bend 43; LUpper Arm Bend –86; RUpper Arm Bend –84; LWrist Bend 13; RWrist Bend 53; Lower Neck Bend –31; Tail 1 Bend 66; Tail 2 Bend 27; Upper Neck Bend –9.

Rear Up: Abdomen Bend –33; Chest Bend –5; Head Bend 6; LAnkles Bend 67; RAnkle Bend 67; LFoot Bend –20; RFoot Bend –20; LForearm Bend 95; RForearm Bend 95; LHand Bend –38; RHand Bend –38; LShin Bend –82; RShin Bend –82; LShoulder Bend 32; RShoulder Bend 32; LThigh Bend –41; RThigh Bend –41; LUpper Arm Bend –84; RUpper Arm Bend –84; LWrist Bend 53; RWrist Bend 53; Lower Neck Bend –13; Tail (1, 2, 3, 4) Bend –45, –13, 23, 33; Upper Neck Bend –32.

The Raptor: A Unique Example

What is interesting about the Raptor is that you can apply some human poses to it. You'll have to tweak various parts of it to get things just right, but it can lead to some very humorous raptor/human blends. The Raptor also responds fairly well when addressed by human BVH motion files.

DAZ 3D's Primates

DAZ 3D markets Poser Chimp and Gorilla models that respond very well to the pose presets in the Poses Library. This isn't too surprising, considering that the anatomy of these creatures is similar in many ways to human anatomy. The Chimp is also perfect for *Walk Designer* sessions. The Chimp has fully articulated hands and feet that can splay and grasp items. If you have the DAZ 3D Chimp, explore the following poses:

Threatening: Leave IK on, and move body down from waist. The knees will bend automatically. Right and Left Shoulder, Bend −60 and 44. Right and Left Forearm, Bend −53 and 40. Mouth Open 4.2.

Knuckle Walk: Abdomen Bend 90. Head Bend −75. Right and Left Shoulder Front To Back 50 and −88. Right and Left Forearm Side to Side, −24 and −30. Left and Right Thigh and Shin Bend −15 and 70. Right and Left Foot Bend −44 and −12.

Sitting: Abdomen Bend 90. Right Thigh/Shin/Foot Bend −40, 70, −25. Left Thigh/Shin/Foot Bend −46, 77, −12. Right Shoulder: Twist −27, Front to Back 50, Bend 46. Right Forearm: Twist −47, Side to Side 54, Bend 30. Right Hand: Twist −117, Bend 47. Left Shoulder: Twist −72, Front to Back −64, Bend −122. Left Forearm: Twist 31, Side to Side −43, Bend −91. Left Hand: Twist −6, Side to Side 30, Bend 3.

The Chimp's hands respond fairly well to the human hand poses from the Hand Poses Library folders. Because the Chimp has some finger and thumb dimensions that are different from human hand proportions, you might have to tweak the results after assigning a posed hand. However, that beats having to pose the Chimp's hands one digit at a time.

Assigning Human Characteristics to Animals

If you are creating a cartoon for a children's show or art for a children's storybook, posing animals as if they were mimicking humans might be of great interest to you. In all cases, because of the way that the Animal model is articulated, there is no global guarantee that you can simply select a human pose from the Poses Library and apply it to an animal. Sometimes this works, and sometimes it causes bizarre and unpredictable results.

In general, there are two ways to transform animal poses into a more human look:

- Use a pose from the People Poses Library on the animal. Note that you will have to tweak the results by hand, because the animal anatomy is probably going to warp a bit in the attempt to fit the pose.
- Resize or rescale one or more of the animal's appendages or extremities to mimic human arms and legs. This can be very effective, although it works better for some animals and not for others.

Whatever human pose you assign to an Animal model, rest assured that you will have to fine-tune it by hand.

Customizing Animal Models

Each Animal model can be customized in major ways by using two basic parameter dial ranges or Editing tools: Tapering and Resizing. Add some rotation when it's called for, and you can greatly expand your animal collection. Using these two parameter attributes, you'll be surprised at how many animal model variations you'll be able to create. True, some will be strange fantasy creatures, but all will differ from the original animal. You can then save your new animal creations to a new Animals Library folder for future use. Explore your own animal variation by using Scaling and Tapering on various animal parts.

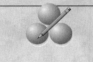

TUTORIAL

DEFORMING ANIMAL MODELS

You can deform animal figures with the same procedures used to deform Poser's human characters.

1. Select the body part of the figure to which you want to add a deformation.
2. If you want the deformation to address just a section of that body part, then you have to set it up by using the Grouping process. If you want the deformation to address the whole of that body part, no grouping is necessary (in that case, skip step number 3).
3. If you need to use the Grouping process, click on the Grouping tool with the needed body part selected. Click on New Group and name it. Now, take the mouse and click-drag a marquee around the area you want to target a deformation to. When it lights up, you have defined the area, and can close the Grouping window.
4. Add a Magnet or Wave Deformer from the Object menu. Select its Zone of influence, and bring up the Properties window. In the Properties window, click on Group, and find the name of the Group that is to be targeted. Close the Properties window, and configure the deform by adjusting the parameters for that Deformation object and tweaking it until you have achieved what you require.
5. Once the deformation looks good, select the body part. Spawn a Morph Target, and name it as you like. It will appear as a parameter dial. You can now delete the Deformation object. Do this with as many deformations for the figure as you like, following the same procedure. When finished, save the figure to a Poser Library or to another space on a disk. That's it. You are now a Deformation master of the Morphed Universe!

CONCLUSION

In this chapter, we covered a number of posing and modification procedures made possible in Poser. This completes the part of the book targeted to beginning users. The next part deals with Poser animation.

PART
II

POSER ANIMATION

125

ANIMATION CONTROLS

In This Chapter

- The Idea Behind Keyframing
- Two Animation Control Environments
- The Animation Menu
- Inverse Kinematics
- Preparatory Movements
- The Walk Designer
- The Out-Of-Body Experience
- Walk Design Parameters
- Walk Design Parameter Combinations
- Paths
- Transitional Walks
- Animals and the Walk Designer
- Using Other Animals with the Walk Designer
- Using BVH Motion Files

Poser has evolved from a 2D graphics utility in Poser 1 (with no animation capabilities), through a user-friendly animation toy in Poser 2, to a more professional set of animation features in Poser 3, to a fully customizable art and animation application in Poser 4. Now, in Poser 5, we are rewarded with very high-end animation features such as collision detection, wind, and much more. What began as software dedicated to supporting 2D painting applications (allowing you to import 3D posed figures into Adobe Photoshop and Corel Painter) has risen far from its original roots. Not that you can't use Poser 5 renders for 2D image compositing, but Poser 5 continues to boast anatomical animation capabilities no other software at any price can compete with. All of this has been accomplished in an intuitive creative environment with a very easy learning curve, so that beginners and professionals alike can create startling animated figures in just a few minutes. This chapter and the two that follow are dedicated to Poser's animation options and techniques, targeted to the beginning and advanced user alike.

THE IDEA BEHIND KEYFRAMING

The terms *keyframe* and *keyframing* are used a lot around animation studios. Traditionally, there were two classes of animators: keyframers and tweeners. A keyframer was an artist who drew the main poses for an animated sequence, while the tweener filled in all of the intervening frames, the "in-betweens," from one keyframe to the next. Both took a lot of work and a lot of thought to craft, although computers have somewhat lessened the drudgery and terror. When the computer came on the animation scene, everyone began to realize that the manual labor of tweening was about to be replaced by a nonhuman approach. As a number cruncher and data analyzer, the computer rules. In a computer animation application, all the computer needs is an indication of where the keyframes, the main poses, are at. From there, all of the in-betweens can be interpolated mathematically, so there is a smooth motion from one keyframe to the next. The main job of the Poser 5 animator is to set up the keyframe poses—which is not always as easy as it sounds.

A walk cycle is the most common example of this. In a walk cycle, several things are happening simultaneously. Legs are in motion, joints are bending, arms are swinging, the torso might be bending or swaying from side to side, and the head might be bobbing around. The best way to handle keyframes is to get the gross movements under control first, and then move to the finer motion attributes. In a walk cycle, the simplest way to do this is to set up keyframes that show the left leg at its forward-

most position, and the right arm at its backward-most position at the first frame. Then, set the middle keyframe with the right leg at its most forward position, and the left arm at its most backward position. The last keyframe would be a repeat of the first frame, so that the animation could loop and show the cycle repeating (Figure 9.1).

FIGURE 9.1 The standard keyframe poses in one walk cycling animation example.

We'll have more information on walk cycles at the end of this chapter, when we take a detailed look at Poser's Walk Designer, and when we explore the uses of Inverse Kinematics (IK) later in this chapter. For now, let's look at the Poser modules that allow us to set keyframes, and the associated animation menu commands in Poser 5.

The trick behind good keyframing is to use only enough keyframes to accomplish the movement you want. Keyframing every frame makes it very difficult to edit a frame, because it can lead to jumpy and strange movements in the surrounding frames.

TWO ANIMATION CONTROL ENVIRONMENTS

Poser has two separate but linked control environments where animations can be composed and edited: the Animation Controller, and the Animation Palette.

The Animation Controller

The Animation Controller is located at the bottom of the Poser 4 screen, and is brought up by clicking on its control bar (Figure 9.2).

FIGURE 9.2 The Animation Controller.

Let's spend a little time looking at each element on the Animation Controller interface, describing what each of the components does.

At the top left are the VCR controls. These are used to locate any frame in an animation sequence, and to play/stop a preview animation (Figure 9.3).

FIGURE 9.3 The VCR controls, left to right: First Frame, Last Frame, Stop, Play, Previous Frame, and Next Frame.

At the center are two input areas is a Frame Counter that tells you what frame you are at, and the total number of frames in the sequence. To set the number of total frames in a sequence, just click in this second area and type in the number of frames you want. By the way, if you attempt to enter a number in the frame field that is higher than the number of frames in the animation, you will get an error message that states that your number is out of range. The very first thing you should do when starting to configure an animation is to set the total number of frames you want. Remember that the frame rate (frames per second) will determine how much time the animation will take to run from beginning to end (Figure 9.4).

FIGURE 9.4 The Frame Counter and Number of Frames indicators.

At the top right of the Animation Controller are controls for setting and maneuvering keyframes (Figure 9.5).

FIGURE 9.5 These controls, from left to right, do the following: Previous Keyframe, Next Keyframe, Edit Keyframes (brings up the Animation Palette), Add Keyframe, and Delete Keyframe.

 Note that Previous and Next keyframe will take you to the frame for the selected element. If that element has no keyframes, you will not move to another frame.

At the bottom left the word *Loop* appears. There is a small light next to it. Clicking on this area turns the light on or off. When on, your preview animation will play over and over again until manually shut off. If the light is off, the preview will only play once (Figure 9.6).

FIGURE 9.6 The Loop Indicator.

In the center is the Interactive Frame Slider. Moving the frame indicator arrow allows you to go to any frame on the timeline. The Frame Number Indicator above displays the frame number (Figure 9.7).

FRAME 9.7 The Interactive Frame Slider.

Last, the Skip Frames Indicator is on the bottom right. This toggle allows the preview to play the keyframes, or every frame in the sequence.

FRAME 9.8 The Skip Frames Indicator.

Animation Controller Hints and Tips

When using the Animation Controller, here are some things to keep in mind:

- Always set the number of frames first, realizing that the number, when divided by the frames per second rate, gives you the runtime of the animation.
- As a default, keep looping on. When a preview runs a few times, you can see flaws more clearly, and then find the offending frame(s) and make necessary corrections.
- You seldom have to use the "+" key to create a keyframe, as every time you adjust an element in the Document window a keyframe is created automatically. We sometimes use it as a "paranoid factor,"

just to make doubly sure that a keyframe has been made at a certain frame. Using the "-" key, however, is a different matter, since removing offending keyframes is often necessary to get the exact movements you want.

- Assign your gross movements first, and preview the results. Then, add finer motions, previewing as you go. Set the Skip Frames to Off so you can see the details in the preview.

The Animation Palette

Clicking on the *Key* Symbol in the Animation Controller brings up the Animation Palette, which has its own definitive controls for editing the animation (Figure 9.9).

FIGURE 9.9 The Animation Palette.

Just as we did with the Animation Controller, let's walk through each of the elements that make up the Animation Palette.

Our first stop is at the bottom of the palette. You should see a green line with an arrow on each end. This represents the *Play Range* of the animation. You can move the right arrow to the right until it reaches the last frame in the sequence, and to the left to any frame before that. You can move the left arrow to the right to any frame before the right arrow,

and to the left as far as the first frame. Limiting the play range allows you to preview a sequence of any length, which is very useful for catching and correcting unwanted glitches (Figure 9.10).

FIGURE 9.10 The interactive Play Range indicator.

Our next stop on the tour of the Animation Palette is the area at the center. You will notice a long list of items on the left, representing every element in your Document window. Highlighting any element by clicking on its name will also highlight all of its frames to the right of the name, which turn white. Green frames indicate that there are some keyframes already set for that element and that they are Spline Interpolated, and red frame indicators tell you exactly where the keyframes are located. Pinkish frames indicate that a Linear Interpolation is going on. You can click on any frame to highlight it, and the resulting vertical highlighted column tells you exactly what each element is doing at that particular frame. If any element in the vertical stack is red, it is a keyframed element. If it is green, it is an element in motion between keyframes (a tween). If it is white (or gray when not selected), it is stationary (Figure 9.11).

FIGURE 9.11 The element list on the left, and the frame indicators on the right.

Right above this area are four text-based controls: *Skip Frames, Loop, This Element,* and *All Elements.* We already discussed the first two, Skip Frames and Loop, in our detailed look at the Animation Controller. This Element and All Elements are two sides (toggles) of one control, since selecting one inhibits the other. What are they used for? If you select any element frame in the frame area, you will see a vertical highlighted stack, showing each element in your document at that point in time. If you wanted to press the Plus key to make that frame a keyframe, or the Minus key to delete it as a keyframe, it would matter if either This Element or All Elements were chosen. Selecting This Element would act to add or delete a keyframe for just that element. Selecting All Elements would add or delete keyframes for every element in the highlighted vertical stack (Figure 9.12).

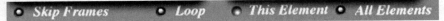

FIGURE 9.12 The most important commands here are the last two: *This Element* and *All Elements,* and how they each address keyframe alterations.

Above the text-based controls are three rows of buttons. The first is the familiar VCR controls already covered under the Animation Controller. The second row is also familiar, with the exception of the center button, which is unique to the Animation Palette. This center button, with the symbol of a squiggly line on top, is the *Graph Display Toggle,* which we'll detail later. The third row contains three *Interpolation* buttons, and is better left untouched, because these three Interpolation buttons also appear in the Graph Display. They make more sense to use there (Figure 9.13).

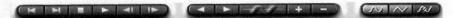

FIGURE 9.13 The three control groups of buttons: the VCR controls, the Keyframe controls, and the Interpolation controls.

At the very top are the time and frame displays, and the Options menu. The displays address *Frame Rate* (frames per second), *Timecode indicator* (Hour / Minute / Second / Frame), *Present Frame,* and *Total Number of Frames.* This is a display, and is not meant to be altered. The Options list includes the following items that can be selected or deselected, simply by accessing them: *Display Frames/Timecode, Loop Interpolation,* and *Quaternion Interpolation.* Selecting either Frame Display or Timecode Display will use that system as a rule of measurement over the frame selection area. Loop

Interpolation and Quaternion Interpolation are separate items, and both can be selected or deselected individually (Figure 9.14).

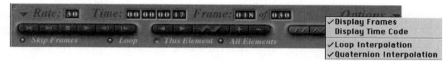

FIGURE 9.14 The top row of display items and the Options menu.

Loop Interpolation/Quaternion Interpolation

Larry Weiner, Poser's master programmer, submits the following definitions for loop interpolation and quaternion interpolation.

> Quaternion interpolation is a special mathematical interpolation technique that produces in-between motions that are more predictable between poses, but can cause strange-looking discontinuities when you look at the graphs of individual rotation parameters. The interpolation happens by using all three rotation channels at once, instead of simply interpolating each one individually (which is the default). It's only useful for animators who are really getting into the nitty-gritty of working out animations, and are having trouble with fine-tuning their animations. If you don't need it, it's probably easiest not to use it.
>
> Loop interpolation allows for easier creation of cycling animations. If you have a 30-frame sequence, and put keyframes only at frames 1 and 15 (introducing some change at 15), and turn on loop interpolation, you will see that the animation smoothly blends through frame 30 back to frame 1. Viewing the graph will also show this. If you put keyframes near the end that are not similar to frame 1, you might get some very unexpected and strange in-betweens in the frames just before these because the last frame is essentially the frame before the first frame. Viewing the graphs really helps make it clear what is going on.

The Graph Display

Clicking on the Graph Display button brings up the Graph Display for whatever item is selected in the scene or hierarchy list. Readjusting the display via a Splined or Linear curve allows the selected element to have whatever priority that is selected animated according to the shape of the curve. The properties include Taper, Scale, XScale, YScale, ZScale, Twist, Side-to-Side, and Bend. If the head is selected, all of the animatable

elements can be edited via a motion graph. It takes practice to configure animations with the Graph Display of specific elements, so be prepared to spend some time learning the techniques (Figure 9.15).

The best way to learn to configure animations with the Graph Display is to avoid setting any movement with the Animation Controller at first. Simply set the number of frames, jump onto a selected element's Graph Display, and modify the graph. Preview the animation to see what you've accomplished.

Using the Graph Display and altering mouth attributes and eye blinks leads to more realistic movements, and is much faster than accomplishing the same animated poses with the parameter dials.

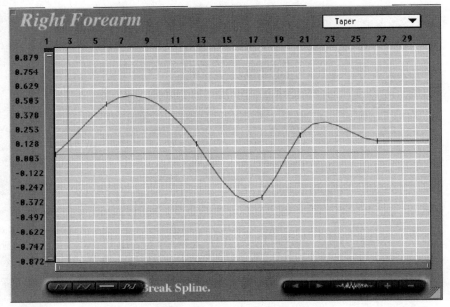

FIGURE 9.15 The Graph Display modified to animate lip movements on a human model's head.

Animating to Sound

If you will notice, the bottom right row of buttons on the Graph Display shows what appears to be a sound wave. Clicking on this button will bring up a visual display of a sound file, if one is loaded into the document. By following the amplitude shape of the wave (where it is higher and lower) you can edit the motion curve of any selected element to move accordingly. In this manner, you can accomplish lip syncing and

other choreography. Be sure to read Chapters 25 through 28 of this book if audio topics are of interest to you.

THE ANIMATION MENU

The Animation menu at the top of your screen contains essential items that you must be aware of in order to creatively interact with your Poser 5 animations. Let's look at each of the listings in some detail (Figure 9.16).

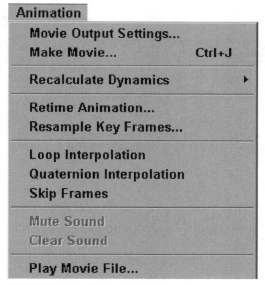

FIGURE 9.16 The listings in the Animation menu.

Movie Output Settings

Gone is the basic Poser 4 dialog for setting output parameters. In its place is a full-featured dialog that gives you control over every output parameter. This is where you configure the animation output settings, including Frame Rate, Output Size, Frame Count, and Duration. It's also where you determine whether to use Production/Draft output, and what renderer is to be used. It's much easier to do this all in one place, rather than address these parameters in a series of different locations. If you are a Poser beginner, or even an intermediate user who is unfamiliar with some of the terms used here, leave the items you are unfamiliar with at their defaults for later exploration (Figure 9.17).

FIGURE 9.17 The Animation Output Settings dialog.

Make Movie

When you are ready to record your masterpiece, this is the doorway to enter. You'll be taken through three separate steps, each with its own dialog: Movie Parameter Settings, Compression Settings, and the Save Path dialog. When using compression, we prefer Cinepak at full quality, but you can explore other options (Figure 9.18).

Recalculation Dynamics

This is a new option in Poser 5. It has three suboptions: *All Cloth*, *All Hair*, and *All Cloth and Hair*. With the new Cloth and Hair features in Poser 5, these options are selected when you alter either or both Cloth and Hair items and they have to be recalculated for the animation.

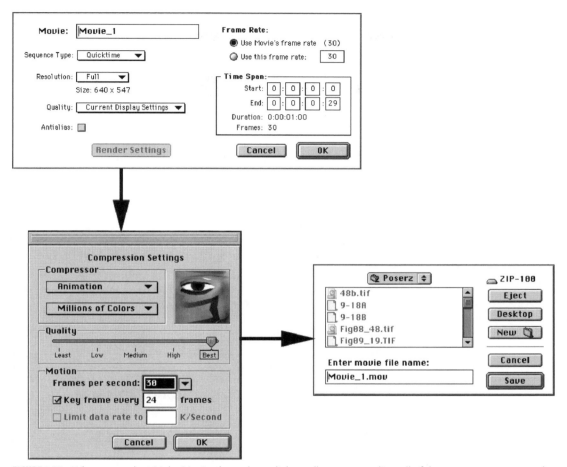

FIGURE 9.18 When you select Make Movie, these three dialogs allow you to adjust all of the parameters you need.

Retime Animation

You might decide that the animation has to fit into a different time slot, and that you can't spare the time to reconfigure all of the keyframes. In that case, you can use this simple process to retime it from one length to another (Figure 9.19).

Resample Keyframes

When would you need to resample the keyframes? If you've done a lot of editing on separate elements in the animation, and you notice that there are places in the preview that look less smooth than you would have hoped, resampling the keyframes might help. You can either resample

FIGURE 9.19 The Retime Animation dialog.

the animation by giving the computer the power to select where resampling should occur, or set resampling to force the addition of keyframes every nth frame. There's no guarantee that this will solve all of your concerns, but it might be worth a try (Figure 9.20).

FIGURE 9.20 The Resample Keyframes dialog.

Skip Frames

This is a menu repeat of the same item shown in the Animation Controller.

Mute Sound/Clear Sound

These commands work when you have an audio file loaded as part of the animation. Without audio loaded, they remain ghosted out.

Play Movie File

You can play AVI movies inside of Poser 5. This is useful when previewing an animation you just rendered, previewing an animation you are considering for use as a background, or to map to an object.

INVERSE KINEMATICS

Poser 5 has a very powerful IK engine. *Kinematics* itself refers to the movement of chained elements. The best example as far as the human body is concerned are the links between the shoulder, upper arm, lower arm, and hand, or that between the thigh, shin, and foot. Many Human and Animal models come into Poser 4 with two or four limbs IK enabled by default. We usually disable it for most animations, but your work habits might incline you to leave it assigned.

We prefer to use IK when there is no looping of the animation involved. Using IK on a looped sequence can lead to some run-ins with chaos, because many adjustments have to be made to make the last frame equal to the first as far as the modification of the elements. You can think of IK as glue. With IK enabled for a limb, the end element of that limb will remain glued to the spot if any elements higher in the chain are moved or rotated. This is great when a figure is to do push-ups, since the hands (if the arm is IK enabled) will remain on the floor. It's even okay if the figure is to throw a ball, as long as you maneuver the hand and not any other part of the arm. It is less useful if the throwing motion is to be repeated in a continuous loop, because the position of all of the elements will have to be returned to their original orientation, by using either the parameter dials or the Motion Graph.

PREPARATORY MOVEMENTS

Just a word or two about preparatory movements in an animation. Before an actor participates in an action, there is usually some hint about what is to occur. Think of a tiger about to leap on its prey. The tiger's body tenses, it goes into an anticipatory crouch, and its powerful muscles ready for the jump. A warrior is about to cast a spear. The spear hand is

brought back slowly, and a concentrated look zeroes in on the target. The spear arm is brought back on a line to the target. The release is sudden, compared to the preparation. Preparatory motions create more realistic animations. Compared to actions, like leaping or throwing, preparatory motions take up to three or four times (and sometimes more) what the action will take. Actions are sudden, so that the keyframes set up for a quick action are very close together. Preparatory movements, on the other hand, take much longer. The keyframes are widely spaced apart, leading to slower and smoother motion overall. It is this preparatory movement that lends an air of anticipation and suspense to an animation.

THE WALK DESIGNER

Poser addresses one of the most complex, and often supremely annoying, tasks that an animator faces: how to create a realistic walk pattern for a targeted character. To use the Walk Designer facility in Poser, the targeted character has to be bi-pedal. The Walk Designer is one of the most powerful features of Poser, although it is quite simple to use and master.

The Walk Designer Control Dialog

The Walk Designer control dialog is an interactive display that shows you exactly what the various parameter dials do as you adjust them (Figure 9.21).

Let's take a quick tour of this dialog (refer to Figure 9.21). On the left is an animated display that shows you exactly what your walk looks like as you adjust the dials on the right. You can watch the walk from a 3/4, top, side, or front view. It is highly recommended that you switch among all of these view options before designing a walk, since that enables you to catch any anomalies in your walk design that might be hidden from one view alone.

On the right are two groups of parameter dials: *Blend Styles* and *Tweaks*. Think of Blend Styles as the major parameters, and Tweaks as adjustments within those parameters. In Table 9.1 later in this chapter, we will look at each of the Blend Styles and Tweaks in detail, describing what various parameter settings can do.

Below the Tweaks parameter dials are three buttons: *Default*, *Load*, and *Save*. Default zeroes out all of the parameters. Anytime you design a walk that you like, you can save it to disk by first clicking the Save button and then selecting a name and target drive path. Click Load to import previously saved walk designs.

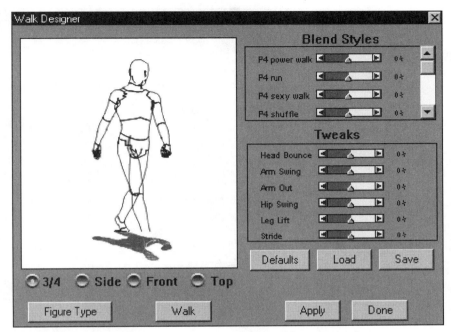

FIGURE 9.21 The Walk Designer control window, accessed from the Window menu.

The bottom row of buttons includes *Walk*, *Apply*, and *Done*. Click on Walk (which then becomes Stop) to activate the mannequin walking with your adjusted walk style, and click Stop to cease its motion. Apply brings up the Apply dialog, with another list of specific parameters to decide upon before committing the walk to the target model. After modifying all of the Apply parameters as you want them, you are returned to the Walk Designer control dialog to click Done.

The Apply Dialog

After the walk has been designed to your liking, clicking Apply is the next step. This brings up the Apply dialog (Figure 9.22).

Refer to Figure 9.22 as we explore each option in the Apply dialog. At the very top of the dialog are two input areas, one for Start Frame and one for End Frame. The simplest way to configure the frames being addressed is to leave these settings at their default indications, as this represents the total length of your frame settings, beginning to end. However, as we'll see a little later in this chapter (under Non-Sequential Walks), there are reasons for selecting other than the defaulted frame number

FIGURE 9.22 The Apply dialog.

references here. Leaving this at the defaulted numbers results in the walk being applied to every frame in your present sequence.

Under the frame settings is a list of the Figures (models) in your Document window. Select the model from this list to which you want to apply the present walk. The walk remains resident in the Walk Designer, so you can apply the same walk to another model after applying it to the one selected, although it's always safer to save your customized walks before applying them to the model.

The next setting consists of a checkbox for *Walk in Place*. Walk in Place is most useful when you are going to export the animated sequence in order to set the figure on a path in that environment. Walk in Place is also useful when it's enough to show the figure walking in place for the project you're creating (perhaps a project that doesn't even require showing all of the foot movements). Walking and running in place over a moving backdrop is an old movie trick, and this can be duplicated in Poser. Another Walk in Place use comes about when you are going to map the animation file to a moving plane in another 3D application, and

set the plane in motion. Most professional 3D applications allow you to do this, dropping out the background color. This is a way to export Poser 4 animation files to most every 3D application around, making no difference if Poser directly supports that application. On the right is another input area that remains ghosted out unless Walk in Place is checked, Cycle Repeat. If a model is walking in place, without moving on a path, you can set the Cycle Repeat to any whole number. The higher this value, the faster the walk will seem, since the walk has to be stuffed into a finite number of frames. The number placed here is in direct proportion to speed, so 2 will create a walk speed two times as fast as 1, 3 would be three times as fast, and so on.

If you have designed a path in your Document window, it will appear in the Path selections, and can be chosen from there. Obviously, you cannot set the model on a path and have it walk in place at the same time. There is an interesting optical illusion possible, however, as presented in the following tutorial.

TUTORIAL

THE OUT-OF-BODY EXPERIENCE

1. Create two figures exactly the same, and have them occupy the same exact space in your document. Create a Path for one (covered later under Paths if you need a refresher), and not for the other.
2. Apply the same Walk Design to both, except make the one with no path Walk in Place. The path for the other should be circular.

Can you guess the result? The figure will walk out of itself like a ghost, and then return to itself in perfect harmony. Use this technique to create an "out-of-body experience" animation.

At the bottom half of the Assign dialog is a series of checkboxes: *Always Complete Last Step*, *Transition From Pose/To Pose*, and *Align Head To*.

Always Complete Last Step

If the animation is to loop, then this should be checked. If it is to be part of a patched sequence, then it need not be.

Transition From Pose/To Pose

Your model might be sitting at the start of an animation, and then get up, assume a pose, and walk away. In this case, the model will need some number of frames to complete its initial movements. Checking Transition From Pose and inputting a number in the associated area (a path has to be assigned for this to make any sense) allows you to reserve frames for the initial pre-walking movements. In the same manner, Transition To Pose allows a model to end a walk by assuming another pose not associated with that walk. You have to carefully explore each of these options. Do not expect to get what you want on the first try. The main caution is to allow enough frames at the start and/or end of the walk sequence for the changes in action. The more radical the poses are from each other, the more transitional frames you will need.

Align Head To

If you have set the *Walk on a Path* option, then you might command the model to look in specific directions while it is moving on the path. There are three options: One Step Ahead, End of Path, and Next Sharp Turn. The model's head will then move according to your selection.

Do not assign any Head Bounce to the walking model when using the Align Head To *options, or at most, very small values. It is disconcerting to see the model looking in a direction while its head is also bobbing up and down, unless you are trying to emulate a serious nervous condition.*

WALK DESIGN PARAMETERS

Table 9.1 details what each of the Blend Styles and Tweaks accomplish when set to five different values: all the way down, halfway down, defaulted, halfway up, and all the way up. Note that the Blend Styles range from –200 to +200, while the Tweaks range from –100 to +100. Settings in between those indicated moderate the detailed results.

WALK DESIGN PARAMETER COMBINATIONS

The real magic of the Walk Designer comes when you combine more than one Blend Style and Tweak. These combined parameters lead to all types of unique walk looks. We have detailed some of them in Table 9.2.

TABLE 9.1 Parameter setting conditions for Blend Styles and Tweaks. Note that these are examined here as unitary options, with all other settings defaulted to zero.

THE WALK DESIGNER

PARAMETER SETTING	ALL THE WAY DOWN	HALFWAY DOWN	DEFAULTED AT ZERO	HALFWAY UP	ALL THE WAY UP
BLEND STYLES					
Power Walk Used at positive values to give the targeted figure a more purposeful walk style.	Creates a jumbled chaotic walk style, so the figure looks out of appendage control.	Makes the movements look slightly out of control, as if the figure can't keep its mind on what it is doing.	No Power Walk effect.	Lends a march-like quality to the walk, determined and precise movements.	Gives an excessive power stride, as that of a robot or giant who won't allow anything to stand in its way.
Run This setting differentiates between walks and runs.	Creates a whacky bouncing motion that can seriously jumble appendages such as arms and hand positions.	Creates a skipping motion.	Creates a normalized walk.	Creates a bounding run, good for a fast race.	Creates a chaotic bouncy run, and can cause overlaps in arm swings and positions.
Sexy Walk This lends a seductive appearance to the figure's movements.	Creates a "gimpy" walk, as if the figure has some problems controlling the sureness of its movements.	Creates a lazy walk, likened to someone walking down a country road in a very relaxed fashion.	Devoid of seductive content.	Creates a very natural s exy walk with a noticeable hip swing.	Creates a radical and almost cartoon-like sexy walk, with more hip swing than the body can almost handle.

(Continues)

TABLE 9.1 Parameter setting conditions for Blend Styles and Tweaks (*continued*).

THE WALK DESIGNER

PARAMETER SETTING	ALL THE WAY DOWN	HALFWAY DOWN	DEFAULTED AT ZERO	HALFWAY UP	ALL THE WAY UP
BLEND STYLES (*continued*)					
Shuffle A shuffle is defined as a walk with a relaxed attitude.	Creates a jumbled disorganized skip.	Creates an arrogant walk, as if the model were self satisfied beyond criticism.	No effect on the walk.	Creates a plodding shuffle, as if the figure were looking at the sidewalk and just ambling along.	Creates an erratic shuffle, making the figure look like something is physically wrong with the legs.
Sneak Defined as a walk that remains unexpected when practiced.	Jumbles the entire upper body in a tangle.	Still pretty radical because it distorts other body parts.	No effect.	A caricature of a sneak, more like a New Orleans strut.	A cartoony strut, with the body bending back and forth radically at the hip.
Strut A strut is a display of pride, sometimes pride, sometimes used to attract the opposite sex to one's importance.	Creates a movement in the arms reminiscent of dancing, or what some communities call the "Hand Jive."	Creates a strut that makes the arms look like they're swatting flies when the arms are extended outward.	No effect.	A real determined strut.	A strut that makes the arms look like they're shadow boxing.
TWEAKS					
Head Bounce The head bounces naturally to compensate for rhythmic impacts suffered by the lower body.	Makes the head shake violently, which would break the neck.	Creates a head bounce that makes the head shake as in signifying "yes."	No effect.	Reverse of –50%	Reverse of –100%

TABLE 9.1 Parameter setting conditions for Blend Styles and Tweaks (*continued*).

Parameter					
Arm Swing There is always arm swing in a walk, so this parameter setting just emphasizes it to various degrees.	Arms swing rather limply.	Arms swing a little less limp.	No effect, normal arm swing.	Arms swing a little more purposefully.	Arm swing is very purposeful, as in a march.
Arm Out This parameter forces the arms away from or closer to the torso (definitely move the arms away from the torso in a walk if the model is heavy).	Arms crossed in front of chest for the entire walk.	Arms crossed in front of pelvis for the entire walk.	No effect.	Arms pushed away from the body, as if the model had very muscular arms.	Arms radically pushed away, forming a cross with the torso.
Hip Swing Used to emulate a seductive feminine walk.	Hips sway radically.	Moderate hip sway.	No movement.	Hip sway opposite of −50%.	Hip sway opposite of −100%.
Leg Lift This parameter sets the height of the legs at their maximum.	Legs sort of slide along the ground.	Legs off the ground a little.	Normal height above ground during walk.	Legs lifted up noticeably.	Legs lifted off ground as in a march.
Stride This represents the distance covered with each step.	Walk in place.	Short stride.	Normal stride.	Above normal stride.	Very long stride, like Groucho Marx.

TABLE 9.2 Unlike Table 9.1 (which shows the effects of just single parameter settings), this table shows how various combined parameter values create six unique walk styles. Input these values, and then explore your own settings. Save the Walk Designs that you like.

SETTINGS	LEAPING RUN	MAX PRONGING	CREEPY MONSTER	OH YEAH!	TROMP ROMP	MARCH
Run	83	−120	−3	0	3	0
Shuffle	0	0	0	0	−18	0
Sneak	0	18	25	0	25	0
Strut	0	0	0	0	0	0
Head Bounce	23	0	0	49	0	0
Arm Swing	20	−74	−100	0	−100	100
Arm Out	−38	100	100	0	38	0
Hip Swing	0	100	0	−100	0	0
Leg Lift	0	0	0	0	56	100
Stride	100	100	−70	0	−52	30

TUTORIAL ## PATHS

Poser offers you the chance to set objects and models in motion on a selected path. To draw an animation path in Poser, do the following:

1. Click on the model to be animated to select it (or select it from the selection options), and go to the Top camera view.
2. Go to Figure>Create Walk Path.
3. You will see a path line extending out from the figure in the Top view. Clicking on this line activates the path creation options. The Nodes that are displayed can be moved. Clicking on the path where no Node is present places a Node at that point, and dragging a Node alters the path's direction at that point (Figure 9.23).

Human and animal figures can be assigned to the path in the Walk Designer, but Props cannot. Props have to be keyframe-animated. Whenever you design a path, it is given a sequential numerical name (Path 1, Path 2, and so on).

Note that a path cannot be moved in the Y-axis (up or down), and that it always rests on the ground plane.

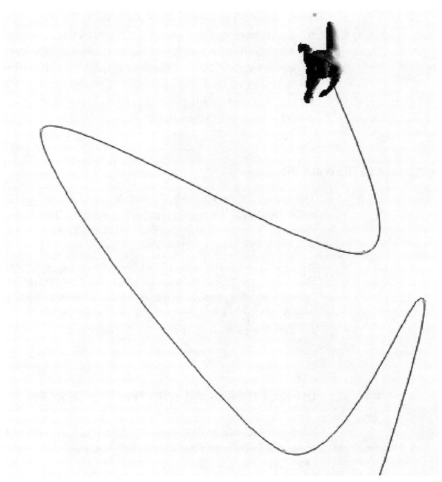

FIGURE 9.23 Use the mouse to place and move path Nodes in the Top view.

Clicking on a path activates it and brings up its parameter dials, where it can be scaled and/or translated along its X- or Z-axis, and rotated on the Y-axis.

TRANSITIONAL WALKS

By "transitional walk" we are referring to a walk assigned from the Walk Designer that targets less frames than the total number in your sequence. The extra frames can be at the start, end, or at both the start and end of your animation. This necessitates checking the Transition From at Path

Start and/or Transition To at Path End. Be aware that a transitional walk might require some tweaking of your poses, since movement from one pose to another in a set number of frames might jostle elements you want to remain stable. In that case, simply go into the Motion Graph and delete the keyframes that are causing the problem. Applying a walk to a figure sets up keyframes for every frame, which often have to be deleted and re-posed when anomalies occur.

ANIMALS AND THE WALK DESIGNER

The only three animals in the present collections that work very well with the Walk Designer are the DAZ 3D Chimpanzee (best), the Raptor (second best), and the Gorilla (sort of). To some extent, you can also use the DAZ 3D Penguin, but some frames might render with severe polygonal distortion, and the poses will have to be tweaked. The Chimp and Raptor have to be positioned first to mimic the standing position of a human model, before applying Walk Designer parameters. The DAZ 3D Alien, Baby, and Baby Sumo can also be considered standard human models for purposes of the Walk Designer.

TUTORIAL

USING OTHER ANIMALS WITH THE WALK DESIGNER

Here is a technique that allows you to have varying degrees of success using the Walk Designer to animate other Poser animals (except for fish and snakes, of course). Do the following:

1. After importing the selected animal from the Figure Library folder, go to the Right Side view camera.
2. Turn off all IK settings. Bend the animal at the waist.
3. In the Front camera view, use the Side-to-Side parameter to rotate each shoulder 90 degrees.
4. Go to the Walk Designer, and apply a walk to the animal. You will notice that most of the time, the animal's arms will be crossed when you preview the walk pose.
5. To fix the arms, go to the Keyframe Editor. Place a marquee around the left and right shoulders, and all of their children (upper arms, forearms, and hands). Delete all of these keyframes.
6. Back on your Document window, you can now keyframe animate the arms again, having deleted all of the Walk Designer keyframes. Exploring these

options further, and perfecting their technique, you can develop an entire library of animals perfect for fables and fairy stories.

USING BVH MOTION FILES

Import a BVH Motion File, and it is instantly associated with your selected figure. We've found that the Z-axis option works best, when the question comes up on import. We've also found that the standard Poser figures work with BVH files better than many of the Zygote extras models. This is especially true when it comes to hand and arm twists, which if pushed too far distort the model. You'll have to explore BVH files on a case-by-case basis. If you find them useful for your work, you can contact BioVision or House of Moves via their Web sites. They often post freebies, which you can download and explore within Poser 4. BVH data works well when you expand the animation to a larger sequence. The motions still appear realistic when the sequence is expanded.

 If you have any uses for BVH motion files in your Poser productions, do not *miss the opportunity to avail yourself of the awesome collection of BVH animated content from Credo International. Be sure to read Chapter 20 of this book.*

CONCLUSION

This chapter opens the door to configuring animations in Poser. In the remaining chapters in this animation section we'll explore how various elements in a document can be prepared for animated output.

10

ANIMATING CHARACTERS

In This Chapter

- Animating Articulated Hands
- Animated Hand Projects
- Facial, Mouth, and Eye Movements
- Animal Animation
- Using the Muybridge Books with Poser
- Composite Character Animation
- The Rapskelion
- Shooting a Cannonball
- Hand 'O Heads

The Poser Character Library keeps expanding, thanks to the efforts of a number of talented 3D developers. Characters designed for Poser are created to be animated, giving them life and movements in your stories.

ANIMATING ARTICULATED HANDS

One of the most spectacular attributes in Poser is the sculpted excellence of the Hand elements and the ability to animate all of the digits. The Hand models are of such high quality that they can appear photographic under the right lighting. Poser hands exist as two types of objects: those connected to figures, and stand-alone models. Each type has its uses.

Connected Hands

In this chapter, when we use the word *hands*, we are speaking about the hands on Poser's human models. Some of the animal models have front paws or claws that are called "hands" as far as their parameters, but we'll leave animal model animation for later. *Connected hands* refer to the hands that come as part of a Human model. Hands are always animated by position whenever you move any body part that causes the hand to tag along. The simplest and most common case would be any movement of the arm parts to which the hand is attached. To make a model wave hello, for example, is to animate the forearm to which that hand is attached (Figures 10.1 and 10.2).

FIGURE 10.1 The hand in this sequence can be seen waving, because the forearm to which it is attached is set to animate from side to side.

FIGURE 10.2 In this sequence, the hand itself is seen waving side to side, while the forearm remains stationary.

To pose and animate the separate digits of a hand in Poser requires a close-up of the hand, and the use of either the Left- or Right-Hand cameras (Figures 10.3 and 10.4).

FIGURE 10.3 The Hand camera controls zoom in on the hands.

FIGURE 10.4 The right hand in Figure 10.2 is zoomed in on using the Right-Hand camera.

Manually Animating a Hand

Having zoomed in on a hand with either the Left- or Right-Hand camera, you are set to animate its separate parts.

1. Move any of the elements you want to pose.
2. Go to the Animation Controller, and move to another frame.
3. Pose the Hand elements again.
4. Repeat this process until you have posed the elements at the last frame.
5. Preview the results, edit where necessary, and save to disk (Figure 10.5).

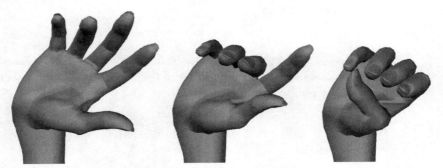

FIGURE 10.5 By selecting any of the movable elements of a hand, while in the appropriate Hand Camera mode, you can keyframe-animate the hand with the Rotation tool.

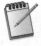

If you decide to animate the hands on a figure that is also to be animated in other ways, we strongly suggest that you animate the rest of the figure first, and save the hands for last. That way, you can animate the hand elements and adjust whatever positions in space the hand is to be at the same time.

A Simpler Way to Animate Hands

There is a far simpler method to use when it comes time to animate hands. Instead of starting from scratch, use one of the pre-set poses from the Hands Library as a start, and tweak the elements as necessary. Go to the last keyframe in your sequence, select another pose from the Hands Library, and tweak that into position. This is much faster than trying to shape the poses manually (Figure 10.6).

Stand-Alone Hands

There are stand-alone hands, left and right, in the Additional Figures folder in the Figures Library. These hands float in air, and can be used

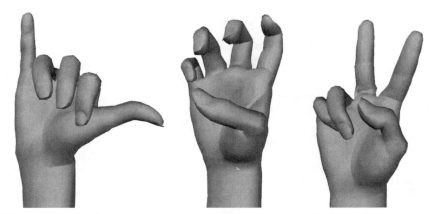

FIGURE 10.6 These three poses from the Hands Library can be used as keyframes, so you can animate from one to the other.

when you need just the hand in a scene, without the rendering or storage overhead of including other body elements. As we'll see in Chapter 13, "Creating Articulated Poseable Models," they can also be used to create some unique animated effects (Figure 10.7).

FIGURE 10.7 The stand-alone hands float free of any body element connection.

Animating Stand-Alone Hands

You can use all of the techniques available to you for animating pre-attached hands to animate the stand-alone hands. Just select the element you need to adjust, go to the keyframe you want, and use the Rotation tool to reposition it.

Animating Stand-Alone Hands with the Hands Library Presets

You can use all of the techniques available to you for animating connected hands to animate the stand-alone hands, using the Hands Library method. Just select the element you need to adjust, go to the keyframe you want, and select a new hand preset pose from the Hands Library. Tweak as needed.

TUTORIAL

ANIMATED HAND PROJECTS

There is an infinite variety of situations where you might focus on animating the hands of a model, or other situations where using the stand-alone hands might suffice. Here are just a few ideas that challenge your Poser 4 interactions:

1. **The Balinese Dancer:** Balinese ritual dances are known throughout the world for the intricate and animated hand movements required of the practitioners. If you want this animation to be authentic, it will require a lot of research on your part, either from books or detailed videos, or both. Make sure you are zoomed in close enough to allow the viewer to appreciate all of your detailed hand posing if you take this project on.
2. **Pebble Pickup:** This project can use either hands attached to a figure (in which case you'll also have to animate the figure stooping down), or with a stand-alone hand. Prepare for this animation by observing your hand, or a friend's hand, doing this task. Watch the way the hand prepares to close on the object (which can be a ball from the Props Library), and observe how each finger plays a part in the action. You can do all the keyframing manually, use the Grasp parameter when the hand is over the ball, and use it again (negatively) when the hand is to release the ball.

If you notice that your Hand model is shaking in the animation, which makes you think the hand has the shivers, you can correct this in the Motion Graph. Just select the offending finger elements, and go to the Bend option in the list. If the motion curve jogs up and down, simply straighten it out in the frames where there is to be no bending. You will probably have to break the curve as well at those keyframe points (Figure 10.8).

Be aware that the Grasp parameter places a keyframe at every tween, so editing might take a while.

FIGURE 10.8 If there is shaking going on that you want to stabilize, open the offending elements' Motion Graph and straighten out the keyframes. The keyframes on the left have been straightened out.

Hand Jewelry

Using a few simple props creates hand jewelry, which can be animated itself.

Strange Hand

Resizing and elongating the elements of a hand on various axes leads to some strange hands, like those used in a horror movie, as the actor transforms into a creature less than human. Using a resizing animation, you can also make a thumb throb, as if hit with a hammer (Figure 10.9).

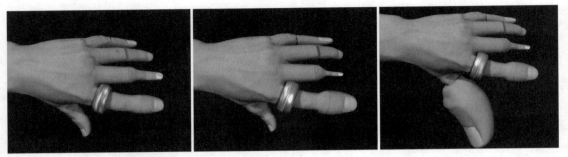

FIGURE 10.9 Hands may be animated to throb and morph.

Talking Head Ring

Using a Torus for a ring, you can easily attach a free standing Head to it. Once the Head is attached, it can be animated, providing the viewer with an eerie apparition. See Figures 10.10 and 10.11.

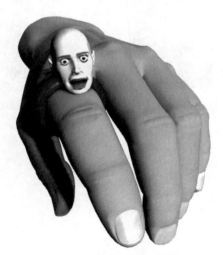

FIGURE 10.10 The Talking Head Ring sits on an animated hand.

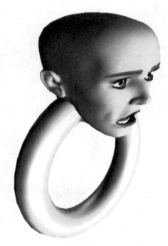

FIGURE 10.11 The Talking Head Ring close up, ready to slip on a finger.

Sharp Warrior Wrist Bands

In the movie *Ben Hur*, the chariots are outfitted with sharp blades. You can easily place a wristband around a hand that has retractable knives. Just use cone props, and elongate them in a keyframe animation to create this effect (Figure 10.12).

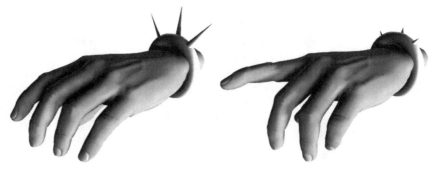

FIGURE 10.12 A threatening animated wristband.

Study Your Body

When you need a special animated hand gesture, you have the best modeling tool at your disposal, your own hands. Open your hand and slowly make a fist. Watch how each finger and your thumb moves, some parts moving faster than others, and some at different angles. The animator has two friends, his or her own body, and a mirror. Using these two readily available study items, any body part can be animated realistically.

FACIAL, MOUTH, AND EYE MOVEMENTS

With just a few turns of a set of parameter dials, any targeted Poser head can be reshaped into a new expression or even an entirely new personality. This breaks open the craft of character development and animation to all Poser users. Even if you have no interest in animating anything else in Poser, you're sure to spend hundreds of hours staring at the screen as your animated characters' faces come to expressive life.

Animating the Mouth

The mouth of any person we meet, along with the eyes, tells an immediate story about that person's intentions and motives. Not a word need be spoken for this to occur. Think of the times that you have met someone new, and just the way that his or her lips looked suggested either an invitation to deeper communication, or a warning that you had best maintain your distance. Animation is about observation, because you can't shape a story for anyone else until you are well aware of all of the ways that stories can be told without a single word being spoken.

Animating with Mouth Controls

Poser 4 offered three parameters for shaping the mouth for keyframe-animation and static poses: *Open/Close Lips*, *Smile*, and *Frown*. The new standard Poser 5 models (designed by Runtime DNA) give you far more parameters, adding *Upper/Lower Lip Retract*, *Thinner Upper/Lower Lip*, *Mouth-CornerOut R/L*, *Mouth Wider*, *Mouth Frown L/R*, *Sneer R/L*, *SidesMouth R/L*, *MouthHooks R/L*, *Mouth Angry*, *Mouth Crying*, *MouthCry Open/Closed*, *Mouth Enraged*, *Mouth Fear*, *Mouth Furious*, *Mouth Laughing*, *Mouth NearCrying*, *MouthPain*, *MouthRepulsion*, *MouthSad*, *MouthSmileClosed*, *MouthSmileOpen*, *MouthSmug*, *MouthStern*, *MouthSurprise*, *MouthTerror*, *MouthWorry*, and more. Add to this a number of new expressive Tongue parameters, and you can see that the range of emotive capacity for the mouth alone is nearly infinite (considering that any of these parameters can be set to positive or negative and combined with one another). See Figure 10.13.

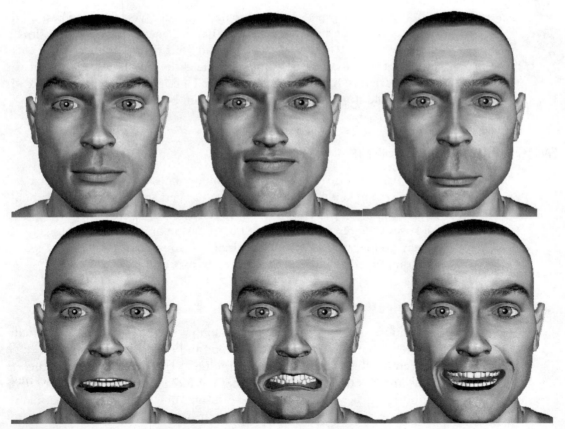

FIGURE 10.13 A series of mouth shapes that can be used as keyframes to animate a character's head. Each mouth shape uses a mix of Mouth parameter settings.

The New Poser 5 Mouth Parameter Dials

With all of the new mouth pose capabilities addressed in the Poser 5 models, the parameter dial arrangement in Poser 4 would be seriously overworked and confusing to manipulate. The new Poser 5 parameter dial structure makes it simple, however, because the parameters are separated by groups into collapsible lists. This opens the way to even more customized facial morphs for targeted figures (Figure 10.14).

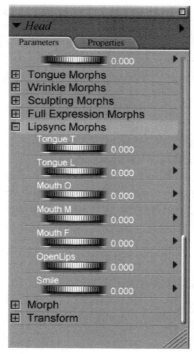

FIGURE 10.14 By clicking on a "+" button next to a parameter group, a new list of Mouth and Face parameters opens for applying new mouth and other emotional shapes to augment the model's personality.

Practice Sessions

• Create an animation, keyframing nothing but the Open Mouth parameter at different values. Use the Face camera. Using just the Mouth Open parameters, you can simulate a chewing action. The new Mouth Up/Down parameter is useful for chewing as well.

• Create an animation, keyframing nothing but the Smile parameter at different values. Use the Face camera. Using just the Smile parameters, you can simulate an emotional roller coaster.

- Create three animations, keyframing nothing but each of these three mouth shapes separately, adjusting the parameters to different values. Use the Face camera. Using just these three Mouth parameters, see what words or sounds you can "hear" as the mouth moves.

You can apply phoneme mouth shapes very quickly by simply assigning them from the ready-made poses in the Phonemes folder in the Faces Library.

The Tongue

The placement of the tongue plays a large role in producing sounds, and the tongue parameter dial settings in Poser 4 help you create the look of certain letters.

Practice Session

Create a few animations, keyframing nothing but the tongue shapes with an open mouth, adjusting the Tongue parameters to different values. Use the Face camera. See what words or sounds you can "hear" as the mouth moves. The Tongue parameters act as interesting modifiers to other Mouth parameters. Using a series of alternate parameter settings for the tongue's "L" shape, with the mouth open at 1.5, you can create a character that is singing "La" sounds, just right for virtual caroling on the holidays.

Animating the Eyes

The ancient proverb says that the eyes are the windows to the soul. When we want to know if someone is lying, or what his or her real intentions are, we look deep into the eyes. The way that eyes dart around or remain focused and steady indicates a lot about the personality of a person. Everything that the eyes do has a powerful effect on the total personality.

Size Matters

Small beady eyes, like those of the rat, are interpreted by us as evidence of a sneaky or conniving character. Large wide eyes, like those of the doe, are interpreted by us as a sign of docility or child-like innocence. You can easily alter the size of a model's eyes in Poser (Figure 10.15).

Vampires, villains, and addicts are usually depicted with small beady eyes. Heroes and lovable characters are usually depicted with larger eyes,

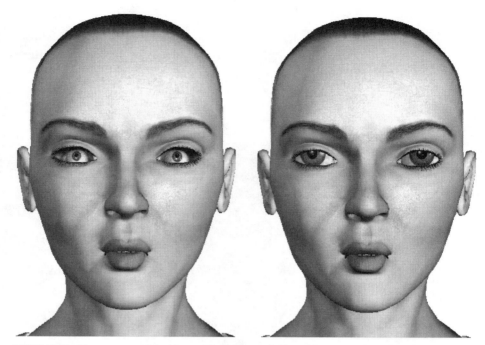

FIGURE 10.15 The same model with small beady eyes (left) and large eyes (122%) (right).

although when they bulge out excessively, the personality types become more disturbing. Poser 5 has new parameter settings for altering the size of the iris and pupil as well.

The difference between large eyes and bulging eyes is their placement on the Z (in and out) axis. To keep large eyes without making them bulge, move them on the Z-axis a distance of from −.002 to −.004.

Blinks and Winks

A blink works on both eyes at the same time, while a wink works on only one eye. Use the Left and Right Blink parameter dials to animate either. Using a negative value opens the eye very wide, and can be useful for emotional responses such as surprise or shock.

If your character's eyes are to blink during an animated sequence, do not time them too symmetrically. Instead, add some randomness to the timing of the keyframes for a more natural look.

Sproing!

By using the Z Trans parameter dial with higher values, you can move the eyeballs right out of the head, for a pretty startling animated effect (Figure 10.16).

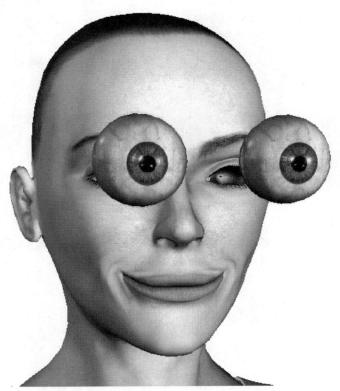

FIGURE 10.16 Using higher and higher Z Trans values, you can pop the eyes out of and away from the head.

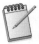

An interesting variation on this effect is to make the eyes smaller (40%) in the first frame, and larger as they leave the eye socket (200% for the last frame).

Attention to Eyebrows

You should always think about adding animation to the eyebrows to enhance whatever animated expressions your model is evoking. The eyebrow movements in Poser also pull at the skin around the eyes, further enhancing any animated eye movements. Eyebrow parameter dials exist for separate movements, including Up, Down, and Worry.

Practice Sessions

Create a few animations, keyframing nothing but the Eyebrow parameters separately, adjusting the values. Use the Face camera. Using just the Eyebrow parameters, a wide range of emotions can be indicated.

Two Approaches to Animating Facial Characteristics

There are two main approaches to animating faces. One is to animate the distortions of the face caused by altering tapers and sizes, while the second is to animate the mouth, eye, and eyebrow features. Both of these options can also incorporate Morphing Targets. Using tapers and resizing, as well as animating features (since distortions are involved) can be considered internal morphing. All of these methods can be used singularly or in combination, depending on your needs and goals.

Facial Distortion Animations

You can alter the tapering of the head, positively or negatively, to create interesting facial animations. The eyes are not included in tapering the head, so they will have to be treated separately, unless you want to leave them as they are. The eyes are included when you alter the head's size. Any prop attached, like hair, has to be treated separately in these modifications.

Size-Wise

You can use any of the Scale Transform parameter dials to scale the head on a selected XYZ-axis, which will severely distort the face at higher values. For example, shortening the Y-axis and widening the X-axis creates a character that can be used as a bully. Other axis modifications create different character types. Animating the Scale parameter creates a head that bulges in and out, useful for cartoon or science fiction projects.

Practice Session

Create an animation that starts with a head's Y-axis globally sized to 0% and ends with the Y-axis globally sized to 125%. Watch the head grow on the neck like a strange melon.

Tapering Reality

A positive taper on a head creates a conehead figure, while a negative taper creates a figure wider at the bottom of the face. Alter between the two for a bizarre face-warping animation.

Face Library Keyframing

Every time you create a face that displays an interesting emotion, or a distortion that you appreciate, save it to the Faces Library in your own custom folder. Faces can be applied as instant keyframes later, to any figure, saving you a lot of time and energy.

 If you are serious about creating characters that can be animated in Poser, with all of the facial subtleties that represent living beings, you should investigate the purchase of two excellent resource volumes from Charles River Media: Animating Facial Features and Expressions *by Bill Fleming and Darris Dobbs (ISBN 1-886801-81-9), and* 3D Creature Workshop, Second Edition *by Bill Fleming (ISBN 1-58450-021-2). These are absolutely vital resources for your library.*

ANIMAL ANIMATION

We share the world in which we live with a myriad of other creatures, creatures with personalities and lives very different from ours. For the animator, animals represent a unique opportunity to tell stories. Disney Studios keeps the mythic tradition alive by introducing films every year that allow animals to speak as stand-ins for human characters and personality types. This tradition is worldwide, since animals have always played a major role in children's fables and teaching stories. Every culture has its favorite animal myths, from the Trickster Raccoons of native America to the Tigers of India. The animal models included with Poser 5, and the additional animal models offered by DAZ 3D and other Poser developers, provide new resources for the computer animator to retell the old stories, as well as to create new integrated human and animal model productions.

Where Are the Poser Animals?

The Poser Animals can be found in your Figures>Animals directory, as well as in any other folders added since the shipping version of Poser 5. If you have purchased the DAZ 3D Animals collection, they can be found in the same directory in a folder called DAZ 3D Animals. The standard animals included with Poser are the Cat, Dog, Dolphin, Horse, Frog, Angelfish, Lion, Snake, Wolf, and Raptor. The DAZ 3D Animals include the Doe, Bass, Bear, Buck, Chimpanzee, Cow, Killer Whale, Penguin, Shark, Zebra, and more.

There is no way that this book can walk you through definitive animation controls for all of the animal models that ship with Poser, much less for the dozens of add-on animal models you purchase or download

and install. Learning how animals move requires both study and attention to detail. If you are interested in creating realistic animations for your Poser animals, we highly recommend that you observe animals in motion every chance you get. Many of you probably have house pets, which is a good place to start. Cats and dogs are always on the move. Carry a sketch book with you, or a digital camera, and record the major points of their anatomy that determine their movement poses—where their feet are, what their heads are doing, and what bends first and in what order when they walk or run or recline.

You can also take a trip to a local zoo, carrying along the same sketchbook or camera. Look at the animals that match those offered in Poser. Spend a day recording their movements, and how their movements reflect their attitudes. If you do this five or six times, you'll be amazed at how much your observations will be translated into your Poser animation pursuits. You can also watch, and even purchase, a collection of the nature shows offered on public television or other suitable TV channels. Those of you that have the appropriate hardware can even capture frames of an animal's movements, so that you can study them more closely. In addition, you can consult the classic *Muybridge Complete Animal and Human Locomotion* volumes.

Eadweard Muybridge

If you've never heard or seen the name Eadweard Muybridge ("Eadweard" is pronounced "Edward," by the way), then you haven't explored the history of animation. Muybridge was one of the founders of the principles of creature animation, and his work still holds a sacred place among the texts that all animators are required to study.

The story of how Muybridge got into animation in the first place is fascinating. Reportedly, someone made a bet with him that a running horse always has at least one foot on the ground. This was in the late 1800s, and photography was just in its infancy. Muybridge set up an ingenious experiment to prove once and for all if the running horse ever had all of its feet off of the ground at any point. He set up a series of cameras at a racetrack, with each camera connected to a trip wire. The rest is history. When the photos were developed, they showed clearly that at one point in the horse's stride, all of its feet left the ground. After this experiment, Muybridge spent the rest of his life filming motion studies of humans and animals.

Since the last copyright on Muybridge's work was filed at the turn of the century, his books and photos are copyright free. This means that you can use his extensive single frame animation studies any way you want

to, and even republish them on your own. Muybridge has three published volumes (lately republished), sold by Dover Press (order numbers 23792, 23793, and 23794).

Dover Publications, Inc.
31 East 2nd Street
Minneola, NY 11501
(516) 294-7000

TUTORIAL

USING THE MUYBRIDGE BOOKS WITH POSER

The Muybridge books are packed with single-frame sequences taken from Muybridge's movies. The sequences depict various animals and humans in different kinds of motion. Many of the animals are ones not yet addressed as Poser models, although the list of available animal models is sure to expand in the future. Because they are copyright free, you can scan in the pages and put the animations back together as a movie if you like. Their real value for Poser studies, however, comes after you scan them in and use the separated animation frames. Here's how:

1. Scan in a page from a Muybridge volume that depicts an animal in motion that resembles one of the Poser animal models you have. The horse might be a good example.
2. In a suitable paint application, cut out and save each frame separately. Make sure that each frame is saved at the same size.
3. Open Poser and load in the animal model that is represented in the Muybridge files you saved out. Import the first frame of those files as a Poser background, and place the animal in the same position and size as indicated by the imported frame.
4. Turn off IK. Rotate the animal's limbs until they match the background pose as closely as possible. Save out this pose in a separate folder in your Poses Library.
5. Load in the second frame, and go through the same process. Repeat this process for every frame you have to pose.
6. Delete the figure, and start a new Poser document. Configure an animation with a length equal to the movie you will create. To determine the length, multiply the motion frames you will be importing by 15. For example, if the Muybridge motion frames number eight, then the length of your movie will be 8 x 15 = 120. At 30 frames a second, this works out to a four-second animation.

7. Load in your figure again. At every 15th frame, starting with frame #1, load in the poses you saved out. These will be the keyframes in the animation, and your computer will create the tweens. When you are finished, you will have a real-world animal animation study!

All of the Muybridge studies are in various stages of completion, so to use the poses in a finished animation you'll have to adjust and add keyframes. You can apply the poses to any model, although when animal poses are applied to a human model, be ready for some hysterical surprises.

Composite Character Animation

Depending on the type of composited model you are working with, some problem areas might arise when you try to animate it. In this chapter, we'll look at how to animate three different types of composites: multiple composite Poser models, prop composites, and composites that combine models and props.

Some of the tutorials that follow mention that you should turn off visibility of selected elements in the Properties window. When it comes to making a large number of figure elements invisible, it is simpler to do this by clicking on the Eye icon for that element in the Hierarchy Editor.

Multiple Composite Poser Models

It is very possible to combine two or more Poser models into one character, making unwanted parts invisible. We'll use two models from the standard models that ship with Poser, just to make sure everyone has them and can follow along.

TUTORIAL

The Rapskelion

For this exercise, we'll use the Male Skeleton from the Additional Figures folder, and the Raptor from the Animals folder. Do the following:

1. Open Poser, and load in the Male Skeleton and Raptor models. Make the neck, jaw, and head of the Skeleton invisible in the Male Skeleton's Properties dialog. Make everything on the Raptor model invisible except for the neck sections and the Raptor's head.

 Always remove all Inverse Kinematics from all models used to construct a composited figure.

2. Turn both models so they are facing in the same direction. You will have to adjust the Skeleton so it is larger, and the Raptor so it is smaller as we go along, so the parts look like a natural fit. Select the Raptor Body from the list, and carefully move the Raptor Body until the head sits on the Male Skeleton's upper chest (Figure 10.17).

3. Select Raptor>Neck 2. Go to Figure>Set Figure Parent, and select the Skeleton's upper chest as the parent of the Raptor.

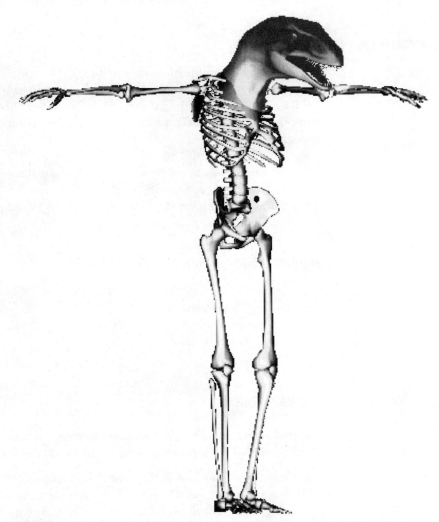

FIGURE 10.17 The Raptor body is moved so the Raptor head sits on the Skeleton body.

4. In the list, if the Skeleton was added first, it shows up as Figure 1, and the Raptor as Figure 2. When you want to move body parts of the Skeleton, make sure Figure 1 is selected. Select Figure 2 when you want to animate the Raptor's head parts.

 Make sure you save this figure as a Poser Document file, and not as a Library figure. The reason is that if saved as a figure, only the selected half of the model will be saved.

5. Select the Skeleton's body. Go to the Animation Sets folder in the Poses Library, and double-click on any of the walking or running sets. You'll see how many frames it takes below its name. Change the number of frames in your animation to 120 at 30 fps (that's four seconds).
6. The animated pose has been added starting at frame 1 of your animation, but the entire animated pose only covers part of your 120 frames, so you have to expand the animation to address all of your frames. Open the Retime Animation dialog in the Animation menu in the top toolbar.
7. Input the number of frames in the animated poses you loaded in. If that number was 24, for example, the first row should read 1 to 24. You shouldn't have to do anything in the second row, as that lists the total number of animated frames; in this case, 1 to 120. Click OK. The animation is now retimed. You can also compress animated frames in the same manner.
8. Preview the animation. Tweak where necessary, and when satisfied, render to disk.

 Make sure you check out the animation from different angles before rendering. You might even want to render more than one angle for later stitching together.

Congratulations! You have now created the Rapskelion, a genetic mutation that combines the Raptor and Skeleton models in Poser. What other strange life forms can you conjure up by using this method? Explore the possibilities.

Prop Composites

There might be times when you want to create an animation in Poser that has no human or animal models in it. It might be that you need a background animation, or perhaps an animation for a non-Poser project. You can use Poser to animate any props in the Props Library, or any 3D objects whose file format Poser can import. Poser's keyframe animation

capability is far more variable than addressing human and animal models alone.

The best way to learn how to animate complex prop scenes is to start with simple objects. That way, your interest is centered on the animation, not the allure of the objects themselves. The same principle is applied to movie-making in general. If you can tell a story with basic objects, think how much more you can do when it comes to developing themes with more complex objects. Basic objects are seen as symbols anyway, and can sometimes force viewers to create their own imagined dialog.

Objects can easily be linked or parented to each other in Poser, simply by moving elements around in the Hierarchy window to create new parenting relationships.

Mixed Composite Combination Animations

In addition to replacing a figure element with a prop, you also have the option of parenting the prop and any selected element of the model. Using a sword prop, for example, you can move it into position over one of the hands of the model, and use that same hand as the prop's parent. The prop still has independent movement on its own when it is selected, but any additional movement of its parent element will also animate the parented prop.

Set rotation to zero after importing a prop. Then, move the Origin Point so that it centers on the object. Use the Outline Display Mode when moving the Origin Point so you can see it more clearly, and jump between views to center it. Delete the object from the Library (but not from the document). Then, add it to the Library again, making sure to click OK on the dialog, and not press the Return key on your keyboard. You will now have a color icon in the Library. That fixes everything. When you make a composited model using that prop, it will come in perfectly centered for positioning and rotation.

Rules for Using Props with Human and Animal Models

Whether attaching a sword to an animated character or a hat to a horse, here are some suggested rules to follow:

- Always move the prop into position before posing the model. Use the Orthographic views to make sure the prop is positioned exactly where you want it.

- Turn off IK, so that any necessary editing avoids having keyframes assigned to every frame.
- Turn on *Full Tracking* in the Display menu when positioning props, so you are aware of the exact position of the prop as related to the body of the model when moving it.
- When placing a prop in the model's hand, leave the hand open. After it is placed, close the hand on the prop by using the hand's *Grasp* parameter.
- If you are creating an animation with more than one human or animal model in it, you might explore (when possible) fully animating the first figure before loading the next one in. Otherwise, the edits can get very tricky, and you will definitely have to adjust the motion curves.

T U T O R I A L

SHOOTING A CANNONBALL

One of the props in the Zygote Tools and Weapons collection (available from DAZ 3D) is a cannon. To do this exercise, you will need to have the DAZ 3D Props folder installed in your Props Library. Do the following:

1. Load the Zygote Sumo Baby, or any other model you would like to use as the cannoneer. Load the Zygote Cannon prop. Face them both away from the camera.
2. Make this a 150-frame animation. Move the cannoneer's arms at frame 1 so they are up in the air, and down at the side in frame 100. This is the "Fire" command.
3. You will be adding two Ball props; one for the cannon explosion, and the other for the cannonball. Place the Ball prop to act as the explosion around the front of the cannon, and set its size to 0 at frame 1. Set its size to .001 at frame 99, and to 400% at frame 101. Set its size to 0 again at frame 106. Color it red.
4. For the cannonball, resize the Ball object so that it fits comfortably in the barrel of the cannon, and color it dark blue. Place it just inside of the cannon barrel at frame 1, and set its protrusion to .001 from the barrel in frame 107. In frame 150, set its distance from the cannon on a straight trajectory off the screen. If you've done this right, the preview will show an explosion followed by the cannonball flying straight out of the barrel of the cannon.
5. Within plain view in your Document window, load one of the heads from the Additional Figures folder. Set it up so the mouth is in a direct line in

front of the cannon. Set frame 1 and 80 to keyframe the mouth closed. Keyframe 105 to a wide open mouth. Add some expression to the eyes and eyebrows at this same point.

6. The cannonball should head right into the wide open mouth. At frame 125, close the mouth and give it a smile. Return the mouth to no smile and closed at the last frame, so the animation can loop.

7. If you like, you can add some other props in the scene just for interest. Save the animation to disk after you render it (Figure 10.18).

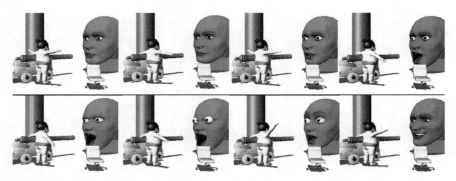

FIGURE 10.18 Selected frames from the Cannonball animation, displaying the items described in the tutorial.

HAND 'O HEADS

In this final animation walkthrough in this chapter, we will create an animation that would be nearly impossible to design with anything else but Poser. It's called "Hand 'O Heads," and you'll see why. Do the following:

1. Load the Left Hand from the Additional Figures folder. This is a stand-alone hand. Open it so that all of the fingers are pretty straight, and rotate it so that it is vertical with fingers upward as seen by the camera. Create a little space between the fingers.

2. Now, load five stand-alone Heads from the Additional Figures folder. They can be any mix of the male and female heads.

3. Resize each head so it looks natural on top of a finger of the hand, and place the resultant heads on the four fingers and the thumb. Each head should be parented to the third finger or thumb part on which it sits.

4. Place some props, hair and/or hats, on each of the heads. Parent the hats and hair to the same finger part to which each respective head is parented. Give each of the faces a different expression.

5. Keyframe animate each head, altering its expression and rotation, and animate a slight movement into the fingers on which each sits. Make this a 180-frame animation. Render, save to disk, and amaze your friends and family.

CONCLUSION

In this chapter, we explored creating different types of animations. In the next chapter, we'll look at the animation of lights and cameras.

11

CAMERAS, LIGHTS, AND ANIMATION RENDERING TIPS

In This Chapter

- Cameras
- Animated Reflections
- Animated Shadow Maps
- Shadow Spotlights
- Lights and Lighting
- More on Rendering
- Poser Flying Logos

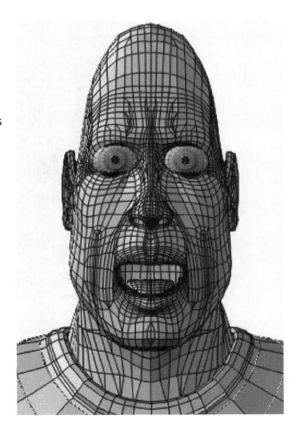

I n this chapter, we'll look at two Poser attributes whose use and modifications can alter your animations in major ways: *cameras* and *lights*. Also included is a *Rendering Tips* section that presents a number of ideas that can make your animations even more interesting.

CAMERAS

Poser features a number of camera options that address viewpoints for you to render and record your output from, as well as make your compositions easier to navigate. Camera adjustments are made in the Camera Parameters palette under the Parameters tab and Properties tab (Figure 11.1).

FIGURE 11.1 Use the parameter dials and checkboxes in the Parameters palette for any camera to adjust the selected camera's settings and parameters.

The *Other* Parameters

Listed under Other in the Parameters tab of the Parameters palette for a selected camera are three options: *Focal*, *Perspective*, and *Hither*. Animating the values of any of these options can help you create interesting and

unique animations. Keyframe-animating the Focal Length of the camera produces animations that can emulate bizarre dream sequences by altering the view of a scene from wide angle to fish lens effects. The Hither value adjust what is known as a *clip plane*, an imaginary plane that determines the visibility or invisibility of everything in a scene. Objects, and parts of objects, between the placement of the clip plane and the camera will become invisible to the camera, while objects farther out than the clip plane will be visible.

The Animating Camera

All camera movements create automatic keyframes when the *Animating camera* is switched on. It is toggled on/off by selecting the icon on the left of the Select Camera icon under the Camera Controls. Gray is on, and orange is off. When it's on, your camera movements are recorded as keyframes wherever you're at on the timeline. Leave the Animating Camera off when you are posing a figure, and turn it on after all figures are posed and separately keyframed. This allows you to worry about one thing at a time, and prevents the camera from animating when all you want to do is to get it to see another view of the scene (Figure 11.2).

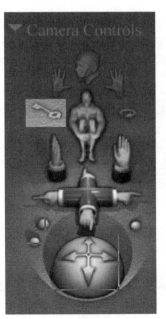

FIGURE 11.2 The Animating Camera icon, shaped like a key, toggles whether the camera changes will be recorded as keyframes.

Camera Library Animations

Just as you can apply different faces or full poses to alternate keyframes to create an animation, so too can you apply different camera views from the Camera Library at different points on the timeline, as long as *Animating camera* is on. The best advice is to spend a day or two exploring different camera angles and perspectives, saving those you like to your Camera Library. When they're needed, for still positions or keyframes, you'll have your favorites from which to select.

TUTORIAL

ANIMATED REFLECTIONS

Here's an animation that you can create, showing a person moving in front of a mirror, without bothering to make the Mirror object reflective. Do the following.

1. Select any one of the Poser figures, or even an animal, as your main character, and place it in the center of your Poser document. Turn the Ground Plane on, and adjust the lighting so the figure is well lit. Make the background a light blue color.
2. Create a 120-frame animation, set to 30 fps. Make the figure move however you want it to, but for this project allow its feet to remain in place (you can do this easily by making sure that IK is on for each leg). When you are satisfied with the choreography, render and save the animation.
3. Next, turn IK off for all body parts. Select the figure's body. Use the Y-axis parameter dial to rotate the figure exactly 180 degrees, so its back is facing the camera. Do not alter any other elements of the figure.
4. Now set the Document Size to the same size as the animation you rendered.
5. You can use your favorite 3D application, or a post-production application to perform the next step. The object is to reverse (flip) the horizontal for the animation you just rendered. We used After Effects for this task. After reading in the animation, we used the Basic 3D Effect, altering the Swivel radial dial to read 180 degrees. Then we re-recorded the animation again, so that it would play with everything horizontally flipped.

Why are we flipping the animation horizontally? Because a common mirror flips what is reflected horizontally. Otherwise, the reflection will not match the movements of the figure standing in front of the mirror.

6. After the flipped animation has been rendered, import it into your Poser scene, and use it as a background.

7. As you can see, the foreground figure is a bit too small. Resize it so that it is a bit larger than the animation, which will now become its reflection.
8. Next, we have to build a wall, so that it looks like a mirror is set within it. You can either do that in an external 3D application and import it, or construct it out of blocks.
9. Now, animate the entire scene, and you will see the mirrored result. The important thing about the camera in this project demonstrates how important it is to keep it the same throughout. Otherwise, the reflected effect will look very strange.

Camera Close-Ups and Textures

One thing to consider whenever you do extreme close-ups (zooms) with any camera is to use just colors for items that are not involved in zoomed views. For items that are involved in zoomed close-ups, use high-resolution textures. This simulates something computer artists call *level of detail*, or LOD. Save detailed textures for items closer to the cameras. The same holds for shots that picture an action figure with a crowd of onlookers in the background. If you use textures for important figures alone, the viewer will see the background figures as hazed out, and without adjusting the camera itself, you will create more perceived depth in the scene.

On the Inside

All of the objects you place in a scene have both an inside and an outside. If you keep zooming in on a selected object or figure, there will come a point at which the camera is literally "inside" of the targeted model. In most cases, you will not know it, because it will seem as if you just passed through the targeted element. This is because most objects in Poser are one-sided polygons, so the computer does not spend any time rendering their inside faces.

This is not true for the mouth, however, and it's easy to understand why. If the inside of the mouth were constructed from one-sided polygons, then every time the mouth opened, you would see right through the character's head! Since this is not exactly the way the real world presents itself to us, the mouth is created from double-sided polygons for a realistic view.

What does this have to do with the camera? Simple, it allows us to fly the camera inside of the mouth of a figure, so that we can view the world as if we were sitting at the back of a figure's throat. Admittedly, this has limited use, but it might be an effect that you could use when conditions

are right. When you place the camera in the mouth, you can still manip-
ulate the mouth openness and other parameters. This makes the mouth
like a window that can be animated, so you can see whatever is beyond
the mouth in the direction the figure is facing (Figure 11.3).

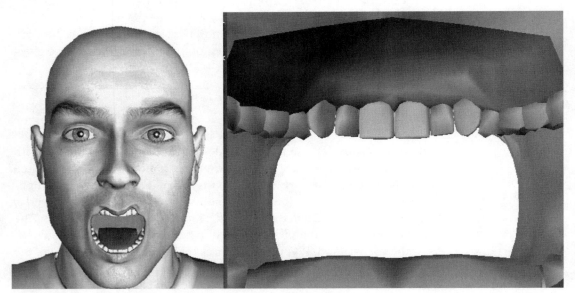

FIGURE 11.3 A view from inside the mouth of a figure shows the back of the teeth, and displays the background or other elements in the scene through the mouth opening.

"Milking" Your Footage

The next time you go to the movies, see how many times the same
footage, from different vantage points, is repeated. Especially watch for
this on expensive takes, such as explosions, and you might also see it
being used when a character is running, walking, or driving. This is a way
that directors often "milk" the footage, and you can take advantage of
this same option with your Poser animations.

After all, it might have taken you hours or even days to get every-
thing in your scene set up just as it should be, with all of the tweaked nu-
ances timed correctly. Why should you settle for just one run-through of
the choreography? Poser's variable camera options are just what you
need to repeat the animation without the type of repetitive loops that do
nothing but bore your audience. Explore these possibilities:

- Render your animation with different camera types, stitching them
 together in the post-production process with Adobe Premiere, After
 Effects, or similar applications. When you stitch them together, use

smaller snips from each animation, so that the viewer is always presented with different perspectives for shorter (three seconds per snip) amounts of time.

- Try rendering the same animation from the same camera using different rendering styles, and then stitch these together. This can lend a subliminal look to an animation.

- Use different zooms, pans, and rotations to add excitement to an animation. You can do this from one camera type by just changing these options with each animation save.

- Cut in views of the face (Face camera) of your character during an animated sequence that shows the figure in action. This allows the viewer to intuit how that character is feeling about what he or she is doing.

- Show the same animation from the perspective of each actor involved. If a flower pot is going to fall on an actor's head, show the view from both the actor and the flower pot. Show the actor looking up, and then become the flower pot looking down. Intersperse these views frequently, until the foreseeable conclusion. This heightens the tension in a scene. If you have two Poser figures engaged in a karate match, show the view from each of the figures, and then perhaps from someone on the sidelines. You'll only have to choreograph the scene once, but you'll be able to get 10 times the footage out of it.

- Allow your camera to fly around the action like an insect, weaving in and out. Do this several different ways on a single animated choreography, and stitch them together.

- Use distorted camera angles to add to user interest, such as a view from the ground up that distorts the perspective. Do this in a variety of ways in any single animation.

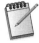 *For the quickest way to achieve interesting perspective views, use the Trackball.*

Most importantly, use any or all of these techniques together, adding even more variety (and viewer appreciation time) to any animation.

LIGHTS AND LIGHTING

Here's a collection of hints and tips concerning how lights can be used to enhance and modify your animations:

- If you want your character to be influenced by an explosion in its proximity, use a few keyframes to turn a light's intensity to 1000 or more. This will wash out the details of the figure, so that it will seem like a fiery event has occurred nearby. Use a white light for an atomic

flash, a red light for a fiery burst, or a blue-green light when the event is being caused by an extraterrestrial source.

- Do you need a night scene, an environment with no moon or stars, but just your actor(s) moving in the dark? Make sure all three lights are set to pure black or a very deep purple. Then, take one light and aim it at the actor(s). Set the other two lights so they shine from above. Set the first light's intensity to 1000. You scene will show up clearly, but will be cast in deep darkness. To make your character's eyes glow in the dark when using this lighting method, turn off all texture for the eyeballs. Set Highlight to full intensity, and select a yellow or yellow-green color. Use a dark blue Ambient color to give the eyeballs a 3D look. This effect is very eerie. You could also use a blood red, giving the eyes a nightmarish glow.

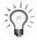 *If you are going to use a background image or movie, make sure it is appropriately dark as well, since Poser's lights have no effect on background footage.*

- Use spotlights of different colors to give your scenes more color depth. This is especially effective when you use complimentary colors on the left and right side of the scene (e.g., red and green or blue and orange).
- For a very dramatic lighting effect, use just one light, and switch the others off. You'll be able to control shadows much more effectively using this method. Turn the light that is activated so that it casts part of the object in shadow. This effect also creates a better 3D depth than multiple lights do. Use this method in conjunction with extreme camera close-ups.

Light Library Animations

Just as you can apply different faces, full poses, or camera positions to alternate keyframes to create an animation, so too can you apply different light colors and positions from the Lights Library at different points on the timeline. The best advice is to spend a day or two exploring different light configurations, saving all of those you like to your Lights Library. When they're needed, for still images or keyframes, you'll have many from which to choose.

MORE ON RENDERING

Poser allows you to use various rendering options for images and animations. These can be set by selecting the one you want from the Document Display Style buttons. If you want to use your display settings for an ani-

mation, just make sure that *Current Display Settings* is selected in the Make Movie dialog (Figures 11.4 and 11.5).

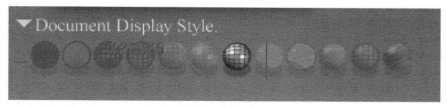

FIGURE 11.4 The Document Display Style buttons.

FIGURE 11.5 As long as *Current Display Settings* is selected in the Make Movie dialog, your animation will use the current display setting in the render.

TUTORIAL

ANIMATED SHADOW MAPS

You can use Poser to create content for an alpha channel in your favorite post-editing application (e.g., Adobe's After Effects). An alpha channel contains only grayscale data, and can be either in black and white or in 256 shades that range from black to white. Pure white prints itself on the channel that the alpha is placed above, while pure black acts a drop-out mask. The grays in between act as different levels of transparency; the blacker the gray, the more opaque it is.

Rendering an image or animation using the Silhouette renderer is perfect for creating alpha channel information, since it creates a two-color render. If the background is black, and the figure white, only the inside of the figure will allow data to be written over the next layer down in your post-editing composition.

If all of these terms seem strange to you, you probably have no experience using a post-editing application. In that case, you can either skip this section and move on, or you can get access to a post-editing application to explore what it can do, and reach a general understanding of these terms.

Essentially, you would use an alpha map to make sure that any effect applied in your post-production software addresses only the Poser figure(s), still or animated. There's yet another suggestion for you to explore. Let's say that all you want to include on a layer in your composition is a shadow of a figure, perhaps a human, animal, or even a prop. Poser can help you do this, and here's how:

1. Create a Poser animation as you normally would, using any of the tools and techniques required to do the job.
2. Make sure that Ground Shadows are on. Make the Shadow Color white, and the Background black. Use the Silhouette renderer. All that you should see in the Document is the white shadow, with everything else being black.
3. Move the object or figure upward along the Y-axis. Notice that the shadow size does not change. Render the animation.
4. Use this animation as an Alpha Shadow mask in your post-production application. Whatever effects are applied to it will only affect the white areas of this Alpha layer, so creating things like shimmering shadows is a snap.

Render Styles

More than any other 3D application, Poser makes it extremely easy to alter the rendering styles on your display screen. Pushing the envelope even further, Poser allows you to select any and all of the elements on screen for different rendering styles (Display/Element Style). This makes it easy to render one part of the document as a silhouette, another as a wireframe, and yet another as a shaded render, leading to all sorts of creative possibilities. Here are a few suggested uses that you might want to explore:

- Create a group animation, using several Poser figures. Use the Render Styles to display your primary figure as a shaded model, and all the rest as wireframes. Render and save to disk. You will notice that the nonshaded figures appear very ghost-like in the animation.
- Create a Poser animation that incorporates just one figure. Use the Shaded Render Style to render the head, and render the rest of the body parts as silhouettes. Render and save the animation. Import the animation into Painter, which will bring it in as single frames in a stack. Go through the stack and apply a texture or effect to the inside of all of the silhouetted body parts—which is easy because they will all be a single color block. Save out the stack as a new animation, and play it. All types of magical effects can be applied to Poser figures using this technique.
- Create a Poser head that uses a Hidden Line Render Style, except for the eyes. Render the eyes as a Textured Render Style. This looks very bizarre, and when animated, calls extreme attention to the eyes.
- Create an animation that shows a figure interacting with and among several props. Use the full Textured Render Style on the figure, and the Sketch Render Style on the props. This method creates a life-like figure moving in a cartoon world.

There are dozens of other mix-and-match explorations you can make using Render Styles. Take some time to explore as many as possible.

 If you want to use the Render Styles in an animation, just make sure that you reference the Display Settings instead of the Render Settings in the Animation dialog.

The Ground Plane

Ground Plane is a rectangular plane that acts as the recipient for object shadows and as the base on which the actors stand or move. The Ground Plane is toggled on/off by going to Display>Guides>Ground Plane. If

Ground Plane is checked, it's on, even though you might have selected a color that makes it invisible. One way to check for it is to move any figure or object in your scene in a negative Y-axis direction. If the Ground Plane is there, your selected item will start to dissolve as it travels beneath the Ground Plane.

Questions and Answers about the Ground Plane

Here is a listing of general questions and answers that refer to the Ground Plane and its uses.

Can I See the Ground Plane from All Camera Views?

No. The Ground Plane remains hidden in the Front, Left, and Right Side camera views, but is visible in all other views.

Can the Ground Plane Be Rotated?

Yes. The Ground Plane can be rotated in all camera views in which it can be seen. Use the Turn parameter dial to rotate the Ground Plane on its Y (vertical) axis. When in the Dolly, Posing, Left/Right Hand, and Main camera views, you can use the Trackball to rotate the entire scene, and the Ground Plane along with it. There are no independent controls for rotating the Ground Plane left or right, or back to front. For this reason, you can't use the Ground Plane as a wall, except if you reorient the entire scene after using the Trackball.

Can Items Emerge from Beneath the Ground Plane?

Yes! If you have a Ground Plane textured as water or colored blue, for example, you can place the Dolphin beneath it, and have it jump in and out of the virtual "water." To move something beneath the Ground Plane, move it on its negative Y-axis. The only stipulation is that you must Turn Shadows Off, because objects below the Ground Plane cast shadows on the Ground Plane itself, leading to strange perceptual confusion for the viewer. When an object is placed below the Ground Plane, its shadow looks like a hole, colored in the shadow color, that sits on the Ground Plane.

Can the Ground Plane Be Resized?

Yes. It can be resized on its X (horizontal) and Z (in and out) dimensions. It has no thickness, so it can't be resized on its Y (vertical) axis. If you re-

quire a ground with a discernible thickness (a dimension along the Y-axis), then use a resized Box primitive or another imported object that has a flat surface upon which your actors can stand. The Ground Plane can also be resize-animated.

Shadow Letters and Logos

Construct a letter prop out of Cube props, or import a Letter object in one of the formats that Poser accepts, making sure that Shadows are switched on. Turn Shadows on in the Render dialog as well. Place the object out of view on the Y (vertical) axis, so all you can see in the document is its shadow. Try rendering this image with a dark shadow on a light Ground Plane, and as a light shadow on a dark Ground Plane. If you explore the placement of the elements carefully, you'll be able to cast a shadow of a word or even a logo on the Ground Plane and anything else that's resting on it.

SHADOW SPOTLIGHTS

When does a shadow suffice as a spotlight? When it is much lighter than the Ground Plane and the other elements in a Poser document. There is a way that you can achieve this effect in Poser, remembering that the displayed image does not show what light and shadows really look like when rendered, so a screen capture application is sometimes needed if you like what you see in the document display. Do the following:

1. Create a Ground Plane colored black.
2. Place a large ball over it, so that the ball is centered out of sight at the top.
3. Make sure Shadows are turned on in the Display menu, and that the Shadow Color is set to white.
4. Move the lights so that they shine down from above the scene. You should see a white oval on a black ground.
5. When you have the view you want, use your screen capture application to grab just the Document window, avoiding any outlines of the window itself.
6. From your capture application, save out the image in a format that Poser can read.
7. Import the image into Poser as a background. Place any figure you want over it, and the figure will appear to be in a spotlight.

Deformations and the Ground Plane

You can use deformers on the Ground Plane. When you use a Deformer (Magnet of Wave) on the Ground Plane. You effectively give it Y-axis dimensional content and variability. Using a Magnet Deformer on the Ground Plane creates cone-like elevations. The most interesting Ground Plane deformation effects are reserved for the use of the Wave Deformer. Using this deformer in conjunction with grouped areas of the plane creates all manner of wave effects, depending on how you adjust the Wave's parameters. Explore the possibilities.

When you deform the Ground Plane and have a figure standing on it, the Ground Plane might be lowered under the figure. You'll have to lower the figure on its Y-axis until it sits realistically on the now-contoured plane.

Animated Backgrounds

Poser allows you to select an AVI movie file as the background for your compositions (File>Import>AVI Footage). If you face your figure so that its back is facing the camera, and it is rotated so that it seems to be flying into the screen, you can use animated cloud footage in the background to give the scene a real sense of flying motion. This is, in fact, the exact way that superheroes take flight in film work, by being composited against a background in motion. It's very important to remember that any animation you create in Poser can itself become a background animation, for use with additional foreground figures and props. Doing this several times in a row results in very complex animations with several layers of interest.

Internal Replacement Props

You can replace every body part of a figure with a prop and animate the resulting character. All you have to do is to place as many props on the screen as there are parts of the figure and put them in position over the body element they are to substitute for. Next, with each body part selected in turn, go to Replace Body Part With Prop in the Figure menu. When the dialog appears, simply select the prop that will be replacing that body part.

If you plan to replace all of the body parts with props, make sure to use the Stick Figure or mannequin figures as a base. Neither have finger joints, so the replacements are simpler. Of course, if you plan to use posed hands, then you'll have to use an initial figure that has finger joint elements.

Fast Rendering

When rendering for multimedia sizes (320 x 240), your Display renders will look just about as good as the Render Settings renders. The difference being that Display renderings often render three to five times faster. Just make sure that the Display Render selection is on. Keep this in mind when time is a pressing consideration.

Using Display Render Styles for Animations

Refer to Table 11.1 for ideas on where to use various render styles.

 You can render these Display Styles in three ways: You can use the Make Movie operation with Display Settings selected, you can grab the image with a screen grab application, or you can export the image from the File menu. No other rendering method will allow you to render in these styles.

TABLE 11.1 You can select from among render styles to create looks for different uses in Poser.

RENDERING STYLE	MEDIA LOOK	USES
Silhouette	Filled in Silhouette	Use this style when you want to see just the silhouette of the image or animation. This is the option to use when you want to create an alpha matte of the document, useful in Adobe After Effects and other media effects applications.
Outline	Quick Pencil Sketch	This style is resembles what animators call a "pencil test." It's also useful for exporting to a paint application, and applying color or textures there.
Wireframe	Complex Ink Sketch	This style allows you to see all of the data on all of the layers of the Docu_ ment. Use it when you want to create a structural blueprint of the image.
Hidden Line	3D Ink Sketch	This style drops out data hidden by the frontmost layers. Use it to create a more eye-friendly structural image than the Wireframe style.
Lit Wireframe	Colored Pencil	This style creates beautiful color pencil rotoscopes of the data, for use in single images or animations.

(Continues)

TABLE 11.1 **You can select from among render styles to create looks for different uses in Poser** (*continued*).

RENDERING STYLE	MEDIA LOOK	USES
Flat Shaded	Faceted 3D Look	When you want a faceted look, this is the style option to select.
Flat Lined	This selection adds the Hidden Line Wireframe lines to the Flat Shaded selection	Use when you want a faceted look with the Hidden Line Wireframe lines added.
Cartoon (was called Sketch in Poser 3)	Very flat and cartoony— Looks like a Wash media	This is the style to target when you want to create a 2D Anime look.
Cartoon With Lines	This option adds outlines to the Cartoon Shader	The outlines added to this option pop the figures out more against complex backdrops.
Smooth Shaded	Default 3D	This is the default Display style.
Smooth Lined	This adds Hidden Line Wireframe lines to the Smooth option	Use this if you like the added lines.
Texture Shaded	Textured 3D	Click on this style to get a pretty authentic preview of the textures applied to your Document elements.

Finished Rendering

When you are ready to render final images or animations to a file, the Render dialog offers you a number of options (Table 11.2).

Table 11.2 **Finished rendering options and uses.**

RENDERING OPTIONS	USES
Main/New Window	Most of the time, you'll want to render in a new window, because that allows you more options for size and resolution. You can do quick test renders by selecting Main window.
Width/Height	The width and height of your rendered output is based on a proportional size related to your display size. Pixels is the standard measure, although you can also select inches or centimeters (only when New Window is selected).
Resolution	Select 72 dpi for video and multimedia, and at least 300 dpi for print purposes.
Antialias	As a rule, leave this checked on. Jaggies are bad news, and Poser renders fast enough to warrant Antialiasing even for previews.
Use Bump Maps	If you have bump mapped textures in the document, check this option.
Use Texture Maps	If you have texture maps in the document, check this option.

TABLE 11.2 Finished rendering options and uses (continued).

RENDERING OPTIONS	USES
Cast Shadows	This is the one option that can slow your rendering dramatically. Check it for more realistic output that displays the shadows related to the three light sources and their blended colors.
Background Options	Your three choices are Background Color, Black, Background Picture, or Current Background Shader (configured in the Material Room). If you have a background picture (or animation) loaded, select Background Picture. Black makes video output look a lot more three dimensional. Printed images should have a light or white backdrop as a background color.

The Sketch Designer

The Sketch Designer, introduced in Poser 4, is addictive. The Sketch Designer interface is activated when you go to Window>Sketch Designer (Figure 11.6).

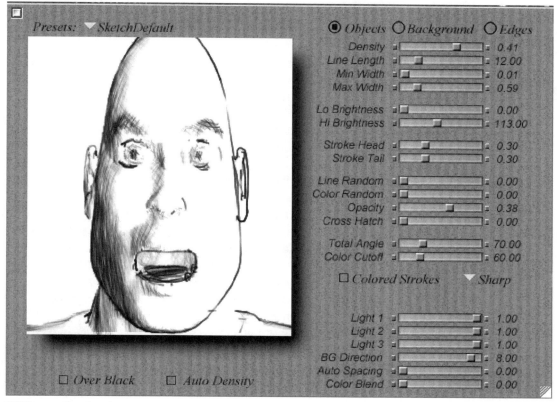

FIGURE 11.6 The Sketch Designer.

 The Sketch Designer options and presets use your selected Display Rendering Style as a base, so select the appropriate rendering style you want first.

The Sketch Designer is especially important to those of you interested in developing "rotoscoping" animations. Rotoscoping is the look created when you transform film footage to natural media looks (e.g., pen, pencil, paint). One of the most important features of the Poser Sketch Designer options is that you need not have any Poser content on screen to use it. You can import a background animation and use Sketch Designer to transform the animation into natural media, and then save out the animation to file. You could even read the animated Sketch Designer background back in as footage for another animated background, and superimpose Poser content (in any combination of Display Rendering Styles and Sketch Designed media) over it.

Understanding the Sketch Designer Options

Referring to Figure 11.6, let's take a brief look at what the commands and options in the Sketch designer do.

- **Presets:** By clicking on the Preset arrow at the top left of the screen, you can access the Sketch Presets that come with Poser. As you select any one of these, the preview image updates to show you exactly what the settings for that look will create if accepted as is. You can also use any of the Presets as a starting point to develop an infinite variety of your own looks. Presets can be deleted from this list, and new ones can be added. Eighteen Presets are included: Caterpillar, Colored Pencil, Colored, Dark Clouds, Inverts, JacksonP-BG, Loose Sketch, Pastel, Pencil and Ink, Psychedelica, Scratchboard, Scratchy, Silky, Sketch-Default, Sketchy, Smoothy, Soft Charcoal, and StrokedBG.
- **Over Black/Auto Density:** Checking either or both of these boxes at the bottom of the Preview area selects that option. Over Black creates a negative of the image. Auto Density allows the system to determine the density of the strokes (this can take a long time to compute, compared to setting the density on your own).
- **Objects, Background, Edges:** You can select variations of the Sketch style for all three of these components. Edges settings determine how the edge of the object(s) is treated, so you can make this a thicker or thinner outline if you like.
- **Density, Line Length, and Width:** Set the Density (0 to 1) to determine the strength of the lines. Line Length (0 to 300) sets the

length of the rendered stroke. Line Width (0 to 40) is set separately for the start and end of the stroke.

- **Lo and High Brightness (0 to 256):** Altering these sliders determines what parts of the targeted object, background, or edge gets a visible stroke. Setting the Lo to minimum and the High slider to about half gives normal results, but each change creates a new Sketch Style (any of which can be saved as a Preset in the list). Moving the High Brightness slider to maximum creates a very dense drawing, with too many strokes. Experiment to learn what you like best.
- **Stroke Head and Tail (0 to 1):** These sliders work in combination with the others to set stroke visibility.
- **Line and Color Randomness (0 to 1), Opacity (0 to 1), and Cross Hatch (0 to 1):** Randomness of either Line and Color attributes adds a looser look to the render. Opacity sets the intensity of the Color areas, while Cross Hatching values determine the extent of the added cross-hatch pattern.
- **Total Angle (0 to 256) and Color Cutoff (0 to 256):** Total Angle helps to set the amount of color strokes applied. Color Cutoff sets a threshold for color strokes.
- **Light 1, 2, 3 (0 to 1):** The higher the value for any of these three sliders, the more that light will influence the direction of the strokes.
- **Background Direction (0 to 9):** This value determines the direction of the strokes used to render the background.
- **Auto Spacing (0 to 3):** This slider determines the space between strokes when Auto Density is enabled.
- **Color Blend (0 to 1):** You can blend the original image content with the Sketch content by manipulating this slider. A "pure" Sketch based color requires this to be set to 0, while a value of 1 blends the original content with the Sketch content color at 100%.

Devote at least a portion of each of your Poser sessions to nothing but exploring different Sketch settings, saving the ones you like to the Presets list.

TUTORIAL

POSER FLYING LOGOS

Flying logos (sometimes called DVEs, or Digital Video Effects) represent one of the common uses of computer graphics and animation, and you can develop Flying Logo content right within Poser. All it takes is the right imported bitmap, and a knowledge of how to use transparency maps. Here's how:

1. Create the content for your logo design in any bitmap application by using white lettering or symbols on a solid black backdrop. Save it in a format that Poser can read (Figure 11.7).

FIGURE 11.7 Create some logo text in an image editing application, and save the image for Poser import.

2. In Poser, add a Square from the Props/Primitives Library.
3. With the square selected, go to the Material Room. In the Transparency Map channel, go to New Node>2D Textures>Image Map, and locate and import your Logo bitmap. Set the Diffuse Color to dark blue. Set the Transparency channel to 1.0, and the Image Mapped option to None. Leave everything else at its default (Figure 11.8).
4. Create an animation that shows the flat square plane flying into the scene and doing some fancy spins. In the industry, this type of animation is called a *flying logo*. All you will see is the logo design because the background square will be totally transparent (Figure 11.9).

FIGURE 11.8 Set the parameters in the Material Room.

FIGURE 11.9 Your flying logo animation will display the logo only; the rest of the square is rendered transparent.

CONCLUSION

In this chapter, we covered a wide range of animation topics. The next chapter begins Part III of the book, "Advanced Topics."

PART

III

ADVANCED TOPICS

12

CHARACTER MAKING IN POSER 5

by S. Brent Bowers

It is with the utmost humility and appreciation that I dedicate this tutorial to all the great texture artists in the 3D community who have both amazed and inspired me since I plugged into this thing they call the Internet and a whole new world of artistic possibility.

In This Chapter

- Template Preparations
- The Face Room

A s you read this chapter, consider this collection of words and ideas by no means a destination. It is intended as a small step in the journey to becoming a better texture artist and creator of Poser textures. This chapter assumes a basic knowledge of Curious Labs' Poser software and Adobe's Photoshop 6.0 or later, although most of these techniques will work with any graphics editing software that supports layers (such as Gimp and Paint Shop Pro 7). The focus will be the custom creation of a photorealistic character texture, and on integrating the texture into a Poser 5 Face Room project. Although methods for creating the body texture with limited source photos will be touched upon, we'll be focusing primarily on the head texture.

The first step in the process is acquiring quality source photos. In most cases, you'll need to shoot these yourself or direct the shooting so that the proper angles are captured. Any decent 35mm camera should suffice. If you're using a digital camera, you'll need a minimum of 2.1 megapixel resolution; 4 megapixels are recommended. The source photos for this tutorial were shot with a Canon Powershot G2.

It's safe to assume that most readers won't have the benefit of a photo studio with professional lighting. As with most things, there's an alternative method that will work. Shoot your model outside on a clear sunny day, between the hours of 10:00 A.M. and 2:00 P.M. Have your model face in the direction of the sun. For each of the poses in Figure 12.1, have your model tilt his or her chin up slightly and use a medium flood fill flash to eliminate shadows under the brows and nose. (An entire tutorial could be dedicated to this step alone.) Your final work can only be as good as your source photos; in other words, "garbage in, garbage out!" Take your time and make sure you have the shots you need before wrapping on your shot. It's quite common to shoot dozens of versions of each pose to get the perfect picture, especially for less experienced photographers. This is a vital step, but you don't have to be Tony Stone to take good source photos for your textures.

Our custom photorealistic character face will be designed for DAZ3D's *Victoria*, available at *www.daz3d.com*. You'll need to download the texture templates, victoriaheadT.jpg and victoriabodyT.jpg, from *www.daz3d.com/store/PoserTemplates/people/VictoriaheadT.jpg*.

TUTORIAL

TEMPLATE PREPARATIONS

Begin by opening victoriaheadT.jpg in Photoshop. The default size for the template is 966 x 966. In order to have a more resolute final product, we'll enlarge

the template size to 1400 x 1400. This step is optional depending on how large a resolution you're aiming for in the finished product. You might run into memory deficiencies if you go much larger than what we suggest here, unless you have copious amounts of RAM in your machine. Do the following:

1. Select the Eyedropper tool by pressing "I" in Photoshop. Sample the color of the dark lines in the template. Press W to select the Magic Wand tool.
2. With the Magic Wand selected as your active tool, ensure that your tolerance is set to around 25. Go to Select/Color Range. Click OK.
3. Press Ctrl+C to copy the lines. Paste onto a new layer by pressing Ctrl+V.
4. In your layer palate, right-click on the new layer and select Properties. Rename the new layer to "Guides."
5. Hold down Ctrl and LMB click on Guides in the Layers palate to select the contents of the layer. With the guidelines selected, select a new foreground color in the Foreground Color Picker box in the Tools palate. We like the neon green, but you'll want to experiment with the color of your guides to find something that works for your eyes. You'll see what we mean a little later.
6. Once you've made your selection, go Edit>Fill>Foreground Color, or simply press Alt+Backspace. Set the Transparency of this layer to 25 in the Layers palate. Press Ctrl+D to deselect all. Select Layer 1.

Now you're ready to grab some source imagery to begin constructing the face.

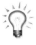 *The model shown in this chapter is Brittany Scott, my esteemed Webmistress. She was good enough to endure many photos until I was happy with the source shots.*

7. Begin by opening your front face shot and copying an oval area of the face from the hairline to just below the chin. In victoriaheadT.jpg, paste this between the Base layer and the Color Guides layer. For the sake of your own sanity down the road, go ahead and label the new layer that you created "Face Front."
8. Select your Color Guides layer and set your Opacity between 25 and 40 for alignment purposes. Nine times out of ten, all the major parts won't fit perfectly to the template. We usually start at the bottom with the lips because they can often be a problem area if you start elsewhere. Once you have the lips aligned with the lips on the guide, save your document. Remember, *"save early and save often."*
9. Now to make all the parts fit. Draw a selection box transecting the philtrum and including the entire upper portion of the Face Front image. Cut this segment and paste it onto a new layer. For Photoshop users, the keyboard shortcut is Ctrl+X followed by Ctrl+V.

10. Select the image from the top of the nose and up. Repeat the Cut and Paste operation so that you now have the face in three segments on three layers (Figure 12.1).

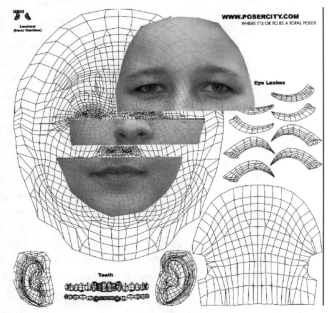

FIGURE 12.1 Cut and paste until you have three segments on three layers.

11. Select the segment with the middle section of the face on it. There's no need to label these items because they'll ultimately become the same layer. Move and scale this segment to match the nostrils to the template nostrils on the Color Guide layer.

12. Using the top segment (unless your model has a perfectly symmetrical face, and no one does), cut it in half and separate two sides on different layers. Split them right down the center of the brow. Individually scale and align them to the template's eyes. Your eye textures will be taken from a different texture, so it's better to have the eyes too small than extending over the line for the items on the templates (Figure 12.2).

13. The eyelashes area under the eye can be thinned down to nearly nothing. When in doubt, go with what is there. This works because the eyelashes are created from a different area of the map and use transmaps.

14. Here's where the real fun begins. Save the head template with the Color Guide layer still on for reference anywhere you like. We recommend creating a custom folder with the name of your character inside of Poser5> Runtime>Textures.

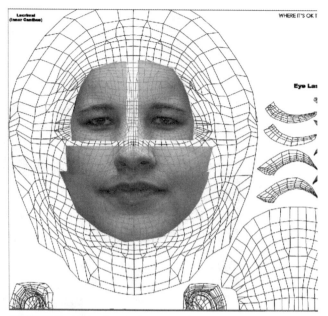

FIGURE 12.2 Move the sections into place.

15. Open Poser 5 and load the Victoria model onto your stage. Use the tab navigation at the top of the Poser 5 interface to enter the Material Room. In your Materials menu window in the Color_Texture box, click on Image_Source at the very top of the list to bring up the Texture Manager where you can browse to find your new texture (Figure 12.3).

16. Once you have it selected, click OK and then jump back to the Pose Room. Select the Face camera and adjust the camera and lighting to your liking. Now, try a production render by pressing Ctrl+R. At a glance, we can see that our initial alignment was pretty close. Now here's where the magic happens. Pull the camera in tighter on the eye, nose, and lips. On closer inspection we can see the areas we need to improve. Brittany's eyelashes are still visible underneath the map lashes (Figure 12.4).

17. Some users find this acceptable enough, and it can look quite natural in most renders as long as there are not any extreme close-ups. We'll fix this with the Clone stamp. The lips are slightly over the border as well. Again, this is a matter of attention to detail and personal standards. Most the time this will look fine as long as it's not too drastic. Many well-known texture artists allow this area to bleed across the border of the lip part of the mesh. Real lips vary in this way as well, with the pinkish fading out on the downslope of the ridge outlining the lips. In this case, leave the border as is, but the dark line at the corner of the mouth will have to go. Again, we'll use

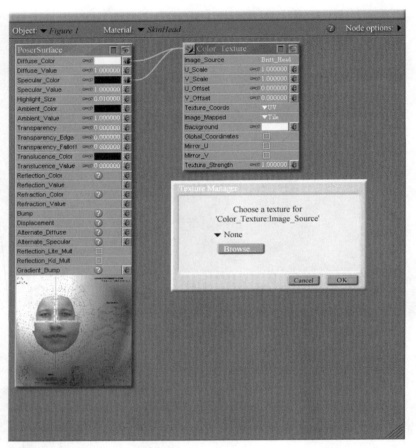

FIGURE 12.3 Enter the Material Room.

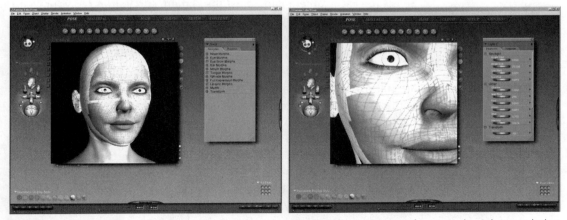

FIGURE 12.4 On the left we can see that the alignment is pretty close. Zooming in, as shown on the right, reveals that Brittany's eyelashes are still visible underneath the map lashes.

the Clone tool to fix this. We'll sample the directory next to the offending line and proceed to cover it. Tweak your head texture until all the alignment issues are corrected. Now it's time to consolidate the layers and fill in the blank areas.

18. With the layer holding the middle section of the face selected, we'll add a layer mask and select Reveal All. Now, in case you aren't familiar with them, layer masks are the coolest thing since sliced bread. Select the Paintbrush and set the flow to 22% or so. In the area where the mid face layer overlaps the layer beneath it (the one that holds the bottom portion of the face), we want to lightly dab the brush in this area. It will begin to erase the midface layer revealing the layer beneath. This is the trick to blending the two. If you remove too much, don't worry; you can add it back selecting white and use the brush in the same area. You'll need to play with the brush settings to get a flow and opacity that suits you. However, this is the area where you'll really sell the face as a single piece as opposed to a patchwork of pictures.

19. Once you are satisfied with the blending, merge the two layers together into a single layer. In Photoshop, select the mid face layer and press Ctrl+E to combine the layers. Next, select the layer with the top of the face both left and right and repeat the process. All the pieces of the face should be properly aligned and on a single layer.

20. Time to fill in the gaps. Re-open the original photo of your model's front face shot, make the same selection you started with, and paste it into your new texture psd, beneath the Face Front layer. Scale the new section to approximately the same size as the Face Front layer and line it up directly behind.

21. Select the Face Front layer and add a layer mask, revealing all. Use the Paint brush in a spot dabbing method as opposed to holding and dragging in straight lines. This helps make the blending of seams invisible.

22. Once you're satisfied with the blending, combine the two layers and use the Clone stamp sparingly to fix areas that don't look like they match properly. You want to pay particular attention to any areas that seem to be shadows. Most of those should be cloned out, because they can look fine in one render and bizarre in another depending on the scene's lighting. Even tones are the most desirable in a texture map. We want to let Poser create the shadows. If you've taken your time with the aligning and blending, you should have something that looks like Figure 12.5.

23. Now we need to create the skin base for the rest of the head. Select an even toned area from one of your source photos that represents a good median value of the subject's skin tone. Copy this and create a new document in Photoshop.

24. Select>All, and go into Pattern Maker under the Filter menu.

FIGURE 12.5 Your figure should resemble this.

25. Once you have the seamless tile of the skin generated, with all selected under the Edit menu, define a pattern called Skin 1. Back on the Head Texture psd, create a new layer above Base and name it Skin. Select the entire layer and fill it with your tiling pattern. Sometimes the pattern creates visible boxes that aren't truly seamless—don't worry, we can fix this. If you're not using Photoshop and don't have access to a seamless pattern maker, you can just create a pattern with the source selection and we can fix it here. Take the Clone stamp on the Skin layer and clone away all the visible lines. Take your time with this part; it's important.
26. Next, we turn the Color Guide layer back on and add the rest of the parts from the photo samples. The ears are pretty straightforward.
27. The teeth will always look better if you cut each from a picture source individually and scale and paste it into place as opposed to using a single tooth picture source to fill in all the teeth. Most people have color variance in their tooth enamel; you've probably never seen a real person with one-color teeth.
28. Just a word about the body texture. You can use the same extrapolated Skin 1 tiling texture to fill in the entire template for the body skin. If you

choose, you can cut photo fingernails and toenails from photos and paste into the template. In this case, we took the shortcut and just filled a solid color for nail and toe polish.

29. Now for the nipples. If your model is willing to pose naked, more power to you. If not, how do we fake it? There's an easy way indeed. The color of the outer rim of the lips usually makes a pleasing color match when used as a fill for the nipples. You want to remember to use a minimum of three shades, getting gradually lighter as you go inward. Of course, you could always troll the Net for images of nipples; however, we don't recommend it due to copyright infringement issues.

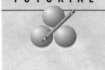

T U T O R I A L

THE FACE ROOM

The reason why many people were ecstatically awaiting Poser 5 was the promise of the Face Room. This new functionality makes creating a custom morph in the shape of your subject's face an absolute breeze. Although it offers the ability to import the reference images as textures, you really want to avoid using this feature when possible. It only exports as a 512 x 512 map. Perhaps in the future this output size will be increased. In any case, for our purposes we just want the morph. Do the following:

1. Begin your Face Room work by importing the front and profile views of your model (Figure 12.6).
2. Poser will ask you to point out the top of the right ear and the point of the chin to help with aligning the image to the morphing geometry. Follow the onscreen prompts. Start with the front view.
3. Using your mouse pointer, click and drag the green dots to align the red line with your subject's facial outline. Make small adjustments with each pull until you have a close proximity to the shape of the face. Remember to account for hair by guessing where the edge of the head would be under the hair. Adjust the profile outline until you are satisfied.
4. You can zoom into the picture you're working on to help you get the geometry aligned as closely as possible by clicking and dragging the Magnifying Glass tool to left of the view you're working in. The Hand tool beneath it will reposition your view. Both are useful tools in tweaking the shape.
5. Once you're satisfied with both views, click the Apply Shape button to see the effects in the right display field that shows the actual morph on Victoria. Now go back to each view and perform additional tweaks and watch its real-time effect on the texture in the Preview window. You have to click

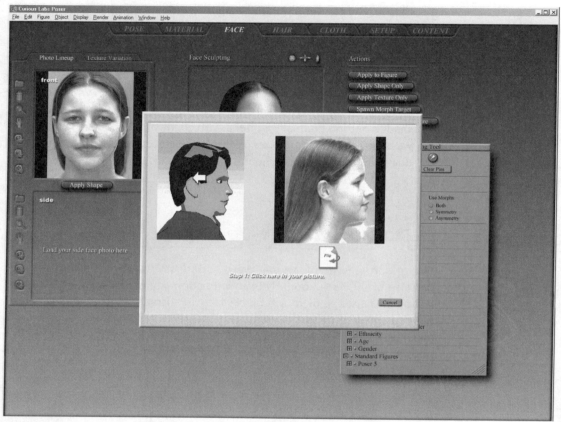

FIGURE 12.6 Import the front and profile views into the Face Room.

the Apply Shape button to see the effect of changes to the morph each time you make an adjustment.

6. Now for the eyes. In the new Poser 5 Material Room, the results you can achieve with the many sub-object textures exceed what a photographic texture map can do. We recommend texturing your character's eyes in the Material Room instead of creating a photographic texture map for the eyes. In special cases where you need to see the veins in the eyes or some other eye effect (vampire, cat creature, etc.), the map options are available.

There you have it. Say "Hello" to Virtual Brittany (Figure 12.7).

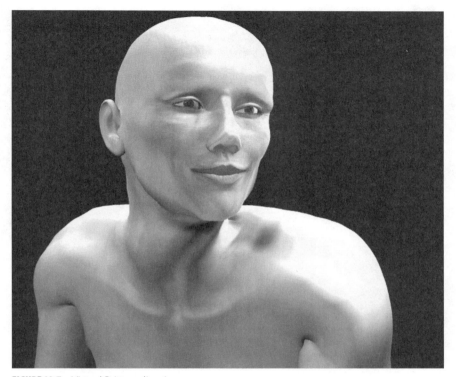

FIGURE 12.7 Virtual Brittany lives!

CONCLUSION

In this chapter we have explored the creation of a unique face for a Poser model, using all of the tools and features in the Face Room.

CREATING ARTICULATED POSEABLE MODELS

by David Richmond (Brycetech)

In This Chapter

- Basic Model Making

- Considerations when Creating 3D Models

- Polygon Shape and Polygon Count

- Normals

- Construction Planes

- Symmetry

- Naming Standards

- Model Preparation

- Naming, Grouping, and Mapping in UVMapper

- PHI Building

- Hierarchy Conversion

- Parameter Dial Naming

- Joint Setup

- Blend Zones

- Advanced Modelers

- Virtual Materials

S o, you want to make a poseable figure and animate it. Maybe you want to make a freebie to give to your friends, perhaps you have a character that you want to see move, or maybe you have it in your head to make poseable characters and sell them. Admittedly, once an artist has a model, animating it is the logical progression. This chapter will walk you through all the necessary steps of creating a poseable figure for Poser.

ON THE CD

The exercises in this chapter were done with the trial model of an ant (included in the Models/Brycetech folder on the companion CD-ROM), Steve Cox's UVMapper (the professional version of which can be purchased at *www.uvmapper.com*, or you can explore the lite version included on this book's CD-ROM in the Extras folder), PHI Builder or a text editor (e.g., Notepad), and an image editor (e.g., PhotoShop, PhotoPaint, PaintShop Pro, or another suitable application).

The process detailed in this chapter is one that you should participate in actively if you want to learn how to do each step. Simply reading the steps will *not* prepare you for the vast amount of material you must be fluent in to make a poseable model. In addition, keep in mind that many forums on the Internet have talented people well versed in the intricacies of modeling, texturing, and posing a character.

BASIC MODEL MAKING

Simply slapping a few lines together to create a 3D mesh and saying "I'm ready to make this poseable" is not enough. You have to plan what you intend the model to do from the very beginning of the project. Deciding later might be too late if the model is not properly planned and set up at the start. To create a 3D model, you must be conversant with one of the 3D modeling applications such as Rhino, Amapi, LightWave, 3ds max, Carrara/Raydream, Amorphium, ElectricImage, Maya, or another suitable application. You can always search out one of the many sources on the Internet for help in learning how to use your 3D application to create 3D models. Both 3D Commune (*www.3dcommune.com*) and Renderosity (*www.renderosity.com*) provide both general and application-specific forums in which you can exchange ideas and get links to information from a wealth of talented artists.

Poseable models can take a variety of shapes. The 3D model might be comprised of a single 3D mesh (e.g., a dinosaur or a humanoid character), a segmented form (e.g., an insect character), a combination of the two, or a combination of the two plus props. A single 3D mesh object is an object or character that is constructed from one model (Figure 13.1).

FIGURE 13.1 A single mesh model.

There are of course other single shapes within this model (one for each eye, teeth, tongue, etc.). However, the standard Poser4 Nude Female model would be considered a single mesh model because the overall shape of the figure is achieved from one polygonal mesh.

In contrast, a poseable model can be made up of many individual models that when combined make a character. In Figure 13.2, the insect is comprised of multiple single meshes that are assembled into one larger character.

The method used to make a model depends on your skill level and how you want your model to appear. Remember that a poseable model

FIGURE 13.2 Separate models make up the segments, which in turn make up each joint of the legs, head, thorax, wings, and abdomen.

does not have to be an animal or insect; it can be something as simple as a rope, cane, or chain maul. The "poseable" aspect allows for multiple appearances and animation possibilities.

CONSIDERATIONS WHEN CREATING 3D MODELS

One thing to consider when creating your model is the number of raw polygons you need. The number of polygons adds detail and morphing capabilities to your model; however, it also adds to file size. Some respected artists made broad statements in the past that high-resolution textures should be avoided and that excessively low polygon counts were found to reduce quality. Statements like "Poser characters are not high enough in quality for me to use" are simply a result of the belief that Poser characters should stay below approximately 35,000 polygons. That polygon count is not high enough for high-resolution close-ups for film or broadcast display.

With computer CPU speed increasing and the relatively low cost of RAM, low polygon count is not as important as it once was. However, making more polygons just for the sake of making more polygons is not a good practice either. Make the number of polygons in a 3D model high enough to achieve the effect you want. If you are creating very high-resolution images or animations that require your character to be close to the camera, a higher polygon count is a must. Conversely, if you are creating desktop images and low-resolution animations, a high polygon count is both unnecessary and a waste of resources. If you want the general Poser community to use your character (e.g., if you want to sell characters at one of the forum stores), relatively low polygon count is important in order to allow more people to download and use the character without experiencing memory problems.

POLYGON SHAPE AND POLYGON COUNT

Polygon shape is also a consideration when creating Poser models. A polygon can have a variable number of sides, but to achieve the best results, three or four work best. A triangular polygon can give a smoother appearance on a curved surface, while a quadrangular polygon can give the overall model more detail. Quadrangular polygonal models can have fewer polygons overall than the same model created with triangular polys (Figure 13.3).

What do you intend to do with your model when it is finished? Is it a snake that has to bend very smoothly, or is it going to be part of a *stiff* ob-

FIGURE 13.3 On the left, the model exhibits triangles as the basis for its shape. The polygon count for this model is 6447 and its file size is 585KB. On the right, the same model is created with quadrangular polys. The polygon count for this model is 3262 and its file size is 497KB. This is about 15% smaller with the same level of detail.

ject? If it is going to be a stiff object (e.g., a statue, or a segment on an insect's leg), you can use a *decimate* function on the model to reduce polygon count. Doing so will reduce the polygon count significantly while trying to retain the overall shape of your model, most likely resulting in triangular polygons. The triangular polygons created through decimation are perfectly acceptable on a stationary model (Figure 13.4).

FIGURE 13.4 Try to imagine a straight line across this surface. You are very limited to where one could be created, if at all.

If you want the model to bend, the triangular shapes or *jaggies* created by a decimation algorithm can result in irregularities within your model that can make it very difficult to make it poseable. The jaggies prevent the object from bending smoothly. Think of it like this: if you are holding a triangle in your hand and you want to bend it, there is no way to do so without causing a crease in one of the lines of the sides. A computer graphics application cannot bend this line either, because there must be a vertex for the polygon to bend on. Creating a model with very symmetrical polygons allows you to break it up smoothly and thus bend it smoothly. This will become clearer later in this chapter (Figure 13.5).

FIGURE 13.5 It would be easy to draw a straight line across the surface in many places. This line would be where the model would bend.

NORMALS

Polygon *Normals* should also be checked to make sure they are consistent. Think of Normals as a one-way mirror. When standing on the mirror side, you can see a reflection. If you are on the other side, you see through the mirror with no reflection. This same idea applies to the Normals of a polygon. If they are inverted, Poser will not read them as you anticipated. In fact, you will be looking at the inside walls of the model (Figure 13.6).

Adjusting Normals can be done on groups within Poser itself. Some 3D applications can maul a model's Normals if you aren't careful. Regularly check the Normals in your modeling program to make sure that they are as you expect, before exporting to Poser (Figure 13.7).

FIGURE 13.6 On the left, the chest Normals of a Poser figure are inverted. On the right, the chest Normals are correct.

FIGURE 13.7 This image shows how some 3D applications can maul a character's Normals to the point of making it very difficult to fix. Notice how it looks like a big bite has been taken out of the lizard's head. This is the result of inverted Normals.

CONSTRUCTION PLANES

If the model's body parts are built on a plane, when the hierarchy conversion is done within Poser much of the joint setup will be properly applied by default. This will save you a lot of time. One of the biggest time-robbing mistakes commonly made by a Poser character modeler is that of building the model in an already posed position. Notice in Figure 13.8 that the legs of the ant are bent as if in a posed position. Although the posed position looks very good in the modeling program, it will add a lot of time to the joint setup process within Poser itself (Figure 13.8).

FIGURE 13.8 The ant's legs are in a posed position.

Why does this add time to the joint setup within Poser? When Poser converts a hierarchy, it looks at each group in the model that is being converted. It then creates an imaginary bounding box that encompasses each body part. Consider Figure 13.9, which shows a leg from the ant that is in a posed position before the model is converted. The box around it represents the bounding box that Poser would use as a reference when creating the joint setup during the hierarchy conversion.

During the conversion, Poser uses the center of the bounding box along the twist axis to create the center of rotation for the body part. In the case of the bent leg, it would use the centers indicated on the left in Figure 13.10.

This center of rotation error means that each body part would have to have the joint manually adjusted with the joint editor. Both the cen-

FIGURE 13.9 The bounding box that Poser would use as a reference when creating the joint setup during the hierarchy conversion.

FIGURE 13.10 On the left, you can see that if the body part were rotated around the "X" indicators, the part would not be rotating from the correct centers. The desired centers are indicated on the right.

ters of rotation and the falloff zones would have to be corrected. Assume that each body part takes eight minutes to adjust the centers and falloff zones for each bent body part. This ant has six legs, each comprised of five joints. That means that the leg adjustments alone would take up to four hours—and probably longer.

Now, let's assume that the legs are not posed when brought into Poser for conversion. The ant in Figure 13.11 is created with each body part on a plane and remains unposed.

FIGURE 13.11 On the left is the unposed ant model. On the right is one of the leg segments. The black box that encompasses it is the box that Poser would use to create the joint during the hierarchy conversion. Notice that the "X" indicators are almost perfectly placed for centers of rotation. In fact, they will work fine in Poser as the center of rotation. Moreover, when Poser creates the falloff zones, they will be perfectly acceptable for almost all of the leg joints.

Portions of the model will still have to have the centers of rotation changed and/or corrections made for the falloff zones. However, the number of body parts that require these adjustments will be greatly reduced simply by creating the model's body parts on a plane.

SYMMETRY

If the model exhibits a plane that has symmetry, you will want to pay attention to this property. Symmetry is a model's inherent property whereby one of the model's sides is the mirror of the other. An example of this would be the left and right side of a head. Many modeling programs will allow you to create one side of the model and then automatically create the mirrored side. This cuts the work of creating a model in half. Once you have the model made, you need to export it in the OBJ (Wavefront) format. If your modeling program does not support OBJ export, you can export in some other format and convert it with an application such as 3dexploration. You can also do the conversion from within Poser (or from within Corel's Bryce).

Symmetry as It Relates to Poser

If you make your character symmetrically (where its left and right halves look the same, for example), then you only have to set up the joints for one side of the figure. After doing so, you can use the *symmetry* feature in Poser to automatically copy your joint setup from one side of the figure to the other. This can save a lot of time during the model-to-poser process, especially on models that have spherical falloff zones in the joint setup. To use the symmetry feature of Poser, you must have *l* and *r* as the first

letters in your character's body parts for *left* and *right*, respectively. Calling one *leg 1* and the other *leg 2* will not get the symmetry function to work because you do not have the *l* or *r* indicated. If you use *lleg* and *rleg*, then Poser's symmetry function would work fine (Figure 13.12).

FIGURE 13.12 Assume that the joints are set up for the left side of the model. Now, all you have to do is use the symmetry feature from the Poser menu and click Yes in the message box that asks if you want to copy the joint setup.

Creating a model for posing is no small task. You must be able to use one of the many 3D model-making applications out there to create your model. Not only must you be able to use the program, you must think about the construction of the model while you are making it. Put very simply: plan ahead. A few moments of planning can save you hours of angst later.

NAMING STANDARDS

There are certain standards when it comes to naming your models. Of course, no one is going to call the Poser police if you decide to break the rules here and there. However, following the rules can give your model a bit more overall usability and can result in far less work in the joint setup process. The following names are the default names used by the Poser characters. If you use these names, most of the poses that come with Poser will work with your characters.

hip	lHand	rHand
abdomen	lIndex1	rIndex1
chest	lIndex2	rIndex2
neck	lIndex3	rIndex3
head	lMid1	rMid1

rightEye	lMid2	rMid2
leftEye	lMid3	rMid3
lCollar	lPinky1	rPinky1
lShldr	lPinky2	rPinky2
lForeArm	lPinky3	rPinky3
lThigh	lRing1	rRing1
lShin	lRing2	rRing2
lFoot	lRing3	rRing3
lToe	lThumb1	rThumb1
rCollar	lThumb2	rThumb2
rShldr	lThumb3	rThumb3
rForeArm		
rThigh		
rShin		
rFoot		
rToe		

Whether you want to use the names as indicated is up to you and the character you are creating. For example, a six-legged insect will not benefit much from the preceding names; however, a humanoid or four-legged animal will. This simply means that making your characters can be easier if you use the naming standards. You might want to be different; if so, great, have fun! You do have to stretch the name meanings a bit in some characters. For example, a horse has four legs, but with these naming standards, you think of the front two legs as "arms" and use the names associated with an arm instead of a leg (e.g., collar, shoulder, forearm, hand). You can name the parts in various ways. Depending on how the model is created in your modeling program, you can name the parts there. Often it is easier to give names in this program because of its stability and ease of use.

Poser filenames have some inherent limitations; for example, the name cannot be more than 16 characters long. If you try to use a model that has a part name containing more than 16 characters, you will get an error telling you that Poser cannot find the geometry. Poser might generate other errors as well, but this long-name issue explains all of the *unfound geometry* errors. You should also avoid using names on dials and body parts that are Poser specific. Examples of names *not* to use would be *body* for a figure part and *curve* for a morph.

MODEL PREPARATION

Before you get too far along in the process, you should begin preparation for the actual input into Poser. Poser models are teeny-tiny in a virtual 3D space sense. If you create a model in a 3D application such as Amapi, Carrara, or Rhino and import it into Poser without a little preparation first, odds are that it will be ridiculously large and nearly impossible to work with.

ON THE CD

Open Poser and import the trial "ant2.obj" model from the companion CD-ROM (in the Models/Brycetech folder) using the appropriate options from the File menu. Depending on what type of model you import, you might change the import settings. The Import menu indicates that the model will be imported as a prop. This indication is unimportant. At this time, all you are doing is using Poser to resize the model to a size that is relative to the standard Poser figure. In this case, since you are importing an insect character that will stand alone, leave the *Percent of standard figure size* option at 100%. If, however, you were importing an object to be used as a costume prop such as a elbow guard for a suit of armor, you would make the percent value significantly smaller, perhaps 20%. Here is a brief description of the important menu options in the Import window:

- **Centered:** Places the object at world center in Poser. This is important to do so that later everything will work properly when doing symmetry or similar functions.
- **Place on Floor:** Does exactly that. It places the model on the ground plane.
- **Percent of Figure Size:** Gives a proportional scale to the standard Poser figure. If you do not know what to use here, leave it at 100%. Setting all imported objects at 100% means that every Poser figure you make will be roughly the same size. For example, an ant or giraffe will be roughly the same size as the Poser human. Changing this value to a higher (or lower) value means that the user will have to zoom in or out to use the figure. A user can use the Size parameter dial to easily change the scale of a figure if it should be larger or smaller.
- **Make Polygon Normals Consistent:** Leave this as it is unless you are experiencing problems with the display of a model. Unchecking this option might help in that case. When the model imports, look to see that the polygon Normals are okay. If they are, you can proceed. If not, you must fix the Normals in your modeling application first before proceeding. You want the model you are working with to be placed as you would expect it to be in the final version. For example, the armor model shown in Figure 13.13 is faced to the side. We can

tell this by changing the camera to Front view. At this view, the figure should be facing the camera so that later everything will be laid out properly.

FIGURE 13.13 From the Front view camera, the model on the left is not facing front. By simply rotating the object on the Y-axis until it faces the Front view camera and then exporting to Poser (as shown on the right), the object is positioned correctly.

Such rotational considerations apply to all body orientations; for example, if the model were standing on its head, this would need correction as well. If all is okay, as is the case with the imported ant model, simply import it into Poser. Check the boxes as indicated in Figure 13.14 so that it imports properly with the group names intact.

These steps accomplish two things: a proper working size and rotation is assigned to your character, and you can check the Normals before spending a lot of time on other things just to find out you have a big problem that you need to go back and fix in your modeling program. To be on the safe side, if your imported model has to have rotational changes, you might want to import the model again following the same steps as previously. Doing this can ensure that the model is indeed centered and on the ground plane. You can then import the model into Poser a second time using the same settings.

COLOR PLATE 1 Top: *SciFi* by S. Brent Bowers. Bottom: *Victoria 3* from DAZ 3D.

COLOR PLATE 2 Top: *Search for a spy* by Lee Chapel. Bottom: *Gallery* by Shamms Mortier.

COLOR PLATE 3 *Mer* by Celia Ziemer.

COLOR PLATE 4 Top: *Prairie Dog Serenade* by Ken Gilliland. Bottom: *Junkyard Faeries* by Celia Ziemer.

Greg Henle 2002

COLOR PLATE 5 Top: *A Taste of Creole* by Gregory L. Henle. Bottom: *The Wall of Faces* by Ralf Zeigermann.

COLOR PLATE 6 Top: *Dragon Lullaby* by Sandra Haverty. Bottom: *The Fountain of Time* by Shamms Mortier.

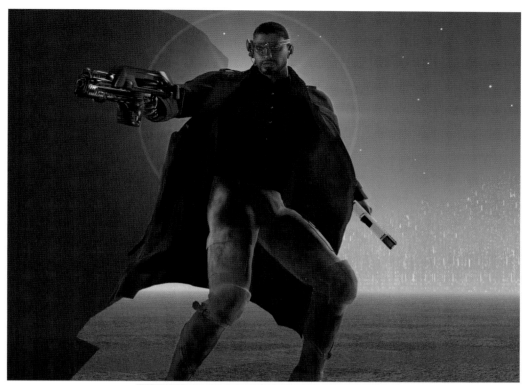

COLOR PLATE 7 Top: *Beyond the City* by Terri Morgan-Lindsey. Bottom: *Reading Comics* by Shamms Mortier.

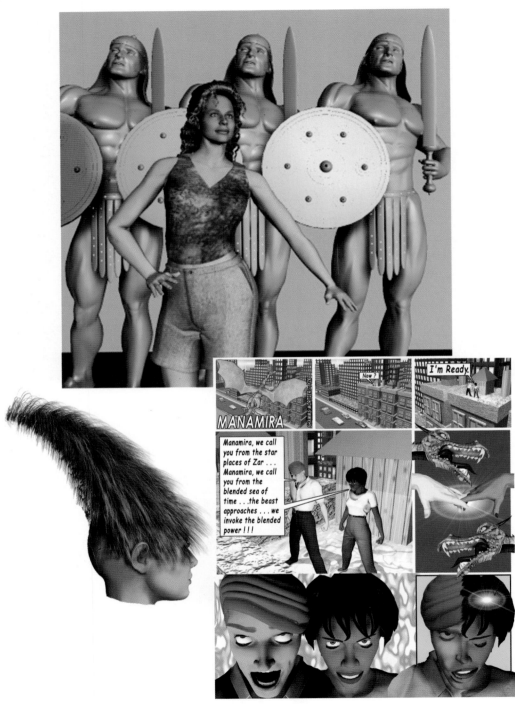

COLOR PLATE 8 *Three Guardians* (top), *Cone Hair* (bottom left), and *Comics Page* (bottom right) by Shamms Mortier.

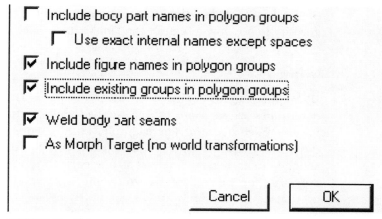

FIGURE 13.14 Make sure these options are checked.

Now that the object is prepared for Poser, you can begin working on other aspects. From this point on you will be using the model you just prepared in Poser. It is wise to save this duplicate model to a different name, just in case you made an error that was not immediately visible on your initial inspection. You should import and export the trial ant2.obj model from the Models/Brycetech folder on the companion CD-ROM to gain experience with this process.

ON THE CD

NAMING, GROUPING, AND MAPPING IN UVMAPPER

ON THE CD

Classic is included in the Extras folder on the companion CD-ROM.

After the initial preparation is finished, you can take an OBJ model into UVMapper to perform many additional functions. This little application is an absolute *must* for any 3D model creator who works with OBJ models and/or Poser figures. UVMapper is primarily used to assign UV mapping to a model.

UV Mapping

UV mapping is a way of creating a visual representation of a 3D model on a 2D surface so that the artist can actually see what texture is applied to all parts of the model. This creates characters that are more realistic because correctly placed textures add more realism to the model. A good model is important, but no more important than a good texture. Mapping and texture creation is an art unto itself. Take a few moments to look at

the images created by the great textures available at 3dcommune or Renderosity to see how a texture can "make the model."

Grouping

UVMapper can also be used for *group assignment*. Grouping is how Poser determines where joints will be applied and is extremely important for Poser model creation. For example, lShldr, lForeArm, and lHand tell Poser that there will be three joints along this part and that the polygons assigned to each group will act as one part. Grouping is also used to create a base for the texture that you apply to the model.

Note to UVMapper for Mac users: There are differences between the Windows and Mac versions of UVMapper. If you should find yourself unable to perform one of the options detailed in this tutorial, it is most likely due to the differences in the versions.

A Warning about UV Mapping

Many 3D modeling applications will not support the advanced features of UV mapping. Once you get to the stage of assigning materials to groups, you can pretty much count out using your 3D modeler unless you want to lose a lot of work. There are ways around these program limitations, which we will discuss later. If a 3D modeling application properly supports UV mapping, you can import a model and export it (without making polygonal count changes) and experience no UV mapping changes.

ON THE CD

Load the "ant1.obj" model from the companion CD-ROM (in the Models/Brycetech folder) into UVMapper. You will see an image like the one in Figure 13.15. This image represents the current UV mapping of the "ant1.obj" model. This mapping is a jumble. With experience you can make sense of such confusion (and even use it), but there is a much easier way to proceed (Figure 13.15).

Give the Object a New Mapping

The mapping options you select from UVMapper's Edit>New UV Map menu (Planar, Box, Cylindrical, Cylindrical Cap, and Spherical) will affect the appearance of the final UV map of the model. Experiment with each mapping type to see how the image mapping is affected by the different options. You can get entirely different results for each mode. You can also apply different modes to separate parts of the model (Figure 13.16).

FIGURE 13.15 A jumbled UV map from the ant1 model appears in UVMapper.

FIGURE 13.16 Using Planar mapping in the case of the ant1 object, you can actually recognize the model in the resulting UV map.

By saving the model and this new UV mapping template from UVMapper, you can take this map into any suitable image editor (PhotoShop, PhotoPaint, or others) and paint any type of textures you need. Then, simply apply this new image as a texture in Poser and it will map properly.

More on UV Mapping

You can use Planer and Spherical mapping in UVMapper at the same time by simply selecting the separate parts you want to map. You can even map different parts from different planes. Figure 13.17 shows a re-orientation of the mapping of the "ant1.obj" model on the book's CD-ROM using different mapping types.

FIGURE 13.17 The UV map for the ant1 object. The various parts were separated out and given a different mapping, making it possible to apply a detailed texture to each.

The mapping in Figure 13.18 was created by giving a new UV map along the Y-axis (this option is available in the Edit>New UV Map> Planar>check Y and split by orientation command in UVMapper).

By separating the orientation, you can paint on one side or the other without affecting the opposite side. If you don't separate the orientation, when you apply a texture on one side, its mirror appears on the other side. Imagine painting a word on one side; on the other side, the word would be backward. By splitting the mapping as shown in Figure 13.18, the mirrored texture will not appear on the opposite side. The method of mapping that is used is largely dependent upon the model type, the overall model shape, and the experience of the texture maker. There are advantages and disadvantages to all methods of UV mapping.

Depending on what type of model you made, you might have been able to name the body parts in your modeling program. If this is not the case, now comes the task of giving the model's parts meaningful names.

FIGURE 13.18 A different UV map is created.

This can be done by selecting the parts and assigning them to a new group. You can select objects by drawing a marquee with the mouse or by selecting them from the menu in UVMapper. In this case, we want to use the menu option Edit>Select>By Group, which will present a menu showing the different names of the object. Select the name you want to change from the menu. Once you have it selected in UVMapper, the wire frame representation will change to a red color. This shows you what part of the model you have currently selected; in this case, the abdomen of the ant (Figure 13.19).

As you can see, this is the first joint at the rear of the model. The ant model already has names properly assigned. However, for the sake of experience let's assume you want to rename this part to "tail"; you would assign this selection to the group "tail." Simply type the new name into the *Assign Selection to Group* text box and click OK. UVMapper will display a warning message that this group does not exist. Simply click OK to apply the change. To reduce the clutter of the extra names, save the file periodically, close UVMapper, and re-open it. Then, re-open the file. Repeat this process until you have every part named as you want them to be. Group naming is a basic step in creation of a poseable figure. Be sure to name the body parts correctly. Not doing so (e.g., instead of joint3, joint4, joint5 you accidentally put joint3, joint5, joint4), will cause you a major headache in Poser that you will have to come back and fix.

FIGURE 13.19 UVMapper has selected the abdomen of the ant.

You can also have UVMapper display using various colors for groups or materials. This is a very useful function to ensure that you have things the way you want. Once you have the groups of your model named appropriately, it's time to assign materials. These materials can be applied using the new Material Room in Poser 5. You can also use the grouped elements to help separate the model so you can paint more easily on the different model portions in a 2D painting application.

There are multiple ways to select parts of the model in UVMapper via the Edit>Select menu. One option is to select by *material*. Any material names that originally were assigned to the object still exist; thus, you can select these by using this method. When mapping, you do not have to have the same material on a group. For example, the mandible that is part of the head can have a different material from the actual head itself. Simply select the model and apply the material *jaws* to it.

A very common mistake when assigning names and materials is to accidentally assign a material name to a group or assign a group to a material. This is done by selecting the wrong menu option because they are so close in proximity to one another in the Edit>Select menu. Be sure to read the heading of the *assign* box to ensure that you are doing what you intend to do. You can easily destroy a great deal of work by assigning a name to the wrong selection. For this reason, we recommend saving often and to different filenames. That way, if you make a mistake that is

unrecoverable (and you will probably do that eventually), you can always go back to an earlier version of the saved file. Notice how the materials are assigned in the model. Remember, you can have UVMapper display the color based on "Material" if you want.

UV Mapping Conclusion

The final mapping you select depends on you. Experiment with the various mapping options and explore dragging portions around and resizing. Any group names assigned during UV mapping should follow standard naming practices as mentioned earlier. Due to the stability and ease of use of UVMapper, we find it easier to assign group names in UVMapper than in a modeling program.

At any time, you can remap the entire object back to the first mapping. Just because you pull a polygon out from the model does not mean it cannot be put back—simply remap the model. Learn the basic keyboard shortcuts for UVMapper, especially for *hide* and *unhide*. These are listed in the UVMapper Help menu. You can hide individual parts or the entire model. You can select hidden objects via the Selection menu options and reveal them to perform work on a small portion of the model at any time. Now that you have the model mapped, save the model. It's okay to use the default settings that UVMapper supplies for export. You will also want to save the texture map. You must save the model with its new mapping and new texture map if you want to create a painted texture. Now you can open the texture map in your image editing program and paint on it. Pretend you are painting directly onto the model—write words on the body or whatever. Then later, in Poser (or some other rendering application). apply this new texture to your model to display the texture you created. UVMapper pro will do this automatically. See UVMapper Pro at *www.uvmapper.com* for details and requirements.

Since the ant is not your normal figure, the naming conventions have not been used. It was created with individual parts to begin with (a segmented model), so it was treated differently than a mesh model would have been. For a mesh model, as in the elephant shown in Figure 13.20, you have to use the mouse and draw a marquee over the portions of the model to break it up into group names.

You can drag individual polygons into a pile and assign the pile to a group if that is the only way you can get the groups to behave the way you want. Try this with a model just to see how it works. You can use the ant object as a test. Simply select polygons with the mouse and drag small portions to a pile. You can always remap the model back to a recognizable state. Remember that mapping does not affect the shape of a model; all it

FIGURE 13.20 Use the Selection marquee in UVMapper to separate the elements into proper groups.

does is affect the way a material is applied to it and offer the ability to assign group names for use in Poser. To get to the various portions of the body that are opposite one another, use different mappings and hide/unhide until you get all of the parts named (Figure 13.21).

FIGURE 13.21 Here, the body of the elephant was hidden and a different mapping was used so that both legs can be seen. Names can now be assigned to these groups. When finished assigning groups, a new mapping can be assigned to the entire elephant to get it back to a recognizable form.

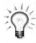

If you have the model prepared as shown earlier, the right part of the model is on the left of the screen display, and the left part of the model is on the right of the screen display. In other words, body parts are exactly opposite yours (as if the figure is facing you).

You can come back later to create your final image texture. First, you should name the parts of the figure. After doing so, you can apply a new mapping and separate out the parts the way you want (Figure 13.22).

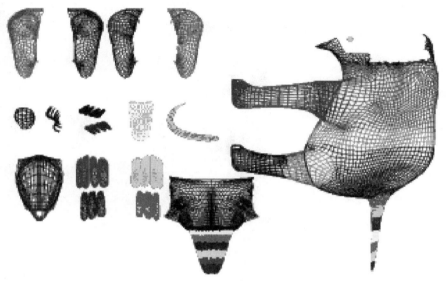

FIGURE 13.22 A new mapping type is applied to the elephant's texture map.

To reduce stretching of the material around the face, the polygons of the head have been pulled away to a different pile and given a "cylindrical" mapping. This way, they can be painted on. This illustrates that you can have different mappings on the model and different mappings on one group. When you create your texture, the map will determine what part of the texture is applied to what part of the model. The texture can be created using images as textures that are carefully placed onto the texture template. The texture shown in Figure 13.23 was made in PhotoShop using layers.

Remember to save your model *and* your texture template. The template size should probably be a minimum of 1024 x 1024 pixels (this is assigned in UVMapper via the Edit menu with *settings*) (Figure 13.24).

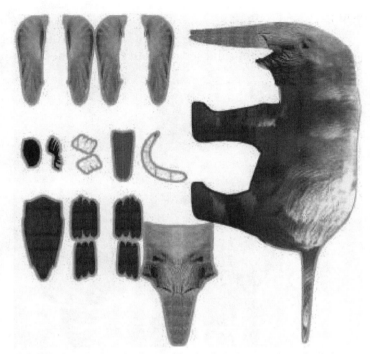

FIGURE 13.23 The head in front of the body in the texture to the right is not necessary; it was used it to help get the mouth texture more realistic.

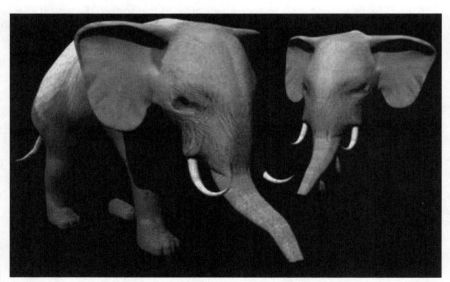

FIGURE 13.24 How the elephant texture image looks when applied to the UV mapped model.

PHI BUILDING

ON THE CD

Now that you have the groups set up for the ant (the names used here are as they appear on the ant1.obj model on the companion CD-ROM), you have to set up a hierarchical relationship file (a PHI file) that tells Poser how to handle the parts. A hierarchy determines how the body moves by assigning parent and child relationships. A parent object will affect the child object when it moves; however, a child does not necessarily affect a parent. For example, your arm is made up of a hierarchy. When you move your upper arm (shoulder), the lower arm (forearm and hand) moves. You can, however, move the forearm without moving the upper arm. The shoulder is the parent of the forearm. The forearm is the child of the shoulder. The forearm is the parent of the hand. The hand is the child of the forearm. As shown in Figure 13.25, there has to be a beginning (i.e., "the main parent") and an end. Therefore, in the case of the maul, when you move the handle the entire maul moves, but when you move link 3, only the parts above it are affected.

FIGURE 13.25 When you move the handle, the entire maul moves, but when you move link 3, only the parts above it are affected. The head is the child of the top link in the chain, and each succeeding link is the parent of the preceding one. The handle is the main parent.

In real life, you could move the center link without moving either the ball or the handle; however, this is a computer simulation. A similar effect can be achieved with the use of Inverse Kinematics (IK). This is not the same as "real world" effects, but is a close simulation in comparison. A PHI file is a text file that assigns this hierarchy to a model so that Poser knows how to move each part. That way, if you move tail joint 1 of a crocodile, it knows to move any joints beyond (ideally joint2, joint3, etc.) to complete the effect of tail movement. A PHI file can be created by using a standard text editor, or you can use a *PHI Builder* (go to *www.royriggs.com/* to download the free Windows version) to make it easier.

Hierarchy Relationships

Before you use the PHI Builder mentioned previously for the ant2 model, create a folder in your Poser/runtime/geometries/ folder called "ant." Put the OBJ file into this folder. The ant model can actually be put in any folder immediately beneath the Geometries folder, but for simplicity, the "ant" folder is being used. Install PHI Builder as indicated in its readme file. It should be in the same folder as your Poser.exe file. Open PHI Builder and click the OBJ button. Locate the ant object file within your Poser/runtime/geometries/ant folder. The group assignments will import. When the ant is imported into PHI Builder, the order is incorrect and you have to change it. The tree view of the PHI Builder can be used to drag and drop the parts into a hierarchical order, or you can use the text view and type directly into the file. If you are creating the PHI file in a text editor, the line that begins with "objFile" gives the relative location of the OBJ file using the Mac file setup. Instead of the back slash "\" that Windows uses for file folders, use the colon (:). Change the hierarchy so that it appears as indicated next. An explanation of what is represented on each line follows.

The PHI hierarchy for the ant model:

#This file generated by Model Packager PHI Generator v1.0.

```
objFile :Runtime:Geometries:ant:ant.obj

1 thorax zyx
  2 l1_0 zyx
        3 l1_1 xyz
              4 l1_2 xyz
                    5 l1_3 xyz
                          6 l1_4 xyz
```

```
2 l2_0 xyz
      3 l2_1 xyz
             4 l2_2 xyz
                    5 l2_3 xyz
                           6 l2_4 xyz
2 l3_0 xyz
      3 l3_1 xyz
             4 l3_2 xyz
                    5 l3_3 xyz
                           6 l3_4 xyz
2 r1_0 xyz
      3 r1_1 xyz
             4 r1_2 xyz
                    5 r1_3 xyz
                           6 r1_4 xyz
2 r2_0 xyz
      3 r2_1 xyz
             4 r2_2 xyz
                    5 r2_3 xyz
                           6 r2_4 xyz
2 r3_0 xyz
      3 r3_1 xyz
             4 r3_2 xyz
                    5 r3_3 xyz
                           6 r3_4 xyz
2 head zyx
      3 lantenna1 yzx
             4 lantenna2 zyx
      3 rantenna1 yzx
             4 rantenna2 zyx
2 connector1 zyx
      3 connector2 zyx
             4 abdomen zyx
ikChain Right_Leg1 r1_0 r1_1 r1_2 r1_3 r1_4
ikChain Right_Leg2 r2_0 r2_1 r2_2 r2_3 r2_4
ikChain Right_Leg3 r3_0 r3_1 r3_2 r3_3 r3_4
ikChain Left_Leg1 l1_0 l1_1 l1_2 l1_3 l1_4
ikChain Left_Leg2 l2_0 l2_1 l2_2 l2_3 l2_4
ikChain Left_Leg3 l3_0 l3_1 l3_2 l3_3 l3_4
```

Hierarchy Depth Numbers

The initial numbers found at the beginning of a PHI file line indicate the depth of that body part in the hierarchy.

```
1 thorax zyx
  2 l1_0 zyx
        3 l1_1 xyz
              4 l1_2 xyz
                    5 l1_3 xyz
                          6 l1_4 xyz
*snip*
Indenting the file using the Tab key makes the hierarchy easier to
read.
```

Body Part Names

The next part of a PHI file line is the body part name. In the following example, the l1_0 body part is the child of the thorax, the body part l1_1 is the child of body part l1_0, and so on.

```
1 thorax zyx
  2 l1_0 zyx
        3 l1_1 xyz
              4 l1_2 xyz
                    5 l1_3 xyz
                          6 l1_4 xyz
*snip*
```

Rotational Plane Assignments

Next, we have to set up the rotational order of the model.

```
1 thorax zyx
  2 l1_0 zyx
        3 l1_1 xyz
              4 l1_2 xyz
                    5 l1_3 xyz
                          6 l1_4 xyz
*snip*
```

The setup should be set up with the twist axis first, the side/side axis second, and the bend axis third. To understand which axis to use, you have to get a mental picture of how they are laid out in Poser. The plane from left to right is the X-axis. The plane from top to bottom is the Y-axis. The plane from front to back is the Z-axis (Figure 13.26).

If you did the preparation shown earlier, it should be relatively easy to set up your joints. Again, the Poser police aren't going to come to your

FIGURE 13.26 X = side/side, Y = top/bottom, Z = front/back.

house if you exchange the "side/side" and "bend" planes. However, the "twist" plane *must* be the first plane, or you are asking for lots of posing trouble later. The ant model as it appears in Poser is shown in Figure 13.27. Based on this picture, you should be able to change each part's rotational order.

FIGURE 13.27 The ant model as it appears in Poser.

If you are unsure what part of an object to assign to "bend" and "side/side," try to put the part that would most likely achieve a 90-degree angle in the "bend" plane. If two are equally likely to achieve this angle, then use the world as your reference. If you were standing in front of the object, use this point of view as your reference for "side/side" and "bend"; i.e. "z" is the "side/side" plane and "x" is the "bend" plane.

The acceptable rotation combinations are:

- xyz
- xzy
- yxz
- yzx
- zxy
- zyx

The rotational order set up for this model was indicated previously. Study it and figure out why each rotation was set up the way it was. The three previously mentioned PHI components (hierarchy depth number, body part name, body part rotation) must be included in the PHI file for each body part.

Joint Types

Additional parameters can be dictated by your PHI file. Notice the word *curve* after a few of the joints in the previous example. This tells Poser to treat this joint as a curved joint such as you would find in a tentacle, rope, snake body, long neck, and so forth.

```
#This file generated by PHI Builder V2.0
objFile :Runtime:Geometries:brycetech:Octopus.obj

1 hip yxz
  2 Head yxz
        3 lteye xyz
        3 rteye xyz
  2 t1joint1 zyx
        3 t1joint2 zyx curve
              4 t1joint3 zyx curve
                    5 t1joint4 zyx curve
                          6 t1joint5 zyx curve
                                7 t1joint6 zyx curve
                                      8 t1joint7 zyx
curve
                                            9 t1joint8
zyx curve
*snip*
```

However, when you use this type of joint you lose a great deal of edit potential of the joint within Poser. You can achieve a similar, if not better, result by making smaller groups in your OBJ model and making multiple joints. Double-click the joint in PHI Builder to bring up a menu that allows you to select "curve," or enter the text edit mode and type it in should you desire to have curve modes. Additional components that can be assigned for each body part line in a PHI file are not covered in this chapter.

Inverse Kinematics

ON THE CD

There is one last thing to consider when setting up a PHI file: the IK setup. The ikChains for the ant should appear as follows when using the names supplied with the model on the companion CD-ROM in the Models/Brycetech folder.

```
ikChain Right_Leg1 r1_0 r1_1 r1_2 r1_3 r1_4
ikChain Right_Leg2 r2_0 r2_1 r2_2 r2_3 r2_4
ikChain Right_Leg3 r3_0 r3_1 r3_2 r3_3 r3_4
ikChain Left_Leg1 l1_0 l1_1 l1_2 l1_3 l1_4
ikChain Left_Leg2 l2_0 l2_1 l2_2 l2_3 l2_4
ikChain Left_Leg3 l3_0 l3_1 l3_2 l3_3 l3_4
```

IK chains determine what part of the model would you like to be able to "pull" and have it affect other parts of the model. For example, the standard Poser figure has IK on each leg (Figure 13.28).

Setting Up an IK Chain

Do the following to set up an IK Chain:

- The first word in your new line is *ikChain*.
- The next word is the name of the IK chain. This name cannot contain spaces.
- The last is the order of the IK chain from the base to the target, which in this case is the ball.

Example IK Chains

```
ikChain Left_Front_Leg ltshoulder ltforearm ltfrontfoot
ikChain left_leg_1 l1jt1 l1jt2 l1jt3 l1jt4 l1jt5 l1jt6
ikChain Right_Arm rShldr rForearm rHandjtcontrol rHand
ikChain Left_Leg lThigh lShin lFoot
```

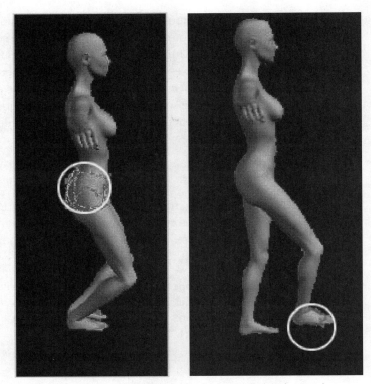

FIGURE 13.28 If you pull the hip down, the legs will also change shape according to this IK setup. If you pull the foot, the leg joints will follow in a "natural" motion.

Now that you have the PHI file created, you can save the file (use the extension .phi for Windows) and proceed to the next step. Remember that you can create this entire file with a text editor.

No matter what type of character you make, the previous steps will apply. You can opt not to assign IK, but doing so usually makes the model much easier to pose.

HIERARCHY CONVERSION

Now that the OBJ file is grouped and the PHI file created, it is time to open Poser and start to work on the actual figure. Once you have Poser open, open the hierarchy file you created using the File>Convert heir file menu option. The new figure you just made will be in the Figures Library in Poser under *New Figures*. Double-click on the thumbnail to have Poser create the model. If you made a mistake in the hierarchy file, you're

going to see it during the conversion or during the first creation of the model. Possible errors you might see are ones related to *no corresponding geometry found*. This can happen for a number of reasons:

- A name for a group is over 16 characters in length.
- You have called a group name in the PHI file that does not exist (e.g., rForeArm is in the OBJ, but rForearm is in the PHI. Uppercase counts!).
- You have included an additional space in your IK chain (e.g., ikChain leftleg lthigh lcalf lfoot versus ikChain leftleg lthigh lcalf lfoot—the extra space between leftleg and lthigh can cause errors).
- A space in the name of the ikChain (e.g., "right leg" is not a valid name for an ikChain

Quick Tests

It is vital to test your work before continuing. Do the following:

- Check that the Normals are still okay. Check the polygon Normals with a quick glance over the model.
- Do a quick scan for polygon holes.
- Check that your IK chains appear in the menu. You do not enable them, but you do want to check to be sure they are there and are properly indicated.

If the IK chains are okay, you can now open the "joint editor" window and the "hierarchy editor" window, and proceed from there.

PARAMETER DIAL NAMING

Each figure part can be selected in the hierarchy window. Select *Figure1* and change the name to *red ant*. Change the dial names for rotation to a meaningful name. Do this by double-clicking on the dial's title and typing in a new name in the box that appears. Remember how you intended each rotation to occur: Z is "twist," X is "bend," and Y is "side/side" for this body part. Keep this in mind as you change the names of the rotational dials. You can change these names to be something relevant to your character. For example, if you were making a dragonfly, you could choose to use *twist, spread,* and *flap* for the wings.

JOINT SETUP

Over the course of setting the rotational values, you will find that you will want to reset the rotational values to "0." You can reset all of the

rotational dials to "0" by clicking *zero figure* in the Joint Parameters window. For each of the joint parameters, you will want to make changes (if required) to provide a realistic movement. For example, check that the center is where you want it to be for each part. This is not the center of the object, but the center of rotation. A green cross will appear at the center of rotation. Figure 13.29 illustrates the center for a joint of the ant's leg. This default center location is okay. The center of rotation should be as close to the location of a joint if there is one in that area, such as a shoulder joint, elbow, and so forth (Figure 13.29).

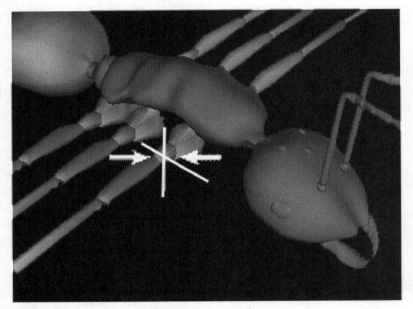

FIGURE 13.29 The center for the joint on the ant's leg.

Adjust the centers for the body parts of the ant.

You can rotate a center of rotation. Sometimes you will achieve better rotational results for a figure's joints by aligning the center of rotation with the way the body part extends away from the body rather than leaving it parallel to a plane. To do this, simply click the "align" button within the joint editor window. You can adjust the falloff areas by dragging the red or green lines.

BLEND ZONES

The *Blend Zones* are accessed from a drop-down menu in the joint editor.

Twist Zone

The twist zone is indicated to the right. Notice that there are two colors along this planar representation of rotation. Everything beyond green is 100% affected by the rotation along this plane. Everything behind the red is 100% unaffected, and the objects in the hierarchy between the red and green are blended to complete the twist. Rotational zones should be adjusted individually and tested as you make them to ensure that they work properly.

Side/Side and Bend Zones

These zones are indicated to the right. Notice that there are two colors along this planar representation of rotation. Everything beyond green is 100% affected by the rotation along this plane. Everything behind the red is 100% unaffected, and the objects in the hierarchy between the red and green are blended to complete the rotation. Rotational zones should be adjusted individually and tested as you make them to ensure that they work properly.

Spherical Falloff Zones

There is an option to use spherical falloff zones in the joint editor window. These are used to help reduce the way a rotational value affects a model. Everything within the green sphere is 100% affected. Everything outside the red sphere is 100% unaffected. Everything between the two zones is blended. Green spheres take precedence over red spheres.

No Spherical Falloff Zones

Rotational values directly affect the parent and the child. In Figure 13.30, the child (tusk) extends back into the parent (head). Therefore, when the tusk is rotated, the head is affected, thus breaking the head away from the trunk. However, if you apply spherical falloff zones, you can restrict the area of the head that is affected by the tusk rotation (Figure 13.31).

You can open individual models in Poser and look at their rotational setup for reference if you are unsure how to make the joint work properly.

Using the previous information as a guide, adjust the falloff zones of the ant's body parts. Experiment with the motion of the body part using your new joint setup assignments by using the parameter dials to rotate it. Once you have the joints set up, save the model to your Figures Library by clicking the Add button. Apply some default diffuse materials to

FIGURE 13.30 Notice how the head breaks from the trunk of this elephant model when the tusk is rotated.

FIGURE 13.31 Top view of spherical falloff zones for an elephant model. The areas outside of the red sphere (shown in white here) are not affected, thus keeping the head from being distorted by the tusk rotation.

the figure in the Material Room. In this case, red has been applied to all materials but the eyes (Figure 13.32).

FIGURE 13.32 Now we have a poseable Poser figure.

Breaking the Hierarchy

In the case of the ant model, the body parts are segmented and do not necessarily affect the parent body part in a real ant. Therefore, if you would like to make each body part not affect the parent, you can have Poser change the way it handles the blends between parent and child.

There are several ways to break the Poser hierarchy. Poser offers a way to turn bending off for a part of an object. Often, you can uncheck the *bend* checkbox in the Element's Properties window to stop undesired blend zone deformations. However, unchecking this option is often not sufficient to accomplish the desired result.

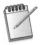

If a figure is saved to the Library with the bend option unchecked, the CR2 for the figure would have "bend 1" changed to "bend 0" for the body part.

You can also add an additional part between the moving parts to break the hierarchy in the Hierarchy window. The advantage to this is there is no CR2 editing required. An actual physical additional joint does not have to be present. A reference to a joint (even though it is not there) is sufficient. This would be accomplished in the PHI file. You can also edit the CR2 and remove all of the blend zones on a figure with one change.

Near the bottom of the file, below the lines that contain the *weld* information, you will see a line that references *allowsBending*. Change this line to *allowsBending 0*, and save the file. Now the blend zones are removed from the figure. We need to do this for the ant so that each body part will move without deforming its neighbor.

ADVANCED MODELERS

Perhaps you have only one part of an object that you would like to move freely without deforming the model; for example, the eyes of a figure. You can indeed perform CR2 edits and make it so that the movement of the eyes does not affect the head. This does not apply to the ant figure we are posing. It would apply to a different type of figure, such as a human, animal, and so forth. It could be used in the ant, but would require far more CR2 editing than is necessary.

You start by going to the CR2 of the model you are working on and find the parent (the head) where it starts the properties of the actor. Notice in the following demonstration that the reference to "actor head:2" is in the CR2. The number after the colon might be different in your file (which is okay); what you are looking for is the reference to the head as an actor.

```
actor head:2
{
name GetStringRes(1024,2)
on
bend 1
dynamicsLock 0
hidden 0
addToMenu 1
castsShadow 1
includeInDepthCue 1
parent neck:2
channels
```

Notice in this section that some areas are clearly separated from one another (see the following). The actors are broken up into various partitions. Calls for taper, rotations, and so forth are found with each actor's reference in the CR2.

```
taperY taper
{
```

```
name GetStringRes(1028,1)
initValue 0
hidden 0
forceLimits 0
min -100000
max 100000
trackingScale 0.04
keys
{
static 0
k 0 0
}
interpStyleLocked 0
}
```

The first part of the line will contain various names for associated dials or properties. Look for all of the names that reference the eye; that is, "eye" will actually be part of the first line. You do this for the head in this example, but this would apply to the parent of any part from which you want to remove the blend zones. Notice that the first part has "eye" in it. Now, go through and select all of the calls for "eye," including everything enclosed in the brackets after it, and delete this. Do that for every reference to "eye" within the head actor. Here is one instance that would need to be deleted:

```
twistX leftEye_twistx
{
name leftEye_twistx
initValue 0
hidden 1
forceLimits 0
min -100000
max 100000
trackingScale 1
keys
{
static 0
k 0 0
}
interpStyleLocked 0
flipped
center 0.024409 0.473528 0.094441
startPt 0.024409
endPt 0.078115
```

```
otherActor leftEye
calcWeights
}
```

You can then go to the *eye* itself and remove all calls for "joint"; they will look similar to this:

```
jointZ jointz
{
name jointz
initValue 0
hidden 1
forceLimits 0
min -100000
max 100000
trackingScale 1
keys
{
static 0
k 0 0
}
interpStyleLocked 0
angles 135.000000 45.000000 315.000000 225.000000
otherActor head
matrixActor NULL
center 0.024409 0.473528 0.094441
doBulge 0
posBulgeLeft 0
posBulgeRight 0
negBulgeLeft 0
negBulgeRight 0
negBulgeRight 0
jointMult 1
calcWeights
}
```

Delete the line and, again, be sure to delete everything enclosed in the brackets following. There are two calls for "joint" in the eyes; delete both of those. After these is a call "twist" that you also delete. Of course, with the eyes, you would have to do this for both the left and right eye. Therefore, for the eye itself (the child), delete two things ("joint" and the "'twist" immediately following). For the head (the parent), delete everything that references "eye" (the child). This same procedure would be used on any parent/child relationship where you want to remove the

blend zones for only part of the model. Be very comfortable editing CR2 files before attempting this type of edit, and perform this edit on a duplicate file (not the main one) so that you can test your changes before you actually apply them to a final figure.

Even with this new improved body part rotational value, it is still possible to bend the body parts into one another. Although you can work around this with careful posing, settings within Poser can inhibit this. These are called *limits*, which we discuss next.

Limits

Poser models have a way to limit the movement of a figure part. This limitation can reduce the likelihood of a part looking abnormal due to over-rotation; for example, one body part entering the space of another body part. In the case of the ant, you might want to set limits so that the body parts do not so easily bend into one another. Select the abdomen and double-click on a rotational dial. A window will open that will allow you to set a limit for rotation (Figure 13.33).

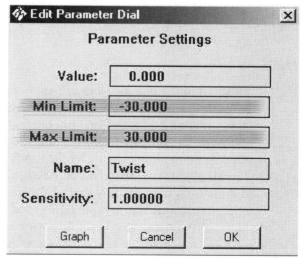

FIGURE 13.33 For this particular dial, notice that we changed the min limit and max limit to –30 and +30, respectively. These are the maximum and minimum angles that can be obtained by this object's rotation for this plane.

You will want to do this for each rotational dial for each body part of the ant. To make Poser use your limits, select Figure>Use Limits from the menu bar. When you set the Use Limits option, you can see them applied

immediately. You can institute the use of limits on a figure even if the Use Limits option is not checked in the menu. This is done via CR2 editing. Although not an actual requirement, this is another option you can use. To do this, open the CR2 for your figure and locate the line *forceLimits 0* for the rotational plane you want to restrict. You can force the limits on any dial in the figure, including taper, scale, and so forth. Change this to *forceLimits 1*. The numbers indicated for min and max are default *high* values.

You might think that looking for each rotational dial and setting is too labor intensive. You might want to do it quicker—and you can. Simply use your text editor and perform a "replace" operation. This will replace all of the "forceLimits 0' calls in the CR2; however, if the limit is a very high value (as in the previous example), it will be the same as not having them set for that part. If the limit is set (as for the rotational planes of the ant figure), then the limits will be enforced. Once the limits have been set, the body parts will not bend into one another as easily as they did before. Of course, it is still possible to move and rotate the objects into one another, but it is not as likely.

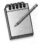

We did not include limits for the body parts in the final ant character.

VIRTUAL MATERIALS

This part of the chapter does not apply to the ant model, but is important to understand when creating your own models and textures. Within many of the Poser files are references to the location of any external image maps. You will usually find these references toward the bottom of the file. For example, in a CR2 file it will look like the reference line: textureMap "C:\My Documents\african1.jpg." This indicates the full path to the material used for this part of the model. However, let's assume that you want to distribute your figure and you want to include a material with it. If you use the Poser directory and make a few changes to your CR2 (or other file), you can have the material load automatically on almost any system.

Poser has a directory within the Runtime folder called *Textures*. This is where you will find many of the materials for the models you have. You can create your own folder here or use one of the existing ones for your image textures. We often create a folder called *brycetech_textures*. In this folder, we place all of the image textures and bump map textures (bum) for the characters we create. If a *virtual* call to the image is made, it will

not matter what drive the texture is on. To make this a virtual call to the folder (minus the drive indication), you can set up the call to the folder similar to the following:

```
textureMap "poser:Textures:Brycetech_textures:6serpent1.jpg"
```

When making this virtual call, change the backslashes to colons so that it will work on any system. The colon (:) is the Mac OS way of indicating folder and file subdivisions as opposed to the backslash (/) used by Windows. Poser installed on Windows systems will read both folder subdivision calls.

Now the texture file will load automatically on almost every computer. This virtual call instructs Poser to look in its own directories to find the texture. All that is required is to have the texture unzipped into the proper folder. This call for a texture can be at many places within a CR2 (or other file). If you have all of your textures in one directory, you can make this change very quickly by using the *replace* feature in your text editor.

For instance, assume you have the call:

```
"E:\poser\Runtime\Textures\brycetech_textures\6serptext1.jpg"
```

If you use the *replace* feature of your text editor and replace

```
E:\poser\Runtime\Textures\brycetech_textures\
```

with

```
poser:Runtime:Textures:brycetech_textures:
```

the update will be made very easily to all indications within the file.

```
poser:Runtime:Textures:brycetech_textures:6serptext1.jpg
```

You can save full pathways in a zip file. This will save the folder information. If you saved the folder and file runtime\textures\brycetech_textures\6serptext1.jpg into a zip file, when the user unzips the file into his Poser directory, the file will be properly placed. If a folder needs to be created, it will be created. Then, when the user opens the figure within Poser, the texture files will automatically load.

CONCLUSION

This concludes our discussion on how to make a character in Poser and should get you started with the creation of your own characters. Many more options can be included in a character's creation, but to attempt to cover them all here would be nearly impossible. Have fun!

POSER THUMBNAILS

by David Richmond (Brycetech)

In This Chapter

- Bryce and Thumbs

E ver get tired of looking at those boring thumbnails in the Poser Library? You can make different types. To get the one shown in Figure 14.1, you simply have to have the *Smooth-Shaded Display* chosen from the Display menu and save your model to the Library.

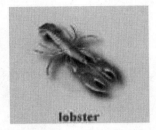

FIGURE 14.1 Smooth-Shaded Display creates a thumbnail like this.

If you use the *Textured-Shaded Display* from the Display menu and save your model, you would get one similar to Figure 14.2.

FIGURE 14.2 Using *Texture-Shaded Display*, the thumbnail looks like this.

Perhaps you would like it to be a bit different? No problem. Render your picture, and then paste the render on the background (Display>Paste Into Background). Move your camera so that only the image is visible and save your model (Figure 14.3).

FIGURE 14.3 The Paste-Into-Background method.

Ok, so you have a model that you'd like to display in full 32-bit color, showing transparencies along with the intricacies of the material. You can do this with the aid of the free program RSR converter. Download it at:

(*http://mail.grand-canyon.az.us/~annamari/tutorials/ RSR_Conversion.html*)

Render your picture and save it as a .pct from Poser. A .pct file extension image contains alpha channel information (Figure 14.4).

FIGURE 14.4 The saved .pct file includes alpha channel data.

Open this file in PhotoShop and go to the channels of the picture. Hide the RGB channels and make the alpha channel visible; then, invert this channel (Image>Adjust>Invert). Next, make all of the channels visible. The image will appear as it does on the right in Figure 14.5. Notice the difference in the mask.

FIGURE 14.5 From the left: Hide the RGB and make the alpha visible and Invert. Make all channels visible, and the image will appear as shown on the right.

The parts in red (shown in light gray in Figure 14.5) in the main window will be visible in the thumbnail. This means that if you used an entirely black image as the alpha channel, you could show a fully decorative thumbnail and even put comments on it. Change the size of this image to 91 × 91 pixels (Image>Image Size). Save this picture with the pct extension. Now, open *RSR Converter* and load your .pct file and the .rsr file for which you want to change the thumbnail. You now have a full 32-bit image with transparent background (Figure 14.6).

FIGURE 14.6 User RSR Converter to change the thumbnail, resulting in the thumbnail at the right.

BRYCE AND THUMBS

Perhaps you have a model that exhibits a high degree of reflection that you would like visible in the thumbnail. You can use an application like Corel's *Bryce* to enhance it. Render a perspective render of the object (these images were rendered in excess of 720 × 720 pixels resolution) and then do a mask render of the object (Figure 14.7).

Open both pictures in PhotoShop. Copy the mask render and paste it into a new channel of your perspective render. This will be your alpha channel. Invert the alpha. Then, hold the Shift key down and draw a square mask (if you haven't rendered it square) and crop to this square. Resize your image to 91 × 91 and save it as a .pct file. Open it and your .rsr in RSR Converter and you have a fully reflective thumbnail. You can make any type of black-and-white image to use as your alpha channel

FIGURE 14.7 On the left is the perspective render, and on the right is the mask render.

mask, even a semitransparent one. The use of the RSR Converter program is limited only by your imagination (Figure 14.8).

FIGURE 14.8 Resize the image in Photoshop and save as a .pct file. After RSR conversion, the new thumbnail is complete (right).

CONCLUSION

In this chapter, we covered Bryce and Thumbs. The next chapter will explore prop scaling, the static Poser prop, a Poser smart prop, and the Poser articulating prop.

PROPS, SMART PROPS, AND ARTICULATING PROPS

by A. Wycoff

In This Chapter

- Prop Scaling
- The Static Poser Prop
- A Poser Smart Prop
- The Poser Articulating Prop
- Creating the Finished Scene

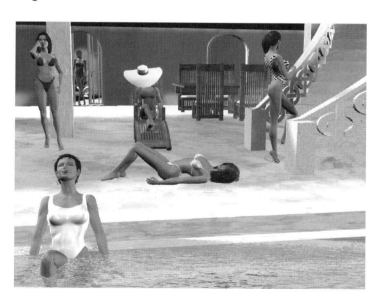

I don't remember the first model I made, but I do remember going to Web site after Web site looking for this particular object and not being able to find it. After reaching the end of the Internet, credit card in hand and still not finding what I was looking for, I decided that I could probably make a rough imitation.

First, I discovered that the ball, box, cane, stairs, cone, cylinder, and torus that came standard with my treasured copy of Poser3 just wouldn't work. Somewhere in all the chaos of trying to find a modeling program that didn't required learning a new language or have a huge learning curve, I started making simple models in Rhinoceros (Rhino). I quickly learned how to make a glass and other objects by drawing a simple curve and revolving (lathing) it 360 degrees on an axis. Although I use others, Rhino remains my primary and favorite modeler.

Find inspiration everywhere and in everything. Life is inspiring. Older buildings with gargoyles, windows with intricately carved frames, doors with beveled and etched glass give inspiration for 1940's superhero stories, detective mysteries, and other period pieces. Glass skyscrapers bring thoughts of futuristic tales. The way a drop of water radiates when it falls in a puddle, a pelican diving into the ocean for dinner are all points of inspiration. A little girl licking ice cream that has dripped from her cone off her fingers, a little boy trying to skateboard like Tony Hawk, a fifty-ish man on a Harley can be the basis of another story. Try capturing the colors of the sky from the pinks and oranges at sunrise, the blue-gray of midday, or the royal blue to indigo gradient just after sunset.

For building and furnishings, architectural books are a wealth of information. The public library is still a dear friend. Finally, memory is a great place to find inspiration for props. Recreate a childhood bedroom, favorite pieces of furniture that lost their luster long ago, Father's easy chair, a Coca-Cola vending machine that dispenses chilled 8-ounce bottles of Coke, the little General Store spotted on a road trip that had an actual functioning soda fountain and lunch counter. Wherever you are, there is something that is a modeling challenge. Try to keep a camera at all times—capture the idea. Failing to remember the camera, roughly sketch the object until you are again safely in front of your monitor.

Before starting, there are three free utilities available on the Internet that you will need:

ON THE CD

UVMapper *www.uvmapper.com/uvmapper.htm* (contained on this book's CD-ROM in the Extras folder)

Objaction Scaler *www.sandylodge.demon.co.uk*, select the utilities page from the sidebar

PHI Builder *www.royriggs.com/poser.html*

PROP SCALING

Poser uses a much smaller object scale than other standard 3D modeling programs do. One option for scaling Poser objects is an excellent free utility *The Objaction Scaler* by MAZ 2000. When using Rhino, another option is to create *scaled templates*. Import the following into separate files: P4 Female, P4 Male, Michael and Victoria in the default standing position and in sitting positions (eight files). Zoom in on the imported Poser speck until it fills the Modeling window. Change the grid spacing from 1 inch to .125 inch, and then save each file as a Rhino *template*. Use one of these templates as the starting point of all Poser modeling. For Poser, there are three types of props: *props, smart props,* and *articulating props*. This chapter will walk you through the creation of three props for import into Poser. The last step will be building the scene.

This chapter focuses on Rhino as the 3D modeling application of choice. However, much of the information contained in this chapter is valuable no matter what 3D application you use to create your initial Poser models.

T U T O R I A L ## THE STATIC POSER PROP

A *prop* is a static object with no movement, or whose movement is independent of other scene figures and elements. Examples of outdoor static props include street lamps, signs, buildings, trees, and billboards, just to name a few. Indoor examples include furniture, paintings, plants, walls, and lamps. These are the scene elements that are positioned in one place and remain in the same place throughout the animation. In this scene, the stairs, building, pool, table, chairs, couch, rug, curtains, and columns are static props. Do the following:

1. Start with the stairs. Using the Polyline tool in Rhino, draw 15 steps three grid squares high and four squares deep. At the top, continue the line down six squares, diagonal across to six squares back form the first polyline kink. Join the first kink in a straight line. Extrude this line 20 squares across (Figure 15.1).

2. Import an Adobe Illustrator design for the stair balustrade—any simple clip art design will do. Extrude this design to the width you want the railing to be. Using the Corner to Corner Box tool, create a box the length of the balustrade and slightly wider. Position the balustrade and railing at the beginning of the stairs. Using the Rotate tool, rotate the balustrade and railing approximately 45 degrees to match the descending angle of

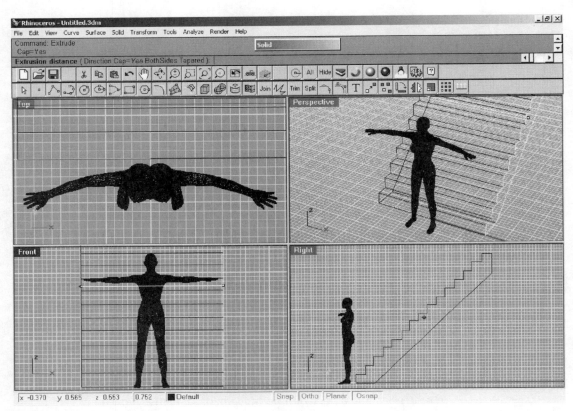

FIGURE 15.1 Create the stairs.

the stairs. Using the Copy tool, copy the balustrade and railing to the opposite of the stairs.

3. Select the stairs, balustrade, and railings. From the Tools menu select –polymesh from NURBS object. In the resulting dialog box, move the slider for more or less polygons for your object. Rectangular, boxy objects require fewer polygons than circular objects do. Since this is a boxy object that will become circular, start in the middle and experiment a little until you achieve the desired effect.

4. From the Transform menu select Bend. Start the bend axis at the bottom and to the right of the stairs in the Top view window. Bend the object 90 degrees, using the grid line for accuracy (Figure 15.2).

5. Save the stairs as a Wavefront OBJ. The dialog box has a slide bar for more or fewer polygons. The more polygons, the larger the saved file will be. Rounded or curved objects require more polygons in order to preserve the original curves. Rectangular objects can be saved with fewer poly-

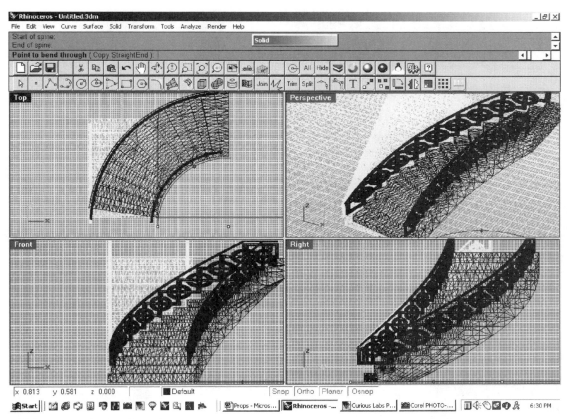

FIGURE 15.2 Apply a Bend transform.

gons. It is a trial and error process. Import the model into Poser with fewer curves to see if it works. Make adjustments according to the file size or number of polygons until you find the proper mix (Figure 15.3).

6. Using the Mirror tool, create the second stairway from the saved prop. Select the second stairway only and save it with a different name.

FIGURE 15.3 Set the density of the polygon mesh.

TUTORIAL **A POSER SMART PROP**

A smart prop is a prop that has been parented (attached) to a part of a figure. The shoes, hat, cell phone, and the glass of tea are all smart props in this scene. Do the following:

1. Using the Cylinder tool, create a cylinder for the tea using the hand of the figure that will hold the tea as a guide to size.
2. Using the Polyline tool, draw a glass around your tea cylinder (Figure 15.4).

FIGURE 15.4 Create the tea glass.

3. Revolve the polyline. From the Surface menu, select Revolve, Start axis at the right bottom of the line in the Right view window. End axis at the top of the line. Hold the Shift key down to keep the axis straight.
4. In the pop-up Revolve Options box, check the Exact box, the start angle is "0," the end angle is "360." At the bottom of the dialog box is a box that asks, "Delete curve to revolve?" Leave this box unchecked unless you are

sure your curve is perfect. It is easier to alter a curve than to alter the resulting object. Click OK.

5. Draw a diagonal line from the bottom of the glass to just above the rim. This will become the straw. With this line selected, from the Solid menu, select Pipe. The starting radius is .003; the end radius is also .003.

6. From the Edit menu, select All Polylines. Delete them. Select all objects, and from the File menu select Export Selected. Save as a Wavefront OBJ.

7. Open the UV Mapper. Load the tea model. From the Edit menu, select New UV Map→Planar. Click OK in the next dialog box to accept the default load properties.

8. From the Edit menu, choose *Select by Group*. Select object 1. With object 1 selected, from the Edit menu select Assign to Group. For the tea glass, there is one group. Assign object 1 to its group.

9. With Object 1 still selected, from the Edit menu select Assign to Material. There are three material groups: the glass, the tea, and the straw. Continue assigning objects to the group and materials until all objects have been grouped.

10. From the File menu, select Save Model and save the mapped model in any folder for use in Poser. Exit UV Mapper.

T U T O R I A L

THE POSER ARTICULATING PROP

Poser articulating props are saved to the *Character* Library. An articulating prop is a prop that has moving parts. Think of doors that open, treasure chests with lids that lift, books that open, desk drawers that work, CD players that open, opening laptops, refrigerators that open with crispers that slide, and flip phones. French doors are the articulating props in this scene. The door has three main parts, the wall, the door, and the doorknob. Do the following:

1. Using the Box tool, draw a rectangle for the wall. Using the Box tool again, draw a rectangle for the floor.

2. Draw a smaller box for the pool. Using the Boolean Difference icon, subtract this box from the floor. Draw another box a little larger than the pool opening and place it inside the opening. Boolean Difference a smaller box to create the pool opening. The ground plane in Poser will be the water.

3. Create a rectangle one-fourth the length of the floor for the balcony. Import one of the stairs to correctly position the height.

4. Using the Boolean Difference, subtract the first box from the wall to create the opening for the door. Resize the second box a little smaller than the door opening and position it on the wall.

5. Using the Curve tool, draw a box with the upper corners rounded off for the door (Figure 15.5).

FIGURE 15.5 Create a shape for the door.

6. Extrude this curve and subtract its created surface from the wall. Draw a smaller square for the doorjamb. Extrude the square and convert it to a mesh object using the Polymesh tool in the Tool menu. Flow the poly-mesh along the curve of the door opening.
7. Create the door by selecting the door curve and extrude the curve to a width slightly less than the width of the wall. Subtract a box from the door to slice it in half.

 Using the Trim or Split tools would create a hollow object rather than a solid door.

8. Using the Box tool, draw a small box for the doorknob faceplate. Draw a sphere using the Sphere tool. This is the doorknob. Select the sphere and the faceplate. Mirror this group on the opposite side of the door, using the Mirror icon.
9. Using the Cylinder tool, create a small thin cylinder connecting the two spheres. Select the door, the knob, and the faceplate. Mirror these objects to the other half of the door opening (Figure 15.6).
10. Select all objects, and from the File menu select Export Selected. Save as a Wavefront OBJ.
11. Open the UV Mapper. Load the door model. From the Edit menu, select New UV Map→Planar. Click OK in the next dialog box to accept the default load properties.
12. From the Edit menu, choose Select by Group. Select object 1. With object 1 selected, from the Edit menu, select Assign to Group. The door has five groups: the wall consisting of the wall, floor, pool, balcony, and doorjamb;

FIGURE 15.6 Create the door opening.

doorA consisting of the door and the faceplate; and doorB consisting of the second door and faceplate The last groups are knobA and knobB. Assign object 1 to its group (Figure 15.7).

13. With object 1 still selected, from the Edit menu select Assign to Material. For the door, there are three material groups: the wall consisting of the wall floor, balcony, pool, and railing; the wood consisting of the doors and the doorjamb; and the doorknob consisting of the knobs and the faceplates.

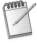

An object's group and its material are not interdependent. For example, the molding is a part of the wall group because it will be attached to the wall, but its material is the door because it will have the same material as the door.

14. Continue assigning objects to groups and materials until all objects have been grouped.

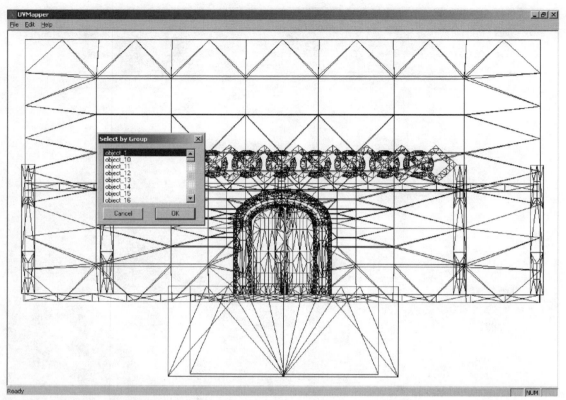

FIGURE 15.7 Choose Select by Group in UVMapper.

15. From the File menu, select Save Model and save the mapped model in any folder in Poser\Runtime\Geometries.
16. Exit UVMapper and Open PHI Builder. Click the OBJ icon. In the dialog box, locate and select the door model.
17. PHI Builder uses a drag-and drop interface. The door is the parent object; therefore, drag the door to the second level (child of the wall). The knob is the child object the door; drag it to the door (Figure 15.8).
18. Click the Test icon. The test will detect obvious errors in positioning and syntax and display the errors in the message box. If the message at the bottom says, "Looks good!" click the Save icon. Save the PHI file. Close PHI Builder.
19. Open Poser. From the File menu select, Convert Hierarchy File. In the dialog box, select the .phi file.

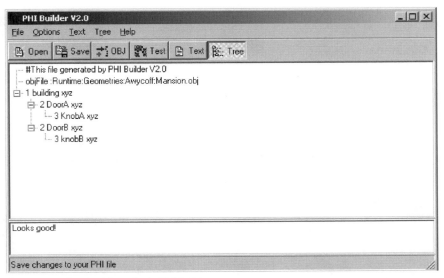

FIGURE 15.8 Set the hierarchy in PHI Builder.

20. After Poser converts the file, the New Set Name dialog box appears. Name the figure. The new figure will be saved to the "New Figures" category of the Figures Library. It will not have a picture. Double-click the icon to insert the figure into the scene.

21. Select the wall. Open the Object Properties dialog box from the Object menu. Uncheck the Bend box. Do the same for the door and the knob. In order for the door to rotate on its hinges, the joint parameters must be set. Open the Joint Editor in the Window menu.

22. Change the document style to wireframe. Select the door. Move the cursor over the green crosshair until a circle with a dot appears. Drag the crosshair to the point on the door where the hinge would be.

23. Repeat the joint parameter steps for the doorknob, placing the crosshair in the center of the knob. Check the joint crosshairs from the side and the top to ensure proper placement. The door will rotate on its Y-axis. The knob rotates on its Z-axis (Figure 15.9).

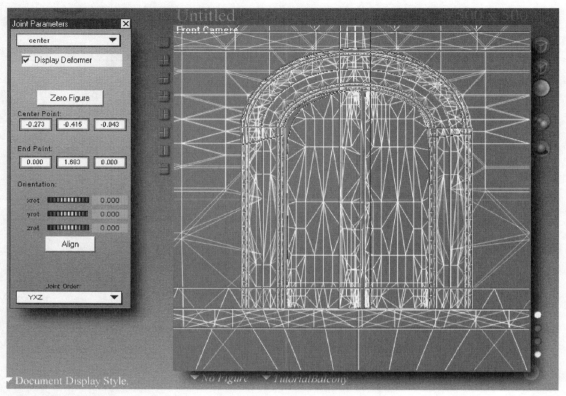

FIGURE 15.9 Set the joint parameters.

CREATING THE FINISHED SCENE

Do the following:

1. Open Poser. From the Character Library, insert the door model created earlier.
2. Import the curved stairway into Poser as a Wavefront OBJ. with the following parameters:

Centered (Places object in center of scene).

Place on floor (when appropriate, places lowest edge of object on the ground plane).

Percent of standard figure size (leave unchecked because model was made proportionately).

Offset (leave unchecked).

Weld identical vertices (leave unchecked. This can be done using the grouping tool if necessary).

Make Polygon Normals Consistent.

Flip Normals (leave unchecked. If the model appears to be see-through, delete it and import again with this box checked).

Flip U Texture Coordinates (leave unchecked).

Flip V Texture Coordinates (leave unchecked) (Figure 15.10).

FIGURE 15.10 Set the import parameters.

3. Click OK. Position the stairway with the following parameters:

yRotate 0
xRotate 0
zRotate 0
Scale 100%
xScale 100%
yScale 100%
zScale 100%
xTran 1.600

yTran 0.732
zTran −1.190

4. Import the second stairway with the following parameters:

yRotate 0
xRotate 0
zRotate 0
Scale 100%
xScale 100%
yScale 100%
zScale 100%
xTran −1.600
yTran 0.732
zTran −1.190

5. From the Props Library, prop types, select the stairs with the following parameters:

Scale 100%
xScale 236%
yScale 100%
zScale 100%
yRotate 0
xRotate 0
zRotate 0
xTran 0
yTran −0.521
zTran 0.607

6. The ground plane will be the water for the pool. Change the following: Scale 110%, zScale 200%, DollyZ 1.708.

7. Add the glass of tea. Select the P4 or P5 Nude Woman from the Figures-People Library. Conform the leotard to the P4 or P5 woman. Import the chaise lounge (included on the companion CD-ROM in the Models/Awycoff/Runtime12/Libraries/Props/AWycoff/BentwoodChaise). Pose the P4 or P5 figure in the chaise lounge. Position the glass of tea in the hand of P4 or P5. Use the right-hand camera to correctly position and check the placement of the glass. Now it is time to parent the tea to the P4 hand.

8. Select the prop and open the Object Properties dialog box. Click Set Parent. If the prop inherits the bends of the parent element, be sure that box is checked. From the Hierarchy List, select the element to which the prop will be attached (Figure 15.11).

ON THE CD

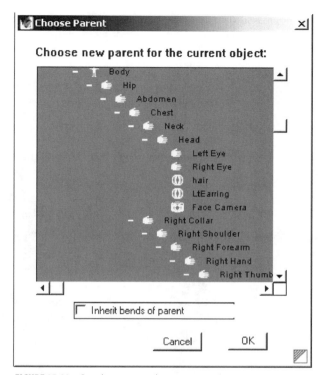

FIGURE 15.11 Set the parent element.

9. Click OK. Save the parented prop in the Prop Library. There will be two dialog boxes. The first asks for the name and subset (any other object that should be included). Select the additional objects from the Hierarchy List. Click OK. The second asks, "This prop has a parent, do you want to save it as a smart prop?" Select Yes.

ON THE CD

10. Now, this is the smart part, the newly saved smart prop will attach to the same element of any selected figure. Import the Ultimate Summer Hat (included on the companion CD-ROM in the Models/AWycoff/Runtime14/Textures/AWycoff folder) and position it on the P4 or P5 figure's head. Import and position the table and chairs.

TUTORIAL

CREATING THE WATER

1. Be sure the ground plane is visible. Display>Guides? Ground Plane should have a check next to it. Change the parameters to: Turn 0%, Scale 260%, xScale 100%, zScale 136%, DollyX 0.000, DollyZ 2.597.

2. Give the water the feel of movement by creating a wave. From the Objects menu, select Create Wave. Because water in a pool is almost still, use small parameter changes. Set the Amplitude to 0.050 and the Offset to .5. The reflection and silvery shimmer were added post render in Adobe Photoshop, although you could also explore developing a suitable texture in the Materials Room.

CONCLUSION

The remaining figures are the P4 or P5 woman with either the leotard or bikini conformed. The hair is standard Poser hair except for the Daz3D gel cut, although you can also explore developing hair in the Hair Room for each character. Use whatever poses suit your scene (Figure 15.12).

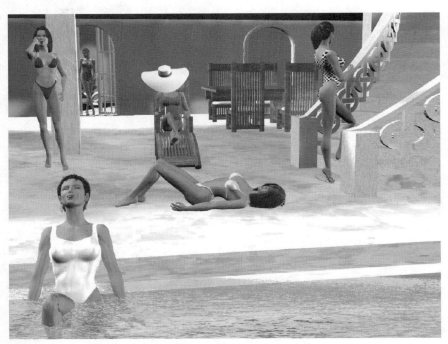

FIGURE 15.12 One idea for the finished scene composition.

POSER CLOTHING
EDITING IN AMAPI 3D

by Steve Coops (aka Scoopey)

In This Chapter

- Time to Start Amapi
- Amapi and Poser

How many times have you considered building your own poser clothing models but thought that it might be a bit too difficult? Perhaps you downloaded an item of clothing that was close to your needs, but it needed some alterations. In this chapter, we'll show you how to alter a clothing mesh in Amapi 4.15. We will assume that you know the basics of both Poser and Amapi. We chose Amapi for this chapter since it has been around for free on several magazines and Web sites in the last couple of years (*www.eovia.com*).

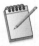

Although this Poser clothes-making tutorial is application specific, you can learn a lot about creating clothes for Poser figures here no matter what 3D application you use.

In this tutorial, the clothing mesh you are going to alter is the standard P4 Catsuit, which will help you to get started in creating your own clothes (Figure 16.1).

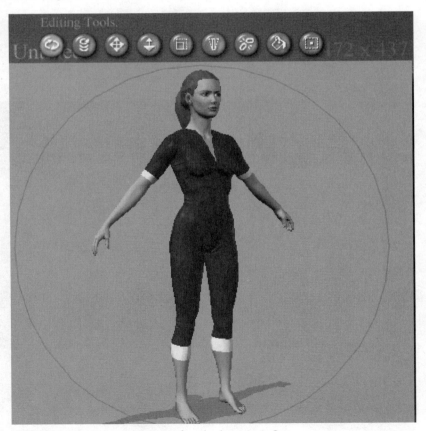

FIGURE 16.1 The Poser Catsuit on a female character in Poser.

 Remember to save your work regularly. There is nothing more annoying than finishing a mesh and having the program crash before you save!

To begin, you will need to find the Catsuit object file in Poser's Geometries folder. Do not use spawned props from within Poser because you will never get your finished items to conform properly. Amapi cannot read Wavefront object (OBJ) files, so you will need to use a small conversion program called *Make Object* by Anthony Appleyard, available from Renderosity (*www.renderosity.com*).

Find the location of the OBJ file that is used to create the Catsuit in Poser. You can look at the CR2 file in a text editor to do this. Just drag the Catsuit CR2 file into Notepad (Windows) from the Runtime/Libraries/Female Clothing folder. In the text editor, you will see the following lines near the top:

```
version
  {
  number 4
  }
figureResFile :Runtime:Geometries:Poser4Clothes:Suits:blcatsuit.obj
```

This tells us where the Catsuit OBJ file is located. Make a note of the location. Knowing where the OBJ file is located, it's time to start the Make Object software. Close Poser. Double-click on the Make Object icon to start it. Go to File>Read Mesh and load the blcatsuit.obj file and it should appear (Figure 16.2).

You will see all the mesh groups including the groups that are normally hidden in Poser. Sometimes Poser has extra elements to help in setting up bulges and conformity, and you might be able to get away with deleting them, although this can be risky. Go to File>Save As, select the 3DS format, and enter a name for your file (catsuit.3ds). By default, it will save the file in the same location as the OBJ file, although you can also save it to a different folder.

TIME TO START AMAPI

We use the standard Amapi interface, which features tools in a vertical tool bar on the left-hand side of the screen and more tools on the bottom bar of the screen (which we will refer to as the *bottom bar*). The tools on the toolbar can be selected by clicking on them with the mouse (LMB for Windows). The tool stays selected until you click on the Magic Wand tool

FIGURE 16.2 The Catsuit mesh appears in the Make Object application.

(the Change Current Object tool). Some tools in Amapi might automatically deselect. If you create anything in Amapi (lines, shapes, etc.), always press Return (Enter) when you have finished. Otherwise, if you click on another tool without pressing Return, the item you just created will be lost.

The tools in the toolbar we will be using in this tutorial include the Magic Wand, Selection tool (which looks like an arrow), Draw tool, Stretch tool, Punch and Delete tools, Mirror tool, and the Rotate and Move tools. If you hover the mouse cursor over the icons, a label is displayed stating what each tool is.

The bottom bar tools are mainly for display purposes and the grouping of objects, as well as showing and hiding objects. The ones we will be using are as follows: the Rear Face tool (this toggles the back faces on and off), the Camera from 2D/3D mode toggle, the Camera Pan and Tilt tools,

the Scroll Camera tool (which moves the camera on its local X- and Y-axis), and the Show and Hide toggle.

The numeric keypad changes the views in 2D and 3D mode, panning the camera when the numeric lock is turned off, and toggles between views when turned on.

If you change any views from the bottom bar, the keypad locks out until you click in the Editing window.

In 3D mode the camera only pans 90 degrees in any direction from the point of origin, so you will still have to change the views, as in 2D mode, to see in any direction. It's often easier to switch to 2D to find the nearest required view and then switch back to 3D mode and pan the camera. If you find that when creating lines the cursor jumps in huge steps, you will need to adjust the measurement units. Just to go to the Edit menu, select Preferences, and select Measurement Units. Choose "mm" or "none" and select OK. Whenever you double-click on an object or mesh in Amapi, the object properties are displayed, a function we will make use of.

Before loading the 3ds file you created previously, you will need to alter a few settings. Go to Edit>Preferences>IO settings. Choose "3ds" from the menu that appears and set the Scaling factor to 100. Set the Switch Axis to "X becomes" to X, "Y becomes" to Y, and "Z becomes" to Z. If you import the mesh and it disappears, recheck these settings again, since closing Preferences without selecting OK causes Amapi to revert to its default settings.

Go to File>Import and select the 3ds file you converted earlier. The Catsuit should appear as shown in Figure 16.3.

Zoom in. Try panning the 3D camera to update the screen display. The mesh appears in different colors, as they are separate grouped mesh sections. The first stage of editing the Catsuit is to delete the parts that will not be required.

If you make a mistake and delete the wrong item, press Ctrl+Z or click Undo in the top toolbar. Now we are going to refine the ends of the mesh and shorten them so that they no longer have jagged ends.

Switch to 2D view mode (Figure 16.5) and zoom in on one of the arms with the numeric keypad, using the Scroll Camera tool (bottom bar) to navigate the view.

LMB (Windows) click on the tool and keep holding the mouse button down while moving the mouse and the view will shift. Once you have found the end of one of the arms, release the mouse button. Now,

FIGURE 16.3 The Catsuit mesh appears in Amapi.

click anywhere in the Editing window so that you can release the Scroll Camera tool. You should end up with a view similar to Figure 16.6.

Draw a cutting line to chop off the end of the mesh. Select the Draw tool (toolbar) and click in the Editing window, and the Lines menu will appear. Select the Polyline (fourth icon from the left), and draw a short line. Continuing to LMB (Windows) click after that adds another point to the end of the line. Press Return (Enter) when you have created enough points. Now you should have something similar to Figure 16.7.

If you need to adjust the line you just created, select the Stretch tool from the toolbar and move each point by clicking and dragging. Make sure that you have already selected the line with the Magic Wand tool, or you could end up moving points on the Catsuit instead!

Next, we will cut off the end of the shoulder, so select the shoulder with the Magic Wand tool, select the Punch tool (tool bar), and then click

FIGURE 16.4 We deleted the head, neck, right and left forearm sections, by selecting the parts with the Magic Wand tool and pressing the Delete key on the keyboard.

on the line. Sometimes the line disappears and nothing happens. To cure this problem, move the line slightly, and/or double-click on the shoulder mesh to bring up the object information and choose Suppress Action. Switch to 3D view and make sure you selected the correct end of the mesh before deleting it. Now, switch back to 2D view mode and do the other shoulder, the two shins, and the neck area (Figure 16.8).

Amapi never deletes your line with Punch, it merely hides it. To view the line again, click on the Ghost tool (Unhide) on the bottom bar and you will see any hidden items. Click on the items you want to see/use again with the cursor (now ghosted) to unhide them, and then click on the Magic Wand tool to return to normal editing mode. This way, you can create a single line to cut both shins by using it twice.

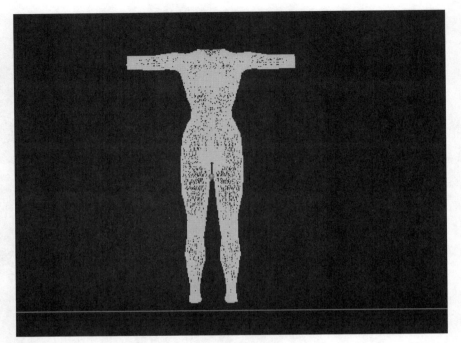

FIGURE 16.5 Navigate to this view.

FIGURE 16.6 Navigate to this view of the mesh.

FIGURE 16.7 The Editing window should now look like this.

FIGURE 16.8 Make sure you select the correct end of the mesh to be deleted in 3D view.

Next, we'll create the V-shaped cut-out in the chest area of the mesh. Create a polyline (as you did for the shoulders) as one side of the V. Mirror this line using the Mirror tool (tool bar) in the 3D view. Be careful and don't double-click, or Amapi will create two lines on top of each other! Quite often, the mirrored item occurs on the wrong axis and needs to be rotated and moved to the correct position with the Move and Rotate tools (tool bar) so that the two lines appear to meet at the bottom forming the "V" (Figure 16.9).

FIGURE 16.9 The V cut is created.

Switch to the 2D view and then hide the chest region by selecting the Hide tool (on the bottom bar). Click on the chest region with the cursor and it will be hidden. Click on the Magic Wand tool to revert to the normal editing mode. Select the Weld tool (tool bar) and drag a box around the bottom points on each line that make up the V, and then press Return (Enter). If the lines do not change to the same color, then the points were not close enough. The easiest way to correct this is with the Stretch tool. Click on one of the points to grab hold of it and move it over the top of the other point, and then press and hold the Shift key before clicking again. The point should snap on top of the other one. Now try to weld the two points again.

Make the chest visible again with the Unhide tool and select it with the Magic Wand, and then use the Punch tool to cut the V shape out of the mesh. Switch to the 3D view and click on the V piece with the Magic Wand tool and check that it consists of two large mesh triangles on the front and back of the chest region. The Punch tool cuts both the back and the front of the mesh, but Amapi still regards the two triangular cuts as one mesh. As long as each of the triangular pieces is not broken up and they are still attached (i.e., the same color as the chest), then you will be okay. If in doubt, check the triangle mesh in Object Properties. If there is not a clean cut or parts are still attached, then you might need to reduce the points on the V line with the Delete tool. You can also move them around slightly and/or select Suppress Action in the chest's Object Properties window and try again (Figure 16.10).

FIGURE 16.10 The new mesh is starting to shape up.

Select the triangular mesh but do not delete it yet, or a chunk will disappear out of the back of the chest as well. Switch to the Top view and select the Delete tool (tool bar) and RMB (Windows) click in the Editing window. An arrow selection cursor will appear. Drag a box around the facets of the "triangle mesh" that are located in the front half of the chest and then press Return (Enter) (Figure 16.11).

FIGURE 16.11 This looks a lot better.

With those front faces deleted, switch to the 3D view and you will now have to re-weld what is left of the triangular mesh (i.e., the rear part) back onto the chest. Simply select the Weld tool and drag around a point on the remaining triangular mesh and the chest fairly close together and press Return (Enter). You should now have a one-piece mesh, with a distinct V-shaped line on the back. Now, double-click on the chest to bring up its Object Properties, and select Kill Co-planar Faces. The line should disappear (Figure 16.12).

FIGURE 16.12 That's more like it!

Occasionally you might get a couple of faceted edges that do not cut properly and are left sticking out. You can correct this by using the Stretch tool to move the individual points back in line. Always remember that the fewer points you use on the cutting line, the less likely it is for a problem to occur.

The final stage in the editing of this mesh is to use the Punch tool on the end of each arm and leg so that the ends of the legs and arms can accept a different material. Just make these sections about cuff size, similar to the very first operation you did in refining the shins and shoulders, but do not delete the ends this time! You can cut up a mesh so that it uses different materials as opposed to creating complex texture maps. The finished Catsuit is shown in its quick rendered form in Figure 16.13.

Before exiting Amapi, change the names of the parts. Amapi by default gives everything names called surf; in other words, surf 1, surf 2, and so forth. You should label the parts with Posers *internal* names from the Object Properties window (e.g., Left Shoulder= lShldr, etc.). Imported meshes retain their original names until altered, so you might find that the hip, abdomen, and thighs still have the correct names. You can leave the names until editing the CR2 later, but it might be easier to alter them now (otherwise, you might not know which part surf1 is!). Any slight spelling mistake or misplaced capital letters will prevent the finished item from conforming to a Poser character. Finally, go to the IO settings in Edit>Preferences and change 3DS to 0.01. Then, export your finished mesh as NewCatsuit.3ds. Save your Amapi file before closing the program.

Open the Make Object program again. Select Read Mesh and load in your NewCatsuit.3ds mesh. Select Write File and choose OBJ file from the menu and save the file as NewCatsuit.obj.

Start Poser and import your new object mesh (without any boxes checked in the Import Prefs window). This is just to check that the scaling on the export from Amapi is okay. It should appear in Poser roughly the correct size. If it appears huge, you might need to re-export the mesh from Amapi and try again (after converting it again). Once you have checked that the mesh is the correct size, you can close Poser again.

There are now two ways of finishing off the mesh so that the separate ends of the shoulders and shins are regrouped with the parent parts, thus becoming separate materials as opposed to separate meshes. The method we suggest, which is easy and highly reliable, is to use Steve Cox's UV Mapper (UVMapper lite is contained in the Extras folder on the companion CD-ROM) available at Renderosity. Start the UV Mapper application by double-clicking on its icon. Go to File>Open and get the New-Catsuit.obj file. You will get a message telling you that there are no UV

ON THE CD

FIGURE 16.13 The finished modified Catsuit in Amapi.

coordinates, so go to Edit>New UV Map>Planar and press OK without altering any settings.

Go to Edit>Select by>group. All the groups will appear in a list, which should match the names you gave them in Amapi. If you find that you made a spelling mistake on one of the group names, then choose that group and in the Edit menu choose Assign>to Group, and all the group names will appear. Put the correct name in the text entry box. UVMapper

will then inform you that this group does not exist and ask you if you want to create a new group. Click Yes. Note that UVMapper does not update its lists until you save the file.

Save your model by selecting File>Save, and in the Save Settings prefs leave all the boxes unchecked apart from Export Normals, Export UV Co-ordinates, Export Materials, and Export UVMapper Regions. Now, reload your model and Choose Select by>Groups and you should find that all of the correct group names are present. While you are still in the group selection mode, select Chest from the list and the chest region will be highlighted. Now go to Edit>Assign to>Material. The word *default* appears in the scroll box, so enter "cloth" in the text entry box to create a new material called "cloth." Choose any other group excluding the shin and shoulder ends, and assign them to the cloth material as well. To check which groups have been assigned to which material, choose Edit>Select by>Material>cloth from the list. All the groups assigned to the cloth material will be highlighted. You will not need to enter "cloth" again in the text entry, as it will appear in the scroll box, so just keep clicking Yes to assign it to that material.

Next, select one of the shoulder and shin ends, and in Edit>Assign to Material enter the word *ends* in the text entry field. Assign the remaining shin and shoulder end groups to the *ends* material. Check that the materials are correct by going to Edit>Select by Material, and you should find that all the ends are assigned to *ends* and the rest to *cloth*.

Save your work again. Now here comes the tricky part. In the Edit menu, Group Selection Mode (Select by and Group) you should choose lShinend, and in the Assign to and Group assign lShin. This is similar to assigning to a material as we did previously, but here we are assigning one group to another. Repeat the operation by assigning rShinend to rShin, lShldrend to lShldr, and rShldrend top rShldr. Note that UVMapper does not remove any of the groups from the list until you save, so be careful not to assign the same group twice. Save your work as NewCatsuita.obj (a slightly different name so you have an "undo" level available) and then reload it. Check that the correct groups with no *end* groups and the materials are also correct. If you made a mistake, you can load the NewCatsuit.obj and try again. You now have one complete mesh (Figure 16.14).

Now to make it conform. Here we use some major league cheating! Open the Poser folder and place your finished NewCatsuita.obj in a new folder called Tutorial in the Geometries folder. Go to the Characters folder and copy the Catsuit.cr2 file and rename it as NewCatsuit.cr2, but leave this in the same folder as the Catsuit. Next, open this CR2 file in a text editor and look for the line you found right at the beginning of this chapter:

FIGURE 16.14 The Catsuit map as it appears with a Planar projection in UVMapper.

```
figureResFile :Runtime:Geometries:Poser4Clothes:Suits:blcatsuit.obj
```

and change it to:

```
figureResFile :Runtime:Geometries:Tutorial:NewCatsuita.obj
```

If you scroll down the text that makes up the file you will find the same line repeated exactly, and you must alter this second line as well so that the new CR2 points to your mesh.

Now, start Poser. Look in the Women's Cloths and find your New-Catsuit CR2 (it will be listed as a *Dork* icon Shrugging his shoulders). Click on it and create a new character. After a short time, as Poser creates the NewCatsuita geometry rsr file, your new Catsuit should appear. If you made a mistake with the naming conventions, Poser will tell you that it cannot find the Geometry file. Create a new P4 female character and set the NewCatsuit figure to *conform*. If the wrong sides move, then you might have named the objects' groups incorrectly. If you have to rename body parts in UVMapper (or alter the mesh), then you must delete the associated geometry rsr file. Go to the Materials menu and you should find

the *ends* and *cloth* materials as well as a few others that are redundant materials from the original Catsuit CR2. Just ignore them. You can now change the colors of the ends and the main material to whatever suits your fancy without texture maps, applying diffuse and other channel contents in the Poser 5 Material Room. Save your new item of clothing under the same name (NewCatsuit) and the default picture will be replaced—there you have it, your first Amapi edited clothing.

AMAPI AND POSER

Some further notes about using Amapi and Poser. You could create an open shirt front by creating a line down the front of the body and *punching* the chest and abdomen, but be careful if Amapi confuses the Normals on import. The more sections of mesh you create, the more likely it is for this problem to occur. The cheating CR2 method works with all files; just try to find a figure that is a similar shape and has the same or greater number of body parts.

You can import the mesh in Poser and assign the material using Poser's Grouping tool. Load your OBJ file and spawn props and delete the original object. Select one of the parts and click on the Grouping icon. Create a new group, select all, and then assign it to the material *cloth* or *ends*. Then, export each of the sectioned groups separately (i.e., export lShinend with the lShin, and export it as lShin; then export rShinend and rShin and export it as rShin, etc.) until all the ends have been exported. When the Export Settings dialog appears, uncheck all six boxes. Next, import them all back in. Then, export all the parts back out again. In The Export Settings dialog, leave everything unchecked except for *Include body part names in polygon groups* and *weld seams*. You might need to check the OBJ file in a text editor to make sure that the external, internal, and group names are correct—much more awkward than using the UVMapper program.

 If you encounter the Normals problem and own Maxon's Cinema 4D (Version 5SE or later), you can often load in the mesh and make the Normals uniform, thereby curing the problem.

CONCLUSION

If your mesh has a section in which the Normals are flipped on one part of the same section of mesh, then usually the mesh might be

unfortunately beyond repair. If you find that small cracks appear in your mesh when you bend it (and you used UVMapper for finishing off the groups), then the vertices might have slipped slightly in Amapi (this sometimes happens in Punching operations). Note which parts do this and go back to your original Amapi file and adjust the mesh using the Stretch tool. Using the Shift key, drag each vertex at the joint so that they meet. It pays to work slowly and methodically with high magnification. It's a bit laborious, but 99% of the time you can cure any problems.

JOINT PARAMETERS

by William P. Capozzi

In This Chapter

- The Basic Model
- Setting Joint Parameters
- Real-World Parameters

*J*oint parameters refer to the rules imposed on a figure's joints, to allow for proper deformation during bending of any particular joint on a figure. The joint parameters control the amount of geometry transformed or moved, the direction the geometry is allowed to transform, and any limitations that make the joint and geometry move in concordance with its real-world counterpart. In this chapter, we will examine a number of joints on a quadruped tiger model. The techniques and tools that we'll explore include Rotation Order, Joint Center, Inclusion and Exclusion Angles, Joint Scale, Spherical Falloff Zones, Joint Limits, Favored IK Angles, and Default Position (Figure 17.1).

FIGURE 17.1 The Bengal Tiger, exported and rendered in LightWave 7.5.

THE BASIC MODEL

Beginning with a common Wavefront OBJ format model created in a 3D modeling application, the possibilities of converting it to an extensively

poseable figure for Poser are impressive. Two concepts to be aware of are Bone Systems and Inverse Kinematics (IK). A bone system in a 3D animation application is the equivalent of an actual skeleton in a human, animal, or creature. It functions as an internal deformation control, and not as part of the geometry of the figure. After setup and editing, bones are only seen as the resulting deformation it creates on the figure during animation and rendering. Inverse kinematics, or IK, is the set of rules that the bone system will follow. For example, a bone and IK system, or "rig," for an arm might contain the defined parameters to make the wrist twist, elbow bend, and shoulder joint rotate simply by pulling the hand of the figure. The joint parameters within Poser also add to this the effect each bone has, or does not have, on its surrounding geometry. For example, the hand bone will only deform the hand geometry, the forearm bone will only deform the geometry between the wrist and the elbow, and will also only allow for the elbow to bend in a single direction to certain degrees so that the elbow doesn't bend backward.

Many 3D animation applications contain a boning system requiring manual placement of bones and complex setup of IK. Sometimes more than one boning system option is available per application, making figure setup a chore. In many cases using high-end software, advanced expressions are required to make the IK and parameters happen. Although Poser doesn't allow deep editing of expressions to control multiple movements in a chain of joints, it does offer excellent and fast creation of very controllable joints in a figure. When set up properly, IK and joint parameters will automatically and transparently create proper movement within the figure when posed, as most of us are used to when using the default or commercial 3D models for Poser.

Traditionally, Poser uses an internal method to create bones based on groups of polygons within the 3D geometry in conjunction with a text hierarchy file that describes the hierarchy and rotations of the groups within the geometry. The hierarchy file is explained in detail in the *Poser 3 Advanced Techniques Guide* available for download from the Curious Labs Web site. The example hierarchy file used for the Bengal Tiger figure is included with the content. Poser 5 has a Setup Room that allows visual placement of bones directly into the model, with extra editing features to make boning your model easy and controllable. The Setup Room boning technique is separate and different from the text hierarchy file technique that will be used here. With the proper polygon groupings and hierarchy file, the initial task of creating a boned figure with IK in Poser is made much easier from the start. At the same time, a higher level of control is available through the use of fall-off zones, joint parameter limits, and joint centering and rotation for figures needing extra functionality

and realistic control over bends and positioning. With those formalities out of the way, we can move on to making a basic model our own.

SETTING JOINT PARAMETERS

The model should first be tested by importing it as solid geometry. Use File>Import>Wavefront OBJ to locate and select your Wavefront OBJ format 3D model. If everything appears to be in order, and the model looks as it should, move on the importing the model using the Poser hierarchy file (.phi file). This model must have the correct groups already in place before importing with this method. The groups must also match the group names listed in the hierarchy file that will be used to import the model for joint editing. Examine the sample hierarchy file and tiger model to see how each is laid out and how the group parts and names correspond between the text file and the 3D model. The next step is to import the model geometry using the hierarchy file.

Go to File>Convert Hier File to locate and load the hierarchy file. Once loaded, you will be asked to give the figure a name. By default, it will be saved in the New Figures Library. You can also save it to an existing or custom library if you prefer. Load the model into your working environment. Once your model is imported, examine the figure for missing pieces. If any part is missing, this means that it is not referenced correctly or left out of the hierarchy file. Check for misspellings and missing group names in the hierarchy file if body parts are excluded. If you are using the Setup Room, your model will be imported and boned using different techniques than what is covered here. Once everything checks out on your model, take a moment to play with it. Pull the arms, legs, and head around to see what happens. More than likely you will quickly end up with a painful-looking tiger. Take a close look at how and where the joints are bending by default. Compare this to any reference images or footage you might have, and picture in your imagination how these joints will need to be modified to bend properly. This will help when it comes to using the actual angle, limit, and fall-off controls that will affect the joints.

With the model left as it is, begin joint parameter editing by opening the Joint Editor window from the Window pull-down menu, and select Outline Mode as your initial viewing mode, turn off IK for any existing IK chains, and importantly, be sure to familiarize yourself with the keyboard shortcuts for the Top (ctrl t), Left (ctrl ;), Front (ctrl f), and Main (ctrl m) camera views. Restrict your work to only one side of the figure, left or right. You will be able to use Symmetry to copy the joint parame-

ters to the opposite side, saving the need to duplicate the entire process on the other side of the figure. An important button to familiarize yourself with is the Zero Figure button. Click this now to reset the figure to its default rest state. The Zero Figure button can be used at any time during editing, and is particularly handy when testing joints as you edit them. As always, save your work frequently. When editing joint parameters, save your figure to the Figures Library, click the Add to Library icon, and during editing use a work name such as bt_work. Overwrite a previous version when necessary. It is also useful to give a figure a new name at decisive increments in the editing process, in case you need to revert to an older version, or want to branch the figure off into something different at a certain point.

Following are descriptions and example images of how each of the joint parameter control options appear when selected for editing. The right thigh of the tiger will be used in all example images. Refer to the default and finished figure to examine the parameter settings.

Rotation Order

ON THE CD

Rotation order is initially set in the hierarchy file. (See the included bengal_tiger_hier.phi file for reference, which is in the Models/Capozzi/ phi_example file on the companion CD-ROM). Typically, the first of the X-, Y-, or Z-axis choices should be the one that aligns with the Twist axis. In the quadruped tiger example, the first order of rotation for an arm or leg should be Y, since the Y-axis in Poser is the Up and Down axis, and the tiger arm or leg will twist around that axis. The second choice for the axis rotation order will be whichever of the two remaining axes is most likely to act as the Side-Side axis. The leftover third choice will obviously be the Bend axis. In this example, the rotation order for the tiger arms and legs should be YZX, Twist on the Y-axis, Side-Side on the Z-axis, and Bend on the X-axis. In comparison, the rotation order for both the head and tail would be ZYX.

Working from the exterior of the model's extremities to the innermost groups, go through each group part and set a logical center position for the joint center, also known as the *origin*. The joint center is the pivot point around which the joint will actually rotate, designated by a green cross. A best position for a joint center can be determined by matching it to a real skeletal counterpart; for example, a shoulder, elbow, or knee joint. An important part of editing the center is also setting a direction of the center, or better stated, a direction to which the invisible bone actually aligns. This can be done by clicking the Align button in the Joint Editor window. You will notice that the center marker has rotated to be

roughly aligned with the direction of the group part, most notably from the center marker to the center of the next connecting joint, or to the red cross-shaped end marker found at the end of a bone chain, as seen in the hip, head, hands, feet, and tail of this model.

The rotation of the center can be customized to allow a joint to act a certain way; in most cases, it is desirable to use the settings determined by clicking the Align button. Position the cursor over the middle of the center marker. You will notice that the cursor turns into a target-shaped concentric circle. This means that it is in position to edit the center. Click and drag the green center marker to a logical location for the pivot center of the group. Work in more than one dimension. Use Top, Front, and Side camera views to precisely position the center marker. Testing the joint is important, too. When you have the center marker in a satisfactory position, test it by twisting and bending the joint to see how it, and the surrounding geometry, reacts. At this point, it is likely that the geometry around the joint will be distorted during bending. Distorted deformations will be solved in the next step. The main concern at this time is to find the correct pivot point for the origin. If the joint appears to move correctly, you can move on to the next in the chain, or on to a different extremity until each on only one side of the figure is complete. Continue until the center of the entire figure is complete, using Symmetry to copy your work to the other side. Detailed editing and fine-tuning of the center pivot point should be done before moving on to the other joint parameters. Keep in mind that changing the center position after editing the other parameters will change the adjustments made to those parameters as well. The centers should be finalized to the best possible position before moving on, to save unnecessary re-adjusting later (Figures 17.2 and 17.3).

Summary of Steps for Joint Center Editing

1. Save your work frequently.
2. Working from the outside extremities of the figure inward, position the center of each selected group.
3. Use the Align button to line the centers up with connecting joints.
4. Using Top, Front, Side, and Main camera views, test the rotations of each center as you go.
5. Fine-tune the position of each center before moving on.

Adjusting the blend zones for each of the Twist, Side-Side, and Bend rotations consists of two different types of blend zone controls. The first is a bar control that will define how far into each connecting group a blending or smoothing will occur when twisting is applied during

FIGURE 17.2 The joint center in its default position.

FIGURE 17.3 The joint center in its edited position.

posing. This twist blend control appears as a white bar with a green end and a red end, and only occurs once per group, always on the twist axis. The twist adjustment is set by placing the cursor over the red or green ends, and moving the end to a position where a smooth blend happens when the group is twisted. This can be set visually by twisting the group first, then adjusting the control ends, and seeing the feedback from the effect as the ends are adjusted. Experimenting is encouraged to find a pleasing blend for the connected groups. Switch your view mode from Outline to Smooth Shaded or Texture Shaded to see the effects on the solid model during testing, and switch your camera views to see it from different angles.

The second type of blend control is the inclusion and exclusion angle. These composite angles, formed out of two sets of angled lines projecting out from the center pivot, work in a similar way to the blend zone control for the twist axis. However, the angles work together to define and create a blend zone between groups that rotate perpendicular to each other, instead of in line with each other as in the twist blend zone control. The noticeable attributes of the angle control mechanism are the red portion and the green portion of the angle. The green defines the area of full effect, or full transformation of the group and surrounding geometry. The red sets the area of zero effect on geometry. The area between the green and red is a blend zone that eases the deformation of geometry from full deform to no deformation. To edit the inclusion and exclusion angles, place the cursor over the outer end point of each of the green and red lines until the cursor turns to the target-like concentric circles, and carefully click and drag the line so that it moves to a position to include or exclude part of the surrounding geometry. Keep in mind that green includes all geometry within its area, red excludes geometry within its area, and the area between green and red is a blend zone. This is very useful when an appendage or a section of a figure needs full deformation, and the connecting and nearby geometry must remain in a static position. The effect can be tested by twisting or rotating the group, and then drag any of the lines into position, while seeing the resulting inclusions or exclusions. As each figure will require a custom setting, this is another control that is best practiced by experimenting, and then setting the final position visually (Figures 17.4 through 17.9).

Summary of Steps for Editing Joint Rotation Blend Zones

1. Save your work frequently.
2. Select the group to be edited, and select Twist from the menu in the Joint Editor window.

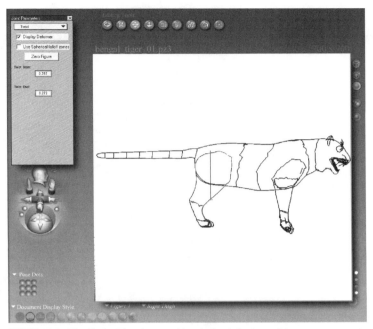

FIGURE 17.4 The Twist Blend control bar in its default position.

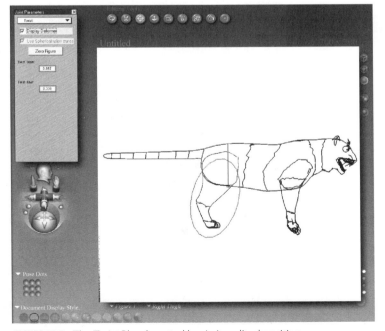

FIGURE 17.5 The Twist Blend control bar in its edited position.

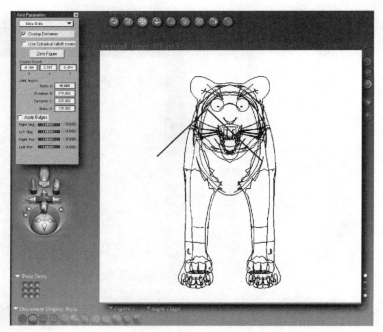

FIGURE 17.6 The Inclusion and Exclusion Angle Side-Side in its default position.

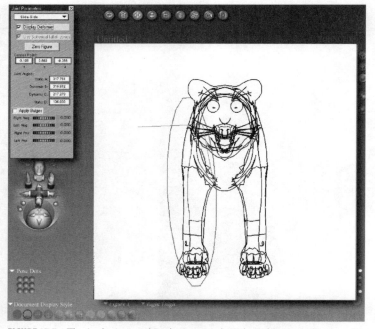

FIGURE 17.7 The Inclusion and Exclusion Angle Side-Side in its edited position.

FIGURE 17.8 The Inclusion and Exclusion Angle Bend in its default position.

FIGURE 17.9 The Inclusion and Exclusion Angle Bend in its edited position.

3. Adjust the green and red ends of the Twist Blend control bar to create a visually appealing blend.
4. Select the Side-Side and Bend rotations in turn, and adjust the green inclusion and red exclusion angle blend zones.
5. Test and refine each of the rotation parameters to achieve a smooth blend and effect area for that joint and surrounding geometry.

Joint Scale

Joint scale is a setting that will limit how far into each connecting group a smooth transition will occur when scaling is applied to that group. In every group where there are other connecting groups, there will be a separate named scale control for each. The Scale Adjustment control appears as a red bar with a green end and a red end. The effect of the scale adjustments will be a visible blend zone in between two groups that can be adjusted to solve transition problems between them when one is scaled. Experimentation is encouraged to find the right blend for each group (Figures 17.10 and 17.11).

FIGURE 17.10 Joint Scale at its default position.

FIGURE 17.11 Joint Scale at its edited position.

Summary of Steps for Editing Joint Scale

1. Save your work frequently.
2. Select the group to be edited, and select one of the scale controls from the menu in the Joint Editor window.
3. Position the green end of the Scale Adjustment bar to create the blend zone.
4. Test and adjust, if necessary, the scale to solve any unwanted deformations when scaling the group.

Spherical Falloff Zones

Spherical falloff zones are not always needed; however, they are an extremely useful and powerful addition to each of the rotation and scale parameters. Adding spherical falloff zones can greatly increase the precision of the effects of any of the rotation parameters that allow it, on the surrounding geometry. Actuate the spherical falloff zones by ticking the appropriate box in the Joint Editor window. Instances where this is needed on the tiger model are each of the shoulder and thigh joints, where they

connect to the chest and hip. Similar to the other blend controls, the spherical falloff zones have a full deformation area, the green inner circle and inward, and a zero deformation area starting at the red outer circle and continuing outward. The area between the green and red circles is the blending zone that will create a smooth transition from full to zero deformation. This is needed in areas where a joint must affect only a certain portion of geometry, and other geometry that might be very near to the bending joint must not move at all in order to keep the integrity of the model.

To use a spherical falloff zone, activate it for a channel, and then hover the cursor over one of the circles, or spheres, as they actually operate in three dimensions. Click and drag on the circle to translate, or move, it to cover an area of geometry that you want to be affected. With the circle still highlighted, use any of the Scale dials to change the size and shape of the circle to affect only the parts of geometry that should be affected or not affected. The green circle includes everything within its area, the red circle excludes everything outside of its area, and the area between the green and red, as before, is a blend zone that causes a smooth transition between fully affected and zero affected geometry. Adjust the green and red circles accordingly to include or exclude portions of geometry. This is a higher level of control than using only basic twist and rotation controls. Not all joints, or joint rotations, will need a spherical falloff zone. With practice, believable joints and great detail within a figure can be achieved using spherical falloff zones (Figures 17.12 and 17.13).

Summary of Steps for Editing Spherical Falloff Zones

1. Save your work frequently.
2. Activate the spherical falloff zone by checking the box in the Joint Editor window.
3. Move and adjust the green sphere to include the geometry to be affected.
4. Move and adjust the red sphere to exclude geometry to be left out of the deformation.
5. Test each of the rotations with the spheres activated to find and fix any problem areas.

Once all of the previous parameters are set, a next optional step is to set joint limits. Joint limits define the range of motion a joint will travel, measured in degrees, with a minimum and a maximum. A perfect example is your elbow. An elbow joint commonly bends in a single plane, or single direction. It also travels only a certain distance in its movement,

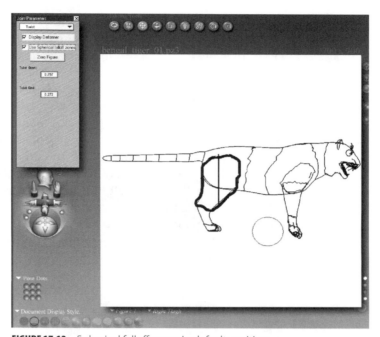

FIGURE 17.12 Spherical falloff zones in default position.

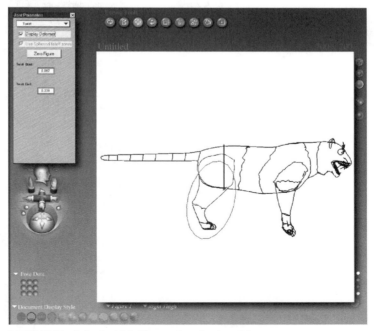

FIGURE 17.13 Spherical falloff zones in edited position.

from fully extended straight arm to fully bent in, as if constricting it to show your bicep muscle. These limits can apply to any of your figure's joints, to allow natural limits to occur when posing your figure. Since this is not always necessary to set, use your judgment on which joints to impose limits. A good way to judge is by how you might need to pose the figure in any situation. The simplest way to access the Limit control is to place your mouse cursor over the Twist, Side-Side, or Bend dial, and double-click on the dial. A window will appear with a number of input boxes. The two that will allow you to enter rotational limits are called *Min Limit* and *Max Limit*. There will be a value already in these boxes; by default, they will allow a full range of movement. Experiment with different values to simulate the actual range of motion a joint might have in reality by comparing it to reference pictures and footage. Each of the Twist, Side-Side, and Bend rotation channels will have its own set of limits to optionally edit (Figure 17.14).

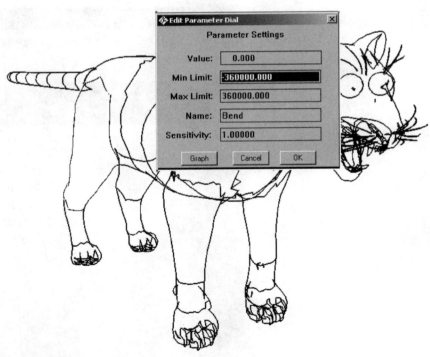

FIGURE 17.14 Setting joint limits.

Summary of Steps for Editing Joint Limits

1. Save your work frequently.
2. Open the Edit Parameter Dial window by double-clicking the dial to be edited.
3. Each of the Twist, Side-Side, and Bend rotations will have a separate set of limits; edit each as needed.
4. Experiment and fine-tune the maximum and minimum limits.

After all of the joint parameters are set on one side of your figure, go to Figure>Symmetry>Left to Right, or Right to Left, depending on which side of the figure you worked, to copy the joint parameters to the opposite side of your figure. Make sure to click Yes in the following dialog window to copy joint parameters when doing this to transfer all parameters to the corresponding parts of the model on the opposite side. Your entire figure will now contain the joint parameters you have set. However, it's not complete yet. Pose your figure so that there is a slight bend in each of the extremities that have IK. The bend must be in the natural direction the joint bends in reality. This will influence IK to always start bending in that direction first. Finally, memorize your figure's complete settings by going to Edit>Memorize>Figure; this will be the default position of your figure every time you begin a new pose session. Save your final work to the Figures Library with an appropriate finalized name. This figure is now *Bengal Tiger*.

CONCLUSION

As seen through these joint setup examples, basic default joint parameters can be extended through bend limits and favored bend directions and falloff zones to mimic more closely their real-world counterparts. Most joints of a real person or animal bend in only one direction, or only bend or twist to a certain degree. Default joints as set in many Poser models allow freedom of movement in all directions, sometimes leaving the joint positions at abnormal settings and bending to be radical and random, with severely deformed figures as a result. That extra extension or mobility of movement might be required at times, though, to achieve certain poses. Keep this in mind when setting parameters, as an unnatural extension might actually be needed to make a certain pose look right, or interesting, or dramatic. Sometimes it is a good idea to set a parameter beyond a natural limit. Much of the time, it is desirable to let the joint parameter limits and IK system rule the position of joints. The setting should be determined by the most common use of the model.

Think ahead to how the figure will most likely be used, and set the parameters accordingly. Differences by example are posing a crouching tiger, and posing the tiger in a dramatic leap. Making the tiger leap, although dramatic, will favor using IK and the natural parameters that mimic actual joint limits of a real tiger. Moreover, the constraints of the different inclusion, exclusion, and blend zones might be required to keep the geometry from distorting when pushing the figure into a leaping pose. Posing the tiger in a restful crouching position, although seemingly a tame and easy pose, will require careful positioning, and possible unnatural bending and deforming to simulate the position. This is a case where an unnatural bend or deformation might help to achieve a hard-to-get pose. A study of reference material picturing actual tigers or large cats lounging will help in creating the pose. Of course, there is the element of artistic license, where a certain look might need to be achieved by exaggerating the model. It's always up to the artist to build and finesse the final result, based on knowledge of manipulating the model in different ways.

MODELING A
MOON-FACED MER

by Celia Ziemer

In This Chapter

- Big Head

- Steps for Extrusions

- Here Comes the Grueling Part: Rayed Fins, Ears, and Fluke

- PHI Foe?

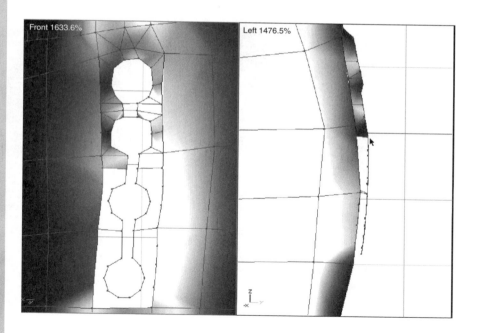

This model is a character with an oversized head and fussy fins. Aside from some interior linking in the fins, it's essentially a single-piece model and hollow for rendering with various transparency settings. Although the steps are oriented to Carrara Studio 2, we have tried to keep them general enough to will work with any modeler that supports editing objects at the master level, welding, and OBJ export. There's nothing revolutionary in the modeling method—modeling half an object, making a mirrored duplicate, then welding the halves together—the origin appears to be lost in the lore. To the person who first had the "Aha!" on this, we extend the continuing gratitude of symmetry-and-time challenged modelers all over the world (Figure 18.1).

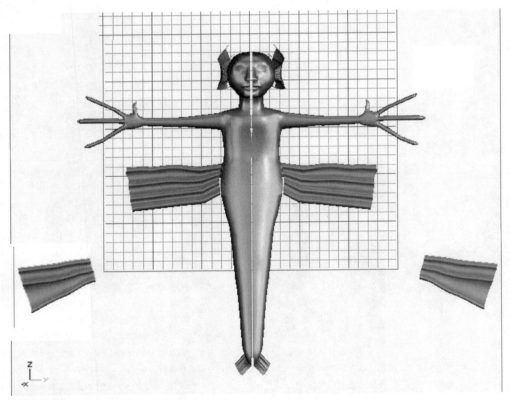

FIGURE 18.1 The Poser Mer model takes advantage of vertical symmetry.

ON THE CD

Look in the Models>Celia folder on the companion CD-ROM for the Poser files for this project.

TUTORIAL

BIG HEAD

Although a sphere is not always the best shape with which to begin a true human head, we used one for this model. It works fine for cartoons and nonhumans (and spherical shapes do so well with transparency fall-off in Poser). When you have the model set up in Poser, you can always grab the Grouping tool to clone off an existing head as a prop and Replace Body Part with Prop. Do the following:

1. Begin with a sphere for the head in Carrara (or use similar tools in your favorite modeling application), and insert a vertex object to open the Vertex Modeler, and then insert a sphere (we started with a 60-polygon sphere around 5). Select half the sphere and delete it.

2. If you're working in Carrara, go back to Assemble, select the hemisphere, and duplicate with symmetry (or duplicate and mirror). Working in the Front view, this will be the X-axis; working in the left view it will be on the Y-axis. Move the hemispheres together so that their open sides touch.

3. Double-click one sphere half to open it in the Vertex Modeler—click Edit the Master Object in the dialog box that appears.

4. In the Vertex Modeler, open the Scene Preview window and drag it out to maximum size. If you can't see the mesh in the Preview window, Zoom to Selection will usually find it (if it doesn't, you've dropped the selection; go back to Assemble and reselect).

5. Add vertices (v+click) to the edges at the front of the hemisphere, link them to form four-sided polygons, and unlink triangles as you go.

6. Pull some edges forward at the center front edge for a big nose; you can extrude a polygon at the bottom side of the nose for the area beside the nostril. (The model has no nostrils. The upward extrusion inside the nose didn't lend itself to transparencies at all.) See Figure 18.2.

7. With the nose in place, you can see where the eye and lips will go. You can "draw" eyehole and lips onto the face by adding vertices and linking—a general diamond shape will do for both. Make the first eyehole shape larger than the intended eye, empty the polygon, add some vertices to smooth it, and then select it and drag it backward into the face a little way. Select the top half and extrude for the upper eyelid, and the bottom half for the bottom. Then, select the whole orbit and rotate it forward to taste (depending on how "fishy" an expression you want) (Figures 18.3 and 18.4).

8. Eyelids and lips need a few extra lines of vertices if you plan to morph target them. For eyelids, run the lines of vertices parallel to the eye opening, and then nudge the new vertices forward in the center to form the curve over the eyeball. To do the lips such that the mouth can be opened, add

FIGURE 18.2 Pull some polygons out to create a nose.

FIGURE 18.3 Create holes where the eyes will go.

FIGURE 18.4 Add the eyelids and lips.

the vertices parallel (and close) to the line between the lips, and then delete the dividing line.

9. When the head is somewhat blocked in, flip it upside down and form half a neck where the neck usually goes—for a stick like this. Move the vertices at the bottom of the head into an open semicircle, shapeless but service-able. You'll probably need to add a few vertices if you've used a low polygon-count sphere.

10. Flip the head right-side up and extrude a couple of short sections for the neck. Since this is a blocky figure, extruded parts usually can be length-ened or shortened to taste at any time in the modeling process.

From here, we used a string of extrusions for the body down to the next-to-last tail segment, and for the arm and hand. You could also loft these by cre-ating all the semicircles for the body and tail, selecting them, and lofting the works simultaneously. Whether you loft or extrude, add a couple of extra cross sections where you intend the joints. Arms, fingers, and tail segments are basi-cally half-cylinders.

TUTORIAL

STEPS FOR EXTRUSIONS

1. Select the bottom of the neck and extrude only a small length. Move the end vertices close to the bottom of the neck and do this two or three more times.
2. Extrude again. This is the start of the shoulder extrusion (it will actually be the top of the chest when it's cut apart), so resize it to something between the size of the bottom of the neck and the size you intend for the shoulders.
3. Extrude again; and again, pull the end of the extrusion fairly close to the previous extrusion. Resize for shoulder width.
4. Make several more extrusions, enough to reach an approximate waist or abdomen bottom. These should be reasonably close together at the top.
5. Go to a Side view and delete some polygons at the side of the chest, enough to form an appropriately sized hole for the collar.
6. Pull the vertices at the edge of the collar hole into an oval shape and make two short extrusions. This is the character's collar (Figure 18.5).

FIGURE 18.5 Create a collar.

7. Extrude the scrawny arm. Where the upper arm (Poser's Shoulder) will meet the elbow, make a couple of short extrusions and then extrude the longer forearm and a couple of short extrusions for the wrist (Figure 18.6).

FIGURE 18.6 Create an arm and wrist by extrusion.

8. Start the hand by making several short extrusions and resizing them for a little taper; the farther from the wrist, the wider. In the same way that the collar and arm were branched from the chest, cut a hole in the top of the hand mesh and extrude the thumb, with short extrusions at the joints.
9. At the open end where the fingers will be, link twice (for three fingers, three times for four fingers) across the opening and extrude very short segments from each of the finger holes. Shape these a little by resizing them smaller, and extrude fingers, again with extra extrusions at the joints (Figure 18.7).
10. At the ends of the fingers and thumb, fill the polygons and tweak the ends close together. You can tweak the mesh on the backsides of the fingers to form fingernails, but unless

FIGURE 18.7 Create a hand.

you need veritable claws, they probably won't show when you have mer-
bodies schooling like sardines.

11. Select the last extrusion you made for the bottom of the abdomen and ex-
trude a few times for the hip.

12. From the bottom of the hip, extrude several sections for the tail . The bot-
tom tail section should be long enough and/or comprise several extru-
sions so that the fluke can be attached to the side of it and curve inward at
the bottom. Note the and/or. We started with 13 extrusions and realized
that we would never get the curve at the bottom the way we wanted it by
extruding and dragging vertices around. Insert a small sphere, cut a quar-
ter section out of it, and delete the rest of it. Reshape its top to line up with
the bottom of the last extruded tail segment, and link its top to the bot-
tom of the last tail segment to close off the bottom.

TUTORIAL

HERE COMES THE GRUELING PART: RAYED FINS, EARS, AND FLUKE

The original fin—a fast spline sweep of circles and a line—flattened when bent
and appeared even flatter with any transparency at all. A solution was found
after some trial and error and a few test runs in Poser with a segmented dupli-
cate of part of the model (head through hip) and a partial .phi file.

1. To create the ears (and the bases for fin and fluke), decide how many rays you'll need and create that many small circles (Insert/Oval) on the drawing plane most nearly parallel to the side of the head (or to the body part on which you want to place a fin). Drag them close together in line, and leave a little space between them. Position them such that there are two vertices at the bottom and two at the top of each oval. Link the ovals together at these points and add a vertex on each new linking edge.

2. Delete the edges between the newly linked pairs of vertices on each oval. This makes a single hollow shape. Duplicate this shape a couple of times and stash the duplicates somewhere out of the way (Figure 18.8).

FIGURE 18.8 The base for ears, fin, and fluke.

3. Unlink vertices on the side of the head to form a single long rectangular polygon a little larger than the ear-base shape, and then select and empty this polygon. Move the ear-base shape into the resulting hole (if you need to rotate some of the shape to fit the curvature of the hole, select the part requiring rotation and Cmd+Opt+click on the vertex to be rotated around). Add enough vertices to the edges of the hole to link the ear-base shape to the sides and top of hole (Figure 18.9).

4. Select the shape and extrude to taste—the length of the extrusions is arbitrary (a section can always be grabbed and lengthened or shortened). Resize the oval parts smaller, space them farther apart (the vertices you

FIGURE 18.9 Link the ear-base shape.

created on the edges between the ovals will anchor the center and pre-
serve direction), and extrude again. Extrude, space, and resize three or
four more times (Figure 18.10).

5. After all the extruding is finished, go back to each extrusion and link the
ovals back together and the corresponding vertices on the membranes—
this is the time-consuming part, in no uncertain terms. To make this easier
to see, select the ear in the Top view, invert the selection (Select/Invert Se-
lection), and hide (View/Hide selection). In the Front view window, drag a
selection frame around all but one extrusion and hide that, leaving only
one shape (cross-section) visible at a time.

6. After linking the vertices on this cross section, ascertain that nothing is se-
lected, and unhide everything else (View/Reveal Hidden Vertices), but
don't deselect it. Invert the selection (this selects the cross section you've
just finished linking—right now we're using it as a marker), and Shift+drag
a selection frame around the next cross section. Two cross sections should
now be selected. Invert the selection again, hide, and deselect the two
cross sections. Select the finished one and hide that. Link the next one. Re-
peat the process to the end of the ear.

7. Next, make the rest of the mesh visible. We want only the ear to show, so
deselect everything, select the ear, invert, and hide. Select the ends of the
membrane and ray and fill the polygons. You can also select the oval

FIGURE 18.10 The spiny extrusions.

sections, one at a time, and extrude them beyond the membrane for a spiney look.

8. Deselect the ear. Reveal hidden vertices (you need the head visible for this), and then Invert Selection to reselect the ear. Go to a Top view, Cmd+Opt+click on a vertex at approximately the top center of the first cross section of the top ray, and rotate it toward the back of the head. Do the same with the other cross sections.

9. The process for the hip fin is about the same as for the ear—unlink at the side to make a long single polygon and empty it (stop a little short of where you intend the bottom of the hip to be)—but you can get by with four or five fat rays. Grab one of the copies you made of the ear-base shape and delete the bottom so that it begins and ends with an oval shape and leaves you two or three oval shapes in the middle—enough ovals for the four or five fat rays (Figure 18.11).

10. Make the first extrusion from the hip very short. This is the buffer zone, the big hinge, between the hip and the fin. Then, extrude a few more times to create the fin shape. As with the ear, hide everything you don't need and perform the inner linkages.

11. The finny fluke is another story. By now you might want to just open an edge on the bottom of the tail and extrude and shape something, or steal

FIGURE 18.11 Create the hip fin.

a fluke from the Poser dolphin. We wanted more rays to grab the light, so we bit the bullet and dragged another copy of the ear-base to the edge of the sphere we'd stuck onto the bottom of the tail. It didn't make enough rays, so we resized it smaller, duplicated it, and linked the duplicate on. Of course, it was then too long and we had lost patience with the whole wretched process. Once the shape was cut to size and grafted into the quarter sphere, we just extruded it, dragged the sections out to form a fan shape and terminal rays, ignored most of the inner linking, and called it a fluke (Figure 18.12).

RESIZE BEFORE THE TWITCHY PARTS

1. This is as good a time as any to export the half-figure to Poser. Set the Percent of Standard Figure Size to 100 or less—it might still come in huge and halfway through the floor. Make it the size you want it ultimately to be; look it over—give it some transparency, play around with lights, and do a couple of quick renderings. This might not be hugely necessary if you intend to export the model as a single mesh for grouping in Poser, but when exporting a pre-segmented model the vertices can sometimes slip, causing an overlap (Figure 18.13).

FIGURE 18.12 The finny fluke.

FIGURE 18.13 The Mer mesh.

2. Export it with *As Morph Target No World Transformations* checked. Create a new file in your modeling software and import the figure (in Carrara, as a vertex primitive with *Disable Auto Scaling* checked and *Auto Position* unchecked to keep it Poser scale. Select the model and Zoom to Selection using the Front camera

3. Open the model in the Vertex Modeler and set the modeler's grid spacing (Cmd+j) to 0.1 and reset the view (View/Reset). Activate at least two viewports (Top and Front). If the model isn't facing you in the Front view, go to the Top view, Select All, Cmd+Opt+click a vertex top center of the head, and rotate so that it is.

4. Set a window to Directors camera view and another to Front. In the Directors camera view, Cmd+Opt+click the left grid to make it the active drawing plane and drag the plane to the open edge of the model. Carefully drag a selection frame around the vertices at the open edge (change the Front view or rotate the Directors camera view to be sure you have all the edge vertices selected).

5. Selection/Move to Drawing Plane.

6. Deselect the edge and Select All. Making sure the drawing plane is still active and has not moved. Duplicate with symmetry; the missing half at last. (It should appear mirror-imaged on the other side of the drawing plane. If it doesn't, zoom out to find it. It's faster to delete it, correct the drawing plane's position, and reduplicate the old half rather than to try to align the new one to the old.)

7. Deselect everything, and in the Front view, drag a selection frame down the center of the two halves—exactly where the drawing plane is. Send the selection to the drawing plane again and Selection/Weld/Use Default Tolerance (Cmd+Shift+W) Check the seam to see that it's all welded, and weld anything that was missed by selecting the two vertices and /Weld/Weld Selected Vertices. Save the file. Save it a couple of times under different names so you can tear into it for morph targets and doodads!

PHI FOE?

Some people *like* the old .phi files; they make short work of going back and forth between Poser and a modeler, they can be truncated or copy/pasted for working with conformable items taken from the original mesh, and you can do the grouping in Carrara (which has terrific magni-

fication—grab the magnifying glass, draw a selection frame with it, and you're nose-to-vertex in nothing flat. If we have to name model parts anyway, we might as well detach them while we have them selected). See Figure 18.14.

FIGURE 18.14 The shaded Mer character.

CONCLUSION

If you intend to bone your model in Poser's set up, you can do the group names either in your modeler before you export the .OBJ file, or in Poser (Figure 8.14). Going the text-based route, detach and name the body

ON THE CD

parts before exporting. There is a .phi tutorial on the Poser 5 companion CD-ROM in the Celia folder (Figure 18.15).

FIGURE 18.15 After adding bones in the Poser 5 Setup Room, the Mer is ready for some serious animating.

THE ART OF COMPOSITION

by Ken Gilliland

In This Chapter

- Knowing the Difference
- Composition in Poser

KNOWING THE DIFFERENCE

It is said with all things that a good, strong foundation is key to success. Houses built on weak foundations succumb to the elements, taking a test without proper study usually supports the base of the grading curves, and relationships based on deceptions eventually fail. The same is true with art. No matter how great the skills or how advanced the tools, without that solid foundation, the composition, the work will fail to achieve its desired goal: to captivate the viewer. Let's not shy away from the truth; as artists, we hope that the viewers will notice our work and enjoy it, but for them to walk away and remember it, ah, that is bliss. Hopefully, in this chapter, we will turn poor and ordinary compositions into good ones, and good ones into great ones.

So, what makes a good composition? To answer that, let's first look at what makes a bad one. While hitting the bull's eye might be great for a sharpshooter, it's a lousy shot for an artist. Your center of focus on the composition is always better off-center, and targeting the thirds marks are best. Known in art history class as "The Golden Means," "The Rule of Three," or "Magic Thirds," this technique dates back to the "old masters" of the Renaissance. What the theory basically says is that the main elements in the composition should be placed one third from the top, bottom, or sides of the work. A composition created with this rule will always be more pleasing to the eye. Sounds too easy? Let's explore an example (Figure 19.1).

"Surfboard Hercules" (Figure 19.1) is a good example of a complex composition that uses "magic thirds" effectively. Notice how the main character, the surfer, is positioned on the left third mark. To further lock his position and solidify the composition, his arms are crossed on the upper third. To balance the composition, the top and base of the surfboards line themselves with the upper and lower thirds. You'll notice that the tipped surfboard almost points to the right third mark—that's no accident. Equally intentional is the space between the left two sunbathers nearly drawing the lower magic third line showing that negative space can be used just as effectively as using your characters or objects. The upper and lower right lines are the most important because when viewing a picture, your eye usually enters the picture in the lower-left corner. The reason for this is that most Western cultures are taught to read left to right. Try not to place too many objects on the right thirds—while "magic thirds" are excellent guidelines, there are problems with too much of a good thing. Too many objects might confuse the viewer. Even with such a complex composition as this, notice that the middle right quadrant hosts only one figure.

FIGURE 19.1 Surfboard Hercules.

Now that we hopefully have a new congregation of "magic thirds" converts, we'll mix things up a bit and tell you that you can make a bull's eye composition work. There are many inherent risks involved, but with the proper tools and skills it can be done. Who has pointed a camera and taken a bull's eye shot? Although hit and miss on composition, some of them work. Why? Well, on the one's that don't work, your eyes don't either. They lock on that bull's eye subject and get bored quickly. The secret is to keep the eyes moving by having an interesting subject matter or subliminal background (Figure 19.2).

With "The Buffalo Marshall" (Figure 19.2), notice that the figure is about as dead center as we can get. The figure on the horse makes the vertical line, and the buffalo herd adds in the horizontal line. Why does it work? Contrast and perspective are the power tools in this image's arsenal. The light colors in the sky raise our eyes upward. The strong textural elements of the grass and rocks bring them back down. Those two white rocks teach us a new way to read, right to left. Although we might start in the lower-left corner, we're immediately thrust to the right side to see the rocks and then begin a gentle rise to the mounted character.

The "prairie dog" view camera angle not only gives us an interesting view, it invites us into the image. By hugging the ground with our

FIGURE 19.2 The Buffalo Marshall.

camera we are no longer third-party observers on the prairie, we're part of the entourage.

While the rule of three is a great starting point, there are other techniques to make a composition better. A good composition tells a story. Just as with a good novel, a good composition is paced by a storyline. The storyline starts with the introduction of the thematic elements that are brought to a climax. Sound crazy for a still picture? A good example of this is "Annual Summer Picnic" (Figure 19.3).

Your eye first picks up the surreal landscape . . . hmmm, not of this world . . . then the aliens—definitely not of this world. Your eye picks up the items while traveling to the background—picnic baskets, bags—okay we get the picnic element, then a cow—okay the artist's a little weird . . . more aliens and then the punch line . . . a cow staring into what's cooking on the barbeque . . . probably a good thing that the aliens didn't abduct any bulls . . . The composition does tell a story and uses an "S" curve of images trailing into the perspective to tell it. The elegant "S" curve is a favorite among artists and is said to evoke grace, beauty, strength, and perfect balance.

While an "S" curve is a safer form of composition, a straight-line approach can work if properly balanced with the right elements. By adding

FIGURE 19.3 Annual Summer Picnic.

the element of camera angle and perspective, one can make a simple straight-line composition elegant. This composition form does not necessarily have to be multiple figures (Figure 19.4).

FIGURE 19.4 Straggler.

In "Straggler" (Figure 19.4), a simple composition is used. Perspective can be a powerful tool. Using this element, your eye is immediately drawn to the cheetah, which is up close and personal. A line of shrubs and grasses is drawn to its intended victim: the buck. While in the distance,

and not immediately noticeable, the surprised buck is still clearly the punch line of the story. Note the clear use of "magic thirds." The movement of the composition from left to right—very easy on the eyes. Here's a good example of how to make a good composition better. The same image could have easily been created without the perspective; the entire cheetah at one third and an equal-sized buck at the other. By dropping the camera view to the character's point of view and panning in on him, we now are in the hunt, too. Moreover, with the use of the diagonal story line, we give the composition a sense of force and energy to the viewer. The cheetah is given the feeling of readying to pounce. This feeling isn't just caused by the pose; the diagonal composition adds the edge. Even the buck has the appearance of heightened alert. If the image were in a horizontal line composition, the energy would be lost and we would have a much calmer scene as we do in "Savannah" (Figure 19.5).

FIGURE 19.5 Savannah.

The most common pitfall for artists trying to avoid the bull's eye composition is to jump to the "bookends" form of composition. Since dead center doesn't work and off center looks funny, they choose to balance the composition with two equal weights positioned each side of the image. This is also known as compositional symmetry. While balance is often safe, it is also boring. Instead, try something asymmetrical. In "Savannah," we have the two bookends with totally different weights. The left side is simple, weighted by a large, solid piece of negative space (the sky) and a stationary animal. The center two trees frame the apex. On the right side, we have trees and active animals with darker tone. The reason for the darker, more active right side is to help us as viewers flow with the natural left-to-right reading of an image. Your eye tends to go the brightest area first, the large section of negative space on the left. It

then moves right, eventually hitting the punch line of this story: the giraffe in the middle side, checking us out. So, here we find that colors and shapes can be used as tools just as effectively as the characters in compositions. In addition, horizontal and vertical line compositions tend to promote calmer, more balanced compositions. This brings up an interesting point: the type of composition you select might help or hinder the message you're trying to portray in your image. In "Stampede" (Figure 19.6), we break some composition rules and take a leap of faith. This again is a horizontal line composition, but this time the main characters do not bookend.

FIGURE 19.6 Stampede.

We in fact throw caution to the wind and heavily weight the left side. There is no vast negative space sky or dark foliage/shapes to save us. In this case, two things make the composition work. The poses of the characters are filled with action. Even the tree shadows charge with them. Our eyes want to stampede right with them to balance that right side. That motion is aided by the second composition tool, mentioned several times before: the natural left-to-right eye movement. This composition would not work as well reversed as seen in Figure 19.7.

Interestingly, the image still reads left to right, not with the herd as you might have expected. And now, your eye is confused, charging into the upcoming herd and wanting to swing back to the left, and then bouncing right back into the herd.

Now that we've had our crash course in composition and stampeded through some theories, let's try to create an award-winning composition in Poser.

FIGURE 19.7 The Stampede image is reversed here.

COMPOSITION AND POSER

My creative process is a strange one. Most of my images in Poser come from simply playing around with characters. Sometimes, when I have a creative block, I'll force myself to try lesser-used models in my Poser arsenal. This allows my thought process to be a bit more inventive and work through different approaches to solve that age-old question: how to fill the canvas, or in our case, the screen.

In this case, since I wanted to stay within Curious Labs' Poser for the entire process, I chose a background model of a sagebrush desert. The model had a built-in sky and ground plane so I wouldn't have to export my image to a 3D terrain program such as Vue D'Esprit or Bryce. The model also had some portable shrubs included to add to the atmosphere. I then loaded the Michael model (from DAZ 3D), dressed him in old western clothes, and began to play with possible poses. When a pose was struck that I liked, I then refined it. During this process, I accidentally posed the left hand in a contorted position. There was the germ of inspiration I was waiting for. I envisioned my character playing a fiddle in the middle of that sagebrush prairie. As he played, his horse longingly looked at him, and creatures from the desert gathered around to hear the "Prairie Dog Serenade". . . So there was my game plan for the image. Our list of characters would include the fiddling cowboy, his horse, maybe a jack rabbit, a bison or two, and of course some prairie dogs. First, let's start by positioning the main character and his horse (Figure 19.8).

Moving characters around can be pretty tricky, especially when conforming clothes are attached, rename the figures to a real name tag rather than "Figure 2" or "Figure 5." To do this, select the figure, then go to the

FIGURE 19.8 First, the main character and his horse are positioned.

Body Part selection menu and choose "BODY." Now, press Ctrl+I (Character Properties) and rename the "Figure 3" to "Horse," for example.

Now that we have the naming process set, let's look at the basic composition. What message do we want to convey? With a humorous piece, the vertical and diagonal are out—they create tension. Perhaps a horizontal line, or better yet an "S" curve composition. An "S" curve could start with some of our small animals, come up to the cowboy, and then end in the magic third right-side slot with the horse. In addition. the camera angle is all wrong in Figure 19.8—a prairie dog perspective is in order. Therefore, let's load in a couple of the small animals and shape the composition (Figure 19.9).

As you can see in Figure 19.9, we now have a stretched-out "S" curve and a new camera position. The camera position was achieved using the rotation trackball and camera plane controls. The focal range was also changed slightly with the camera to give a little depth.

Looking at the image, some items leave are a little awkward. The rabbit and front prairie dog are both the same size and height. They do line up with the lower third, which is good, but it's too much of the same thing. One of the two should be dominant; otherwise, they both fight for control of the start of the "S" curve. The rabbit could be moved back and

FIGURE 19.9 Some small animals are added.

the prairie dog forward and a little left. The second issue is the horse; although proportionally it's correct to our cowboy, the perspective and camera angle make the horse appear smaller than it is. We'll fix this by scaling the horse a less little to mimic the correct size. This technique was also used on the front-left prairie dog to give the illusion of being right behind him. False perspective can be a powerful compositional tools when used wisely; however, there are inherent dangers with this technique as well. The loss of depth in false perspectives might need to be compensated for. In a program such as Vue or Bryce, adjusting haze slightly will do the trick. With Poser, the solution is a bit more complex and time consuming. Reducing Poser's Camera Focal parameters from the default 38% down to the low 30 might work. The other way would be to alter the focus of the background in post, which can be tedious. Another issue is the background plane. By changing the focal range in Poser, our big sky doesn't fill the top of the screen any more. We could scale the backdrop, but drawing in the rest of the sky in post is a better option. Changing the scale might give us pixilated texture map problems later. Now, let's move the models and do a test render for lighting problems (Figure 19.10).

With the test render (Figure 19.10), we see that the changes have helped. The repositioned rabbit starts our "S" curve nicely. The curve

FIGURE 19.10 A test render to check for lighting problems.

does break down a little bit with the middle prairie dogs, but this can be corrected in post by adding foliage and rocks to break up the very plain-looking foreground. Scaling the horse has helped, too. The horse fits comfortably the magic third slot and now looks like he can be taken off the pony ride circuit. Lighting is unfortunately a problem. Lighting can be as important a compositional element as one of the characters if done correctly. In our composition, spotlights added to the cowboy's chest and the horse's head, set without shadows, would give those characters the punch they need. The lighting needs to be subtle, though, because we don't want to give the appearance that we're using spotlights. Setting the light color to pastel shade to reflect twilight will also help to make the spotlight less noticeable. In post, a bedroll added to the horse might be a nice enhancement as well (Figure 19.11).

With the final version (Figure 19.11), in post, some fur was added and the highlights on the front prairie dog's and rabbit's eyes were sharpened. These added details will again draw our eyes to the forefront characters. In addition, wild grasses using Corel's Painter "Image Hose" were sprayed into place, masking the areas with the "freeform selection" tool to avoid overspraying and to layer the grass elements to build perspective. The perspective was also enhanced by building opacity in the layers as they came to the foreground. The tall grasses in the right portion of the

FIGURE 19.11 The final image: Prairiedog Serenade.

foreground help to strengthen that weak part of the "S" curve so now it flows freely, completing our composition. The only thing left is the signature and allowing the public to view it—and hopefully remember it.

CONCLUSION

The rules of composition provide important tools in creating images; however, nothing written here is gospel. Explore and stray from the path. Art is an individual process and should provide you with a unique voice. Remember, as an artist you are allowed to color outside the lines.

20

MOTION CAPTURE EDITING

By Jennifer De Roo

In This Chapter

- Getting Ready
- Exporting the Model from Poser
- Applying Animation
- Thinning Keyframes
- Scaling Animations
- Range Editing
- Mirroring
- Paste Special
- Exporting to Poser

Credo Interactive has two products that might be of particular interest to Poser users: *Life Forms* and *Mega Mocap*. Life Forms is a character motion tool, with powerful editing features for both keyframed and motion capture animations. Life Forms comes with *Power-Moves 1 & 2*, a collection of more than 800 ready-to-use animations.

Mega Mocap is a collection of quality motion capture animations. It encompasses a wide variety of activities, from walking and running, to office work, sports, and many more. It is available in many different file formats, including regular Poser BVH, Millennium Figure Optimized Poser BVH (for the DAZ 3D Poser supermodels), Life Forms lfa, Light-Wave LWS, 3ds max, and more. You can use Mega Mocap as a stand-alone content bundle to bring data capture files directly into Poser, or edit the files with Life Forms, using functions such as thinning keyframes, mirroring, reversing, range editing, and mapping from one model to another to maximize versatility. In this chapter, we will walk through the use of Life Forms to edit some Mega Mocap sample files and apply the motions to the Victoria Millennium Figure and the Michael Millennium Figure (from DAZ 3D).

For this tutorial, you will need:

- Life Forms 4 demo and Mega MoCap sample files, available from *www.charactermotion.com/products/PoserTutorial.html*
- Poser 4 or 5 available from Curious Labs *www.curiouslabs.com*
- Victoria and Michael Millennium figure available from *Daz3D www.daz3d.com*

TUTORIAL

GETTING READY

Do the following:

1. Install the Life Forms demo as downloaded from the site mentioned previously onto your hard drive.
2. Unzip/unstuff the free Mega Mocap files to their default location: C://Program Files/Credo/MegaMocap/Poser Tutorial
3. Make sure Poser, Michael, and Victoria are also installed before proceeding.

EXPORTING THE MODEL FROM POSER

For this example, we will be using both the Victoria and Michael figures. We will first need to export these models from Poser via the BVH export and bring them into Life Forms in order to apply motion data to them.

1. Open Poser 3 or 4.
2. Load Victoria2.pz4.
3. Go to File>Export>BVH motion and save as Vicki.bvh on your hard drive.
4. Repeat these steps for Michael2.pz4, naming him Mike.bvh.

Do not add hair or clothes to the models at this point in time; you can add these after you have applied the animation in Life Forms and brought the motion back to Poser.

5. Now, open Life Forms.

If you have just downloaded and installed the demo, and this is the first time you have used it, you will be asked to enter your name, organization, and serial number. Enter this information—the serial number should have been e-mailed to you, providing you entered your correct serial number during the demo download process. If you did not receive this serial number, you can e-mail support@charactermotion.com to request it.

The first thing we will want to do is to bring the two BVH skeletons into Life Forms.

6. Create a new animation file in Life Forms by going to File>New.
7. Go to File >Browse and the File Browser will open. This feature lets you quickly and easily browse and preview files, as well as import models and motion from them. Select File of Type BVH and click Import Figure. Browse to Vicki.bvh and click Open (Figure 20.1).
8. The figure will appear in the Stage window. Click on the figure, go to Figure>Name, and name the figure Victoria.

Next, we will need to examine the skeleton and make sure that the joint axes are correct.

9. Double-click on the Victoria skeleton and the Figure Editor windows will appear. Select the hips. Sometimes when importing into Life Forms, the hips get the wrong axis direction because they are wider rather than taller, and axis direction assumes the direction of the longest dimension of its geometry
10. Change the joint axis by going to Edit>Set Axis. The pelvis axis should look like it is facing up; instead, it faces out. Set the axis to up (Figure 20.2).
11. Check the head and neck axes in the same way and adjust to face up if necessary.
12. Repeat these steps with Michael.

You now have two Poser skeletons in Life Forms, ready to be animated.

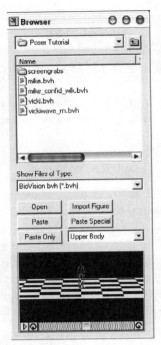

FIGURE 20.1 Open the Vicki.bvh file

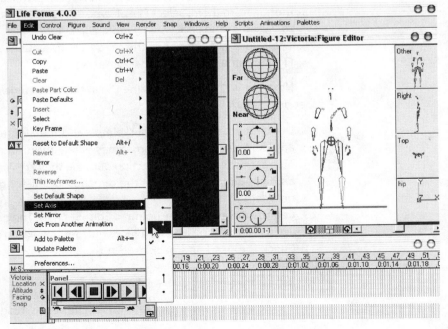

FIGURE 20.2 Change the Joint axis.

APPLYING ANIMATION

1. Click on Victoria in the Stage window to select her.
2. Go to File>Browse to open the File Browser. Select File of Type BVH and browse to your previously installed Mega Mocap Files—the default install location is C://program files/Credo/MegaMocap/Poser Tutorial.
3. Select Vickiwave_run.bvh and click Paste. A dialog box will pop up asking you if you want to change the frame rate. Click Yes.
4. The animation will now be pasted to the model. Click Play and watch the playback in the Stage window.
5. Repeat this process for Michael using the Mike_confident_walk.bvh motion.

THINNING KEYFRAMES

Life Forms can thin dense motion capture data to make it more manageable to work with using the Thin Keyframes tool. Thin Keyframes reduces keyframes in your animation by evenly deleting keyframes by a certain number. For example, if you enter "3" in the Thin Keyframes dialog box, Life Forms will keep each third keyframe and delete the rest.

We will thin all keyframes for both Michael and Victoria to make the animations easier to work with.

1. Go to the timeline and select the entire animation for Victoria. You can do this by clicking in the gray panel to the left of the animation in the timeline.
2. Choose Edit>Thin Keyframes.
3. Enter 3 in the box.

 You can thin keyframes to a higher degree, but it is better to start with a smaller number first, and then play back and view the effect. If you remove too many keyframes, the animation might lose quality.

4. Click Enter.
5. Click Playback to view the animation. You will see that the quality of the animation is still high. In addition, when you look at the timeline you can see that the data is noticeably reduced and easier to work with.

Do the same thing with Michael.

6. Go to File>Save, and name the file Mike_Vicki.lfa. We will use this saved file as a starting point for all the other motion data editing examples.

SCALING ANIMATIONS

Scaling animations means to add or delete frames in order to make the animation length longer or shorter.

SLOWING DOWN ANIMATION

The more space you put between keyframes, the slower the animation will be. Life Forms makes it easy to select and stretch the desired range of keyframes, which will put more spaces between keyframes.

1. To demonstrate this, first open Mike_Vicki.lfa.
2. Select all keyframes in the timeline for Michael.
3. You will see that the frames are surrounded by a red box with handles on the sides of it. Click on the right-hand handle and drag it to the right. You will see the animation expanding to fill the space. Click Playback and you will see that the animation is now slower.

SPEEDING UP ANIMATION

The less space between keyframes, the faster the animation will be. You can speed up the animation by compressing the frames. To do this, again select all keyframes for Michael, and then click and drag the handles to the left as far as they will go. Click Playback and you will see that the walk is faster.

Experiment with this process until the animation is walking at a speed you like.

REVERSING FRAMES

The Reverse command lets you reverse an animation sequence frame by frame. To see how this works, we will reverse the keyframes on Victoria to make her appear to walk backward.

1. Open Mike_Vicki.lfa.
2. Next, go to the timeline and select the entire animation for Victoria.
3. Go to Edit > Reverse.
4. Click Playback and you will see Victoria running backward.

RANGE EDITING

Range editing allows you to change the position of a figure over a range of frames.

OFFSETTING

One useful function when tweaking motion capture data is the ability to offset a joint over a selected range of keyframes. For example, with Michael's walk, the arm is moving at the side of the body. If we wanted the arm to extend up, as if Michael were waving, we could use the Relative option for range editing to achieve the desired change. The Relative option will apply the change made in the joint's position relative to the existing movement of the joint. This allows the joint some freedom of movement if it is already animated, rather than an absolute rotation, which would fix the joint in place regardless of the animation already applied.

APPLYING A RELATIVE ROTATION

1. Open Mike_Vicki.lfa.
2. Select Michael and double-click on him to open the Figure Editor window.
3. In the Figure Editor window, activate the Range Editing function.
4. Check on the Relative option.
5. In the timeline, select a range of frames by dragging the mouse over the desired frames. A red box will appear around the frames.
6. You will see that the selection box has a fade-in/fade-out section that appears as an extra box segment at the beginning and end of the selection. Adjust the fade-in and fade-out zones by clicking and dragging on the tabs at the edges of these zones. These zones specify the frames in which a change is gradually applied. In this example, we will use four frames for the fade-in and fade out zone, which means that the change will be applied over four frames. If we chose a shorter zone, the change would be applied faster; if we chose a longer zone, the change would be applied more gradually.
7. Now go to the Figure Editor, select the upper arm and use the Z rotation dial to move it up in the air, at approximately –160 degrees.
8 The timeline window will automatically update, and you will see that the arm is rotated –160 degrees throughout the range of the movement, resulting in Michael walking with his hand in the air.
9. Click Playback to see the result in the Stage window.

MIRRORING

You can mirror paths of figures in your animation along the X-, Y-, or Z-axes, as well as mirror keyframes, facings, and snap. In this example, we will take Victoria and mirror her animation along the Z-axes, which will reverse her

upstage-downstage position. We will mirror around her keyframes around the start frame of the animation.

1. Open Mike_Vicki.lfa.
2. Go to the timeline and select the entire animation for Victoria.
3. Go the Edit > Mirror. The mirror dialog box will open.
4. Select Upstage-Downstage (Z), and choose Around Start.
5. Make sure Up-Down a(Y) and Right-Left (X) checkboxes are not selected. Leave Snap, Facing, and Shapes selected.
6. Click the Play Preview button and watch the playback. The animation should now be moving in the reverse direction.
7. Click Mirror.
8. Play back the animation in the stage, and watch the animation.

PASTE SPECIAL

Life Forms also makes it easy to paste data, or portions of data, from one animation to another. In this example, we will paste Victoria's wave onto Michael.

1. Open Mike_Vicki.lfa.
2. Go to the timeline and zoom in on it until you can see the individual details of each frame. Look at Vicki and select the frames where she is waving, approximately frames 8 through 30. Use File> Copy or Control C to copy the data.
3. Go to Michael, select frames 8 through 30 on him, and go to Edit > Paste Special. The Paste Special dialog box will pop up (Figure 20.3).
4. Select the following checkboxes: Shapes, Show Joint Map, and Selected Joints. Select Right Arm from the drop-down Joint menu. This will ensure that only the motion from Vicki's right arm is pasted onto Mike.
5. Make sure none of the other checkboxes are selected, and then click Paste. The Joint Map Editor will now pop up (Figure 20.4).

The Joint Map Editor allows to you easily map motion from one model to another.

The Joint Map Editor has three modes: Map, Pose, and Test. It will open with Map selected to allow us to create a correspondence between the source and destination joints of the models.

You will see two columns of joint names next to the models—on the left is Victoria, the source model, and on the right is Michael, the destination model.

We will want to map only the right arm joints from Vicki to Michael. You will see that Life Forms has already guessed the mapping of the arms, since we had specified that only the arm motion was to be pasted.

FIGURE 20.3 The Paste Special dialog.

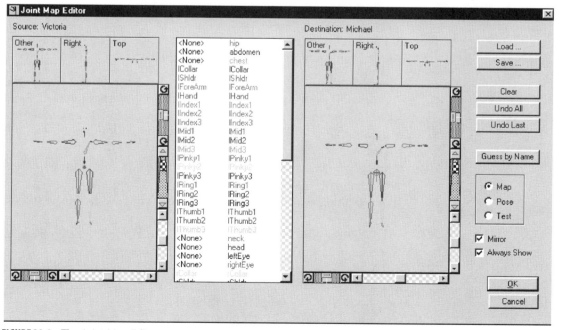

FIGURE 20.4 The Joint Map Editor.

However, it appears that both arms are selected, and we only need the right arm. We will need to unmap the left arm.

1. To do this, first uncheck the Mirror button. Otherwise, the Joint Map Editor will automatically map the left joints when we map the right joints, and vice versa.
2. Now, click on the Left Collar in the column or on the Michael model in the Model View window. To unmap this joint, click on the background of Victoria, the source model.
3. Repeat this with all of the left arm joints, and any other joints that might have been mapped except for the right arm joints.
4. Now we can test the mapping. Click the Test radio button and a scrollbar will appear at the bottom of the Joint Map Editor. Click and drag on it to scroll through the animation and see how it looks.
5. You will notice that only the right arm of the Michael figure is moving, as the rest of the motion has not been mapped.
6. The motion looks fine, so click OK. If we had experienced a problem with the position of the arm, we could have used the Pose mode to adjust the arm slightly, but that will not be necessary for this animation.
7. One you have clicked OK, press the Playback button and watch the animation in the Stage window. Michael is now waving as he walks.

EXPORTING TO POSER

Now that we have seen some of the editing capabilities of Life Forms at work, it's time to take the motion back to Poser and test it on the figures.

1. To export both figures out to BVH, go to File>Export and select File of Type BVH from the selection menu (Figure 20.5). Check One File per Figure and Replace Spaces in Joint Names with Underscores , but leave all other options unchecked.
2. Click OK.
 Life Forms will now export two files, one for each figure—Mike_Vick0.bvh and Mike_Vicki1.bvh2. Mike_Vicki0 will be the first figure in the animation, which is Michael. Mike_Vicki1 will be Victoria, the second figure.
 If you are not sure which figure is first or second, look in the timeline, as the topmost displayed figure will be the first one.
3. Now, go to Poser and load Victoria. To do this, open Poser and load the Vicki2 figure. Next, go to File>Import>BVH motion and browse to Mike_Vicki1. The new animation will now load.
4. Do the same for Michael, browsing to Mike_Vicki0 instead.

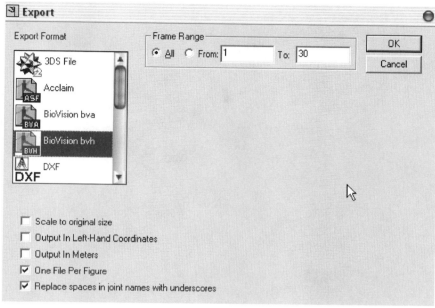

FIGURE 20.5 Export to the BVH format.

CONCLUSION

We have now completed the Life Forms and Poser tutorial. This tutorial illustrates only a few of the motion editing capabilities of Life Forms. For more information on Life Forms, check out the tutorials available from *www.charactermotion.com/support/tutorials.html* or see the *User Guide* under the Help menu within the Life Forms program for more information.

TEXTURE HINTS
AND TIDBITS

by Gregory L. Henle

In This Chapter

- Skin Textures
- General Texture Mapping
- Transparencies and Textures
- Reflection Maps

SKIN TEXTURES

Here are some hints and tips useful in the creation of skin textures for Poser characters.

More than Just One Color

Many colors make up a skin texture. There are reds and yellows, and you can see hints of blues and greens as well. You can see this in a 256-color palette (sorted by hue) of a scan of a hand. You should keep this in mind when painting a skin texture for a model (Figure 21.1).

FIGURE 21.1　In a 256-color palette, you can see the multitude of tones that contribute to a skin texture.

A Little Slice of Imperfection

Nobody is perfect, and it's the imperfections that make a texture believable. Moles, tan lines, and so forth are all very real. To make a "perfect" texture, you should consider adding these imperfections to it.

Before You Add a Skin Texture

Before you add a texture to a prop or figure in Poser, make sure that the color and the reflective color are set to true white (R255, B255, G255),

and highlight and ambient colors are set to true black (R0, G0, B0). Colors other than those specified here will alter the appearance of the texture and might not give you the results you want. This applies to all the materials of the figure or prop as well.

UV Mapping

Poser uses Implicit (UV) mapping to apply the image to surface of the model. UV Mapping is the process of creating the coordinates needed to assign surface attributes to a model. UV coordinates are used to apply two-dimensional textures to surfaces and align the texture to the three-dimensional surface of the object. The UV coordinates are an alias for XY coordinates, with X being the horizontal and V the vertical. If you are creating and mapping your own models, then when creating you own texture templates, you might want to consider overlapping portions of the mesh in the template. The pros are that you can create smaller, more efficient texture maps with the same level of detail; the cons are that you sacrifice some versatility in the texture.

When creating textures in image editing software (e.g., Photoshop), it's a good idea to separate highlights and shadows as well as new alterations on separate layers. Once you're happy with a change, consider merging layers. It's much easier to delete a layer than it is to recreate the texture if you decide later that you don't like the change. Using separate layers and leaving the original render untouched should also be considered in postproduction if possible.

Obtaining Textures

One of the best methods for obtaining background textures is an inexpensive digital camera. If you don't have one, then a quick online search will reveal a number of sources for textures. Please respect people's copyrights, though, and make sure it's okay to use the posted textures for your intended purpose.

Bump Mapping

Bump maps add further realism to a model and are more efficient than trying to create minute surface detail than with geometry alterations. By adding skin pores, scars, and so forth you are adding the necessary imperfections and helping to prevent your model from looking like a plastic action figure. The quickest way to create a bump map is to copy a color

texture, grayscale the image, and invert the colors. When working with textures, you'll need to pay attention to moles, birthmarks, tan lines—any place where the color saturation changes. For example, you'll most likely want to remove any tattoos in the bump map that were on the original texture.

GENERAL TEXTURE MAPPING

Here are some additional hints and tips useful in the creation of general textures for a Poser scene.

Seamless Textures

If you are using Poser 4 and earlier, you cannot tile a texture on the basic props. This isn't a problem in most cases, but what if you want to add a little background to your scene with these? The problem you might encounter is that the texture might map to the object in such a way that it appears too large. Floorboards that appear about a yard or a meter wide can ruin all the effort you put into a scene to make it look realistic.

One way to fix this problem is to create a new larger texture from the original texture by tiling the original texture within it. This works fine if your texture is a seamless texture, but what happens if it isn't? Find another texture? Why not just make a seamless texture from the original? Poser 5 introduces texture tiling by letting you mirror a texture in the U- and V-axes. In addition, Poser 5 lets you control the scale and offset of a texture in the U- and V- axes as well. The following tutorial will show you how to create a texture that can tile seamlessly. From this texture you can then duplicate and repeat the texture in a file with larger dimensions to obtain the desired effect when applied to a prop surface within Poser. It is recommended that you have image editing software capable of using layers, such as Procreate's Painter, PaintShop Pro, or Photoshop. This tutorial also assumes that you already have an understanding of how the respective image editing software functions.

TUTORIAL

CREATING THE TILING TEXTURE

1. **Chopping.** Divide your image into quarters, and separate each quarter on its own layer. A good way to ensure that the image is divided evenly is to add a horizontal and vertical guide and use them as your cut lines.

2. **Swapping.** Moving each quarter to its opposite diagonal corner. You'll want to leave some overlap to blend the edges together. Create some extra guides about 10% of the distance from each edge to help keep your new outside edge lined up.

3. **Layer Order.** You should now have something that looks like Figure 21.2. The quarters can be arranged in any layer order, but the sequence of how they cover the other layers should remain the same from right to left and top to bottom. Thus if the upper-left quarter covers the lower-left quarter, then the upper right should cover the lower right. Similarly, if the upper-left quarter covers the upper-right quarter, then the lower left should cover the lower right. This is important to remember so that the image's edges will match their opposite counterpart. You will know if you have the layers order right if a single vertical line and a single horizontal line can

FIGURE 21.2 Progression of the development of a tiled texture.

trace all the visible edges of the quarters. At this point, it's a good idea to save.

4. **Blending.** Blending is mostly a matter of removing parts of the layers so that the pattern continues without an obvious break; nibbling away at the inside edges until the obvious breaks in the pattern are removed. Tough spots can be fixed with tools such as the Airbrush; however, tools such as a Clone Brush or Stamp come work well too. It is important when blending the pattern back together not to alter the outside edges too much or you will destroy the repeating pattern. Now all you have to do is crop it to the outside edges and save.

5. **Finishing Up.** From this point, it's just a matter of creating a larger image by importing and repeating the seamless texture you just created into a larger image, and then apply this new texture to your large background prop (Figure 21.3).

FIGURE 21.3 If you take the time to develop the tiled texture, the result will be seamless. The original tile is displayed at the lower right.

TRANSPARENCIES AND TEXTURES

Now let's discuss a technique used to create texture and transparency maps for Poser. Many of the figures and props that come with Poser come with texture templates that you can also use to make transparency maps. The problem is that often it isn't clear exactly how the texture will be mapped to the object. Rather than waste hours making a transparency map only to find that it maps to the surface in a way you didn't intend, the first step you should take is to make a very simple transparency map and find out just how the texture is mapped to the surface. Other techniques might involve using the texture template itself. Either way, you'll save yourself a lot of frustration if you simply create a test transparency or texture before creating your final transparency.

We will use the Anime Hair and Victoria, available from DAZ Productions, Inc. (*www.daz3d.com*) as the targeted models. We assume a familiarity with the image editing software of your preference and with Poser on how to apply textures to a figure or prop. We also assume that the image editing software of

you preference has layering capabilities. Textures templates are usually available from the creator of the model either packaged with the model or available by downloading it from the creator's Web site. If the texture template is unavailable, there are programs that can create a texture template directly from the object model itself. One of the most popular is UVMapper Classic (in the Extras folder on the companion CD-ROM).

ON THE CD

PART ONE

Rather than guess at how the texture is mapped to the object, create a very simple transparency map from the texture template with shapes that are easily identifiable and clearly show a direction.

The texture template is shown to the left in Figure 21.4. It seems pretty straightforward. It wouldn't be much help if, at this point we just said, "follow the grid lines and you're done." After importing into your image editing application, we need to create two new layers. Leave the original template alone. It's also a good idea to lock or protect the template layer to prevent it from being altered. The first layer we'll fill completely black (transparent). On the second, top layer we'll paint the shapes in white (visible). If you prefer to paint in black with a white background, that's fine. Just remember to invert the colors before saving the test transparency (Figure 21.4).

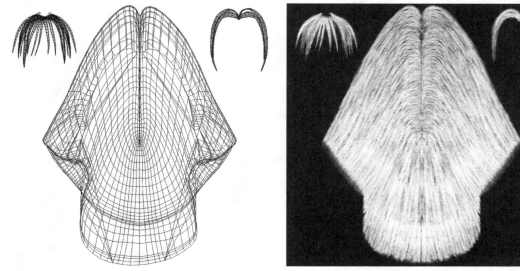

FIGURE 21.4 On the left is the original texture template. On the right is the top layer.

PART TWO

In the test mapping, the edges are marked and labeled so that when the transparency is applied in our test render, we can see where they lie. In addition, arrows were added to show our template edges. Both the arrows and the edges were marked with letters and numbers, respectively, to aid in their identification. The bangs were pretty obvious, so they were left alone with only an outline (Figure 21.5).

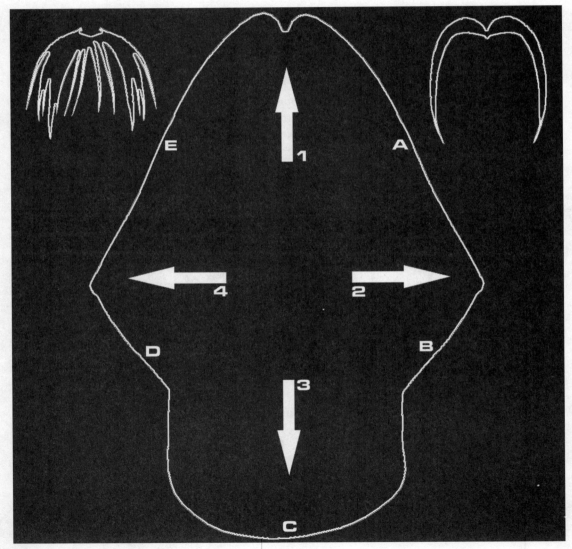

FIGURE 21.5 The test mapping.

The next step is to apply this to our object and create a test render. For the test render, you don't want to set the transparency to 100%. You will want to be able to clearly see the entire prop but also be able to use the references created on this transparency map. Here it's just a matter of preference, but around 80% min and max works well.

Part Three

Now that we've made a few test renders, it's time to take a look at our results. From this, we'll know how to paint the transparency. This might have seemed obvious from the beginning by looking at the template, but unless you were the individual who created the model, or at least the individual who created the UV map, then you'll only be guessing at it. It might be an educated guess, but a guess nevertheless. Comparing the renders to the test transparency and the texture template you can see that the ears will fall where points B and D are and, yes, the hair strands should basically follow the grid lines (Figure 21.6).

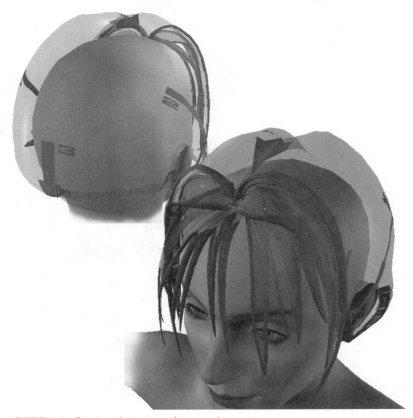

FIGURE 21.6 Preview the test render mapping.

PART FOUR

When painting the transparency, the technique will vary with the type and the tools you have available (software and hardware). For a hair transparency, like the one demonstrated here, a small brush with a few widely spaced points will work very well for painting the hair strands. The technique used for a clothing prop transparency map will most likely be different. For that, selecting large blocks and filling them might work best. One thing you can do to save time when creating a texture or transparency is to look for portions that are symmetrical. Even if you intend to make each half unique, you can eliminate a good portion of the work by painting half and mirroring it to fill the other half (Figure 21.7).

FIGURE 21.7 Paint the transparency map.

PART FIVE

This same technique can be used for textures as well. The transparency map makes an excellent base from which to create the texture (Figure 21.8).

FIGURE 21.8 You can use the transparency map as a base for the creation of the texture map.

The transparency map was duplicated on several layers and the blending options were changed to accentuate the highlights and shadows. A final top layer was added and further highlights and shadows were added with the Airbrush using the same brush technique that was used to create the transparency template. Now it's time to do the first true render and critique your work. From this point on, it's all a matter of personal taste. You might find later that you'll need to change the hue, or that the texture's highlight conflicts with the highlight of another texture (Figure 21.9).

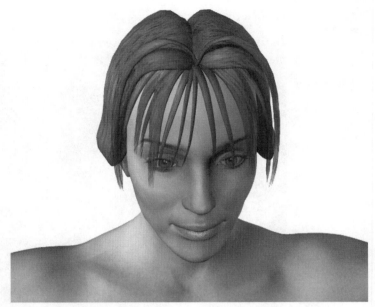

FIGURE 21.9 The finished Anime Hair.

TUTORIAL

REFLECTION MAPS

A reflection map in Poser is a two-dimensional image mapped to a virtual sphere surrounding an object and, in fact, the entire scene. This texture is then reflected onto any objects in the scene to which the reflection map is applied. This is not true reflection, but can be looked at as the image you would see in the reflection (it's called *environment mapping*). *Multiply through Lights* changes the intensity of the reflection map based on light position and how it falls on the object. *Multiply through Object Color* reduces the reflection's intensity by multiplying its result through the color (Diffuse) applied to the object.

If you have 3D software that can render a 360-degree panoramic view of a scene, then creating reflection maps can be as simple as setting up a sky and rendering. If your 3D application doesn't have the capability to create 360-degree panoramic views, you can still create a panoramic map if you have image editing software that can distort polar coordinates to rectangular coordinates such as Photoshop 6 or later.

PART ONE

If you are creating a background in a Poser scene, the most accurate way to create the reflection map of it is to export the background (or import the

model if it was imported into Poser) into the application that will be used for creating the reflection map. Once the scene has been set up, place a 100% reflective sphere as close to the same location as the object that will have the reflection mapped to it. Shadows should be disabled for the sphere. Other settings such as secularity and so forth should be set to have minimum impact on the scene (Figure 21.10).

FIGURE 21.10 Place a 100% reflective sphere in the scene.

Part Two

Place your rendering camera directly above the sphere facing down and render the image as isometric. The reflective sphere's edges should be just within the production frame. After you've rendered the top half of the sphere, repeat the same procedure for the bottom half of the sphere camera facing up. The final aspect ratio of the rendered image should be 1 to 1. In your image editing software, you'll want to crop both images down to the scene's horizon (Figure 21.11).

Conclusion

Distort each image from polar to rectangular coordinates. For the bottom half, you'll need to flip the image vertically. What was once the center of your image should now be the top edge of your texture map. Join the two images

FIGURE 21.11 Reflection map top and bottom.

together to form the full 360-degree panoramic of your scene. You can leave it in this aspect ratio, but we prefer to resample the image to a screen aspect

ratio of 1.33 to 1 (i.e., 1024 pixels by 768 pixels). You now have an image ready for use as a reflection map for Poser (Figure 21.12).

FIGURE 21.12 The reflection map is applied to the DAZ 3D Vicki character.

22

MODELING POSER CLOTHES

By Serge Marck

In this chapter, we will explore how 3ds max can be used to model clothes for Poser figures.

Serge's clothes for Poser are some of the most exquisite clothing props on the market, covering a multitude of period dresses and costuming accessories. You can find his models at www.renderosity.com. *Also check out* www.chaosgroup.com/SimCloth.html *and* http://www.reyes-infografica.com/. *Most of his models are freely downloadable. I use 3ds max to model my clothes items for Poser.*

My first clothes were made using traditional modeling methods, and I was unsatisfied because the natural-looking folds were quite hard to make, and the texture mapping was too much work (planar mapping never produced good results). I was delighted when Reyes Infografica offered its 3ds max plug-in *ClothReyes* for free. With ClothReyes, you start with simple, rounded shapes and then let ClothReyes create the cloth-like bends and folds. I did some tests with simple meshes (cylinders for sleeves, closed cylinder for torso, cylinder for skirt, etc.) and all this was working quite well, but the folds were sometimes strange because of the quadrangular polygon areas.

One day, I found a Maya tutorial concerning the Maya *Cloth Simulator*. The tutorial explained that to simulate realistic cloth moves, you need to create special meshes with varying sizes of triangles that are randomly distributed, with no regularity or stress lines. With standard polygonal objects, you will always get artificial stress lines caused by the regular tessellation. I then discovered another free cloth simulator plug-in named *SimCloth* (based on object collision detection). On the download page was a little plug-in named *ClothMesh*, which could produce planar triangulated meshes to simulate clothes. I also found that Reyes Infografica had something called *Hexamesh* that created similar results. Then Digimation released *Stitch* for 3ds max. I didn't purchase it, but found that it also operated on planar triangulated meshes; triangulated to render the cloth folds realistically, and planar to avoid any extra texture mapping work.

Given all of this research, I decided to develop my own poor man's cloths modeling technique. Do the following:

1. Using your character as a 3D template, draw your patterns (two planar meshes, front and back) with one of the special plug-ins mentioned. Planar map them.
2. Make an animation where your character goes from flat, scaling the Y vertical axis to 1% at the start to its normal size at the end.

3. Place your planar meshes on each size of your character (they should be very near the 3D mesh) and weld the vertices, which will be the "seams" on the borders.
4. Use the 3ds max plug-in that simulates the cloth.
5. To get long skirts with folds conforming was a problem. Making a thin hip part falling to the ground can work with straight skirts or dresses, but is not workable when you have folds. The folds are distorted and don't look natural at all. Therefore, I used morphing for my dresses' hip parts. I got better cloth simulation, although the poses are limited.

This process that Serge engaged in for creating Poser clothes in 3ds max is fairly complex, which required a lot of development and exploration time. The results are very good as far as the modeling goes, although extreme character poses challenge the stability of the clothing meshes. Although this is a possible solution for 3ds max users, Poser 5's new Cloth Room tools present new and simpler ways to create cloths for Poser characters, complete with collisioIn detection parameters that prevent posing problems (Figures 22.1 through 22.3).

FIGURE 22.1 Start your clothes by referencing an imported Poser figure part in your 3D modeling application.

FIGURE 22.2 Add folds in 3ds max by using one of the mentioned plug-ins, or by exploring your own methods. Experiment with different mapping types to add textures.

FIGURE 22.3 The base object you use is important. Starting with a cylinder, for example, creates a different folded look.

FIGURE 22.4 Serge's dress for the DAZ 3D Stephanie model.

CHAPTER

23

DAZ 3D AND POSER'S FUTURE

By the DAZ 3D Staff

I
n this chapter, DAZ 3D previews some future Poser plans.

When Larry Weinberg and Steve Cooper first spoke with us about providing Poser-ready models to be included in Poser 3, although we were both at companies with different names then, we approached it as we would any other custom modeling project. Through creating the new figures for Poser 3, however, we became skilled in the process of optimizing models for Poser, and after we were done with that project we immediately went on to release a collection of plug-in content CDs for Poser. Within the next year, we opened an online Poser-store and began our ongoing tradition of posting a new free Poser model every week. As work on Poser 4 neared completion, we were excited to hear about the development of new capabilities such as conforming figures, full-body morph targets, and transparency mapping. It became more apparent than ever that the potential and need for additional Poser content was endless. As Poser 4 began to hit the street, it became obvious just how much more we wanted to devote our resources to Poser development. We quickly developed plans for the creation of some "next-generation" Poser figures that would use Poser 4's new capabilities even more fully than the figures that we supplied initially for Poser 3. This work evolved into the "Millennium" family of figures of which *Victoria* and *Michael* are a part. DAZ Productions is now entirely devoted to the Poser market (Figure 23.1).

DAZ 3D's experience with production for television, feature film, and gaming industries is producing even more sophisticated models for the new professional tools and features in Poser 5. Poser users can look forward to the continued development for and of the DAZ 3D Millennium models, which have quickly become the standard figures for artists interested in pushing the limits of Poser. Stephanie, the DAZ 3D female figure created directly from Michael's existing mesh, has gained her own ever-growing fan club. Aiko, DAZ 3D's most recent addition to the Millennium family, is the result of an exploration into the Japanese anime-figure genre.

The Stephanie model was built off of the existing Michael mesh due to its extraordinary quality and extreme versatility. Stephanie comes with all the appropriate material zones and UV coordinates for easy mapping. Optimized for use with Poser 4 and 5, this figure comes with hundreds of morphs and is ready to animate. She has 169 morphs for expression and facial structure alone, and endless morph possibilities for the entire body. You can tweak attributes such as physique, age, weight, symmetry, height, and ethnicity. In just this one 3D model, you have the capability to create thousands of custom characters. Stephanie offers

FIGURE 23.1 The DAZ 3D supermodels take advantage of Poser's capabilities.

more overall versatility than any other derivative 3D model available on the market today (Figure 23.2).

Aiko was released in tandem with an innovative new hairstyle known as the Versa-Hair Pak (with ERC). This hairstyle contains what is known as *Enhance Remote Control* joint technology, which allows for such versatility as straight, wavy, curly, twist, and blown-in-the-wind looks. This method of controlling joints within Poser was pioneered by Robert Whisenant, a DAZ team member, and the technique has come a

FIGURE 23.2 Stephanie has limitless personalities.

long way since it was first developed. This technology has been used in DAZ 3D products since Victoria 2.0 was released (Figure 23.3).

Figure creation has come a long way since DAZ 3D originally created the Poser 4 family of figures. From the creation of Victoria 1.0, then Michael 1.0, then the new 2.0 versions of each (plus Stephanie and

FIGURE 23.3 Aiko with Versa Hair.

Aiko), DAZ 3D's commitment to Poser models remains in place. Victoria, the most popular Poser model, will be receiving the most attention in the near future. With Versions 1.0 and 2.0 already widely in use among Poser users and in the 3D character graphics and animation industry at large, Victoria 3.0 should really knock your socks off! With a completely new set of data (both OBJ and library files), including improved morph target functionality and organization, and enhanced resolution in just the right areas, Victoria 3.0 will be positioned to become *the* premiere female figure available for Poser. Along with Victoria 3.0, DAZ 3D is hard at work developing a new generation of animals for release in the near future. Look for a Millennium Dragon very soon, as well as revamped versions of the

original animals that DAZ 3D created for Poser in the past. As the power and availability of Poser continues to evolve, so will the products that DAZ creates (Figures 23.4 and 23.5).

FIGURE 23.4 A preview of the new Dragon model's wireframe.

With the advent of Poser 5 and all the new tools and technology constantly emerging, the market for such high-quality, cutting-edge models is only going to grow. DAZ 3D has been working hard to prepare new content specifically designed to take advantage of this type of technology.

FIGURE 23.5 A preview render of the coming Vicki 3 model, if it's super realism you're after.

Along with the hiring of Robert Whisenant as an additional expert pro-
duction team member, DAZ 3D has recently hired Anton Kisiel, perhaps
the most well-known individual Poser content designer/creator in the
community. Anton has brought powerful insight and a plethora of new
ideas to the DAZ 3D team. With the new Platinum Club portion of the
DAZ online store, customers can take advantage of Mr. Kisiel's new work
(and that of his team) at a fraction of the normal cost while maintaining
the level of quality and individuality for which he has become famous. In
addition to all the time we dedicate toward production, DAZ will con-
tinue to provide highly coveted brokering opportunities for top-quality
work provided by individual artists. The last two years have seen the Bro-
kering department of DAZ Productions grow immensely. As DAZ con-
tinues stressing the importance of premiere quality products from all
brokerage submissions, this program continues to gain momentum.

 Along with the new look and feel of their online store, DAZ 3D has
been busily working on expanding their scope of production in order to
stay competitive in the ever-changing Poser market. With the advent of
collision-detection, hair and cloth simulation, availability of *RenderMan*-
compliant render engines, and advanced shader and material controls,

the utility and appeal of new DAZ 3D content keeps growing exponentially. DAZ 3D plans to release many versatile new products in the very near future with a level of quality and innovation that will be unlike anything else currently available for the Poser market, while staying committed to their Customer Service policy and constantly looking for ways to lower prices for the end user.

MASTERING THE CLOTH ROOM

By Eddie Johnston

In This Chapter

- Creating Layered Clothing
- Clothing the Judy Figure

CREATING LAYERED CLOTHING

In this chapter, we will demonstrate how to create two layers of clothing. We will dress the Poser 5 Judy figure with the beach dress and the Nehru Coat (dynamic clothing props supplied with Poser 5). Generally, dynamic clothing props will be created to fit the figure in the "zero pose." To see what the zero pose is for a figure, disable Inverse Kinematics (IK) by opening the Joint Editor (Window>Joint Editor) and clicking the Zero Figure button.

Now, why is it that the clothing is created for the zero pose? Well, cloth simulation works by performing a physical simulation (i.e., a simulation of physics) on the cloth, approximating the laws of Newtonian mechanics by computing the trajectory of the cloth vertices over time. The forces on each vertex are computed from internal "cloth" forces (e.g., resistance to stretch) and external forces such as gravity and wind. Given the forces on a vertex, we can compute its acceleration (remember the formula force = mass x acceleration? You just knew that this formula was going to be useful one day!). From acceleration, we compute how the velocity of the vertex is changed in a small timestep (e.g., $1/60^{th}$ of a second), and from the new velocity, we compute the new position. This approximates how objects behave in the real world. Generally, we do not see objects instantaneously moving from one place to another. Our shirt does not instantly jump from the closet to our body; we have to follow a gradual process to put it on. In the computer, the physical simulation has to follow a similar restriction. A dynamic cloth object needs to be gradually transformed from one shape and position to another over time.

In Poser, this means that if you want your cloth prop to drape over your figure, Poser has to figure out how to get the cloth from its starting shape to the final drape using a dynamic simulation over a finite period of time. If the clothing is made for the zero pose, then it is a simple matter of gradually transforming the figure from the zero pose to the desired pose and simulating the clothing physics on the cloth during the process. Since Poser always knows what the zero pose is, your clothing props can be easily re-used and shared. If the prop was created with the figure in another pose, you would have to distribute that pose with the prop, and you would not be able to use the "start drape from zero pose" procedure in the Cloth Room (although you could still set keyframes from the original pose to your desired pose and simulate over time, a technique we will explore later in this tutorial).

CLOTHING THE JUDY FIGURE

Now, let's put this theory into action. We are going to pose Judy and dress her with a beach dress and a Nehru coat. Before we do that, however, we will dress Judy in just the beach dress. Do the following:

1. Open Poser and load the Judy Nude figure (Figures>Poser 5). Notice that Judy is *not* in the zero pose.
2. Load the P5WomanBeachDress from the Library (Props>Dynamic Clothing>Female).
3. You will notice that for the most part the dress fits, because the default pose is similar to the zero pose (when not considering the arms). You will see a small poke-through of the thighs (Figure 24.1). This is not a problem; we do not expect the cloth to fit anything except the zero pose.

FIGURE 24.1 A small poke-through is visible.

4. If you like, set Judy to the zero pose to see for yourself that the dress fits. Now we are going to set our pose. Select the Stand 27 pose from the Library (Pose>Female Poses>Standing>Standing Pose). Now the dress seriously does not fit! The right leg pokes through and the arms are going inside the dress.

Before we go on, let's examine the figure more carefully in this pose. Hide the dress by selecting it and using the Object>Properties dialog and deselecting the Visible checkbox. You will see that the forearms are going inside the buttocks in this pose. This might be all right for visual purposes if you are looking from the front, but it will cause big problems for the cloth simulation. Why? The cloth tries to stay "outside" of any object it collides with (that is, objects and body parts that we have chosen for collisions). However, how can the cloth be "outside" the arms *and* outside the body if the arms are inside the body? Something has to give, and since such physically unrealistic scenarios are hard to compute, the simulator will most likely produce some strange results. Therefore, let's fix the pose by moving the arms outside of the body.

5. Now we are going to drape the dress on this pose. Unhide the dress.
6. Go to the Cloth Room. Click New Simulation. Leave the default settings and click OK.
7. Click Clothify. In the Clothify dialog, select the dress from the drop-down list, and click the Clothify button.
8. Click Collide Against.
9. Click Add/Remove, select the entire figure, and then Alt-click on Head, Right Hand, Left Hand, Right Leg, and Left Leg to exclude these body parts and their children. Since the cloth does not come in contact with these parts, we can save simulation time this way, especially since those parts tend to have heavy geometry.
10. Make sure that "Start Draping from zero pose" is selected, and then click OK.
11. We are now ready to compute the drape, which means that we want Poser to gradually morph the figure from the zero pose to our standing pose over time. To do this, click Simulation Settings and set Drape frames to 20 (this means we want the morph from zero pose to our standing pose to happen over a time equal to 20 frames. It has nothing to do with "frame 20" in the timeline. All the simulation is happening at frame 1 during the drape, and even though the simulator is advancing the clock internally, Poser will not affect any other frames). You might need to press Enter after entering the value before the Calculate Drape button becomes active (Figure 24.2).
12. Click Calculate Drape. You will see Judy move from the zero pose to our pose. You might notice that the dress seems to penetrate the body at

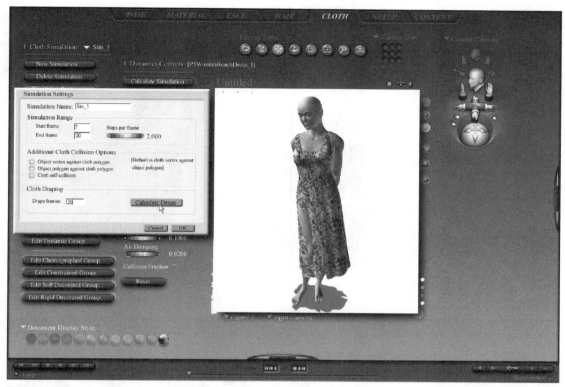

FIGURE 24.2 Drape computing is underway.

times, but that is just a display synchronization issue; the simulator is working properly. When the drape is finished, you should have something like Figure 24.3.

13. Click Edit Rigid Decorated Group. Notice that the buttons are highlighted in red (Figure 24.4).

This means that the buttons are treated as rigid objects rather than cloth. Effectively, those vertices are excluded from the simulation and are "stuck" onto the underlying cloth after the simulation has calculated each step. This group was created with the garment. If you create your own clothing items and import them into Poser, you will have to create these groups. When the prop is saved to the Library, it remembers the groups for the next time you use it. Now we move on to the hard part. We want to put the Nehru coat on top of the dress. We might consider the following methods:

14. Put the coat and the dress in the same simulation and drape them simultaneously. The problem with this is that simulating more than one layer at

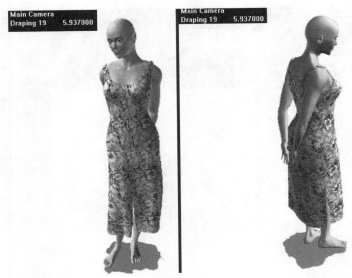

FIGURE 24.3 You should see something like this.

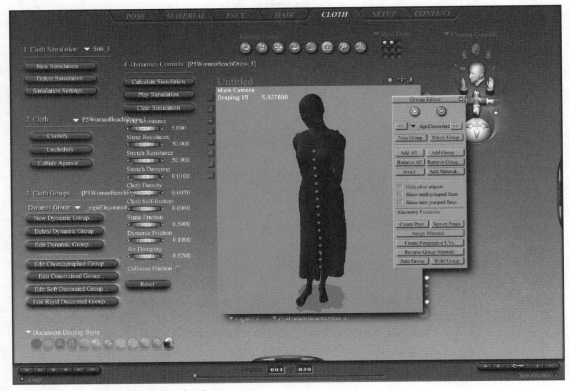

FIGURE 24.4 The buttons are highlighted.

a time really taxes the simulator, since it involves a lot of cloth-cloth collisions. Not only does this slow the simulator, but it can cause problems in highly constrained areas such as the armpits. No less problematic is the fact that when the coat and dress are put on at the zero pose, the coat does not completely lie outside the dress. The coat was designed to fit nicely over the naked figure, but does not take into account whatever other clothing might be underneath (Figure 24.5).

15. Drape the dress first (as we have done) and then drape the jacket on top, treating the body and the dress as "solid" objects. This is a better approach but suffers from two problems:

FIGURE 24.5 The dress pokes through the coat.

 a) At the zero pose, the jacket is not completely outside the dress.

 b) During drape, only the figure is morphed. Thus, the dress will always remain at its draped state, so it will not match the figure during the draping process.

 How to solve this? We will use a variation to find a way around the problems. To alleviate the first problem (the coat is not completely outside the dress), we will push the coat outside the dress. To bypass the second problem, we will simulate over the timeline, using keyframing to accomplish our own draping morph. Unfortunately, we will have to re-do the dress using the timeline to make this work. So, let's start (assuming you have the file from the previous session where we draped the dress):

16. Click Clear Simulation. Select the figure and save the pose to a Pose Dot. Zero the figure.

17. Click Simulation Settings. Set Drape frames to 0 (In this process, we are going to drape the dress over 30 frames of the timeline, where the figure will start out in the zero pose, so we don't need any drape frames.) Click OK.

18. Set Start Frame to 1 and End Frame to 30. Click OK.

19. Go to frame 30 and click the saved Pose Dot to recall our standing pose, and set a keyframe. If you move the time slider, you should observe Judy morphing from the zero pose to our pose over 30 frames. The dress is parented to the hip; notice that it moves with the hip, but there is no draping yet.

20. Click Calculate Simulation. This will simulate the dress from frame 1 to 30. At completion, we should have at frame 30 a drape similar to the one we had before.

21. Now comes the tricky part. We need to somehow push the coat outside the dress. Actually, the way collision detection works allows us to do this. Collision detection actually occurs in a "shell" around the surface of a collision object. The thickness of that shell is equal to the Collision Offset + Collision Depth of that object as set in the "Collide Against" dialog. The shell extends to Collision Offset outside the mesh and Collision Depth inside the mesh. When a cloth vertex finds itself inside this shell, it will be forced to the surface of the shell. This means that if we extend the shell deep enough (but not too deep, because that will cause other problems), we can push a cloth out of a collision object even though it starts out apparently "inside" the object. In this case, the coat is "inside" the dress at certain points. If we make the Collision Depth large enough to capture any coat vertices that are inside the dress, we can force those vertices outside of the dress. In the case of our coat and dress, the default depth of 1.0 cm should be sufficient, as the coat does not seem to go deeper than that.

22. Load P5WomanNehruCoat from the Library (Props>Dynamic Clothing> Female).

23. Click New Simulation, leave the defaults, and click OK.
24. Click Clothify and clothify the coat.
25. Click Collide Against. Click Add/Remove and select the figure (minus head, hands, and feet). Make sure to include the dress. Click OK. Set the Collision Offset to 1.0 (default). Set Collision Depth to 1.0 (default).
26. Click Simulation Settings, set the Drape Frames to 3, and press Enter. We do not need many frames here because the cloth does not have far to travel.
27. Click Calculate Drape. The coat will drape and will be pushed away from the body by 1.0cm (where there is no dress, like at the sleeves) and away from the dress by 1.0cm. The result should look something like Figure 24.6. Now, if we like, we can save the coat at this point to the Library for future use:

FIGURE 24.6 Your figure should look something like this.

28. Select the dress. Open the Library palette at Props>Dynamic Clothing> Female. Add the dress to the Library, saving it as a smart prop. In this variation, the coat should work with most of the other dresses, so you don't have to go repeat the entire process.

We still want to see the coat on Judy at the final pose. We have two choices here. We could delete the coat and reload it from the Library that we just saved, and create a new simulation with 0 drape frames, or we can use the current setup, which will require re-running the drape prior to the simulation (in our scene, the "starting state" of the coat is the non-pushed-out version, and every time we start a drape or a complete simulation, the coat will revert to this state. If we were to save to the Library and re-load, the "starting state" is the pushed-out version, so we can bypass the three draping frames we used to push the coat outside the dress). Let's re-run the drape followed by 30 frames of simulation.

29. Click Calculate Simulation and wait for the 30 frames to complete. Figure 24.7 shows the result.

FIGURE 24.7 The final pose.

OTHER CONSIDERATIONS

It is possible to have different collision settings for the dress and the figure. However, in order to do this, we need to un-parent the dress from the figure. That way, the dress shows up separately in the Collide Against list in the Collide Against dialog.

After clicking Calculate Drape or Calculate Simulation, there is usually a pause before cloth begins to move and the frame counter advances. This is because there is some pre-calculation going on at the start of the simulation. It also explains why the simulation time (which is displayed in the viewport to the right of Simulate Frame at the top left) is generally longer for the first frame.

CONCLUSION

The more complicated the collision objects and cloth, the longer the pre-processing time. Use the principles outlined in this chapter to add cloth attributes and collision detection parameters to your Poser figures.

POSER AUDIO

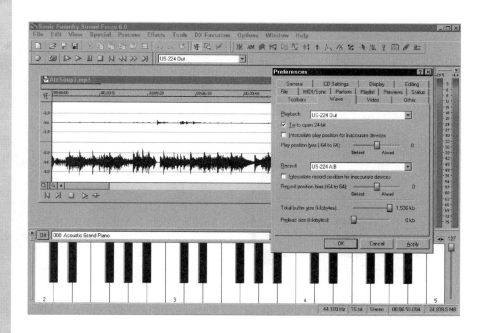

25

ADDING MUSIC AND SOUND F/X

In This Chapter

• The Poser Audio Track

• Professional Audio Track Editing

This part of the book is all about adding audio to your Poser projects and animations. When it comes to adding music tracks and sound F/X, Poser has that capacity built in. If you want your Poser characters to speak, there are some options that require the addition of other software designed for that purpose. This part of the book covers both situations in four chapters. This chapter covers Poser's native audio capabilities. The three chapters that follow look at three separate software applications designed to handshake with Poser in the creation of synthesized and application of speech, automatically moving a character's mouth in the process.

THE POSER AUDIO TRACK

Poser 5's audio capabilities are fairly limited when compared to more full-featured audio production software, which means that you have to prepare your audio before importing it into Poser. Future versions of Poser might include an enhanced audio editing capability, but for now you have to use additional non-Poser preparation steps and/or work with the audio tools available within Poser.

Importing an Audio Track

Go to File>Import>Sound to import a WAV audio file into Poser. A standard path dialog opens up, allowing you to find your WAV audio file location so it can be imported. Select a WAV music track, sound F/X, or a background narrative track.

It is strongly recommended that you do not *use this process to import audio files for* lip sync *operations. Poser 5's native audio capabilities make lip syncing very time consuming. There are far better ways to go about this process to create automated lip sync files with other handshaking software, as covered in the next three chapters.*

Viewing the Imported WAV File

If you want to sync a targeted animation movement to some point in the audio file, especially necessary when you work with sound effects, you have to have a way to see both the audio waveform and the transformations of the object element you're working with at the same time. The spikes in the waveform represent amplitude (volume) of the sounds, giving you exact feedback on where actions in the image sequence should

occur. You can view the waveform of the WAV audio file in one of two ways: through Window>Graph or Edit Keyframes>Graph.

The Window>Graph Method

Going to the menu bar while in any Poser 5 Room and selecting Window>Graph brings up the Graph Editor. Clicking on the waveform icon at the lower right of the Graph Editor displays the WAV waveform superimposed over any selected object's transformation curve (Figure 25.1).

FIGURE 25.1 The Graph Editor can display both a targeted object's transformation curve and the imported WAV waveform.

LMB clicking on the list at the upper right allows you to select one of the transformation parameters for the selected object whose curve you want to edit. By default, this is set to *Scale*. If you reference the spikes on the WAV wave form while using the LMB to select and reconfigure a part of the targeted object's transformation curve at that point, you will alter the scale based on the sound at that frame. If the item in the list reads *ZScale*, you could manipulate the Z scaling factor of the object at specific frames represented by spikes in the waveform (Figure 25.2).

Using the transformation curve editing method, you could tie any transformation components of a selected object (e.g., the arm of a character) to specific parts of the audio waveform, choreographing movements to music or sound effects. You could also move the mouth of a figure to a WAV file of recorded speech, but this would be tedious and time

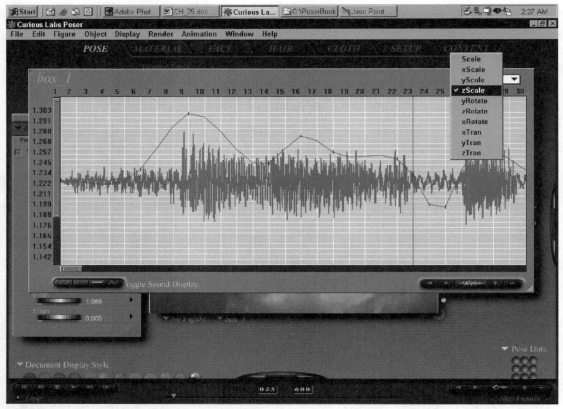

FIGURE 25.2 Here, the object transformation curve for the ZScale component has been modified to more closely resemble the shape of the WAV waveform.

consuming. Lip Syncing is best initiated by using one of the three applications detailed in the next three chapters.

The Edit>Keyframes Graph Method

This is an alternate way to bring up the Graph Editor. Click on the Edit Keyframes icon (shaped like a key) at the upper right of the Animation GUI (Figure 25.3).

FIGURE 25.3 Click on the Edit Keyframes icon.

Clicking on the Edit Keyframes icon brings up the Keyframe Editing window (Figure 25.4).

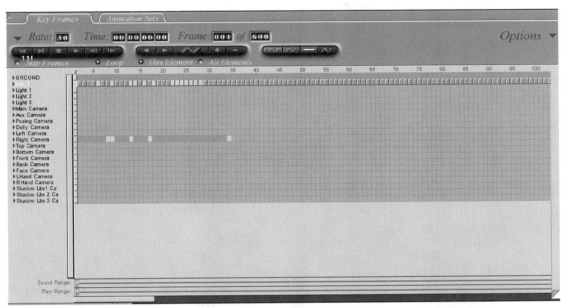

FIGURE 25.4 The Keyframe Editing window.

Refer to Part II of this book on *Poser Animation* if you need to refresh your skills on how to manipulate keyframes in this window. For now, we are interested in the *range bars* and the *Graph Display Trigger*.

The Range Bars

There are two range bars: *Sound* and *Play*. They appear at the bottom of the Keyframe Editing window when you have a WAV file loaded (Figure 25.5).

You can move either end of these bars by clicking and dragging the LMB over the arrows that indicate their beginning and end points. Starting the sound at a different point in the animation than the first frame, by moving the start position of the Sound Range bar, will clip the first part of the audio. Moving the end position of the Sound range bar to the left will clip the audio's end point. You can do this while paying attention to where the keyframes are placed in the data lines above the range bars to set the audio to begin and end at specific frames of an animation. The Play range bar allows you to set the play range of the animation, so that the final animation can be any segment of the whole other than the total.

FIGURE 25.5 The Sound and Play range bars.

The Graph Display Trigger

Clicking on the Graph Display Trigger is an alternate way to get to the Graph Editor, detailed previously. The Graph Display Trigger is the waveform icon at the center of the Keyframe Controls at the top of the Keyframe Editing window (Figure 25.6).

FIGURE 25.6 The Graph Display Trigger.

PROFESSIONAL AUDIO TRACK EDITING

If you have to embed professional audio tracks in a Poser project, it is strongly suggested that you invest in a high-end audio editing application. This will allow you to do all sorts of amazing things to your waveform file before you import it into Poser, including setting the exact timing length, start and stop points, fades, adding chorus and flange effects, altering the pitch at targeted sections of the audio, inverting the sound, and more. One of the best and most reasonably priced audio applications for Windows that does all of this and more is Sonic Foundry's *Sound Forge 6+* (*www.sonicfoundry.com*). See Figure 25.7.

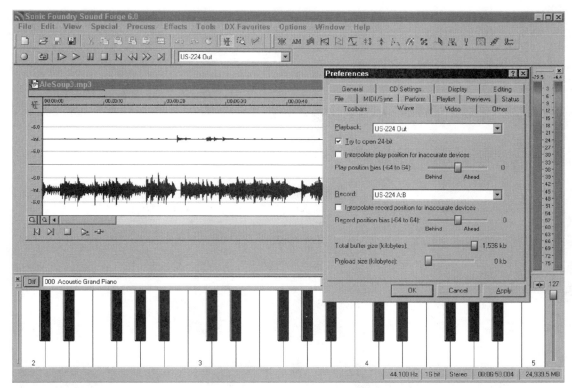

FIGURE 25.7 Sonic Foundry's Sound Forge application allows you to edit any WAV file and add any of dozens of audio effects.

CONCLUSION

Adding audio tracks gives your Poser animations a finished feel. The next three chapters detail additional applications that help you craft Poser soundtracks.

MIMIC

In This Chapter

* Astounding Capabilities
* Running Mimic

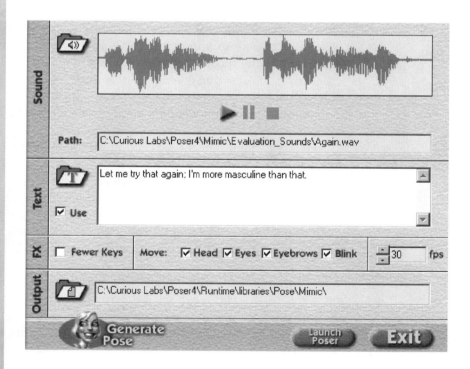

Mimic, from DAZ 3D (*www.daz3d.com*) is a first-rate speech synthesis engine for CuriousLabs' Poser. Mimic is a stand-alone application that greatly enhances Poser's ability to create character speaking animations, by synchronizing the standard parameters of Poser's human models with speech audio files (in the uncompressed WAV format). Mimic makes it very easy to do what has plagued traditional animators for half a century: creating perfect lip-synced audio for a selected character. Mimic generates animation files in the Poser project format (PZ3 files) that are then saved in your Pose Library (Runtime>Librarier>Pose>Mimic) to be accessed directly from inside of Poser.

ASTOUNDING CAPABILITIES

Mimic will produce lip-syncing with just an audio file as input, but accuracy will be increased if a text script of the speech is also supplied. Mimic produces keys for the head morph targets, usually using several dials for each phoneme to fine-tune the resulting mouth shape. Mimic can use just one dial for each phoneme, although the animation quality suffers a bit. Mimic will also automate the head, eye, and eyebrow movements that accompany speech. Some examples of these speech gestures include the automatic insertion of a head nod, an eye blink, or an eyebrow movement at appropriate points in a character's speech.

Mimic is a Windows-only application. Only uncompressed PCM waveform WAV files are supported for the audio input, and text files (txt format) are supported for text input. The Poser model targeted for the Mimic Pose file must have the specific morph targets to which Mimic writes. Mimic uses the following Head Object parameter dials for lip-syncing: OpenLips, Mouth O, Mouth F, Mouth M, Tongue T, and Tongue L. Mimic uses the following Head Object parameter dials for acting: Blink Left, Blink Right, Head Bend, Head Twist, Head Side-Side, LBrowUp, and RBrowUp. In addition, it addresses Left and Right Eye Objects for Up-Down and Side-Side.

Currently, each time Mimic is started, the application will check the system's CD-ROM drive to see if the Mimic CD is in the drive. If the CD is found, the full version of Mimic will be run and can then be used to analyze the user's sound files. After Mimic has been started, the CD can be removed from the drive. Mimic will run in Evaluation mode if the Mimic CD is not in the computer's CD-ROM drive at startup. Evaluation mode only works with the specific audio files that ship with Mimic (Figure 26.1).

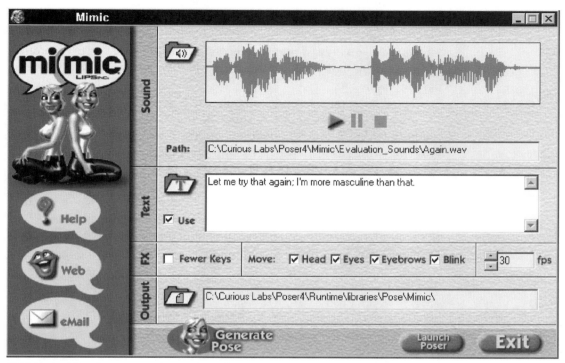

FIGURE 26.1 Mimic's easy-to-understand interface.

RUNNING MIMIC

Mimic operates by allowing you to set the parameters for four distinct elements: Sound, Text, FX, and Output (refer to Figure 26.1).

WAV files act as the audio for your Poser animations. If you have a mic and some sound editing software installed, you can record your own Poser voice files. You can also use non-copyrighted voice data from any source, although segments longer than five minutes are discouraged. When loaded, you will see the waveform displayed in the Sound area of Mimic.

Mimic expects an accompanying text file to be in the same folder from which the WAV file is loaded. The text file is used to shape the Poser Head's features for the animation, so it's important that the text matches the content of the WAV file. Exaggerated spellings create exaggerated mouth shapes for the animation, so the spelling might require some experimentation.

In the FX area of Mimic, you will find checkboxes for Head, Eyes, Eyebrows, and Blink movements. Checking any of these options allows

Mimic to create random pose data for those character features. Since the creation of these attributes is random, changing each time a Mimic file is written out, we suggest that you record at least three seaparte recordings of the data, applying the one that looks best when you apply the Mimic data in Poser.

The final step in Mimic is to create the Poser PZ3 file that will be used to animate the Poser character. This is done by simply clicking the Generate Pose button on the Mimic interface. The Poser data is best saved to a PoserDir>Runtime>Libraries>Pose>Mimic folder.

Once the recording(s) is complete, launch Poser. Load a suitable human character model that will be lip-synced with the Mimic audio. Apply the Mimic pose set to the character and select Yes when asked in the Add Frames pop-up dialog window. Preview the animation, and render if everything looks good. Play the animation, and watch as the character speaks in sync with the audio file.

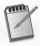
Mimic 1 was purchased by DAZ 3D from LipSync during the production of this book. Its features will no doubt be enhanced by DAZ 3D in the near future, when the next version is released.

CONCLUSION

Mimic has been used by Poser pros to create an array of talking figures. The next two chapters look at two more soundtrack alternatives.

TEXTPUPPET

www.textpuppet.com

In This Chapter

- System Requirements
- The textPuppet Interface

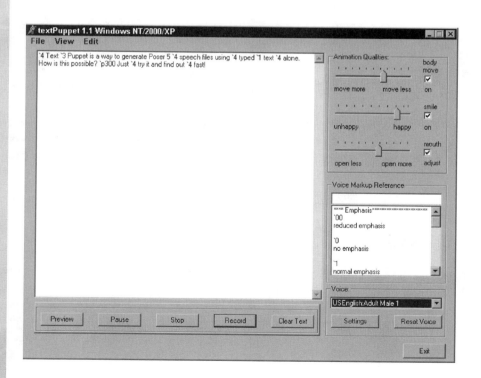

*t*extPuppet (from PuppetSoft LLC) is a speech synthesis system for CuriousLabs' Poser used to produce automatic 3D character speech animation for Poser characters. textPuppet contains a highly user configurable text-to-speech synthesizer that automatically interprets text data for both pronunciation and emphasis, also allowing for further manual fine-tuning via a simple mark-up script. The automatic animation generator also produces realistic blinking, facial expressions, and head and upper-body movements—everything you might want for a talking Poser character. Unlike Mimic (Chapter 26), textPuppet does not input WAV files for audio. Instead, it interprets data in a standard text file (TXT) and transforms it into sound. This is useful for Poser animators who either have no WAV recording capabilities or desire the somewhat more mechanical speech files.

SYSTEM REQUIREMENTS

textPuppet requires Microsoft Windows 95/98/ME/NT/2000/XP with at least 64MB of RAM and a compatible and functioning sound card. An Intel Pentium III 450MHz CPU or faster is suggested. CuriousLabs' Poser 4 or later must be installed as well.

textPuppet is unique, and should be distinguished from Mimic (another Poser speaking application, now owned and distributed by DAZ 3D, covered in the last chapter). It uses synthesized speech versus a prerecorded WAV speech file. It does address the full moving Poser character, however, and works with any needed character camera angles. Since the output is a Pose file, you can apply the speech to any selected Poser character in a scene.

THE textPUPPET INTERFACE

After about 15 minutes of study, any advanced Poser user will know how to use all of the controls in textPuppet (Figure 27.1).

If you look at Figure 27.1, you will see that there are separate controls for customizing your speech files. The large white are is where you can either type the text directly, or where a pre-typed text file is loaded in. You can use the Preview button at any time to hear the text spoken.

The sliders on the right control the non-mouth animated elements of a human Poser character. When checked, they contribute to the saved PZ file. You can control the degree of *Body Movement*, whether the general countenance of the character is *Unhappy/Happy*, and the extent to which

FIGURE 27.1 The main textPuppet interface.

the character's mouth will open (*Open Less/Open More*) when it is speaking the text.

Under that, you can see a scrolling reference for the textPuppet markup language. Because synthesized speech has a tendency to sound fake, textPuppet includes its own markup indicators that can add emphasis/de-emphasis to words, spell words out, and add timed pauses anywhere in the typed text. Here's one example text line using the Markup tags:

```
`4 Text `4 Puppet is a way to generate Poser `4 speech files using
`4 typed `3 text alone. How is this possible? `p300 Just `4 try it
and find out `4 fast!
```

The `number marks are emphasis marks, ranging from `00 (no emphasis) to `4 (maximum emphasis). Question marks are correctly inter-

preted as questions, as different from periods. The `p300 indicates a pause of 1/3 of a second in the speech.

 When using textPuppet, it's a good idea to place a pause at the start of the text. Starting the text at frame 1 often causes glitches in the playback.

Advanced Settings

LMB clicking on Settings>Advanced Settings at the lower right of the main textPuppet interface brings up the Advanced Settings parameter controls (Figure 27.2).

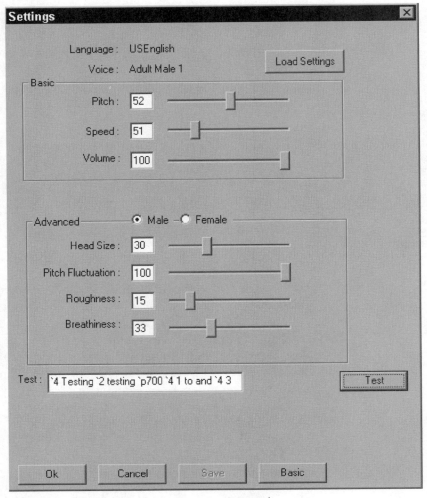

FIGURE 27.2 The Advanced Settings parameter controls.

Here's where you can move any of the labeled sliders to add far more distinctive qualities to the synthesized speech, from gender-specific voice parameters to roughness and whisper qualities. When everything is set and the preview sounds interesting, save the file and its settings and click the Record button. The text file, a PZ file, and a WAV file are saved to a data folder in the textPuppet directory. The next step is to copy the PZ file into your Pose directory, in a folder called Answerman (Poser>Runtime> Libraries>Pose>Answerman>PZ file).

Next, open Poser, load an interesting human character, and apply the textPuppet PZ file from the Pose>Answerman Library folder. Preview, and record an animation using the Face camera when ready (you can use any camera, but that's the standard one for face close-ups).

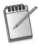 *You can tweak any of the other face parameters allowed for the character. The best characters to apply a textPuppet pose to are the new P5 characters or the DAZ 3D Millennium characters.*

CONCLUSION

textPuppet is an alternative way to create speaking Poser figures. One more alternative is presented in the next chapter.

28

CRAZYTALK

www.reallusion.com

In This Chapter

- Working with Crazy Talk and Poser

Crazy Talk is for users who need to have an image speak, without having to do it in a 3D environment. Any front-facing image will do—human, animal, or alien. All you need is a WAV file with some clear speaking content and a frontal face image from your own files or one of the included presets. The result is an animated face with moving mouth and blinking eyes that speaks the contents of the WAV file. You could apply the speech to any frontal facing head photo, and it's a perfect quick solution for Poser heads as well.

CrazyTalk works by matching the contents of the WAV file to the mouth and eye (for blinking) shapes imposed on the imported image data. Everything is tied to a morphing image map superimposed over the graphic. Pros might want to tweak the point controls of the image map to get a better fit for a customized photo, and this is easily doable inside of CrazyTalk. You can move and adjust the control points for the morphs, and even reduce/enlarge the entire control map. CrazyTalk works best when your image has a slightly open mouth, with no visible teeth. Other than that, the image can be of any face, even a talking mechanical device with no discernable mouth. The effect is a bit like the old *Clutch Cargo* cartoons, where the mouth of a rendered face moves while everything else stands still, except for the blinking eyes. The *Web Edition* is the latest version of the software. You can download the free classic version from the Reallusion Web site.

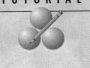

TUTORIAL

WORKING WITH CRAZY TALK AND POSER

Do the following to use CrazyTalk with Poser:

1. Create a suitable front-facing character in Poser, and use the Face camera to do a close-up of the head. Apply some hair, render, and save the image as a high-quality JPEG or a BMP format (that's all CrazyTalk accepts right now). See Figure 28.1.
2. Open the CrazyTalk Fitting Editor, and File>Import Photo to import your Poser head image.
3. Use the fitting controls to move the eye and mouth control points where they belong on the Poser image (Figure 28.2).
4. Save the file, and apply the changes. The image now appears on the CrazyTalk main screen. Text can be added by selecting a WAV file, or by using more synthetic speech from typed-in text (Figure 28.3).
5. Play All to preview, and if everything checks out, save as an AVI animation.

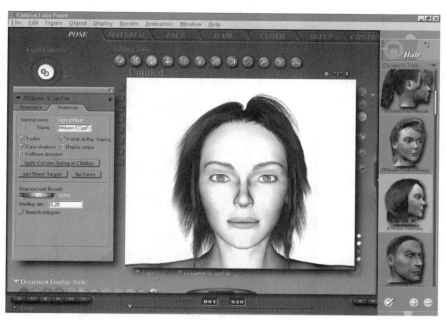

FIGURE 28.1 Create a rendered head in Poser.

FIGURE 28.2 Fit the control points for eyes and mouth to the Poser image.

FIGURE 28.3 The main screen displays both the waveform of the speech file and the Poser face image.

CrazyTalk has both advantages and disadvantages over Mimic and textPuppet (detailed in previous chapters) when you need a talking Poser character.

- With CrazyTalk, no PZ file is involved. That's positive as far as saving some steps, but negative if you want to use other than a frontal view of the speaking character.
- Any rendered Poser character can be made to speak—not just human ones—which is not something supported by other synthetic speech applications.
- The CrazyTalk process is quick, but lacks addressing any character morphs. This results in a less believable mouth movement to shape the speech phonemes.

CONCLUSION

In this chapter, we detailed the use of CrazyTalk as an application that adds speaking tracks to a Poser head.

CHAPTER

29

ADDENDA

In This Chapter

- Terrain Modeling Plug-Ins
- Color Plate Details

O K. Time to tie up the book in a silver bow. This last chapter includes some details about two Poser plug-ins and a concluding section about the color plates in the gallery section.

TERRAIN MODELING PLUG-INS

Since the release of Poser 4, the number of developers who have added quality content to Poser has exploded. You can find these developers at different sites on the Web, but most are also represented at the Renderosity site (*www.renderosity.com*).

Two developers are presented here because they provide the Poser user with a way to generate 3D environmental content inside of Poser itself. Many Poser users port their characters to other applications when they need to place them in 3D worlds. CuriousLabs provides plug-ins for this purpose for 3ds max, LightWave, and Cinema 4D, and the list of supported 3D applications is growing. Some users export their Poser figures to Procreate's (a division of Corel) Bryce or Eon's Vue d'Esprit. Any of these options can help you integrate the right 3D environment for your Poser figures, but wouldn't it also be nice if you could create a quality 3D environment within Poser itself? Two excellent Poser add-on options make this very doable.

3D World Kit

www.daz3d.com

The *3D World Kit* unpacks to about 70MB, so make sure your system has enough storage space to hold it. The 3D World Kit is not Bryce or Vue D'Esprit, because it does not offer all of the terrain modeling bells and whistles of these and other environment creation software applications; however, it will certainly do for many of your Poser projects. The best part of it is that the 3D World Kit allows you to work in Poser, without porting your project anywhere else. This can be a very important consideration for Poser users who are somewhat financially challenged at the moment, lacking the means to invest in other professional graphics software.

The 3D World Kit comes with presets for terrains, cliffs, water, sky domes, new Poser lights and cameras, and the capacity for creating large environment sets for your characters to frolic in. Everything can be positioned and rotated, and in many cases morphed, so fully animated backdrops are easily attained. The content of the 3D World Kit is constantly being expanded for even more environmental variations.

The components of the 3D World Kit are true 3D mesh objects, which is why this Poser add-on demands so much storage space. New 3D content is continuously in development for inclusion in the 3D World Kit (Figure 29.1).

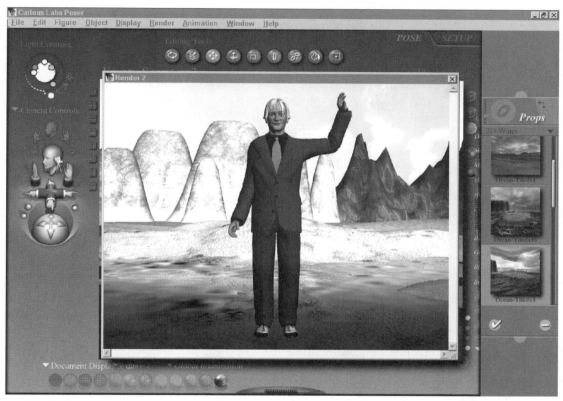

FIGURE 29.1 Using the 3D World Kit, you can add true 3D content to a Poser scene, including cliffs, mountain ranges, and ground options. New Poser lights and sky presets are also included.

WorldZ

www.3dmodelz.com

WorldZ from 3dmodelz is a Poser series of environment *props* that allow you to create land, horizon, and sky content, as well as a poseable moon. Renders are super fast because WorldZ has a remarkably low amount of geometry, depending instead on prioritized image mapping addressed to both planar and curved surfaces.

A tutorial, which launches itself immediately after the product is installed, covers all of the basic operation of WorldZ, although WorldZ is

capable of far more complex renders than those covered in the tutorial. WorldZ offers a high degree of user customization. The basic component pieces of WorldZ includes a Land Plane, Horizon Plane, two Sky Planes, and a poseable Moon. By manipulating these base objects, a wide range of variation is possible. You can customize the background color, object color, object textures, object bump maps, and object transparency maps, working in conjunction with the Material Room features. The Land Plane provides the ground upon which scene content will be placed, using both texture and bump maps to provide a realistic surface. The Horizon Plane encompasses the circumference of WorldZ, the transition point between land and sky. The Horizon Plane uses textures, bump maps, and transparency maps to achieve its variations. The Horizon Plane can be rotated through a full 360 degrees as well as raised or lowered. The Sky Planes (1 and 2) create a multilayered sky, using textures, bump maps, and transparency maps in the process. Sky Plane 1 is the *inner* Sky Plane, the layer upon which clouds can be made to move over the face of the moon. Sky Plane 2 is positioned *behind* the moon, allowing for the positioning of stars and other cosmic elements.

The WorldZ Moon is a morphable object. It can be moved around the sky, resized, and reshaped. The Moon uses textures, bump maps, and transparency maps. A Master Control is used to place the Moon to any desired position in the sky. The WorldZ *add-on packs* are sets of additional textures for use in WorldZ, and also contain some additional props available for free download. *New WorldZ* are *expansion packs*, containing new and specialized geometry. Coming releases include *Space*, *Underwater*, and *Prehistoric* environments.

COLOR PLATE DETAILS

More than likely, you went straight to the color pages when you opened this book. The color plates contained in the Color Gallery section were created by a number of different Poser artists, each with his or her own way of using Poser to create unique images. Here are some details about the color plates.

Color Plate 1: Top

SciFi by S. Brent Bowers

This is the Virtual Brittany character developed by Brent Bowers in Chapter 12, "Character Making in Poser 5." The chapter walks you through the process of using photographs to create both the geometry

COLOR PLATE 1 (Top) *SciFi* by Brent Bowers.

and the texture for a new Poser figure. In the color plate, the Brittany character is artfully placed in a dramatic science fiction scene.

Color Plate 1: Bottom

Victoria 3 from DAZ 3D

If it's photorealism you're after, then this image of the new Poser Victoria model (generation 3) should knock your socks off. Victoria 3 was not yet released as this book was going to print, but this close-up preview is truly amazing, and should whet your appetite for the full model when it hits the market. The DAZ 3D team's previous releases of the Victoria, Michael, and other Millennium models set a new standard for Poser content.

Color Plate 2: Top

Search for a Spy by Lee Chapel

Here are Lee's own words on the creation of this image.

"This picture was originally conceived as a woman hiding behind a pillar and listening to the conversation of two other people

COLOR PLATE 1 (Bottom) *Victoria 3* from DAZ 3D.

COLOR PLATE 2 (Top) *Search for a Spy* by Lee Chapel.

seated at a nearby table. Initially she was dressed in a swashbuck-
ler outfit, but it proved to be a bit too showy, so I changed it to the
hooded robe. The swashbuckler outfit was still used in the wanted
poster that the man is holding in the final picture. The picture on
the poster that the man is holding was created in the Poser sketch
renderer. The sketch renderer is one of the fun things in Poser to
play with; you can create some very nice pictures with it. For the
poster I used the Scratchboard setting with a few minor adjust-
ments. The sketch rendering was in black and white and I used
Paint Shop Pro to add a sepia tone to the image to age it slightly.

"The two women in the picture are DAZ 3D's Stephanie model,
and the man is DAZ 3D's Michael 2 model. The clothing and hair
are all also from DAZ 3D. The tavern, tables, chairs, bottles, picture
frames, and antlers are the creations of Web Vogel and available on
the Renderosity Web site (*www.renderosity.com*) in the Free Stuff
section. The pictures in the frames on the walls are various pictures
I have created, as are the pictures in the centers of the plates over
the fireplace.

"I had to remap the antlers. The original mapping had assigned
the same material to the antlers and the "head" that they were at-
tached to and I wanted them to be different materials. In addition,
the texture template had everything jumbled together so that you
couldn't tell the various pieces apart from each other, making it im-
possible to paint the various parts. I used the free version of
UVMapper by Steve Cox (*www.uvmapper.com*) to change the map-
ping and separate the antlers into three materials: the antlers, the
"head," and the base. (*UVMapper* is a crucial tool for every Poser
user, and is contained on this book's CD-ROM in the Extras folder).
I used Paint Shop Pro to create a new texture map and bump map
for the antlers.

ON THE CD

"It was important to get the people's faces right in this picture.
To set the proper mood, the viewer has to see the concern on the
spy's face, the man's inquiring look, and the lady's attentive gaze.
One thing that helps make faces more realistic is to make the face
less symmetrical. After all, nobody has identical left and right sides
of their face. For example, the spy's right ear is a little higher than
the left ear, and her right eye is slightly higher than the left eye.
You normally don't need or want too big a difference.

"The nice thing with the Millennium figures from DAZ 3D is
that you have lots of parameter dials to play with for creating ex-
pressions. You want to be sure to use multiple dials when creating
a person's expression. You shouldn't use just the Frown dial to

make a Poser figure frown. Of course, in this picture the spy's frown did use the Frown dial, and the FrownLeft and FrownRight dials. The FrownLeft and FrownRight dials were set to slightly different values, making the frown less symmetrical. Using the Smile dial with a negative value helped improve the frown.

"As for Michael, I wanted him show a little age and have him speaking to the lady at the table. I turned the Old1 and Old2 morphs of his face up just slightly, enough to age his face a little. I also used the ForhdWrinkle dial to add the lines to his forehead. The HdNatvAmer dial helped give a somewhat tougher, more rugged look to his face. By using the BrowFrown and BrowWorry dials, I added to the look I wanted. Using a combination of various mouth dials, including the PurseLips, ParseLips, PartLips, Open-Lips, OpenMouth, Smile, and Frown dials, I made him look as if he is speaking.

"Certain parts of a pose can often take a lot of time and patience to get things just right. Getting the hands just right can be a time-consuming task. I had to do a lot of tweaking to the fingers of both Michael and the lady at the table in order to get them just the way I wanted. For Michael, after I got his arms positioned, I used a grasping Hand pose from the Hands library on both of his hands. The arms had to be tweaked a little more after applying the Hand pose to get the hands into the appropriate places around the poster. Once the hands were grasping the poster more or less correctly, I had to go in and tweak several of the finger joints, since some fingers were either not touching the poster or poking through it.

"I wanted the lady's right hand to appear as if she were just setting her glass down on the table. The most difficult part was getting the index finger and thumb to line up properly. Even in the final version they're still a little bit off, but the camera angle prevents the viewer from seeing the flaws.

"Pointing the eyes was also important. For the lady at the table, I created a Ball prop and placed it in the poster where I wanted her to be looking. I then hid the ball by selecting the ball, pressing Ctrl-I, and clearing the checkmark next to Visible in the window that appeared. While the Properties window was open, I also clicked the Select Parent button and selected the poster to be the ball's parent. This way, if I needed to move the poster, the ball would move with it and the lady's eyes would follow the ball (and the poster). Once I had the ball set up, I selected each of the lady's eyes, went to the Object menu and chose Object, Point At;t.;t.;t., and then selected the ball from the hierarchal tree that was displayed.

"I ended up using several Poser documents to create this picture. This saved on memory and made it easier to manipulate objects in the scene. The spy and the main tavern were in the first file I created. The soldier and the seated woman, along with the table and chair and the items on the table, were created in a separate document. A third document contained the plates, fireplace, a picture frame, and the original antlers. The fourth document I created was one that had the various bottles, glasses, the other table, and chairs. I later created another Poser document after I remapped the antlers, as mentioned earlier, which contained only the antlers. (By the time I decided to remap the antlers, I had already imported everything into *Vue d'Esprit* and thus only needed a document containing the new antlers.)

"Each of the Poser documents was imported into Vue d'Esprit, which I had decided to use for the final rendering. The spy and tavern were imported first, so as to have a reference for everything else that would be in the scene. The other Poser files were imported one at a time and the items in them moved into their final positions. Although Vue does an excellent job of importing Poser files, the textures usually need some tweaking. (Make sure you have the latest patch for Vue if you use it, as not all Poser files imported properly in the original version, especially those containing Michael.) The bump maps and highlights are the things that usually need tweaking. The Gain of the bump maps tends to be set higher than is needed, and the highlights often make the skin take on a plastic sheen. In this picture, I made the skin highlights a light pink and set the intensity and size to 50 and 20, respectively.

"The one thing I really like about this picture is how the lighting turned out. The main lights are a point light in the fireplace and point lights in the two lamps. A low-power point light illuminated the spy, suggesting lighting from other lights off-screen. Other low-power point lights illuminated the faces of the man and the lady at the table in order to bring out their features. None of these low-power lights had Shadows turned on; they were added merely to bring out details that would otherwise have been hidden in darkness.

"One thing that caused some headaches was the outfit the lady at the table was wearing. When sitting down, part of the front of the skirt went up into the air, looking very unnatural, and blocking portions of the table and fire. (This tends to often happen in Poser with conforming skirts and dresses.) At first I tried to use magnets to pull the skirt back down onto to the knees, but couldn't get it to

look right. I finally gave up trying to use magnets and imported the figures into Vue d'Esprit as they were. I had to render two versions of the picture, one with the skirt and one with no clothing below the belt. I then used Paint Shop Pro to combine the two pictures. I first loaded the picture with no skirt. Then, I loaded the other picture and added it as a layer on top of the first picture. I used the Lasso tool to select the parts of the skirt that were sticking out in the wrong places and then cut away those areas, allowing the parts of the layer below to show through. When the extra pieces of skirt had been removed, the two layers were merged into a single layer. A portion of the right leg that should have been covered was now bare, so I had to cut and clone parts of the skirt over that area to produce the final version of the outfit.

"I also used Paint Shop Pro to clean up areas where there were odd creases in the joints or skin poking through clothing. For example, the spy had a tiny patch of hair poking through her hood, so I cloned a neighboring area of the hood over the hair. Once all these little defects were corrected, the picture was done."

Color Plate 2: Bottom

Gallery by Shamms Mortier

"I love to create scenes using multiple Poser figures, with several narratives going on at the same time. This scene uses models from DAZ 3D, except for the triceratops sitting in the hand at the back, which is a model from Brycetech. The images in the two framed pictures on the wall are from Celia Ziemer's *Mer* character, referenced in Color Plate 3.

"Although I could have put this scene together in Poser, it would have slowed the program tremendously. Poser does not like to handle a dozen figures in a scene. As a result, I posed each model separately, and saved them out in the 3ds format. I then imported them individually int o 3ds max (version 5) where I composited the final scene. Some of the textures were left as they were in Poser, while others were replaced by 3ds max textures. I used a total of three lights in max to illuminate what I needed to, with one light illuminating just the DAZ 3D Millennium Baby dancing in the foreground. The best thing about using max's lights for Poser components is that you can select which items in a scene to include/exclude from any light's rays."

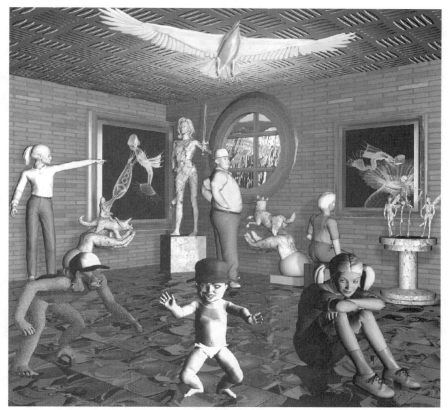

COLOR PLATE 2 (Bottom) *Gallery* by Shamms Mortier.

Color Plate 3

Mers by Celia Ziemer

Celia Ziemer's Poser work stands out as unique and original. You can read her description about the modeling of the Mer creature in Chapter 18, "Modeling a Moon-Faced Mer." Clockwise from the upper left, Celia describes the four images used in this color plate.

Herders

"This is one model with two different head-pieces (a duplicate of the top and back of the head mesh with a center fin) and conformable "tail-sox," rendered in Poser. The Mer-creatures have a low transparency setting (0–25) with a high fall-off, and derive most of their color from colored spotlights (orange, blue, and around 50% gray); their ambient color is black. The object of their

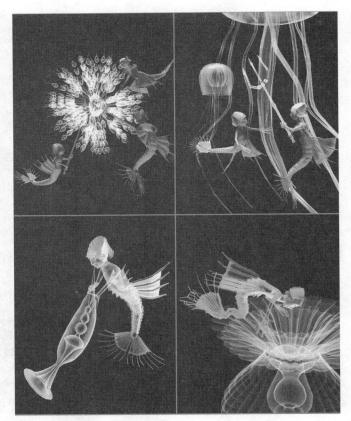

COLOR PLATE 3 *Mers* by Celia Ziemer.

attention is a prop created in Eovia's Carrara using the Digital Carvers Guild's Anything Grows plug-in—its ambient is white, and the transparency is 25–100 with low fall-off."

It Followed Me Home, Mama, Can I Keep It?

"Cultural relativity in the briny deep. The light is one bright spot at the top and three colored fill lights. This has the same colors in the spotlights (if orange light in the briny deep bothers you, assume the presence of a black smoker or underwater volcanism), but more transparency on the Mers. The brightest light was placed above and a little to the left-front of the scene. The jelly creatures have an ambience of approximately 75% white; the jelly-belly on the young Mer is a rescale of the abdomen on the Z-axis and taper on chest and hip. It's not known which child has a new pet."

Whonk!

"There's more transparency and higher ambience this time, and I enlarged the tail-sock to grab more brightness."

Exploration

"This scene has one pinkish spotlight placed at the bottom center of the prop pointed to the Mer's head. I combined a morph target and Taper on the tail fin to get the scraggly look. The transparency on the headpiece is about one-half the transparency of everything else to prevent the back ear's taking precedence. The props in all of these, like the model, were made in Carrara Studio 2."

Color Plate 4: Top

Prairie Dog Serenade by Ken Gilliland

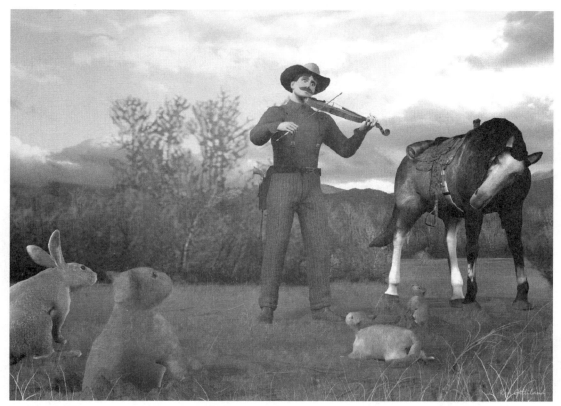

COLOR PLATE 4 (Top) Prairie Dog Serenade by Ken Gilliland.

When it comes to the mastery of the photorealistic narrative, Ken Gilliland sets a new standard for Poser imagery. His compositions demonstrate that the traditional studies of composition still apply in the digital realm. You can learn about his views in Chapter 19, "The Art of Composition," including how this image was put together.

Color Plate 4: Bottom

Junkyard Faeries by Celia Ziemer

COLOR PLATE 4 (Bottom) *Junkyard Faeries* by Celia Ziemer.

Remaining true to her passion for using Poser to create other-worldly environs, this image shows that you don't have to accept Poser figures as they come out of the box. Celia's work teaches you that there are many worlds waiting for your creative Poser exploration.

Color Plate 5: Top

A Taste of Creole by Gregory L. Henle
Read Chapter 21, "Texture Hints and Tidbits, to learn how one of the most respected Poser artists around creates image content. Mr. Henle's work is both seductive and playful.

COLOR PLATE 5 (Top) *A Taste of Creole* by Gregory L. Henle.

Color Plate 5: Bottom

The Wall of Faces by Ralf Zeigermann

In his own words, here is what Mr. Zeigermann has to say about this image:

> "*The Wall of Faces* is a combined Poser/Bryce project. The different heads were all created in Poser, using DAZ 3D's "Victoria" character. In Bryce, a terrain was set up for the wall. The structure was achieved by simply doodling with a fine brush all across the terrain in Bryce's Terrain Editor. The heads were imported into Bryce, smoothed, and placed on top of the terrain and a texture was applied. Six spotlights create the eerie atmosphere."

Color Plate 6: Top

Dragon Lullaby by Sandra Haverty

In her own words, here is Sandra's description of the Dragon Lullaby color plate. One thing should be noticed here, which is that the free

COLOR PLATE 5 (Bottom) *The Wall of Faces* by Ralf Zeigermann.

downloadable content available at Renderosity (*www.renderosity.com*) can be used to your great advantage to create Poser images.

"The idea for *Dragon Lullaby* came from several books, as well as my interest in Fantasy Art. I very much enjoy the author Charles Delint and the magical world he portrays in his books, and I love dragons.

"The first thing I did was download the Toni model by Dave Matthews from the Capsces site. Toni is a P4 female with a cat's head and tail. She comes with Capsces 9 lives cat morphs, so it was easy to morph her into a fox-headed woman. I then ran her through UVMapper, and created a texture map. I loaded the texture into PaintShop Pro 7 and painted the texture. I would first paint a section, and then render her in Poser to check that the seams matched and that she was red where she should be red and white where she should be white. Once I got the texture finished, I bought Valandar's wonderful Dracos Titanicus from the marketplace at Renderosity. While I was there, I downloaded the red texture for it by Masqurade, and the Sleeping Dragon pose made by IvyRoses. I then went to PoserWorld and downloaded the Shania

COLOR PLATE 6 (Top) *Dragon Lullaby* by Sandra Haverty.

Fantasy outfit and the Shania Fantasy headpiece to dress my Foxy-lady in. When I got the Fantasy outfit conformed to her body, I had to make her toes and feet invisible in Poser and scale her forearms down a bit, since those body parts stuck out. I scaled the headpiece larger to fit over her slightly furrier hairdo.

"I put Draco in the workspace with her and applied the Sleep-ing Dragon pose. From there, it was easy to raise and tilt his head a bit and to move his paw out, so the Foxylady would have a place to sit while she played and sang him to sleep. I already had Robin Woods' gorgeous lap harp (*www.robinwoods.com*), and I purchased the extra textures and the pose from her. I applied the pose and im-ported the lap harp. I had to scale it down a bit and move it into her lap, and then I parented it to her left shoulder, as Robin suggested. By moving the Trans parameter dials I was able to move her into position on Draco's leg. Next, I opened the Campfire OBJ file that I had downloaded (made by Mike and Sharon Custer at Sams3D)

and scaled it down and moved it over to where it would shed a little light on their enjoyment. I next downloaded a nice low-res tree from Renderosity's Free Stuff site, and imported, scaled, and moved it behind the figures.

"Then I started working on the lighting. I started out by making a pale blue light, infinite, no shadows, and set at 150% intensity. Next was a clear blue light, infinite that cast shadows set at 200% intensity. Those two made the moonlight. Next I set a light inside the campfire with no shadows, a light-yellow color, and set the intensity at 140%. The last light was a pale greenish spotlight set below the campfire and set at 35%, with shadows to mellow out the campfire. I imported a starry night background and rendered the image at 1040, 300psp with Antialias on. I saved the render as a high-quality JPG. For post work, I opened the JPG in PaintShop Pro and used the Push tool to make Foxy look furrier. Then I loaded it into PaintShop Pro again and used the flame tube to make the fire. I smudged the flames to make it look more realistic, and added a few fireflies from a *tube*. Last, I used the AlienSkin Eyecandy3000 plug-in to make the smoke, completing the image."

Color Plate 6: Bottom

The Fountain of Time by Shamms Mortier

In this image, the models were exported from Poser in the Wavefront OBJ format and imported into Procreate's Bryce, where the scene was composed. The scenic content was originated in Bryce, and all of the Poser models were from DAZ 3D. This image was used as the cover for *The Poser 4 Handbook* from Charles River Media.

Color Plate 7: Top

Beyond the City by Terri Morgan-Lindsey

Here are Terri's own words to describe the details of this color plate:

"I used the following models from DAZ 3D to create this image: Michael 2.0, Morphing Trench Coat, Michael Suit Coat Pack Shirt, and the Priest Shirt MAT.

"The following models from PoserStyle were used: Jeff2k texture for Michael, Cyber Ronin pants and boots, and the Cyber Ronin texture map by Zrincx.

"The following props were used: Plasma Rifle by Questor and the Cyber Ronin Visor.

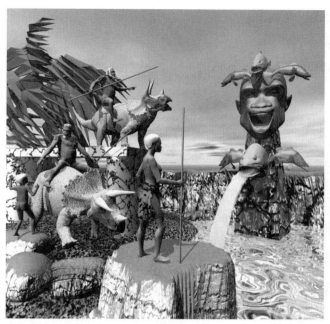

COLOR PLATE 6 (Bottom) The Fountain of Time by Shamms Mortier.

"The background image was modeled and rendered in Vue d' Esprit and imported into Poser for the final render. Post work was done in Photoshop.

"One of my favorite genres is sci-fi, although most of my Poser work is the typical female medieval–barbarian style themes. A good friend suggested that I try doing a sci-fi image, and the idea of "Beyond the City" was born. I knew I wanted something along the lines of *Blade Runner/Matrix/Pitch Black* and having just joined Poserstyle, I found the perfect texture to achieve that renegade bad boy look.

"Posing was a challenge. I tend to pose the figures without clothing to make sure I don't have any odd joint distortions. Once posed, I add clothing. This usually presents a few problems with clothing meshes as they tend to stretch in odd ways at times. Once the clothes are added and textured, I check again for distortion and the feeling of "movement." Alone, the pose was rather plastic, so I added the trench coat and used the morphs to give a feeling of sudden movement. The guns were then added and the pose readjusted, although the coat required some minor tweaking.

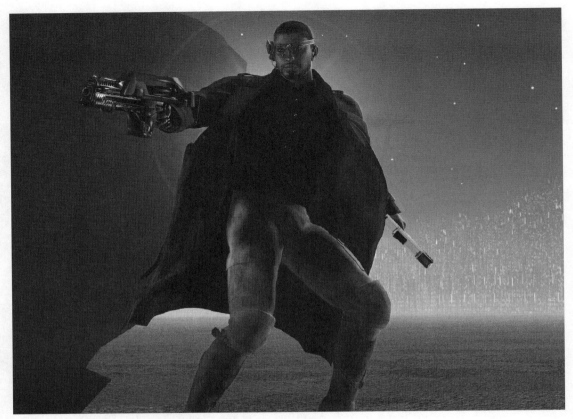

COLOR PLATE 7 (Top) *Beyond the City* by Terri Morgan-Lindsey.

"Lighting was a challenge. Night-time images pose a problem in balancing enough light to illuminate the figure without appearing to be "spotlighted." Since there was a helicopter light behind the figure, I put an infinite light directly behind the figure and dialed the intensity up to 300%. This gave a nice backlight that helped blend the Poser figure in with the Vue background. Four other lights were used to bring out the details of the clothing and facial expression. Three were grouped just above and to the left of the figure using a variation of the three primary colors. Blue, cinnamon, and yellow lights were positioned in an equilateral triangle. The blue light was dialed to 70% intensity and set as a spotlight. The cinnamon and yellow lights were set at 30% infinite lighting with the Cast Shadows turned off. The forth light was set to the lower left at 40% infinite with a light blue color.

Chapter 29 Addenda **443**

"The image was rendered at 3000 x 3000 at 800dpi and exported to PSD format for importing into Photoshop. I really don't have a hard-and-fast formula that I use in post work; rather, I prefer to experiment with different effects. Generally, I try to get the image as close to my idea as possible and use minimal post work painting. With the image in Photoshop, I created a separate layer set to the screen and began enhancing the lights and shadows with a size 9 brush. Another layer was added to enhance the trench coat edges and add a reflected glow to the chrome on the guns."

Color Plate 7: Bottom

Reading Comics by Shamms Mortier

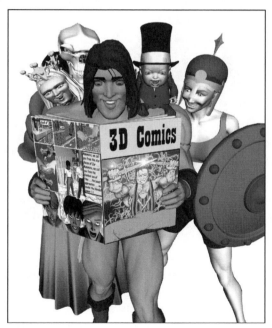

COLOR PLATE 7 (Bottom) *Reading Comics* by Shamms Mortier.

A group of Poser figures is gathered around a character reading a comic book. All of the figures were tweaked from DAZ 3D models. The cover of the comic book was created separately and mapped onto a comic book object (created in 3ds max). This image was used for the cover of the book *3D Comic Design* from Charles River Media.

Color Plate 8: Top

The Three Guardians by Shamms Mortier

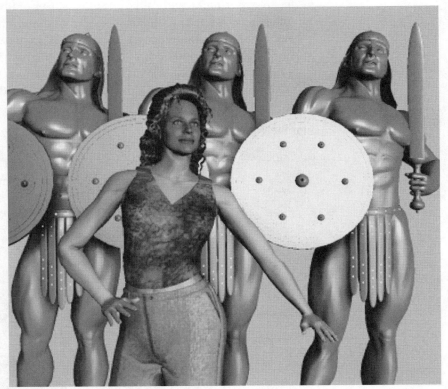

COLOR PLATE 8 (Top) *The Three Guardians* by Shamms Mortier.

"This is the image that was used for the cover of this book. The female model is the new Judy figure that ships with Poser 5. She is sporting a Poser 5 hairpiece, which was tweaked in the Hair Room. The texture for her jacket was created in the new Material Room, using a Marble material. The figures in the background were created in Poser 4, and saved and exported as OBJ models with separate groups switched off. This was done in order to be able to apply a single material to them in the material Room in Poser 5, so that they would look more like statues than organic figures. Interestingly, the three warriors are really about twice the size of the Judy figure. This was done to give them an exaggerated perspective and a look of gigantic proportions. Crafting the lights took a while, since I wanted to keep some shadowing but also

needed major lighting on the main figure. This was accomplished by using color tinted lights, and also by turning the luminosity of all but the main figure light down to about 40%. The single bright shield was a lucky rendering accident, since it balances and brings out the main figure nicely."

Color Plate 8: Bottom Left

Cone Hair by Shamms Mortier

COLOR PLATE 8 (Bottom Left) *Cone Hair* by Shamms Mortier.

"This is an example of how you can use a warped mesh to create a base for hair in Poser 5. The mesh was created in 3ds max 5, and consists of a dense Cone primitive bent on its vertical axis. This was imported into Poser 5's Hair Room, and used to create the hair model, which was then parented to a stand-alone head. This hair model has about 8000 separate hairs. I suppose this same model, perhaps straightened out, could also suffice for a fir tree."

Color Plate 8: Bottom Right

Comics Page by Shamms Mortier

Poser sets the standard when it comes to using 3D software to create comic book figures. This is one page from the *3D Comic Design* from Charles River Media.

COLOR PLATE 8 (Bottom Right) *Comics Page* by Shamms Mortier.

WELL . . .

In the words of a famous cartoon character, "Tha, uh tha, uh that's all folks!" Hopefully, this book has aided you in your creative Poser pursuits, and will continue to serve you into the future. Keep on Poserating!

A

ABOUT THE CD-ROM

The companion CD-ROM to *The Poser 5 Handbook* includes all of the files necessary to reference the tutorials in the book, chapter by chapter. There are almost 600MB of content on the CD-ROM. The content and can be found in the following folders:

- **Anims:** Almost 100MB of animations are included in this folder. The animations were created in both Poser 4 and Poser 5.
- **Extras:** There are two subdirectories in this folder: UVMapper and Carrara. The UVMapper folder contains the classic version of the UVMapper software. The Carrara folder contains a demo version of both Carrara 2 and Amapi 6.1. Of high interest to Poser users, there is also a subfolder of tutorials on creating clothes in Amapi.
- **Models:** This folder contains over 300MB of free and unique Poser models in 10 subdirectories.
- **Scenes:** In this folder are two Poser scenes (PZ3 files).
- **Textures:** Look in this folder for over 50MB of bitmapped textures that you can use as channel content in the new Poser 5 Material Room.

System Requirements

500MHz Pentium class or compatible (700MHz or greater recommended); Windows 98, 2000, ME or XP; 128MB system RAM (256MB or greater recommended); 24-bit color display, 1024 x 768 resolution; 500MB free hard disk space; CD-ROM; Internet connection required for *Content Paradise*, a new Poser 5 content Web connection utility.

CONTRIBUTOR BIOGRAPHIES

Many of the individuals and organizations that contributed content for and advice on this book have been kind enough to submit biographies and site information for inclusion here.

3DMODELZ

3dmodelz is a trio of independent modelers from England. The fusion created by bringing together three very different styles and sets of techniques, has resulted in 3dmodelz developing its own inimitable, and often slightly weird, style. Working with different platforms to achieve different results, 3dmodelz produce both retail and free items of consistently high quality.

The People Involved with 3dmodelz

Paul DeWinter: Paul has an extensive wealth of experience in both computer design and artistic creation. Coming from a literary and artistic background, Paul strives to create ever-better glimpses of his soul, via the conduit of his imagination. Having taught 3D design for several years, he decided to become a freelance illustrator/designer, allowing himself to do what he loves most—create things just for the sheer pleasure of doing so.

Matthew Rolfe: Matthew brings a variety of skills to the 3dmodelz melting pot, foremost of which is his experience in research and development with an international games producer. His prior experience as an

engineer and his resultant vast knowledge has also paid unexpected dividends. Matthew's very mathematical style provides a counterpoint balance, which keeps the collective feet of 3dmodelz firmly on the ground.

Andrew Rolfe: Andrew is the crossover point between the mechanical and artistic aspects of 3dmodelz, combining experience in both fields. Dealing with the administration of the 3dmodelz Web site, he has less time for creating 3D, but when he does, he manages to combine the best of both disciplines, and produces some of 3dmodelz more esoteric items.

BRENT BOWERS

Brent Bowers is a full-time Web designer, graphics artist, and the creator of PoserCity.com, an online community for Poser artists.

LEE CHAPEL

(In his own words.)

> I first started with Poser when I saw copies of Poser 2 and Bryce 3D at a reduced price and decided to purchase and experiment with them. I didn't do much with Poser 2; the characters were pretty crude at that time. The figures were improved in Poser 3, and I've been using Poser figures in most of my pictures ever since, upgrading as each new version comes out. I think that of all the graphics programs I've purchased over the years, Poser is my favorite.
>
> I'm not a professional artist, but work as an Information Systems analyst in the Illinois Environmental Protection Agency's Bureau of Air. A large part of my job is taking care of help desk calls, network administration, and setting up and installing new computers. I occasionally use my talents with Poser and other 3D programs to create graphics for the Bureau of Air's intranet. A collection of some of my better pictures can be found on my Web site: *http://members.aol.com/leec279241/index.htm.*

SANDRA HAVERTY

Sandra has worked with many craft forms over the years, including fabric art, needle work, acrylic, and digital art using PaintShop Professional.

She learned how to use Poser through tutorials found on the Web and through the kind help of many generous, knowledgeable people.

GREG HENLE

(In his own words.)

My interest in 3D began with drafting and advanced mathematics in school, which lead to a career as an operator of a commercial nuclear reactor and then finally progressed to CAD (2D) for the U.S. Defense Technical Information Center. After working for 10 years in places that tended to have very thick walls and very heavy steel doors, it was time to call it quits. I took a job at the Quantico FBI Academy as a landscaper. I also began to expand on the year of Art One I took in school, and started to draw sci-fi and fantasy art that has always interested me. When 3D applications such as trueSpace, Poser, Ray Dream, etc., became available, it was only natural that I take an interest.

TERRI MORGAN-LINDSEY

(In her own words.)

Terri is a Web designer for her company Dark Swan Productions. A full-time mother of three daughters, she is a self-professed Poser addict and computer geekette. It has been alleged that she subsists on a diet of soda and nicotine; however, the rumor cannot be substantiated, as our correspondents have never returned. "If it weren't for Poser, I'd need Prozac."

SHAMMS MORTIER

Shamms is the author of the Poser and Bryce Handbooks, as well as other books, from Charles River Media. His design and audio studio, Eyeful Tower Communications, is in Bristol, Vermont, at the foot of the mighty Hogback Mountains.

POSERWORLD

PoserWorld was created in May 1999 and eventually become a subscription access site in June 2001. PoserWorld Subscriptions has an archive of nearly 6GB of Poser clothes, models/props, textures, and characters. In addition to being a private access site, it also has a forum where subscribers can request items to created and placed on the subscription site. PoserWorld differs from other sites because it is updated several times a month, has high-speed downloads and a great forum for the subscribers. The content on PoserWorld is of the highest quality, and the site personnel are always ready to answer questions and support. All content on PoserWorld Subscriptions is royalty free for commercial use, so there are no limitations as to what the content can be used for. For more information or to preview the site content, please visit *www.poserworld.com*.

RENDEROSITY

www.renderosity.com

Renderosity, the world's largest online graphic artist community, began in 1999 and has grown to 90,000 members in 134 countries. Renderosity was born out of the 2D/3D graphic arts industry's need for a medium of communication that would link this diverse, international group. The name was created and approved by the online community. The site has 54-million hits and 10-million page views per month. Membership is FREE. The community is made up of members who have a passion for helping others learn, share, and grow in 2D/3D art. Renderosity is a very vibrant, interactive community with forums, content, and a marketplace for 2D/3D products.

A. WYCOFF

(In his own words.)

> *www.cmccomplete.com/Entertainment/Free_Models/free_models.html*
> *www.renderosity.com/softgood.ez?Who=awycoff*

While working as a marketing supervisor for an insurance company, I couldn't find the exact clip art needed for a presentation—saw Poser and bought it on a whim. That was over seven or eight years ago and I'm still using Poser.

For business, I am a database administrator and consultant for Complete Multimedia Corporation. For fun, I build computer systems for myself and select friends and family members. Modeling is the dichotomy of my existence. It is the most relaxing and most stressful thing I pursue. Whatever I see, wherever I go, whatever I do, somewhere in the back of my mind is the thought that "this would make a great model or this would be easier to understand if it had a Poser animation." At the movies, my eyes see the switch from actors to real 3D actors, and like the movies, my world is a blend of real and make believe.

RALF ZEIGERMANN

Ralf was born in 1960 in Dortmund, a dull and gray city in Germany's industrial area, the so-called "Ruhrgebiet." After his graduation as a graphics designer, Ralf worked as an art director for several ad agencies in Düsseldorf, Hamburg, and Chicago. He now lives in London, working as a freelance creative director, traveling all over Europe wherever he's needed for creative solutions and concepts. Besides his advertising work, Ralf has written and illustrated a *novel—The Diary of Peter Ludwig Fal— Antarctic Expedition 1931/32* and published a book with his cartoons. He also designed several books for Cambridge University Press, and his illustrations have been published in several German magazines. He has now swapped pen, ink, and markers with Bryce, Vue d'Esprit, and Poser, achieving almost photorealistic results in a fraction of the time needed when using traditional materials. He still enjoys cartooning.

CELIA ZIEMER

Celia is an artist and illustrator whose studio is in the San Francisco area. She has created covers and tutorial art for a number of magazines, and her art can also be appreciated in previous Poser Handbooks, as well as in the Bryce Handbooks.

C

VENDOR CONTACT DATA

Vendor contact data, usually in the form of a Web URL, is folded into every chapter of the book where a vendor is mentioned. Just to underline the importance of a few specific vendors, however, some important contact information is repeated here.

www.curiouslabs.com

CuriousLabs and the development team responsible for the creation of Poser 5.

www.charactermotion.com

Credo Interactive, the developers of LifeForms and various BVH Motion File CDs.

www.charlesriver.com

Charles River Media, the publishers of *The Poser 5 Handbook* and an array of additional graphics and animation titles. You'll also find a helpful monthly newsletter with up-to-date product information on the latest graphics and animation news.

www.daz3d.com

DAZ 3D, the vendor that markets loads of high-quality content for Poser and the Mimic speech synthesizer application.

Check these sites regularly to stay informed.

D

POSER RESOURCES ON THE WEB

There are a number of Web sites that you should browse now and then to check for updated Poser content. Besides those listed here, you can find dozens of others by simply typing the word *Poser* in your favorite search engine.

www.curiouslabs.com

Check the CuriousLabs site at least once a week. This is where you will find downloadable upgrades and bug fixes, information on coming releases, and loads of new content.

www.daz3d.com

Every week, DAZ 3D posts a new freely downloadable model or another Poser-related item. DAZ 3D also keeps the Poser community updated with news of upcoming releases, and acts as a broker for many Poser content developers. Make sure you check this site regularly.

www.renderosity.com

This site has over 3GB of free Poser content downloads, as well as many more GBs of economically priced commercial content. More than that, Renderosity acts a central clearing house and data link to dozens of other Poser content developers.

Index